Sir Joshua Reynolds

THE PAINTER IN SOCIETY

Sir Joshua Reynolds

THE PAINTER IN SOCIETY

Richard Wendorf

HARVARD UNIVERSITY PRESS
Cambridge, Massachusetts
1996

Designed in Minion by Annamarie McMahon

Publication of this book has been aided by a grant from
the John Simon Guggenheim Memorial Foundation

Library of Congress Cataloging-in-Publication Data
Wendorf, Richard
Sir Joshua Reynolds : the painter in society / Richard Wendorf.
p. cm.
Includes bibliographical references and index.
ISBN 0-674-80966-1 (alk. paper)
1. Reynolds, Joshua, Sir, 1723–1792. 2. Portrait painting—18th
century—England. 3. England—Social life and customs—18th
century. I. Title.
ND1329.R4W46 1996
759.2—dc20
95-51750

For Charles Ryskamp

Contents

Illustrations

Following Page 80

COLOR PLATES

A fifth law of nature is *complaisance; that is to say, that every man strive to accommodate himself to the rest.*

<div align="center">

Thomas Hobbes, Leviathan

</div>

Be as select in those whom you endeavour to please, as in those whom you endeavour to imitate. Without the love of fame you can never do any thing excellent.

<div align="center">

Sir Joshua Reynolds, fifth discourse

</div>

The Enquiry in England is not whether a Man has Talents & Genius, But whether he is Passive & Polite & a Virtuous Ass & obedient to Noblemen's Opinions in Art & Science. If he is, he is a Good Man. If Not, he must be Starved.

<div align="center">

William Blake, annotating Reynolds's Discourses on Art

</div>

I must own in walking round the room and perpetually coming to the same thing, I felt a sort of contempt for a man who could pass forty years in painting cheeks, noses, & eyes, with no object but individual character, and no end but individual gratification.

<div align="center">

Benjamin Robert Haydon, after viewing the first retrospective exhibition of Reynolds's work, in 1813

</div>

Introduction

This book explores the enterprise of portrait-painting and the process of social formation in eighteenth-century England. It has been conceived as an experiment in cultural history, written along the fault lines that separate (but also link) the disciplines of art history and literary studies. I argue that an examination of two complicated and intertwining issues is essential to an understanding of portraiture as a historical as well as an aesthetic phenomenon: the question of how portrait-painting is embedded in the social fabric of a given culture, and the question of how portraiture emerges from the social and professional transaction between the artist and his or her subject. I address these central issues by focusing on the relationship between one painter and the society in which—as exemplar as well as chronicler—he was so fully implicated.

In the course of this book I pose a number of central propositions about Sir Joshua Reynolds and the forms of portraiture he practiced. In Chapter 1, and only somewhat less directly in the four chapters that follow, I attempt to recover what I call the discourse of complaisance and complacency, and to suggest the significance of such an ideological system within an aristocratic culture so very different from our own. In examining the complicated arts of pleasing in eighteenth-century England, I place Reynolds within this discourse—and within

a still broader cultural environment marked by deference and pa-tronage—as an example of how people of comparatively modest ori-gins could be almost universally acknowledged to embody contem-porary principles of politeness and amiability once the traditional templates for the "well-born" or "well-bred" person had been dissem-inated within an increasingly public sphere.[1]

That Reynolds was a carefully constructed character there can be little doubt. It is quite difficult, however, to gauge just how quickly and easily the process of self-fashioning took place. While traveling in Scotland, Samuel Johnson argued that "all good-humour and com-plaisance are acquired. Naturally a child seizes directly what it sees, and thinks of pleasing itself only. By degrees, it is taught to please others, and to prefer others; and that this will ultimately produce the greatest happiness. . . . Common language speaks the truth as to this: we say, a person is well-*bred*."[2] In Reynolds's thirteenth discourse on art, moreover, which he delivered in 1786, near the end of his life, the painter reflected on the importance of artistic "sagacity" or "intui-tion," "the accumulated experience of our whole life, [which] has been collected, we do not always know how, or when."[3] I demonstrate, in Chapter 1, how assiduously Reynolds gleaned advice on comportment and behavior from the influential treatises and essays of the period; and in the final chapter I suggest that his early friendships with the Keppels and Edgcumbes—which eventually led to his voyage to Rome—must certainly have played a central role in his personal as well as professional development.

For a young Edgcumbe or Keppel, this process came naturally. Their social development was strongly influenced by what Pierre Bourdieu has called the "habitus": a process of conditioning in which individ-uals adopt the manners and attitudes appropriate to their social sta-tion through their physical environment and personal relationships. Bourdieu sees this as an automatic, virtually unconscious process that, like Reynolds's "intuition," instills knowledge without concepts.[4] In-dividuals ("agents," in Bourdieu's lexicon) are placed in "homoge-

neous conditions of existence imposing homogeneous conditionings and producing homogeneous systems of dispositions capable of generating similar practices."[5] The cultural work of the habitus provides an answer, in other words, to the question (half-query, half-lament) raised by Reynolds's contemporary, Edward Young: "Born *Originals,* how comes it to pass that we die *Copies?*"[6]

For Reynolds, the internalization of a habitus predicated on gentility and aristocratic privilege must have been based on close observation by a partial outsider: someone who had one foot in the door, so to speak; someone who was welcome within, but who was not an actual inhabitant; someone whose own habitus was meant to prepare him for a rather different role in life (that of an apothecary or country physician). But even had this been the case, Reynolds was determined to step outside the habitus of his local Plympton. Here is how his apprentice, James Northcote, himself recently arrived in London from the West Country, put it in a letter home: his master "thinks that had he been breed a Surgeon he should not have been obscure, for as fame was allways his desire he would have study'd physick and at least have attemted if not realy made the greatest physician in the world for you know it is his oppinion that a man who makes a great advancement in any art or science would have done the same in any other if chance had thrown it in his way."[7]

But Joshua Reynolds decided, at an early age, to become a painter, and by the time he was my age—forty-seven—he had become the most successful practitioner of his art in British history: sought after, wealthy, caressed (as his contemporaries would have said), knighted by the King, prevailed upon to serve as the first President of the Royal Academy. The argument I pursue throughout this book is not only that the mature Reynolds embodied the virtues of polite behavior that formed the bulwark of social decorum at the time, but that it was this very integration into society that enabled him to attract (and keep) such a diverse and illustrious clientele during a career spanning forty years (and, I should add, to produce likenesses that were both picto-

rially fresh and representationally convincing). His was, in other words, a *double* art of pleasing, with experience gained at the table or in the club directly influencing the social and aesthetic environment of his octagonal painting room.[8]

In elevating himself, moreover, Reynolds was widely (but not unanimously) perceived as simultaneously raising the entire profession of painting in England. But there was, ironically, a price to be paid by Reynolds's sister, Frances, within what she called the "private domestic sphere" of her brother's household. By raising his family to a higher social station (one of his nieces would eventually become a marchioness), Reynolds was inevitably placing restrictions on his sister's aspirations as a painter, poet, and essayist. For Frances Reynolds to practice her art in any meaningful way meant that she risked sacrificing her own—and her family's—claims to gentility and social respectability. Her troubled life stands, in part, as a counterweight to her brother's successful career, and I therefore examine her divided loyalties at some length in Chapter 2.

As I map the social and professional worlds in which Reynolds practiced his art, moreover, I posit and develop a transactional theory of portraiture. Such a theory, which insists on the social, intellectual, and commercial compact entered into by an artist and his or her subjects, challenges much traditional thinking about portraiture by drawing particular attention to the complicated dynamics of the studio and the sitting: to the importance, that is, of the environment and process out of which the finished canvas emerges. I propose, for instance, that among the many other things it is, a portrait is always a record of the personal and artistic encounter that produced it. One might wish to qualify this proposition in a number of ways, as I have elsewhere done,[9] but it nevertheless remains the case that portraits are "occasional" not only in the sense that they are closely tied to particular events in the lives of their subjects, but in the sense that there is usually an occasion—however brief, uncomfortable, artificial, or unsatisfactory it may prove to be—in which the artist and his or her

subject directly confront each other. The encounter a portrait records is most tangibly the sitting itself. These sittings are social occasions as well as working sessions for the artist; and it is therefore also true, I would argue, that the relationship between artist and sitter recorded in the portrait has the capacity to suggest as strongly as any other feature the character of the individual who has been portrayed.

The sitting itself may be brief or extended, collegial or confrontational. Consider, for a moment, the testimony of two modern photographers. Henri Cartier-Bresson has expressed his passion for portrait photography by characterizing it as "a duel without rules, a delicate rape." Taking a portrait, he argues, "is like a courtesy visit of fifteen to twenty minutes. You can't tie people up for a long time when you're like a mosquito that's about to bite."[10] Metaphors such as these, violent and combative in both vehicle and tenor, contrast quite sharply with Richard Avedon's conception of a sitting: "I often feel that people come to me to be photographed as they would go to a doctor or a fortune teller—to find out how they are." (Or, as Hazlitt put it, who or what they really are.)[11] Cartier-Bresson reveals himself as an interloper and opportunist, whereas Avedon confesses—perhaps uncomfortably—to a role as diagnostician and (by implication) psychic healer: not as someone who necessarily transforms his subjects, but as someone who reveals their essential nature.

In the paradigm that Cartier-Bresson suggests, the artist virtually stalks his prey; in Avedon's view, on the other hand, the sitter actively searches for the artist, trusting that the therapeutic nature of the sitting, like the portrait which is eventually produced, will lead to a form of self-knowledge that has not otherwise been gained. Cartier-Bresson threatens to seize an interpretive likeness, whereas Avedon's sitters believe they will be given something in return for their cooperation. Both photographers appear to agree on one premise, however, which is that the fundamental dynamic in this process—whether successful portraiture be viewed as capturing, revealing, or transforming its subject—lies squarely in the hands of the artist. Even Avedon's sitters are

"dependent on me," he says. "I have to engage them. Otherwise there's nothing to photograph. The concentration has to come from me and involve them."[12]

The transactional view of portraiture that I explore in this book has its roots neither in confrontation nor in consultation, but in active collaboration between the artist and his or her subject. Whenever possible, Reynolds worked closely *with* his sitters, carefully determining the most appropriate setting and pose before rehearsing and building the scene he was to capture. Given Reynolds's predilection for the stage—let alone the artful fashion in which he managed his sittings—one almost automatically finds oneself drawing upon theatrical metaphors in order to describe the nature of this collaborative relationship. But as I argue in Chapter 4, the affinity between the theater and the characteristic forms of Reynolds's portraiture is actually based on the performative nature of both enterprises, with performance itself defined in broad, rather than restrictive, theatrical terms. I therefore adapt performance theory, and in particular an anthropological conception of performance, as I suggest the affinities between portrait-painting and the many other cultural activities that participate in what Richard Schechner has called "restored behavior."

I conclude this book by showing that even though Reynolds was as adept at manipulating the contemporary patronage system as he was in managing his business affairs and pleasing his clients, he was nevertheless caught up in forces near the end of his career that he could no longer control. By closely examining the so-called Bonomi affair of 1789–90 at the Royal Academy—and by suggesting that it served as Sir Joshua's French Revolution—I attempt to show how the divisive battles within a cultural institution directly mirrored and inscribed the pressing social and political issues upon which Reynolds's closest friend, Edmund Burke, was already beginning to reflect. This difficult episode exposed the limits of Reynolds's constitutional complacency as well as the impatience and even outright rebelliousness of his younger, more democratic colleagues.

Reynolds had been born into a world defined by rank and privilege, deference and obligation: what Samuel Johnson called "the great system"; what Isaac Kramnick has recently called "the static stratified society of ascription."[13] Unlike some of his contemporaries—Gainsborough, Fuseli, and Blake immediately come to mind—Reynolds carefully husbanded his considerable talents within this system, remarking at one fateful moment that "I go with the great stream of life."[14] And yet his reputation as a painter has always been based on his sensitive and even heroicizing portraits of similarly talented men and women—the writers, actors, scholars, and statesmen of his age—as well as on his imaginative, pictorial reinforcement of an aristocracy that may have begun to lose confidence in itself (in David Solkin's extreme but provocative view).[15] By the time Reynolds died in 1792, England was still far from embracing the sweeping reforms that would make "a society of achievement, a social order of competitive individualism" possible. And yet (to invoke Kramnick's categories a second time) he did thrive within a society in which, at least in his case, "social mobility was possible and the rightful reward for ingenious people of talent and hard work."[16] Reynolds's troubles at the Royal Academy remind us, however, that it is possible to embody a certain kind of social and professional achievement while simultaneously becoming recalcitrant, ossified, even reactionary in the process.

It is my hope that a different Reynolds will emerge in this book: more sharply defined, more fully fleshed, more capable of provoking ambivalence in the responses of his friends and colleagues—and ultimately in us as well. The evidence of Chapter 1, in which Reynolds is extolled by so many of his contemporaries as the embodiment of affability and polite behavior, must be balanced against those other, hostile voices we encounter in the following chapter, particularly the voices of women, including his closest relatives. John Barrell has recently argued that an approach to art history informed by a concern with the politics of culture will interest itself in "the disunity, the incoherences, the loose ends, the unstable excess in the images it ex-

amines."[17] In the chapters that follow, I argue that what is true of individual images is equally true of the figures who make them. It is only by a careful attention to history, "by the attempt to recover the institutional and discursive contexts in which paintings were made and looked at," Barrell argues, "that we can understand the nature of such conflicts and what is at stake in them."

In attempting to bring Reynolds to life so that we can see precisely what is at stake, I have relied on evidence drawn largely from four sources: Reynolds's own work as a painter and writer; modern social history; biographies, memoirs, letters, minutes, journal entries, and other fragmentary texts; and what might be called the material culture of the painter's everyday life (furniture, books, silver and china, even his mother-of-pearl gaming chips). I have been particularly attentive to contemporary sources, for this book is in large part an exploration of the *appearance* one artist made. As Hazlitt paradoxically remarked, "No man is truly himself, but in the idea which others entertain of him."[18] My interest in these commentaries is considerable (if sometimes skeptical), and five writers in particular—Northcote, Malone, Boswell, Burke, and Hazlitt—cast a long shadow in the following chapters.[19] I treat their reflections and surviving remarks not only as crucial evidence, but as forms of discourse that deserve the same careful, insistent analysis we have traditionally devoted to other literary forms.[20] If it is objected that I have puzzled the surviving conversations and anecdotes rather too much, I would reply by arguing that evidence of this kind is meaningful only when it is closely and even playfully analyzed, and—more important still—that the surviving fragmentary evidence from which we attempt to make sense of the mysteries of identity is at least as complicated and challenging to interpretation as any contemporaneous literary form.

Although this book is heavily indebted to biographical material—and attempts to penetrate both Reynolds's character and his way of thinking about other people—it is not itself a modern, critical biography. You will not find an obsession with chronology here, nor the exhaustive scope and detail that a proper scholarly biography is ex-

pected to bear. And while this book is the first general, critical monograph on Reynolds to be published in English (surprising as this may sound), it is not primarily devoted to the interpretation of images, although I do analyze a number of important paintings in Chapters 1 and 4. In the following pages I investigate the personal, social, and professional formations that make certain paintings and certain achievements possible. I have conceived of this book as a social history of the enterprise of portrait-painting, with the proviso that—unlike Marcia Pointon's recent study, *Hanging the Head*—it focuses on a single painter who flourished in a particular culture.[21]

Within the critical climate in which I write, scholarly books devoted to a single artist are sometimes suspect, for there is often a suspicion that such studies participate in what Griselda Pollock has called "the patriarchal discourses of art history and their celebration of heroic individual creativity, art history's brand of bourgeois individualism."[22] Reynolds was himself distrustful of the celebratory impulse. In the back of one of his notebooks he wrote that "the indiscriminate praise that it is for ever the custom of writers to give to their favorites hurts the cause of Criticism."[23] I am equally distrustful, however, of a discourse of art history in which individuality is entirely subsumed under the cloak of society or the material base. A. L. Rees and Frances Borzello's recent formulation of the "new art history" is worth quoting here: "The strand in mainstream art history which tried to place art in its social context began from the art and worked outwards; the new form reverses the procedure, looking from the social fabric to the art it produces. Its central interests lie in how the social order is represented and endorsed by art and in the analysis of the institutions of art, including art history itself."[24] Rather than embracing either of the alternatives offered here, I find myself most comfortable playing the two extremes against each other, examining what I see as a complex *reciprocal* relationship between the artist and the culture in which he worked, and thereby suggesting what is either socially or individually significant.

Consider, for example, E. P. Thompson's elaboration of the "field-

of-force" model he has employed to describe the social polarization of—and interactions between—patrician and plebeian culture during the eighteenth and early nineteenth centuries. Focusing on a social chasm far broader than that dividing a painter and his aristocratic patrons, Thompson prefers to define the relationship between gentry and crowd as a reciprocal and dynamic structure, and he sees the relationship between paternalism and deference as an "equilibrium" rather than as a "formula." There is a sense, he argues, in which those who ruled and those who were subjected to rule "needed each other, watched each other, performed theatre and countertheatre to each other's auditorium, moderated each other's political behaviour." Seen in this way, the poor imposed upon the rich "some of the duties and functions of paternalism just as much as deference was in turn imposed upon them. Both parties to the question were constrained within a common field-of-force."[25] In a similar mode, much of the burden of this study of Reynolds lies in an exploration of the painter's role within a society that is seen not as a formulaic or theoretical construct—as an intellectually fashionable abstraction—but as a site of intersecting forces: sometimes untidy, often ambiguous, always filled with the voices of those who knew Sir Joshua well.

Why, finally, was Reynolds so remarkably successful? Why did he—and his art—flourish in England during the second half of the eighteenth century? The answers to these questions, I suggest, hinge neither on the conviction that "the work of art is a vessel for individual genius," located "somehow 'above' society or out of its reach," which is the traditional alternative Rees and Borzello resuscitate for us, nor on the assumption that the artist serves as an otherwise empty vessel through which the social fabric "produces" its artistic wares. In thinking about Reynolds's relationship to the culture in which he worked, I have attempted to keep the dialectical nature of this relationship in play, proceeding not only inductively but almost instinctually, guided by my sense that the materials at hand were complex even when they pretended not to be.

I have therefore created, as Hester Thrale Piozzi said of her verbal portrait of Samuel Johnson, a variegated mosaic, with the individual pieces drawn from a wide range of sources. The chapters of this book are so closely linked, in fact, that it has often been difficult for me to decide exactly where certain questions and materials should be introduced. It is impossible, for example, to discuss the art of pleasing in society (the focus of Chapter 1) as fully as possible without considering Reynolds's attempt to inscribe the forms and conventions of social interaction within his own house and studio (the subject of Chapter 3) or his relations with those who served as his patrons (the subject of Chapter 5)—and so on. I have finally chosen the following organization for these closely entwined issues, but it is the very *seamlessness* of these personal, professional, and political concerns that will emerge, I trust, as the thematic focus of this book. I have placed these concerns under the rubric of complaisance and complacence, concluding that portrait-painting—as enterprise, as text, as context—is inextricably enmeshed in the art of pleasing and in the perils of acquiescence, self-satisfaction, and self-preservation.

The Art of Pleasing

I want to begin by focusing on the hour of our death, for it is at this moment, more than any other, that the process of personal and professional scrutiny and revaluation begins. It also, of course, marks the point at which the emotional relationship between the quick and the dead is most tellingly discovered. It marks the site of bitterness and envy as well as sadness and affection; and it marks the origin of biographical distortion, which may take the form of irony or invective as well as simple piety or full-blown hagiography. Distortions such as these, moreover, are an essential part of the story I shall tell, for an examination of the painter *in* society depends to a great extent on how his friends and colleagues viewed him. These portraits of the artist— most of them flattering, some of them surprisingly hostile (as we shall see in the following chapter)—provide our primary evidence for gauging the social and professional formations that enabled Reynolds to become Sir Joshua.

In February 1792, on the day Reynolds died, Edmund Burke sat down in the painter's house to write an obituary notice of the man who had long been one of his closest friends. Reynolds's humility, modesty, and candor never forsook him, Burke wrote, "even on surprise or provo-

cation, nor was the least degree of arrogance or assumption visible to the most scrutinizing eye, in any part of his Conduct or discourse."[1] Burke recorded his impression of Reynolds only a few hours following his death, but what he wrote then was consistent with what others had said of Reynolds throughout his lifetime. Johnson characterized him as "the most invulnerable man I know; the man with whom if you should quarrel, you should find the most difficulty how to abuse."[2] He told Frances Burney that Reynolds "possesses the largest share of inoffensiveness of any man that I know."[3] Boswell dedicated his *Life of Johnson* to Reynolds by extolling his friend's "equal and placid temper, your variety of conversation, your true politeness, by which you are so amiable in private society,"[4] a judgment that echoes Goldsmith's verdict in the "Retaliation"—where Reynolds's manners are described as "gentle, complying and bland"[5]—and anticipates Burke's obituary notice, which praises the painter's "social Virtues in all the relations, and all the habitudes of Life."[6]

Reynolds's contemporaries had two cognate words to describe the man who was polite, agreeable, reluctant to give offense: they called him "complacent" or "complaisant," and they applied both terms to Reynolds himself. In his *Dictionary* Johnson noted considerable similarity in the meaning of these two words but he discriminated between the sense of complacent as "affable" or "soft" (gentle of manners) and the sense of complaisant as "desirous to please." The first term describes innate or acquired character, and it is appropriate that Johnson quotes a passage from Addison: "His great humanity appeared in the benevolence of his aspect, the complacency of his behaviour, and the tone of his voice." The second term, on the other hand, implies greater activity—a conscious act of ceremony, compliance, a desire to please—and the appended quotation is fittingly drawn from Pope: "There are to whom my satire seems too bold; / Scarce to wise Peter complaisant enough, / And something said of Charters much too rough."

The most forceful argument on behalf of the importance of complaisance—which, in this context, might be paraphrased as both agree-

ableness and the ability to make others agreeable—appears in *Guardian* No. 162 (1713), where Addison remarks that it "gives a Lustre to every Talent a Man can be possest of."[7] Just as Plato advised a young, unpolished writer to sacrifice to the graces (an uncanny and perhaps influential harbinger of Reynolds's portrayal of Lady Sarah Bunbury), so Addison counsels "every Man of Learning, who would not appear in the World a meer Scholar, or Philosopher, to make himself Master of the Social Virtue which I have here mentioned."[8] Complaisance, he continues,

> renders a Superior amiable, an Equal agreeable, and an Inferior acceptable. It smooths Distinction, sweetens Conversation, and makes every one in the Company pleased with himself. It produces Good-nature and mutual Benevolence, encourages the Timorous, sooths the Turbulent, humanises the Fierce and distinguishes a Society of Civilised Persons from a Confusion of Savages. In a word, Complaisance is a Virtue that blends all Orders of Men together in a Friendly Intercourse of Words and Actions, and is suited to that Equality in Human Nature which every one ought to consider, so far as it is consistent with the Order and the Œconomy of the World.[9]

Many of the remembrances of Reynolds with which his friends filled their letters or journals after he died are little more than a reworking of this seminal description of the agreeable man, the person who (in Hobbes's phrase) strives to accommodate himself to the rest of mankind. I shall, in fact, raise few issues about social and political deportment here and in the following chapters that are not anticipated in this remarkable passage.

Above all else, Addison's decision to champion the art of accommodation, of mutual agreeability, is based on his understanding of a world that is otherwise divided by birth and social position. Complaisance enables a person to interact with superiors and inferiors as well as equals; it smooths distinction; it blends orders of men together; and it is therefore particularly suited to an "Equality in Human Nature"

that Addison must inevitably qualify by arguing that it can be acknowledged and embraced only so far as it is consistent with the social economy of the world. Complaisance is also a humanizing force: it distinguishes modern society from a Hobbesian "Confusion of Savages." It produces good nature (a claim that is not entirely consistent with Addison's earlier thoughts on polite society, as we shall see) and, in making everyone "pleased with himself," it nudges toward our more modern sense of complacency.

From the point of view of a young painter born into a provincial family of modest means and few social pretensions, complaisance provides a blueprint for making an "Inferior acceptable" to his superiors. "I know nothing so effectual to raise a Man's Fortune as Complaisance," Addison adds, "which recommends more to the Favour of the Great, than Wit, Knowledge, or any other Talent whatsoever."[10] But in the "little wild *Arabian* Tale" that he hopes will illustrate this point at the end of his essay, Addison unwittingly discloses the severe constraints that are imposed by the art of accommodation. The starving but ingenious Schacabac, tortured by the eccentric behavior of his host, finally manages to box the nobleman's ears and still receive the dinner he desperately desires, but he does so only after a series of humiliations that prove him to be "a complaisant fellow" who can accommodate himself to another man's humor.[11]

The most complete identification of Reynolds with the virtues of amiability appears in the memorandum that the painter's executor and first biographer, Edmond Malone, recorded immediately following his friend's death: "He was blessed with such complacency and equality of temper, was so easy, so uniformly cheerful, so willing to please and be pleased, so fond of the company of literary men, so well read in mankind, so curious an observer of character, and so replete with various knowledge and entertaining anecdotes, that not to have loved as well as admired him would have shown great want of taste and sensibility."[12] So willing to please and be pleased: this is the essence of complaisance as it was described by Addison and, at even greater length, by Colonel

James Forrester in *The Polite Philosopher: Or, An Essay on That Art Which Makes a Man happy in Himself, and agreeable to Others* (1734), a courtesy book reprinted throughout the century. Forrester argued that "a Thousand little *Civilities, Complacencies,* and *Endeavours* to give others Pleasure, are requisite to keep up the Relish of Life, and procure us that Affection and Esteem, which every Man, who has a sense of it, must desire."[13] In the world Forrester describes, complaisance works on behalf of a young man's political or professional "Interest,"[14] but it functions, above all, as a social virtue that evokes reciprocity in others. In the couplet with which he closes his book, for example, Forrester acknowledges that his goal lies in "Teaching this ART——to pass thro' Life at Ease, / Pleas'd in our selves, while all around we please."[15] It is only by pleasing others that we shall procure "that Affection and Esteem" which every sensible person desires.

These references by Addison, Malone, and Forrester to the art of pleasing naturally center on the activity embedded in their understanding of complaisance, but we should also note that Malone separates Reynolds's "complacency" from his ability "to please and be pleased" and aligns it, instead, with the painter's "equality of temper" and constitutional cheerfulness. These are phrases that echo throughout the surviving evidence, as in Boswell's attention to his friend's "equal and placid temper" or Johnson's comment that "Sir Joshua Reynolds is the same all the year round."[16] But it is probable that Malone also has in mind not only Reynolds's unstinting affability but what the *Oxford English Dictionary* calls "tranquil pleasure or satisfaction in something or someone" or "contented acquiescence or consent." This is clearly the sense at play when Malone, in his biography, tells us that Reynolds was "presented with the freedom of the Painter's Company, an honour which, though to him of little value, he received with his usual complacency and politeness."[17] This is yet another act of gracious accommodation—accommodation *downward,* in this case, to the wishes of one's professional inferiors—but it nevertheless raises (even in Malone's mind) the question of how far affability and acquiescence can be strained.

Perhaps the most telling example of how far Reynolds was willing to bend—in this case, to his social superiors—is supplied by James Northcote in his lengthy biography of his former master:

> On one of the evenings, when Sir Joshua delivered his discourse to the Royal Academy, the audience, as usual on those occasions, was numerous; composed not only of artists, but also of the learned and the great. The Earl of C————, who was one of the company present, came up to him, immediately after he had finished his lecture, saying, "Sir Joshua, you read your discourse in so low a tone that I did not distinguish one word you said." To which the president, with a smile replied, "That was to my advantage."[18]

Here, in the face of criticism, the artist responds with self-deprecation. Instead of repudiating the rebuke, Reynolds deflects it by compounding it, gracefully (and even graciously) offering a witty reply in return for a querulous complaint. The Earl of Carlisle, after all, had paid Reynolds the compliment of desiring to have heard what the President of the Academy had to say, and Reynolds replied with both complacency (unruffled affability, acquiescence in what he knew was a just remark) and complaisance (the ability to please, even in spite of Carlisle's blunt behavior).

Reynolds's career suggests that the art of pleasing eventually paid off. Carlisle would remain a friend and Reynolds's professional associates would relish his reply, accommodating themselves to its own accommodations. Twenty-two years later, for example, a "turbulent audience" would again have trouble hearing the President's discourse (his last), but most of those present at the Academy remained throughout the lecture even though two loud creaks in the flooring accurately signaled the precariousness of their safety. Dr. Charles Burney, who sent his daughter a detailed account of the evening's adventures, wrote that he and a few others later "went up to Sr. Jos . . . to thank him for our entertainmt.—& he sd. we had pd. him the highest possible Compt. by staying perhaps at the risk of our lives . . . But we are universally abused by our friends for our fool-hardy complaisance to Sir Jos. in not making

the best of our way out at the 1st. warning."[19] Here Reynolds's politeness—in inviting his friends to the Academy, sharing his final discourse with them, and thanking them for their complimentary behavior—kindles a corresponding complaisance in others.

Reciprocity of this kind lays the groundwork for social relations. It enables us, in Forrester's words, "to pass thro' Life at Ease, / Pleas'd in our selves, while all around we please." Here we discover complacency and complaisance yoked together, the first directed toward ourselves, the second toward others. Although our modern, pejorative sense of complacency—as self-satisfaction characterized by smugness and an absence of self-questioning—does not appear in Johnson's *Dictionary* of 1755, it begins to emerge in passages such as this. The danger of being too pleased with one's actions or condition is that self-satisfaction (what was called self-complacency in the eighteenth century) would be too easily tinged by vanity and too likely to lead to social inertia.

In his life of Reynolds, for instance, the ambivalent Northcote tells us that, near the beginning of the painter's career, "true taste was wanting: vanity, however, was not wanting; and the desire to perpetuate the form of self-complacency crowded his sitting room with women who wished to be transmitted as angels, and with men who wanted to appear as heroes and philosophers."[20] Northcote's image of rampant desire crowding the sitting room is almost Popean in its vivid abstraction and careful antitheses, and the conclusion he reaches—"From Reynolds's pencil they were sure to be gratified"—sustains the irony and reinforces the absence of direct agency here. But Northcote continues by emphasizing "the force and felicity" of Reynolds's portraits and by arguing that the same talent that brought him the custom of the opulent and the beautiful also earned him the admiration and intimacy of the most distinguished men of his age ("so attractive were his manners as well as his talents"). "In this assemblage of genius," Northcote adds, "each was improved by each." The dangers of self-complacency have given way to the active virtue of complaisance: "Reynolds, like a man of a great mind, always cultivated the acquain-

tance and friendship of the first characters of his time; and often assisted those who were in difficulties, both with his advice and his purse."[21]

Reynolds himself was not one to deplore his lot in life. In a letter to Malone, Burke remarked that their friend "enjoyd every Circumstance of his good fortune and had no affectation on that Subject," and Boswell characterized him as "he who used to be looked upon as perhaps the most happy man in the world."[22] Both viewed Reynolds as a pre-eminently satisfied man, and Johnson noted more than once that Reynolds was that rare person whose success had not gone to his head ("Prosperity will not spoil him").[23] But it is only a short step, especially in the eyes of a critical observer (a Blake or James Barry, for instance), to interpret satisfaction as self-satisfaction and compliance or softness of manners as a perilous form of contented acquiescence. The same interpretation has been extended to the painter's art in Nikolaus Pevsner's exploration of Reynolds's "detachment," by which Pevsner means not only judiciousness and objectivity—"the attitude which allows reflections on what style to choose for what job"—but also the temperance and moderation that produced what Pevsner sees as serious compromises in much of Reynolds's portraiture.[24]

The specter of aesthetic compromise seems to haunt the reputation of almost every artist who has made a living by painting portraits; in all fairness to Reynolds, one would have to measure his works against the demands of his patrons and the practice of his contemporaries before deciding that his compromises were flagrant. Given the rich biographical and artistic evidence that has survived, however, what we clearly cannot dispute is Reynolds's profound commitment to a life of hard work, experimentation, and improvement. The infamous technical experiments, the long hours and violated Sundays, the obsessive tendency to treat all that he experienced as material for his art, the insistence on fresh poses, the unwillingness to put his brush down once success had been achieved—all pay eloquent testimony to his conviction that "Kneller, Lilly, and Hudson will not do now."[25] At the beginning of his career, he writes, his colleagues were so indiscriminate in

their use of well-worn formulas that their pictures looked "like so many sign-post paintings"; in their haste to steal from each other they forgot to take "the trouble of thinking for themselves."[26] Near the end of his career, in a letter to a young artist, he writes that "a painter who has no rivals, and who never sees better works than his own, is but too apt to rest satisfied, and not take what appears to be a needless trouble, of exerting himself to the utmost, pressing his Genius as far as it will go."[27] Self-congratulation, to borrow Reynolds's own term, should not be confused with an implicit resistance to change.[28]

The subtle and sometimes ambivalent connections between complaisance and complacency can also be detected in two other influential approaches to Reynolds's work. The first interpretation is based on an awareness that Reynolds painted different kinds of portraits when he depicted different kinds of people, and that he was also attentive to the occasions and contexts to which these pictures belonged. This attempt to discriminate among the various forms of Reynolds's portraiture was first proposed by Edgar Wind in a pioneering essay fifty years ago, and although we may quarrel with the sometimes rigid categories that he suggested, Wind at least implicitly acknowledged that Reynolds responded quite sensitively to the social pressures of the portrait-painter's profession.[29] Wind's own methodology begins to anticipate Pevsner's sense of detachment in Reynolds's art: a willingness to adapt, to oblige, to please. This is the art of complaisance; it succeeds by satisfying the demands of the patron.

The second approach has been succinctly stated by Reynolds's Victorian biographer, Tom Taylor:

All the people he paints seem, as it were, irradiated by something of amiability, breeding, and sense that comes from the painter. And herein, no doubt, lies much of the secret of effect in all fine portraiture. It depends more on what emanates from the painter than the sitter, and comes to its best in cases where there is a subtle harmony and intercommunication of appreciation and esteem or regard between painter and sitter. I cannot separate the character of Reynolds—calm, simple, un-

fussy, amiable, and tolerant, prompt to kindly construction of words and things, keenly relishing life and character and social enjoyments, yet not overvaluing money or distinction—from the delightfulness of his pictures.[30]

Here we have the other side of the linguistic coin, and a very different explanation of how great portraits are created. In Taylor's view, the very affability or good breeding of the artist—his complacency—finds its natural expression and register in patrons (perhaps we should now call them subjects) of a similar disposition. Taylor offers a fundamentally romantic conception of artistic creativity, but he must curiously adapt it to the demands of the artist who paradoxically expresses himself by painting portraits of other people.

As unlike as these two interpretations of Reynolds's artistry are, they both draw our attention to the crucial relationship between the painter and his sitter. And it is here, I believe, that any serious examination of Reynolds must eventually focus: not merely on the friendship between artist and subject—for much of the time these "relationships" were simply contractual agreements—but on the ways in which the painter's temperament was suited or adapted to the society he "captured" and in which he thrived. In the rest of this chapter I therefore attempt to place the painter more fully in the social matrix in which he flourished by examining his behavior in polite company—what Burke called his "social virtues in all the relations and all the habitudes of life"—his characterization as a gentleman, and his role as a host and *bon vivant*. But first I must return to the art of pleasing, and to its troubled status in debates about the nature of the gentleman in early eighteenth-century society.

ARTIFICIAL HUMANITY

Although Addison began his essay in the *Guardian* by allowing that complaisance is "scarce reckoned in the number of Moral Virtues," he

eventually concluded that, "as it is a virtue," it should be defined as "*a constant Endeavour to please those whom we converse with, so far as we may do it Innocently.*"[31] And thus when Addison's contemporaries attempted to characterize politeness, good breeding, or gentlemanly behavior, they almost invariably had recourse to complaisance as an important or essential attribute in their descriptions. In his "Essay on Conversation," for example, Fielding argued that good breeding is "the Art of pleasing" and that its essence lies in our ability "to contribute as much as possible to the Ease and Happiness of Mankind."[32] Complaisance in conversation, in other words, lies in direct opposition to Johnson's infamous—and frequently terrifying—predilection for "talking for victory."

Steele's definition of "*a true Fine Gentleman*" (in *Guardian* No. 34) is so ambitious that he is forced to conclude that "a finished Gentleman is perhaps the most uncommon of all the great Characters in Life," but he nevertheless stipulates, under the heading of "manners," that his idealized courtier should be "obliging and complaisant without Servility, chearful and in good Humour without Noise."[33] Hazlitt put it even more succinctly in one of his conversations with Northcote a century later: natural politeness is "a perception of and attention to the feelings of others, which is the same thing, whether it is neglected by the Great or practised by the vulgar."[34]

Any definition of social behavior raises—at least implicitly—the increasingly complicated relation between breeding and birth.[35] Shaftesbury, for instance, encountered articulate foes in Addison, Steele, Fielding, and Jonathan Richardson when he argued that noble birth was an essential condition of a man's status as a gentleman.[36] (Defoe nimbly concluded that the "compleat" gentleman required good breeding as well as birth.)[37] But even those who championed a more egalitarian view of mankind faced problems when they reflected on the potential discrepancy between a person's actions and his or her actual character. Addison, after all, had qualified his praise of complaisance by noting that we should strive to please others "*innocently*"; earlier, in *Spectator* No. 169, he wrestled even more directly with this dilemma:

There is no Society or Conversation to be kept up in the World without Good-nature, or something which must bear its Appearance, and supply its Place. For this Reason Mankind have been forced to invent a kind of artificial Humanity, which is what we express by the Word *Good-Breeding*. For if we examine thoroughly the Idea of what we call so, we shall find it to be nothing else but an Imitation and Mimickry of Good-nature, or in other Terms, Affability, Complaisance and Easiness of Temper reduced into an Art.[38]

Courtesy literature—to which Addison himself contributed so much—might be characterized as just such a "reduction" or artful prescription, and thus it was extremely important to him that these "exterior Shows and Appearances of Humanity" be founded upon "a real Good-nature." If they are not, they resemble religious hypocrisy, "a bare Form of Holiness" that is even more detestable than professed impiety.

Politeness or good breeding, Abel Boyer argued earlier in the century, "does not always inspire a Man with Humanity, Justice, Complaisance and Gratitude, but yet it gives him the outside of these vertues, and makes him in appearance what he should be in reality."[39] Such a display may be seen as the theatrical presentation of the self (as in Shaftesbury's formulation of the role of politeness)[40] or as the intentional *suppression* of one's real character (and the simultaneous deception of others). Thus Richard Head (in 1675): some may call social relationships pursued for the sake of personal advantage "complaisance," but in reality this is simply the "*Art of Insinuation,* or Dissimulation, compounded of mental reservation, seeming patience and humility, (self-obliging) civility, and a more than common affability, all of which club to please, and consequently to gain by conversation."[41] And even Steele, in the prologomena to his portrait of the ideal gentleman in *Guardian* No. 34, confessed that although he strongly disagreed with the remarks of his female friends, "in Complaisance, I disguised my Sentiments, to keep up the good Humour of my fair Companions, and to avoid being looked upon as a testy old Fellow."[42]

The conception of complaisance, politeness, or good breeding as a kind of artificial humanity poses a double problem for painters—es-

pecially portrait-painters, whose canvases themselves strive to mirror human nature. On the one hand, even in an increasingly egalitarian society, proper behavior in a commoner is not the same as good breeding *combined* with proper descent because it supposedly lacks this natural safeguard against dissimulation and imposition. The unprecedented dissemination of blueprints for polite behavior (in the periodical essays of Addison and Steele as well as in more traditional forms) ironically provides the means for ingratiation, deception, and outright fraud. If the art of pleasing is an essential element in portraiture, can a painter's behavior be trusted? And then (on the other hand), even if an artist's politeness has proven to be invulnerable, a painter such as Reynolds is still confronted by this dilemma in other people, including those he portrays. In *The Analysis of Beauty,* for example, Hogarth noted that a hypocrite "may so manage his muscles, by teaching them to contradict his heart, that little of his mind may be gather'd from his countenance";[43] and in a remark made to Boswell (to which I shall return) Reynolds pointed out that "the habits of my profession unluckily extend to the consideration of so much only of character as lies on the surface, as is expressed in the lineaments of the countenance. An attempt to go deeper and investigate the peculiar colouring of [Johnson's] mind, as distinguished from all other minds, nothing but your earnest desire can excuse the presumption even of attempting."[44] And if the portrait-painter is bound to the surface and by the moment, he or she also faces the task of interpreting character even before the act of representation begins. And here even the most socially adept and aesthetically sophisticated painters can make disastrous mistakes. Witness the accomplished Angelica Kauffman, with whom Reynolds was romantically linked: Kauffman married "Count Frederic de Horn" only to learn, a few weeks later, that her husband was actually the nobleman's valet.[45]

John Barrell has carefully traced Reynolds's efforts—and those of Jonathan Richardson before him—to establish painting as a liberal art and to broaden the republic of taste so as to include men of good

breeding as well as those of gentle birth.[46] Reynolds acknowledged the powerful influence of Richardson's *Theory of Painting* throughout his life, and Malone and Northcote dutifully record its importance in the opening pages of their biographies. In its impassioned emphasis on the integrity of the artist, however, Richardson's argument encompasses moral and social as well as political and professional concerns; and these passages, together with those devoted to the nobility of art, are frequently quoted and commented upon by Reynolds's early memorialists. Samuel Felton, for instance, draws attention to Richardson's assertion that "a painter ought to have a sweet and happy turn of mind, that great and lovely ideas may have reception there," and William Cotton explicitly praises the moral importance of a passage such as this:

> His business is to express great and noble sentiments: let him make them familiar to him and his own, and form *himself* into as bright a character as any he can draw. His art is of vast extent, and he stands in need of all the time, and all the vigour of body and mind allowed to human nature. He should take care to husband and improve them as much as possible by prudence and virtue. The way to be an excellent Painter is to be an excellent man, and these united make a character that would shine even in a better world than this.[47]

It is not simply a matter of learning to think and act like a gentleman, but of *becoming* one: making noble sentiments "his own," forming himself into the kind of character a painter himself would desire to paint. Richardson's lofty prescription disregards the forms of behavior that we associate with "artificial humanity" and focuses, instead, on the mind of the painter. And this, of course, is precisely where Reynolds takes up the argument in his seminal seventh discourse, where the labor he principally extols "is not the industry of the *hands,* but of the *mind,*"[48] and where he follows Richardson's lead in recommending that his aspiring students look within as well as without: "A knowledge of the disposition and character of the human mind can be acquired only by experience: a great deal will be learned, I admit, by a habit of ex-

amining what passes in our bosoms, what are our own motives of action, and of what kind of sentiments we are conscious on any occasion."[49] Reynolds's admonition is grounded not only on "a general uniformity and agreement in the minds of men,"[50] but on the Richardsonian assumption that in the minds and hearts of excellent painters these "motives" and "sentiments" possess a nobility of their own.

THE GREAT STREAM OF LIFE

Important as they may be, contemporary discussions of complaisance and gentlemanly behavior serve at best as a contextual backdrop for Reynolds's social practice. Richardson prescribed no rules for social advancement in his many treatises, and his own social—as well as artistic—successes were severely limited.[51] Reynolds was more inclined than his predecessor to draw attention to "the general principles of urbanity, politeness, or civility," to point out their essential uniformity, and to reflect on how "the mode in which they are dressed" is culturally determined.[52] But an exploration of the painter in society must ultimately focus on the actual experiences of the artist, either as he recorded them or as they were remembered by others. And here, for once, we can draw upon a wealth of contemporary evidence that will enable us to gauge how well Reynolds personified the social ideal that we have found in Addison, Fielding, Forrester, and (so memorably) in Chesterfield's advice to his son: "Know then, that as learning, honour and virtue are absolutely necessary to gain the esteem and admiration of mankind, [so] politeness and good breeding are equally necessary to make you welcome and agreeable in conversation and common life."[53]

Let us begin with the tribute of Elizabeth Montagu, "Queen of the Blues," who wrote to James Beattie (whose allegorical portrait Reynolds was then painting) to say that she longs "to see the picture he is now designing; virtue and truth are subjects worthy of the artist and the man. He has an excellent moral character, and is most pleasing and amiable in society; and with great talents has uncommon humility and

gentleness."[54] The first half of this assessment is a virtual distillation of Richardson, while the second finds an echo in numerous statements by Northcote. Reynolds knew that "a certain degree of pride, enough to take off any timourousness, ... is a necessary qualification in a painter,"[55] but pride in one's profession must also be tempered by a modesty that, in Reynolds's case, was legendary. Humility, as Reynolds defined it, "is not to despise any thing, especially mankind,"[56] and Northcote believed that "the fine example of modesty which he exhibited had an effect on all the inferior painters of his day; but there is not one now to serve as a model in point of good breeding."[57]

Reynolds once observed that polite behavior and "a refined address"—like good paintings—"make the least show to ordinary eyes,"[58] but his friends had no difficulty in discerning a placidity, softness, and amiability that were all the more impressive because they were so constant. "With an uncommon equability of temper, which, however, never degenerated into insipidity or apathy," Malone notes, "he possessed a constant flow of spirits, which rendered him at all times a most pleasing companion; always cheerful, and ready to be amused."[59] According to Northcote, "He had studied himself thoroughly; and, besides, had great equanimity of temper, which, to be sure, it is difficult to acquire, if it is not natural."[60] Joseph Farington, writing at a greater distance, agreed: "Placability of temper may be said to have been his characteristic."[61] Boswell remembered him as "that most ingenious and amiable man—I had almost used the lady's word *charming*," and Goldsmith (as we have seen) praised him in "The Retaliation" for manners that were "gentle, complying and bland."[62] Goldsmith's triplet clearly reverberated in the ears of later commentators, for we find Hazlitt relishing a prose style that is "gentle, flowing, and bland"[63] and Malone describing "the epithet *bland*" as "characteristick of his easy and placid manners."[64]

Like "complacency," "blandness" has lost most of its positive connotative value during the past two centuries, but its eighteenth-century usage (to describe someone who is soothing and gentle) fits perfectly

with what Malone called his friend's "mildness and suavity of deport-ment."[65] And even if we begin to sense more modern nuances in the contemporary use of this word, we must also acknowledge the habitual behavior with which it was associated. Much of Reynolds's attractive-ness as a friend appears, in fact, to have resided in his dependability. Johnson, for instance, told an ailing Reynolds that "if I should lose you, I should lose almost the only Man whom I call a Friend"; later, when Johnson himself was dying, he wrote that "we are now old acquain-tance, and perhaps few people have lived so much and so long together, with less cause of complaint on either side."[66] The threads of friendship that bound Johnson and Reynolds together for so long are both nu-merous and complex, but it is clear that Johnson relied upon the pla-cidity of someone who was "the same all the year round" just as Reynolds sought the unpredictable company of a companion who could always be counted on to say something new.[67]

The highly charged friendships that Reynolds cultivated for so many years with both the tumultuous Johnson and the passionate Burke took their emotional toll on the painter, but it is characteristic of Reynolds that he kept his wounded feelings virtually to himself. In an unpub-lished memoir of Reynolds that Dr. Charles Burney wrote in 1792, the distinguished musicologist discloses that his friend

> never lost his temper in the most vehement debates, wth. Dr. Johnson & Mr. Burk, who were both impatient [of control] & sometimes so violent as to treat him harshly & unworthily. This he never resented or seemed to remember, though in our tete à tete conversations he used to complain to me of their rudeness and violence. He had a true veneration for those 2 great men, and knew their value so much to exceed their imperfections, that he never let them know how much they wounded his feelings by their loud voice & unguarded expressions.[68]

Burney knew his friend well: from 1774 until the painter's death Burney lived with his family in St. Martin's Street "scarcely twenty yards" from Reynolds's house in Leicester Fields. He tells us in his memoir of

Reynolds that for almost twenty years they often breakfasted together, attended the same parties in the evening, and almost invariably invited each other to their own entertainments. We "used to read the same books," Burney writes, "discuss their subjects & openly and without reserve exchange opinions. I never met with a more strait forward understanding, he threw away no words in deviating from the direct line to truth."[69] As he once wrote to his daughter, Reynolds "has a bit of divinity in his heart as well as *hand*."[70]

Reynolds believed that his prescription for happiness could be summarized in a simple maxim: "The great principle of being happy in this world is not to regard or be affected with small things."[71] Northcote (who recorded this remark in his biography) later expanded upon it in one of his conversations with Hazlitt: "He said it was one of Sir Joshua's maxims that the art of life consisted in not being overset by trifles. We should look at the bottom of the account, not at each individual item in it, and see how the balance stands at the end of the year. We should be satisfied if the path of life is clear before us, and not fret at the straws or pebbles that lie in our way."[72] But Hazlitt was not convinced. Reynolds, he argued, owed his happiness not to his contempt of little things but to his success in great ones; it was, in fact, precisely Reynolds's success that enabled him to disregard these small vexations. Hazlitt also sensed the extent to which Reynolds's unruffled serenity was based on the painter's social accomplishments; he owed his happiness "in no small degree to the coronet-coaches that besieged his doors, to the great names that sat at his table, to the beauty that crowded his painting-room, and reflected its loveliness back from the lucid mirror of his canvas." These things do indeed "put a man above minding little inconveniences," and even Reynolds, he concludes, became peevish when he lost the sight of one eye: "Suppose the same loss to have happened to him in the meridian of his fame, we fear that all his consciousness of merit, and all his efforts of industry, would have been insufficient to have supplied that unruffled felicity which we are here taught to refer exclusively to these high sources."[73]

There is little to suggest that Reynolds experienced any real difficulty in adapting to his social environment. During a dispute with Sir William Chambers over professorial titles at the Royal Academy, Reynolds firmly stated that "I do not feel myself possessed of that grandeur of soul sufficient to give me any pretensions of looking down with such philosophical contempt upon titles. Distinction is what we all seek after, and the world does set a value on them, and I go with the great stream of life."[74] Northcote repeatedly mentions Reynolds's "disinclination to oppose the popular opinion," and records a telling anecdote about John Singleton Copley, who had recently returned from the continent:

> amongst other matters, [Copley] said he had been in company with Werter's Charlotte; but Sir Joshua not comprehending whom he meant, Copley explained; when Sir Joshua replied, "I am ashamed to say that I have never read the story of Werter and Charlotte." I then said that I thought it would have been more proper for him to have been ashamed if he had read it, as it was a novel, and only fit reading for young girls. He tartly answered, that I was in the wrong; for that it was his place to have read that which every person else had read.[75]

And the same holds true for thinking as well as reading. Resisting the authority of others, Reynolds warned in the *Discourses*, "leaves open every avenue to singularity, vanity, self-conceit, obstinacy, and many other vices"; this "submission to others is a deference which we owe, and indeed are forced involuntarily to pay," for, never satisfied with our own opinions, we dispute and wrangle forever, endeavoring "to get men to come to us, when we do not go to them."[76] This is an argument with which Johnson could easily agree, but Reynolds, unlike his friend, valued knowledge of the social world as well as the intellectual. When the painter told hunting stories, Johnson was sharp in his rebuke: "Sir, when I have as mean a mind as you, I shall be vain of such things."[77] Reynolds fared just as badly when he mentioned that "nobody *wore* laced coats now; and that once every body wore them. 'See now (says Johnson) how absurd that is; as if the bulk of mankind consisted of

fine gentlemen that came to him to sit for their pictures. If every man who wears a laced coat (that he can pay for) was extirpated, who would miss them?' "[78]

As both Johnson and Reynolds must have sensed—in their different ways—intimacy with a wide range of men and women was essential to the portrait-painter's career. Malone notes that "while engaged in his painting-room, he had the pleasure of seeing and conversing with all the beautiful, accomplished, and illustrious characters of his time; and when not employed in his art, his hours were generally passed in the most pleasing and enlightened society that London could produce."[79] Malone's point, moreover, is that much as Reynolds may have enjoyed his fame, he never revealed any consciousness of "the very high rank which he held in the publick estimation," and was "as perfectly free from vanity and ostentation, as he was from artifice or affectation of any kind." We discover a double sense of pride here: Malone rejoices in the absence of self-complacency in his friend, and relishes his social as well as artistic triumphs.

The extent to which Reynolds's behavior was synonymous with polite behavior can be gauged, in fact, by how carefully his biographers have recorded his rare social gaffes. Northcote, for example, tells the story of how Reynolds received a "very cold reception" from "a noble duke" and his duchess when he visited them in the country (at Blenheim): "previously they had always been so gracious: when afterwards relating the circumstance to his sister, she asked him if he appeared before them in his boots, just as he came off his journey, and not in his evening dress; he answered yes. Then said she, that was the very reason; they thought it a mark of great disrespect in your not complying with the etiquette."[80] Reynolds's second major social blunder—at least in the eyes of some—lay in his decision to accompany Boswell to an execution at Newgate. The daily newspapers attacked both men for a lack of proper feeling: "the first person who appeared upon the scaffold yesterday morning was Mr. Boswell. *That* was nothing extraordinary, but it was surprising when he was followed by Sir Joshua Reynolds.—'Evil

communications corrupt good manners.'—It is strange how that hard Scot should have prevailed on the amiable painter to attend so shocking a spectacle."[81] Reynolds must have been stung by the rebuke, for he wrote a long letter to Boswell in which he characterized the event in theatrical terms and compared the spectacle they had witnessed to the representation of a tragedy: "I consider it natural to desire to see such sights, and, if I may venture, to take delight in them, in order to stir and interest the mind, to give it some emotion."[82] This is the voice of the painter speaking, unexpectedly (and uneasily) caught between two different worlds. Most of the time, however, Reynolds balanced his social and professional roles with extraordinary skill. When Thomas Warton was offered the post of Poet Laureate, he immediately turned to Reynolds for advice on how to negotiate the social landscape that lay ahead: "I think I shall have as many titles as yourself. I go to town on Tuesday, and will call on you at night for one half-hour for a little information about royal etiquette, which I never studied much."[83]

We shall never know precisely how much Reynolds actively "studied" polite behavior—either in himself or in others—or how much he simply absorbed, given his family upbringing, his early intimacy with Augustus Keppel and the Edgcumbes, and his experiences abroad. We do know, however, that Reynolds began to teach himself the arts of politeness at a fairly early age. An unpublished commonplace book, entitled "Extracts" and dating from the 1730s, is filled with entries from the books Reynolds had been reading (Figure 1).[84] As he wrote on the very first leaf, "When you have a mind not to forget any thing, commit it to writing. i.e. put it in your Commonplace Book." Many of the quotations are directly associated with Reynolds's emerging interest in painting: "As in an Heroick Poem there should be nothing low and vulgar, so in the Sublime Painting";[85] "Allegory is to have some real person meant by those fictitious shepherds &c. which are introduc'd"; "Terror and Compassion" are listed as the elements of tragedy.[86] Pope's letters are extracted at great length, especially his elegant openings and closings, and later Reynolds quotes

extensively from Pope's poetry, from the meditations of Marcus Au-
relius, and from the writings of Richardson, Charles Alphonse du
Fresnoy, William Aglionby, and Leonardo.

Of greatest interest here are the quotations the young Reynolds
copied out from the *Tatler,* the *Spectator,* and *The Art of Pleasing in
Conversation* (erroneously attributed to Cardinal Richelieu). The *Tatler,*
for instance, is quoted on the first numbered page: "Politeness Is to do
not that which pleases you, but the Person that you converse with."
Similar advice is drawn from Richelieu: "Nothing is more important
in the commerce of life than to please in Conversation"; "We must not
neglect the outside. We should always so order it, that the first impres-
sions turn to our advantage"; "All must appear natural in a Gentleman
& nothing must savour of Art or Affectation";[87] and, most tellingly,
"The best effect of Complaisance is to make us endure the weakness of
a friend and not to yeald to anger when he's disordered by it."[88] This
final quotation is copied out again, more neatly, later in the book, and
it is augmented by two definitions drawn from Theophrastus. Com-
plaisance, we learn, is "a desire to please every body, without regard to
Instress [Interest]," whereas dissimulation occurs "when in every thing
a man does, he designs his own Interest without any regard to Truth."[89]
Here we have, in capsule form, the tensions at the heart of Addison's
"artificial humanity."

We learn from the commonplace book, moreover, that Reynolds was
impressed enough by *Spectator* No. 169 to quote at length from it,
although he actually summarizes Addison's argument in such a way
that the central phrase concerning artificial humanity disappears: "No
conversation or Society to be kept up without good-Nature, or some-
thing which must bear its its [*sic*] appearance, and supply its Place.
Good-Breeding is nothing else but an Imitation and Mimickry of
Goodnature, or in other terms affability complisance [*sic*] and easiness
of temper reduced into an art."[90] In other passages he turns more di-
rectly to the issue of self-assertion. "A man in some measure must be
the Trumpet of his Fame," he quotes from the *Tatler;* "the best way to

seem to be so is to be so in deed. be what you would be thought to be"—a quotation he later ascribed to Archbishop John Tillotson.[91] But the most telling entry in the entire collection is the one he placed under the heading of "Speculations": "Endeavour allways to please and you will allways be loved of course. Father."[92]

Reynolds's commonplace book—bound in vellum, carefully ruled, crammed with observations and with the titles of books he had not yet been able to lay his hands on—provides a remarkable glimpse of the young artist fashioning a social role for himself that would seem to extend far beyond the confines of his native Plympton. One can easily visualize him as just the ideally pliant and impressionable provincial reader that Addison and Steele clearly had in mind. Once he had *arrived*, moreover, once London was much more than a distant world he read about at second hand, he continued to think about the subject of true politeness, as a revealing anecdote recorded by Northcote suggests. Reynolds once paid visits to two noblemen on the same Sunday. The first nobleman was "very desirous to please" but talked about nothing except the painter's art. The second (Northcote thinks that it may have been Lord Chesterfield) "received him with the same freedom as if he had been his equal, never once spoke upon the subject of art, nor observed that Sunday was the day of rest for the laborious; but discoursed on the news and the occurrences of the day, and on such other topics as a gentleman of education is supposed to be acquainted with, and no word escaped him that denoted his recollection of any difference in their stations."[93] Years later Reynolds remembered this experience as "an instance that had struck him very forcibly as a fine contrast."

Reynolds clearly absorbed the various lessons society offered him. Malone, whose brother was raised to the peerage, unequivocally stated that Reynolds's "appearance at first sight impressed the spectator with the idea of a *well-born and well-bred* English gentleman."[94] His opinion was echoed by others. Here is Northcote:

Sir Joshua's name is repeated with more respect than Hogarth's. It is not for his talents, but for his taste and the direction of them. In meeting Sir

Joshua (merely from a knowledge of his works) you would expect to meet a gentleman—not so of Hogarth.[95]

And Edward Edwards:

Sir Joshua in his manners was the well-bred man of sense, equally free from affected consequence or supple compliance.[96]

And Richard Cumberland:

Reynolds was a perfect gentleman, had good sense, great propriety with all the social attributes, and all the graces of hospitality, equal to any man.[97]

And finally Henry William Beechey:

Sir Joshua Reynolds had no real or affected peculiarities, which distinguished him from the plain English gentleman: he was subject to no fits of hysteric enthusiasm, asserted no undue pretensions, and thought nothing beneath his consideration which the rank that he held in society appeared to require at his hands.[98]

These comments—all drawn from professional writers or artists—reinforce our sense that Reynolds's gentlemanly demeanor, far from being at odds with his work as a painter, was in fact essential to his artistic as well as his social success. Hazlitt put the argument in its most extreme form when, in praising Gainsborough and Reynolds for their "natural" gentility, he observed that both men failed to make themselves agreeable at St. James's Palace: Reynolds "kept a certain distance and wished to appear as a gentleman; they wanted a *buffoon* whom they might be familiar with at first, and insult the moment he overstepped the mark, or as soon as they grew tired of him. Their favourites must be like *pet* lap-dogs or monkeys."[99] Reynolds's relations with the royal family were complicated at best, and I shall return to them in my final chapter; what concerns us here is Hazlitt's focus on the painter's natural

dignity and the "certain distance" he kept from those whose patronage exacted an unwelcome toll. In the long run, Reynolds's politeness and gentlemanly behavior were of great benefit not only to him but to his entire profession. In the measured proclamations of Northcote and Farington, for example, he is praised for having realized Richardson's twin desires of exalting the public stature of the painter and inaugurating a great age of native English art. Thus Northcote remarks that his

> general manner, deportment, and behaviour, were amiable and prepossessing; his disposition was naturally courtly. He always evinced a desire to pay a due respect to persons in superior stations, and certainly contrived to move in a higher sphere of society than any other English artist had done before him. Thus he procured for Professors of the Arts a consequence, dignity, and reception, which they had never before possessed in this country.[100]

Farington (the quintessential Academician) has his eye trained on how Reynolds improved the manners of his fellow artists:

> In the example set by Sir Joshua Reynolds, he was supported by some of his contemporaries who were highly respected for the propriety of their conduct and gentlemanly deportment. So striking was the change, that a much-esteemed Artist, far advanced in life, being a few years since at a dinner-table surrounded by men of his own profession, recollecting those of former times, remarked the great difference in their manners, adding, "I now see only gentlemen before me."[101]

The logical extension of this argument centers not just on manners and propriety of conduct but on virtue as well (as in Richardson's doctrine that "the way to be an excellent Painter is to be an excellent man"). And thus late in life, in dialogue with Hazlitt, Northcote condemned Haydon by arguing that no one of a hard, unyielding disposition could possibly seize the nicest inflections of feeling and the evanescent shades

of beauty. Haydon "has not virtue enough. No one can give out to others what he has not in himself." Reynolds may have had his faults, especially in his lack of grandeur, but "he was a man of a mild, bland, amiable character; and this predominant feeling appears so strongly in his works, that you cannot mistake it."[102] Like Tom Taylor, Northcote advocates a theory of painting based on the personal character of the artist, a theory that is both expressive and moralistic without losing sight of the social context in which it is grounded.

It is impossible (as Malone pointed out) that Reynolds was unaware of the respect and affection with which he was treated by the figures he painted as well as by his professional colleagues. But how, precisely, did he view himself? Although I shall attempt, in Chapter 4, to construct a general theory of character based on Reynolds's observation of his own behavior, we must not ignore the visual record that lies even closer to hand. David Mannings has recently traced as many as twenty different portraits in oil that Reynolds painted of himself between roughly 1746, before he left for Italy, and 1788, four years before he died.[103] Most of these paintings are occasional pieces, closely tied to an important event in Reynolds's life: his association with the Society of Dilettanti or the Royal Academy, the mayoralty of his native Plympton, a request from the Florentine Academy, Hester Thrale's plans for decorating her husband's library at Streatham, his Doctor of Civil Law degree from Oxford, and so on.[104] Even the first portrait he painted of himself (Figure 2), in which he peers innocently and openly from the canvas, may be linked to the impending dispersal of his family a few years following his father's death.[105] This remarkable series of paintings may lack the vivacity and drama of Rembrandt's self-portraits (to which they occasionally allude), but they nevertheless disclose the essential contours of a carefully observed life. We discover the advance of age (and girth), the accumulation of professional honors, and—in the final pictures—a narrowing of focus that forces us to confront the mortality displayed in the painter's face.

Considered as a succession of representations, the self-portraits

therefore reveal a process of physical accretion and gradual paring away, and the restricted compass of the final images is consistent, moreover, with Reynolds's parallel treatment of Johnson and Garrick, whom he accompanied through life.[106] At the same time, Reynolds's self-portraits differ from the majority of his depictions of Johnson, Garrick, and other writers, architects, and scholars because they are tellingly reticent about his profession as a painter. Mannings has concluded that only one of the self-portraits represents Reynolds actually at work: the early, intimate portrait in which the young painter, shielding his eyes from the light, confronts his countenance in a mirror (Plate I).[107] There is increasing agreement that this is a very early painting indeed, completed before rather than after Reynolds's sojourn in Rome (c. 1747–48). If this is true, it reinforces our sense of the painter's early accomplishments— particularly in the fresh pose and the confident handling of chiaroscuro—and is consonant with a frequent predicament of the young artist, in which he is forced to paint one of the few models available to him. There is, moreover, a second picture, said to have been painted considerably later (in 1772), in which Reynolds depicts himself standing before an easel with his brush in his right hand and his palette in his left.[108] The painter stares directly at us, as if *we* were his subjects; his canvas, however, is blank (although, at one point, it is said to have contained a landscape!). Mannings has concluded that the face alone is autograph, and that the other elements in the image, including the canvas and easel, were added later by an unknown hand, either posthumously or without the artist's approval.[109] It is surely significant that the picture was eventually owned by two of his colleagues—first (it is said) by Farington, then by Sir Thomas Lawrence—both of whom may have been drawn to this particular portrait because of its unusual (and presumably unsanctioned) focus on the actual practice of painting. Of the fourteen "types" of self-portrait that I have been able to identify, only the important early chiaroscuro image reveals the artist within his studio.

I do not want to argue that, in portraying himself at work so infre-

quently, Reynolds was ashamed of associating himself with his profession as a painter, for we know that he harbored nothing but happiness and pride in his choice of career. But if we ask how Reynolds normally chose to represent himself, we suddenly realize how often he painted himself in other guises: not in fanciful or humorous or heroic roles, but in poses and with attributes related to the other faces of his public life (as a writer, man of learning, or local dignitary). In choosing to portray himself in these ways, Reynolds was essentially faithful to the example of Lely and Kneller and at odds with the practice of his rival in Leicester Fields. In *his* three self-portraits, Hogarth depicted himself with a palette in his hand, or painting the comic muse, or as an image on an unframed canvas surrounded by the paraphernalia of the artist's studio.

If we examine how others painted Reynolds—as in the remarkably warm and informal portrait of 1767 by Angelica Kauffman (Plate II)—we immediately find him in an environment of books, manuscripts, bust, and easel that even the envious Hogarth would have found congenial. These objects have been carefully chosen: Kauffman includes a print of an antique statue, Goldsmith's "The Traveller," Johnson's *Idler* (to which Reynolds had contributed) as well as the *Rambler,* Burke's treatise on the sublime and the beautiful, and Daniele da Volterra's bust of Michelangelo.[110] These are not, strictly speaking, iconographical attributes, for even though they draw our attention beyond the confines of the canvas to the various facets of Reynolds's career, they would also have found a natural place in the artist's painting room (although perhaps not so conveniently collected together). The most intriguing aspect of this assemblage of books, papers, and prints, moreover, is the fact that Reynolds is *not* paying attention to them. Wearing his own hair and with the collar of a Van Dyck suit loosely tied, the painter turns instead to "Miss Angel"—as he now does to us—and listens to what she says. The restless left hand has settled, at least for the moment, on the stocking of his left leg, and the right hand, propped up by the books and manuscripts beneath it, supports an attentive face while also

suggesting the effort the partially deaf Reynolds must make to hear his companion speak.

Kauffman's warm and knowing portrait of her friend, painted very soon after she met him in 1766,[111] should be juxtaposed to the much more serious portrait the young Gilbert Stuart painted of Reynolds in 1784 (Plate III). Reynolds sat to very few fellow painters, and it is thus remarkable indeed that Stuart was allowed the opportunity to portray him. (Reynolds presumably consented to the sitting because the portrait was to be included in a series of fifteen images of artists commissioned by the indefatigable John Boydell.) It is also remarkable that this beautiful painting has received so little critical attention, especially given the delicacy and sureness of Stuart's brushwork here, which at least begins to suggest some of the relatively unfinished, impressionistic techniques that Reynolds would associate with Gainsborough in his fourteenth discourse four years later.[112] Compared to Kauffman's Reynolds, Stuart's is formal, reticent, reserved. The scrolls in the background suggest the sitter's personage rather than his character. The only point of contact between the painter and his subject appears to be their common addiction to snuff; and it is entirely possible that, if Reynolds did in fact disapprove of this portrait, he did so because of Stuart's audacious strategy of depicting the President of the Royal Academy with a snuffbox in his hands.[113]

But the real point of convergence between Stuart and Reynolds is that both were painters—and portrait-painters at that. Stuart, however, has not reminded us that Reynolds is a painter (as Kauffman did), nor does he depict him at work in his studio with palette and mahlstick in hand. Instead, in what I think is a subtle and perhaps subconscious move, he has substituted one form of manual activity for another. The painter's left hand is somewhat open, holding the snuffbox virtually as if it were his palette, while the work of the right hand—the painting hand—is temporarily suspended. Stuart's strategy is not unlike Van Dyck's in his famous *Self-Portrait with a Sunflower,* in which a painter who absolutely refused to portray himself as an artist nevertheless allowed his pointing and open hands to speak on his behalf.[114] Stuart, in

other words, made the best of what may well have been a difficult situation. By introducing this stage business involving snuff, he was able to forge a common bond, personalize (and thus humanize) his sitter, and thereby suggest at least *some* element of activity within an otherwise static portrait. In painting what he saw, moreover, Stuart was able to capture a reserve, a cautiousness, even an iciness that we know was part of Reynolds's character even though it surfaced only occasionally.

This is the *"very cool man"* to whom I turn in the following chapter, a reserved character whose image might profitably be compared with the strong but wooden icon Stuart painted in 1796 of George Washington (Figure 3), another difficult sitter (this one notoriously so). The juxtaposition may at first glance seem odd, but the visual similarities in Stuart's handling of the two figures are in fact quite noticeable. On the one hand we have the first President of the United States, on the other the first President of the Royal Academy. Reynolds's retirement from his presidential chair was rather less graceful than Washington's: the one renounced the possibility of dictatorship by retiring, like Cincinnatus, to his rural estate, while the other found it impossible to retire gracefully from a forum in which he had ruled as a benign monarch for more than twenty years. The point I wish to make, however, is that Stuart's depiction of Reynolds must be carefully compared to the many encomiastic or eulogistic remarks in Reynolds's honor, particularly a verdict such as Burke's that never "was the least degree of arrogance or assumption visible to the most scrutinising eye, in any part of his Conduct or discourse."[115] The paradox, finally, of Stuart's portrait of Reynolds is that it simultaneously captures a side of him that is relatively unknown while recording a sitting—a social and professional transaction—that was arguably a failure.[116] Stuart may have been desirous to please, but the portrait he completed suggests that his subject was anything but complacent. Reynolds's own particular talent lay, ironically, in his ability to overcome the kinds of difficulties that he himself imposed on Gilbert Stuart.

Throughout the 1750s, 1760s, and early 1770s, Reynolds continued to

experiment with the various pictorial elements available to an artist who was determined to depict himself as a socially or intellectually engaged character. All of the self-portraits are half-lengths that capture Reynolds in three-quarter profile; one hand is normally included, occasionally two. The earlier canvases suggest that Reynolds paid considerable attention to his clothing, perhaps more so than his biographers have usually acknowledged. We normally associate him with the elegant—and plain—red or brown velvet suits of the later self-portraits, and Northcote in fact wrote in his letters home (in 1771) that Reynolds detested fops. Although his master "dresses very grand commonly wareing cut Velvet yet there is not the least appearance but rather the reverse to foppery. he cannot bare Horneck who is a vast fop and is the jest of people of sence."[117] Reynolds can be seen at his most modest in a self-portrait with Rembrandtesque tones painted in the early 1750s (Figure 4).[118] We know, however, that he owned at least one court suit—a three-piece ensemble of apricot ribbed silk (Plate IV) whose size confirms Farington's measurement of the artist as 5 feet, 5 ⅛ inches tall[119]—and that he painted himself in a fashionable blue waistcoat even in the intimate self-portrait I have already examined (Plate I). In a Roman portrait of the early 1750s, moreover, we find him attired in a remarkably unappealing wide-brimmed hat (his first gesture toward Rembrandtesque dress);[120] by 1760 he is wearing a red cloak with a dark fur collar, and a few years later he appears in a cape.[121] In each of these pictures, the fancy dress enlivens the stock pose and prevents us—at least temporarily—from realizing that the painter is empty-handed: the hands, if included, literally have nothing to do.

Reynolds resolved this dilemma by the time he painted his self-portrait for the Society of Dilettanti in 1766 (Figure 5), for here he exchanges fashionable dress for a plain brown cloak (as shapeless and classical as any gown his female sitters were wearing at the moment) and cups his right hand over the top edge of a large book. The folio in turn became a portfolio—that is, a collection of drawings to be studied by an accomplished connoisseur—in a painting of the same period,[122] before disappearing altogether in the various self-portraits dating to

1773 or so in which Reynolds can paint himself in his newly-bestowed doctoral robes and handsome white cravat (Figure 6).[123] From this point onward, the trajectory of Reynolds's self-portraits is toward consolidation rather than experimentation: by 1775, in the well-known Uffizi portrait, he has added the soft black cap that complements his doctoral robes, and his right hand holds not a book or portfolio but a roll of paper that bears the inscription "Disegni del Divino / Michelagnolo Bon."[124] It is now only a step to the culmination of this careful accretion of elements in the great self-portrait Reynolds painted for the Royal Academy in 1780 (Plate V). Here we find the doctoral robes, the elegant white cravat, the black bonnet, the rolled paper, *and* the shadowy bust of Michelangelo by da Volterra. Both the extended left arm, which rests comfortably on the massive table, and the right arm—which is painted akimbo—suggest the assurance, the authority, and the control that now characterize the Academy's first President.

It is perhaps worth reminding ourselves, moreover, that the contextual bust in the background (a visual counterpart to the foregrounded figure of the painter on the left) is the only element in the picture that draws attention to Reynolds's profession as an artist. The academic gown and rolled drawing or manuscript point to the subject's intellectual accomplishments, and even the figure of Michelangelo—often the subject of Reynolds's *Discourses*—would not have been out of place in a standard portrait of the eighteenth-century man of *virtù*. When Valentine Green engraved the painting, he in fact emphasized these very qualities by inscribing the following titles beneath Sir Joshua's name: "President of the Royal Academy, Member of the Imperial Academy at Florence, Doctor of Laws of the Universities of Oxford and Dublin, and Fellow of the Royal Society."[125] The Italian bust, moreover, especially conjoined as it is to the velvet Rembrandtesque hat, invokes another painting rather than painting itself.[126] Unlike Rembrandt's Aristotle, Reynolds glances intently outward, at us, in a pose that anticipates the even more direct relationship between painter and audience that we find in his later self-portraits.

The unusual painting in which Reynolds draws attention to his loss

of hearing (Figure 7), which can be dated to roughly 1775, has histori-
cally been linked with a similar portrait of Samuel Johnson (Figure 8),
and for good reason. Both pictures are small, half-length images in
which the subject is shown at close range (Reynolds painted Giuseppe
Baretti in a similar format), and both draw attention to their subjects'
physical limitations. Johnson in fact complained to Hesther Thrale that
" 'he would not be known by posterity for his *defects* only, let Sir Joshua
do his worst.' I said in reply, that Reynolds had no such difficulties
about himself, and that he might observe the picture which hung up
in the room where we were talking, represented Sir Joshua holding his
ear in his hand to catch the sound. 'He may paint himself as deaf if he
chuses (replied Johnson); but I will not be *blinking Sam*.' "[127] The por-
traits of Johnson and Baretti, moreover, show their sitters absorbed in
the act of reading, whereas Reynolds's self-portrait once again reveals
the painter in the act of listening to someone else. Reynolds may be
absorbed, but he is not self-absorbed; unlike Johnson or Baretti (or
Goldsmith, for that matter), Reynolds looks out into a sociable world.

We discover a similar intensity, this time heightened by the only
appearance of spectacles in one of Reynolds's self-portraits, in a picture
painted at the very close of his career (Figure 9). The silver spectacles
(which Reynolds had long worn in the painting room) and the slightly
extended arms again suggest physical activity—perhaps even the ac-
tivity of painting. But Reynolds (like Van Dyck before him) raises this
possibility only to suppress it. Elegantly dressed and with his mouth
slightly open, Reynolds once again appears in a social role, ready to
join in the conversation of his friends. Malone noted, in fact, not only
that the likeness was extremely good, but also that the portrait repre-
sented him "exactly as he appeared in his latter days, in domestick
life."[128] When Frances Burney, in the memoirs of her father, thought
back on her friendship with Reynolds, she remembered that there was
little "play of countenance, beyond cheerfulness or sadness," in the
painter's features. In his eyes, however, there was a "searching look"
that seemed to fix, in his mind, the facial attitude that would be most

striking in a picture. If we sense this kind of intensity in this late self-portrait, we must also qualify it by quoting Burney's conclusion, in which she adds that the painter's searching look was "rarely obvious, and never disconcerting; he was eminently unassuming, unpretending, and natural."[129]

Reynolds's "searching look" in his final self-portrait *is* disconcerting, however, for it records the artist's chilling stare at the mortal image he encounters in his mirror (Figure 10). This is not a portrait of the painter in society. The silver spectacles are gone. The sitter peers closely, at short range, into his cheval-glass, his mouth open even further than in the previous painting. His figure has receded slightly in the picture space, and his body has simultaneously receded into the great velvet collar of his coat. Boswell remarked that the face had "a sort of *pulled-up* look, and not the placid gentleness of his smiling manner; but the features, though rather too largely and strongly limned, are most exactly portrayed, and the dress in every respect being such as he usually wore, I think it the best representation of my celebrated friend."[130] Reynolds's look is actually frozen as well as pulled up. His features are white, dry, and somewhat fuzzy, and his wig seems to have symbolically stiffened (especially if we compare it with the one he wears in the previous portrait). It is, in short, a startling representation, a candid acknowledgment of infirmity and dissolution that is surely only partially explained by its own physical deterioration on the canvas.[131]

AT THE TABLE AND IN THE CLUB

Reynolds's great portrait of himself in doctoral robes (Plate V) was painted for the Royal Academy years after he had been asked to serve as its first President, and it does not appear that we can associate any other self-portrait with this crucial moment in Reynolds's career. The hurried events of December 1768 may never be entirely untangled, but it is clear that Reynolds's assumption of the Presidency signaled his professional pre-eminence among his colleagues just as the King's be-

stowal of knighthood symbolized his accomplishments in social as well as artistic terms. Reynolds was only the second English painter to receive this honor (following Sir James Thornhill, Hogarth's father-in-law), and the King made it known that his gift was tied to a request by the Duke of Grafton (the Prime Minister) on Reynolds's behalf rather than to the office of the Presidency itself.[132]

Reynolds's knighthood was certain to irritate some of his envious colleagues. Allan Ramsay, the Principal Painter in Ordinary to the King, was reported to have declined such an honor; and even Gainsborough, in a letter to Lord Dartmouth dated 18 April 1771, complained that he "never could have patience to read poetical impossibilities, the very food of a painter, especially if he intends to be knighted in this land of roast beef."[133] By far the most hostile attack came from a partisan of the Incorporated Society of Artists, whose control of the profession of painting vanished with the establishment of an academy patronized by the King. Reynolds had wisely chosen to stay clear of the various skirmishes that eventually led Sir William Chambers and others to desert the Society, and it is possible that Reynolds's neutrality made him an even more attractive candidate when the fledgling academy chose its first leader.

His antagonist in the *Middlesex Journal* saw things differently, however: "You reasoned with an adroitness as acute as it was profound. You well knew that if you were to remain with the Society of Artists you could not possibly gain anything more than a good name, and that there were the most flattering hopes that should you give a civil leer at the other you might gain a title." Comparing Chambers and his colleagues to infernal rebels who paved the way—like Sin and Death—for Reynolds to follow, "Fresnoy" argues that "it was a matter of the utmost indifference to you who was damned for it so that you got up to the heaven of a knighthood. Heaven itself cannot produce a more flagrant instance of base apostacy." And then, yoking his assault on Reynolds with a side glance at Johnson, he observes that there "is a perfect mu-

tuality in this for he has an undeserved pension and you a title; he has abused the King and the King has abused you—happy rogues to be so repaid!"[134]

But even "Fresnoy" was forced to admit that Reynolds's elevation had not lost him the company of his closest friends, who rejoiced in his personal success. Burke remarked that "the sound of the name was so well adapted for a title, that it seemed as if it had been chosen for the purpose," and Johnson, after ten years of abstinence, "drank one glass of wine to the health of Sir Joshua Reynolds, on the evening of the day on which he was knighted."[135] The King's gift—combined with the Presidency of the Academy—was clearly a turning point in Reynolds's career. Northcote reports that in the latter part of his life Reynolds was "treated like a beauty, for he was so flattered and caressed," and he remembers a servant telling him "that he was always excited when he had to call out his master's name at receptions and such like; the people, he said, all turned round and stared so, upon hearing Sir Joshua's name announced, and they even made a lane for him to pass through, whereas when a duke or an earl was announced, few of the people took any notice." "This shows us the respect and admiration which are paid to great and acknowledged talent," Northcote concludes, "beyond what rank—mere rank alone—can never hope to claim."[136]

Reynolds noted this critical moment in his life by writing the following memorandum in large letters in his notebook for 21 April 1769: "12 1/2 The King's Levee—Knighted at St. James'."[137] Five days later he celebrated by giving a small party for several of his closest friends (none a fellow Academician). The guest list included Johnson, Burke, Thomas Percy, Robert Chambers, Dr. Christopher Nugent, Bennet Langton, Sir William Jones, Dr. Thomas Leland, and John Hawksworth, most of them members of the so-called Literary Club that Reynolds had helped found in 1764.[138] It is entirely appropriate that Reynolds should celebrate his knighthood by dining with friends, for much of his profes-

sional as well as social success was derived from mixing with "the ingenious and learned men of his own time." Here is how Northcote (like Malone before him) framed the argument:

> Mr. Malone is correct in stating, that finding how little time he could spare from his profession, for the purpose of acquiring, and adding to his knowledge from books, he very early and wisely resolved to partake, as much as possible, of the society of all the ingenious and learned men of his own time; in consequence of which, and his unassuming and gentle manner, and refined habits, his table, for above thirty years, exhibited an assemblage of all the talents of Great Britain and Ireland: there being, during that period, scarce a person in the three kingdoms distinguished for his attainments in literature or the arts, or for his exertions at the bar, in the senate, or the field, who was not occasionally found there.[139]

The table, in other words, provided education as well as entertainment. It was here that Reynolds learned how to listen, reason, argue, and make peace among friends; and it was here—as well as in the studio—that he studied the behavior of the men and women he was currently painting or would eventually portray. As Malone told Farington, "His close study of the characters of men for which He was remarkable, proceeded from the delight He felt in considering Man under all his varieties, and that in fact it was to him an *amusement* rather than a means of using [a] man for any worldly purpose."[140]

We have occasional glimpses, especially in Frances Burney's diary and Boswell's journal, of Reynolds's comportment when he dined out, and numerous accounts fortunately survive of the dinners Reynolds himself gave either in Leicester Fields or at Wick House, the villa Sir William Chambers designed for him in Richmond. Although Reynolds's country house was in itself an emblem of the painter's accomplishments—and although it had a good view, symbolically overlooking the estate of the retired Thomas Hudson, his former master—it never appears to have pleased either Reynolds or his nieces. Farington reported (mistakenly) that the painter never slept there overnight, and his niece

3 Tatler.

The Manner with which men of the World support
and assert the merit of their own Performances.
A man in some measure must be the Trumpet
of his Fame: but endued with a defensive Eloquence
to be capable of expressing the Rules and arts
by which they govern themselves.

No medium in Matrimony.

Learning is not knowledge, but rather the Art
of using it.

Divert your Mistress rather than sigh for her.
That sort of love which generally succeeds is a
stranger to awe and distance

The best way to seem to be so is to be so in deed.
be what you would be thought to be. Tillotson

The Good natur'd muscles of Humphry's countenance.

Figure 1. Reynolds, a page from an early commonplace book.

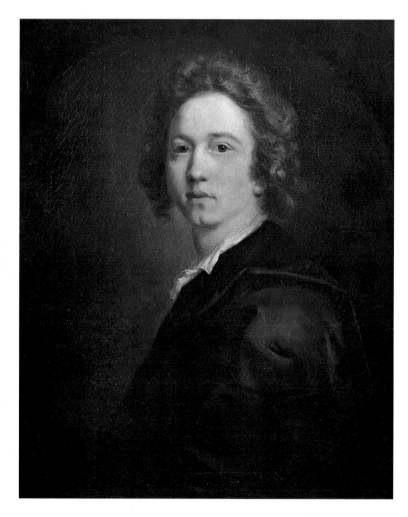

Figure 2. Reynolds, *Self-Portrait,* c. 1746.

Figure 3. Gilbert Stuart, *George Washington*, after 1796.

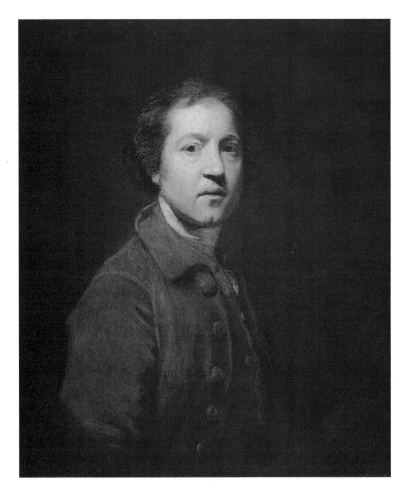

Figure 4. Reynolds, *Self-Portrait*, c. 1753–1755.

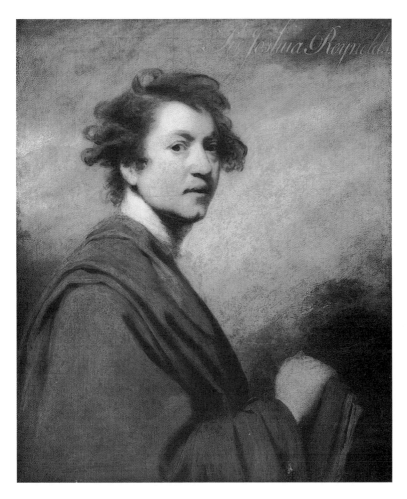

Figure 5. Reynolds, *Self-Portrait*, c. 1766.

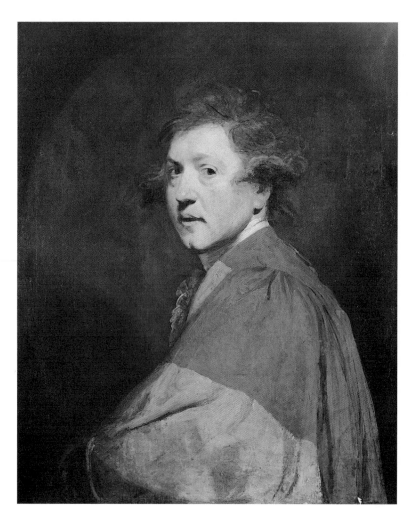

Figure 6. Reynolds, *Self-Portrait,* c. 1773.

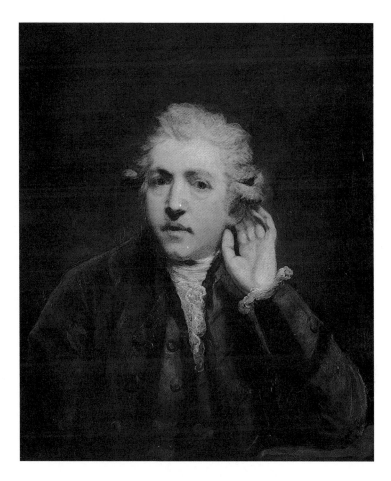

Figure 7. Reynolds, *Self-Portrait*, 1775.

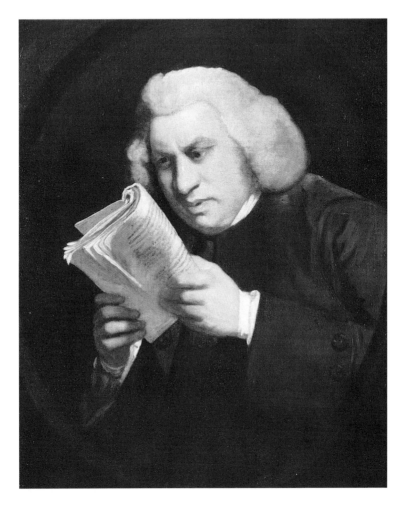

Figure 8. Reynolds, *Samuel Johnson*, 1775.

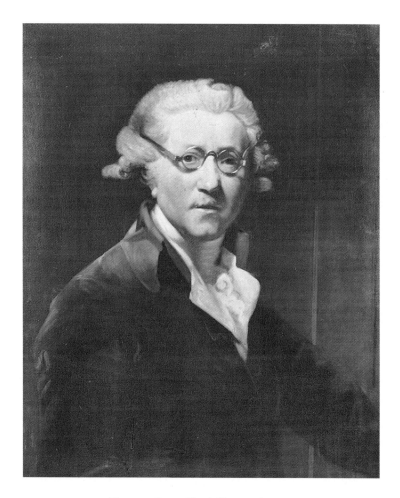

Figure 9. Reynolds, *Self-Portrait,* 1788.

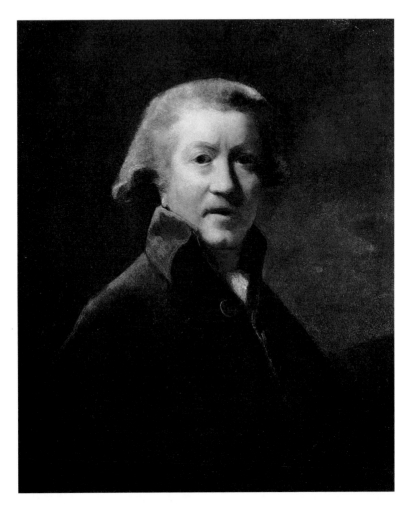

Figure 10. Reynolds, *Self-Portrait*, 1788.

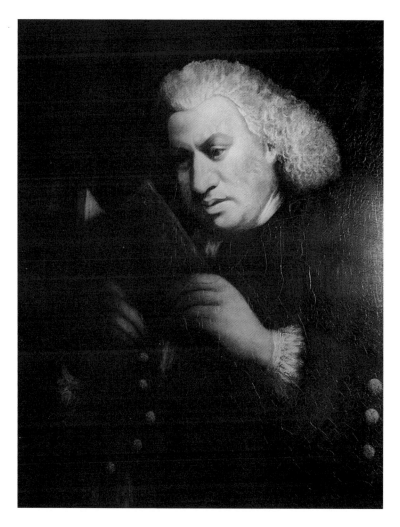

Figure 11. Frances Reynolds, *Samuel Johnson,* c. 1780.

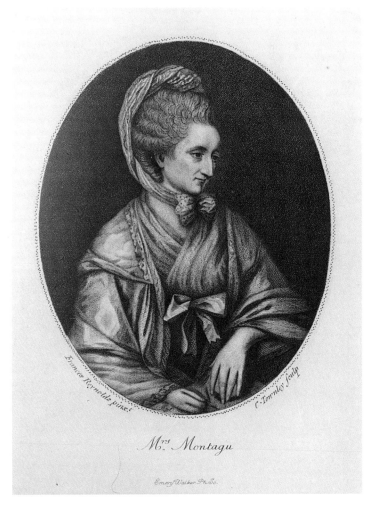

Mrs. Montagu

Figure 12. C. Townley, engraving after Frances Reynolds,
Elizabeth Montagu, c. 1778.

Figure 13. Frances Reynolds, *Self-Portrait with Her Two Sisters,* undated.

to face the preface.

JOHN HOOLE.

Anker Smith sculp.

Figure 14. Anker Smith, engraving after Frances Reynolds,
John Hoole, c. 1783.

Figure 15. One of Reynolds's mother-of-pearl gaming counters (enlarged).

Figure 16. An impression of Pierre Etienne Falconet's "Winter,"
one of Reynolds's seals (enlarged).

Mary Palmer wrote that Wick House combined all the inconveniences of the country *and* the city without any of their comforts; it was, she said, "a house stuck upon the top of a hill, without a bit of garden, or ground of any sort near it, but what is as public as St. James's Park."[141] It was at Wick House, however, that the young Frances Burney first met Edmund Burke, and the marvelous account she has left of that encounter—first in her diary and then later in the memoirs of her father—provides possibly the fullest narrative we have of an evening's entertainment in the eighteenth century.[142]

Charles Burney celebrated his friendship with Reynolds—and his friend's hospitable dinners—in some doggerel verses of 1776:

> At his Table, where true Hospitality reigns
> He assembles together, with skill & with pains
> All men most distinguish'd for science & arts,
> For genius, for learning, acuteness, & parts
> Whose productions or talents have gain'd a high station
> And favour procur'd of the whole British nation.[143]

John Courteney's description of a typical dinner at Reynolds's house is lengthy, but it is nevertheless a vibrant set-piece that deserves to be quoted in full:

> His table was frequented by men of the first talents, who met with mutual complacence and good-humour. Politics and party were never introduced. Literary subjects were discussed with good sense, taste, and fancy, without pedantic, tiresome dissertations. Wit and humour occasionally enlivened the festive board; but story-telling, premeditated *bon-mots,* and studied witticisms, were not tolerated for a moment. Sir Joshua was excellently calculated for promoting lively rational conversation. His mind was active, perpetually at work. He aimed at originality, and threw out observations and sentiments as new, which had been often discussed by various authors; for his knowledge was principally acquired by conversation, and therefore superficial. However, he was a most pleasing, amiable companion; his manners easy, conciliating, and unaffected. He

had great good sense, and an exquisite correct taste; and if his ideas were not always new, they were often set off by liveliness of imagination; and his conversation abounded in pleasing and interesting anecdotes.

There was something singular in the style and œconomy of his table, that contributed to pleasantry and good-humour; a coarse inelegant plenty, without any regard to order and arrangement. A table, prepared for seven or eight, was often compelled to contain fifteen or sixteen. When this pressing difficulty was got over, a deficiency of knives and forks, plates, and glasses succeeded. The attendance was in the same style; and it was absolutely necessary to call instantly for beer, bread, or wine, that you might be supplied before the first course was over. He was once prevailed on to furnish the table with decanters and glasses at dinner, to save time, and prevent the tardy manoeuvres of two or three occasional undisciplined domestics. As these accelerating utensils were demolished in the course of service, Sir Joshua could never be persuaded to replace them. But these trifling embarrassments only served to enhance the hilarity and singular pleasure of the entertainment.

The wine, cookery, and dishes were but little attended to; nor was the fish or venison ever talked of, or recommended. Amidst this convivial, animated bustle amongst his guests, our host sat perfectly composed, always attentive to what was said, never minding what was eat or drank, but left every one at perfect liberty to scramble for himself. Temporal and spiritual peers, physicians, lawyers, actors, and musicians, composed the motley groupe, and played their parts without dissonance or discord.

At five o'clock precisely dinner was served, whether all the invited guests were arrived or not. Sir Joshua was never so fashionably ill-bred as to wait an hour, perhaps, for two or three persons of rank or title, and put the rest of the company out of humour by this invidious distinction.[144]

Virtually every detail in Courteney's description is corroborated by Reynolds's other friends, many of whom were much less cautious in venting their criticism of how he assembled and entertained his guests. Hannah More, for instance, may have believed that Reynolds was "the idol of every company," but she also characterized an "agreeable party" in Richmond as "select, though much too large to please me. There

was hardly a person in company that I would not have chosen as eminently agreable; but I would not have chosen them all together."[145] Boswell complains of low company and bad servants, and even Johnson remarked that "the servants, instead of doing what they are bid, stand round the table in idle clusters, gaping upon the guests; and seem as unfit to attend a company, as to steer a man of war."[146]

The dinners themselves were thought to be *"execrable,"*[147] but it was not for the food that Reynolds's visitors came. As Malone reminded his readers, "there seemed to be a general, though tacit, agreement among the guests, that *mind* should predominate over *body;* that the honours of the turtle and the haunch should give place to the feast of wit, and that for a redundant flow of wine the flow of soul should be substituted."[148] The painter's goal was to promote animated—even vociferous—conversation, and the success of this enterprise rested on two conditions, both of which were noted by Courteney. In the first place, Reynolds enjoyed inviting lively guests who were often of very different opinions. Lord Ashburton is quoted as greeting Reynolds by saying, "Well, Sir Joshua, and who have you got to dine with you to-day? for the last time I dined with you in your house, the assembly was of such a sort, that by G— I believe all the rest of the world were at peace, for that afternoon at least."[149]

Second, Reynolds ensured that this conversation would tumble forth by insisting on an unusual informality and even an element of social chaos at the table. In contemporary terms, Reynolds encouraged civility (inherent politeness and amiability) rather than mere ceremony (an external show of manners related to the artificial humanity that so worried Addison).[150] Frances Burney remarked that Reynolds held ceremony in horror, and I think it is just this measure of anarchy and unpredictability that enabled him to generate conviviality among people who would normally have had very little to do with one another.[151] By seating temporal with spiritual peers, by refusing to wait table for titled late-comers, by inviting guests without guile or stratagem (and often without warning to his own bedraggled staff), Reynolds was

able to forge a social decorum of his own in what Sir William Forbes called "the common centre of union for the great, the accomplished, the learned and the ingenious"[152]—and the "low" and the "rags," Boswell and Johnson added.

It is precisely this social and cultural mix, moreover, that was beginning to be seen as the appropriate milieu for the man of good breeding. When Fielding stated that the essence of gentlemanly behavior "is to contribute as much as possible to the Ease and Happiness of Mankind," he argued that one could accomplish this by bringing "Society as near to a Level at least as he is able" and he adduced Socrates among the dancing-masters as an instructive example.[153] This is a lesson that Reynolds clearly learned. Northcote, for example, remembers a conversation in which he observed to his master that "a certain insignificant person" of their acquaintance was surprisingly successful in drawing persons of the very highest rank to his house. "Sir Joshua, who knew the world much better than I ever shall, set me right by saying, 'If you will but provide suitable entertainment for them, you may easily have for your visitors whoever you choose to invite, from the highest to the lowest.'"[154] Reynolds's particular form of "suitable entertainment," moreover, depended heavily on this social mixture and on his own ability to draw others out. Malone paid his friend an interesting posthumous compliment by telling Farington how "difficult it would be to establish a Plan for collecting select Society in the way Sir Joshua Reynolds carried his on." Three contemporary companions who might appear to be likely candidates—Burke, Sir Joseph Banks, and William Windham—also possessed talents that rendered them "unfit" for this role. Reynolds, by contrast, "relished all the varieties of Character & knowledge, and assuming little himself, each person was encouraged to conversation."[155]

Reynolds's penchant for a variety of characters chosen from an increasingly broad social spectrum ("from the highest to the lowest") can be gauged not only in the parties he gave in Leicester Fields but also in his life-long attachment to the world of the club. If we are to understand

the social dynamic of the eighteenth-century club, John Brewer has argued, we must abandon any notions we may have of "a venerable, neo-classical edifice filled with leather armchairs, musty volumes and antediluvian males."[156] What we may think of as a hotbed of self-complacency was actually a complex and often surprisingly democratic institution. Although "feasting, drinking and conviviality were central to every club's existence," Brewer writes, "the club also performed important social functions as a protection against adversity and as an elaborate system of reciprocal obligation."[157] These microcosms regularly transcended "traditional social, economic and religious boundaries," promoting unanimity and harmony where only conflict had previously existed.[158] Within each group, all were equal; in fact, Brewer argues, "the eighteenth-century club closely approximated to the classical republican ideal so beloved of contemporaries yet so rarely realized in political society at large."[159] And this, we should remind ourselves, is the site of complaisance, the virtue Addison believed would blend "all Orders of Men together in a Friendly Intercourse of Words and Actions."

Reynolds clubbed with a startlingly diverse collection of friends and companions several nights of the week. He belonged to the (Literary) Club, the Devonshire, the Eumelian, the Sons of the Clergy, the Thursday-Night-Club at the Star and Garter, Almack's (a gambling club that included women), and the Society of Dilettanti, whose collective portrait he painted.[160] Like Arthur Pond before him, he inevitably mixed business with pleasure when he met with his fellow members, for social intercourse within the club often led to commissioned paintings and to an ever-widening pool of potential patrons.[161] But Reynolds's clubs—unlike Pond's—did not include fellow artists; the reciprocity that Brewer associates with the club as an institution can best be sensed, in Reynolds's case, in the give and take of ideas and in personal favors that led to social and political preferment. In 1764, for instance, Reynolds proposed the Irish peer Lord Charlemont, whom he had known since his years in Rome, as an original member of the

Club (Charlemont had in fact been the first to suggest such a conversational gathering to his friend). Johnson quashed the nomination, fearing that their fledgling venture would be seen as "*his* club," but Charlmont was eventually elected and, in 1766, successfully nominated Reynolds for membership in the Society of Dilettanti.[162]

We can begin to sense what Reynolds looked for in fellow members by examining some of the comments he made about friends whom he hoped would be elected to the Club, where one black ball would block a candidate's admission. In 1773, in a letter to Elizabeth Montagu, we find Reynolds assuring her that Burke had proposed Agmondisham Vesey by reporting that he was "good humoured sensible, well bred, and had all the social virtues; it was left for you to say that he was a man of Tast without pretensions and so without jealousy and envy. I have too good an opinion of our club to entertain the least suspicion that such a man will not be unanimously elected."[163] Boswell reports, moreover, that "when Mr. Vesey was proposed as a member of the *Literary Club*, Mr. Burke began by saying that he was a man of gentle manners. 'Sir, said Johnson, you need say no more. When you have said a man of gentle manners; you have said enough.' "[164]

By 1790, however, these social virtues were no longer sufficient to ensure election to the Club. Reynolds proposed or seconded five different candidates—including his close friends Philip Metcalfe and the Earl of Carlisle—only to find each blackballed by at least one of his fellow members. In an apparent response to this personal affront, Reynolds vented his anger and frustration by writing that "you wonder men of great and distinguished parts should love the society of plain and insipid men who can furnish only the Chit chat of the day[.] You say [that in] their hours of relaxation from their more serious & weighty business they might as well relax in the company of men of wit." But Reynolds's answer is that it would be mortifying for his fellow club members to listen to witty, spirited conversation without joining in, and that if they did join in, they would be taxed just as seriously as in their professional business and thus lose the sense of relaxation the club

provides.[165] Elsewhere, in a passage from an unknown author that he copied into one of his commonplace books, Reynolds isolated a similar quality that we should associate not only with the world of the club but with his own character as well: "a cheerfull goodnatured man stands as fair a chance to Please in conversation as the wise and learned man."[166]

Reynolds's difficulties in electing his friends to membership in the Club in 1790 were clearly exacerbated not only by his recent troubles at the Royal Academy (which I shall examine in my final chapter) but also by the fact that he himself had been blackballed at White's only a year earlier.[167] White's, of course, was quite different from the Club. When Gibbon wrote to Garrick, asking him to "assure Sir Joshua in particular that I have not lost my relish for *manly* conversation and the society of the brown table,"[168] it was natural that he primarily associated the Club with good talk. White's, by contrast, was a fashionable club devoted to drinking and gambling, two pursuits that we must examine carefully if we are fully to understand the importance of clubbing in Reynolds's life.

We know a good deal about Reynolds's drinking habits simply because Johnson disapproved of them. In 1775, for instance, he informed Boswell that "Reynolds has taken too much to strong liquor, and seems to delight in his new character," a description Boswell called "fanciful."[169] At the same time, when Boswell was about to congratulate himself on his agreeable behavior, he remembered what Johnson had recently said about Reynolds: "He has now got a good deal into great company and drinks to raise himself to a level with his company, without considering that when a man is agreeable to himself, he may not be so to others."[170] (We might characterize this as self-complacency driving out complaisance.) A year later—in Reynolds's presence—Johnson couched the same argument in general terms, with the painter agreeing that this was often the case when men drank to excess, but not when they took their wine in moderation. " 'I am,' said he, 'in very good spirits when I get up in the morning. By dinner-time I am ex-

hausted. Wine puts me in the same state as when I got up, and I am sure that moderate drinking makes people talk better.' " But Johnson was not about to agree: "I do not say it is wrong to produce this self-complacency by drinking. I only deny that it improves the mind."[171] Two years later, with a water-drinking Boswell as mediator, they went at each other once again:

> JOHNSON. "Boswell is a bolder combatant than Sir Joshua: he argues for wine without the help of wine; but Sir Joshua with it." SIR JOSHUA REYNOLDS. "But to please one's company is a strong motive." JOHNSON. (who, from drinking only water, supposed every body who drank wine to be elevated,) "I won't argue any more with you, Sir. You are too far gone." SIR JOSHUA. "I should have thought so indeed, Sir, had I made such a speech, as you have now done." JOHNSON. (drawing himself in, and, I really thought blushing,) "Nay, don't be angry. I did not mean to offend you." SIR JOSHUA. "At first the taste of wine was disagreeable to me; but I brought myself to drink it, that I might be like other people. The pleasure of drinking wine is so connected with pleasing your company, that altogether there is something of social goodness in it."[172]

And so on, with Johnson naturally refusing to accept a social frame-work for drinking—founded on Sir Joshua's complaisance, and perhaps also on the dangers of conformity lurking within the desire to "be like other people"—in lieu of a moral imperative based on Johnsonian self-restraint.

When we turn from drinking to gambling, however, we find that Reynolds was clearly worried about his own self-control.[173] The fullest account of his gambling—and of his belief that it was a natural pro-clivity—appears in Farington's diary:

> Speaking of gaming Lady Inchiquin [Reynolds's niece, Mary Palmer] said Sir Joshua had a strong passion for it, as He himself allowed,—and He was convinced it was inherent in human nature. He said that the

principle of it appeared in a variety of instances.—Offer a beggar as much per week to work moderately as He wd. confess He obtained by soliciting Alms, & He wd. refuse it.—In one case certainty would preclude hope.— Tell a man of 50 that His life shd. be secured to 90 but then it must terminate, He wd. rather take his chance.

Sir Joshua though He had a passion for gaming kept it within bounds.—He once won 70 guineas at a sitting which was the largest sum He ever gained.—If He went into a Company where there was a Pharo table, or any game of chance, He generally left behind him whatever money He had abt. him.[174]

This is an intriguing portrait of a complicated—but, even in his own view, not an extraordinary—individual: fully conscious of his own passion for gambling, for hope rather than certainty; equally convinced that he shares this obsession with "human nature"; but also aware that he is not a talented gambler, and therefore perhaps doubly cautious to keep his passion "within bounds." One of Reynolds's nieces, presumably Mary Palmer, noted, however, that her uncle had become "violently fond of whist" in his later years. "He is not tied down to common rules," she wrote, "but has always some scheme in view, and plays out his trumps always; for it is beneath his style of play ever to give his partner an opportunity of making his trumps: but notwithstanding, he generally wins from holding such fine cards."[175]

We can provide an interesting gloss on Reynolds's juxtaposition of certainty and hope if we return to the execution he attended with Boswell in 1785. The criminal actions that led to these public hangings were themselves calculated gambles that had not paid off; finally, as Reynolds wrote to Boswell, the state of uncertainty for these criminals (including one of Burke's former servants) was brought to an end: "I am convinced from what we saw . . . that it is a state of suspense that is the most irksome and intolerable to the human mind, and that certainty, though of the worst, is a more eligible state; that the mind soon reconciles itself even to the worst, when that worst is fixed as fate."[176] This conclusion may represent a change of mind on Reynolds's part—

a change enforced by the horrors of Tyburn rather than the gaming tables at Almack's—but it is nevertheless manifestly at odds both with his niece's account of his beliefs and with what Boswell confided to his journal later the same day. After breakfasting with Reynolds and Alderman Boydell, Boswell courted a former prostitute about to return to the street by confessing his love to her: "I was vexed at such an instance of depravity. But it was curious. It verified Reynolds's maxim that human nature loves *gaming;* agitation, uncertainty."[177]

Perhaps the least we may conclude from these conflicting sources is that, both as a painter and as a social creature, Reynolds thought carefully about his predilection for hope even at the expense of security, and—aware of his passions—kept a careful eye on his public behavior. We have already seen how seriously he attempted to exonerate his attendance at a public execution; in a similar vein, Northcote reports that Reynolds was "always cautious to preserve an unblemished character, and careful not to make any man his enemy":

> I remember when he was told of some very indiscreet speech or action of Goldsmith, he quickly said, "What a fool he is thus to commit himself, when he has so much more cause to be careful of his reputation than I have of mine!" well recollecting that even the most trivial circumstance which tells against an eminent person, will be remembered as well as those in his favour; and that the world watch those who are distinguished for their abilities with a jealous eye.[178]

Drinking, talking, and gambling—the very lifeblood of the Georgian club—can be both relaxing and invigorating if they are practiced in moderation. "To check too much the natural inclinations may be compar'd to a man who too severely curbs a generous horse which inrages him till he throws him from his back," Reynolds wrote in one of his commonplace books; we should not "deprive a man of all pleasures but guide & moderate them by the reins of reason."[179] But there is also a dark side to each of these social pursuits, for in Reynolds's eyes the

road of excess leaves one uncomfortably vulnerable and exposed, isolated from the social fabric of the club and from the sense of personal and professional identity that it reinforces. As he noted in one of his manuscript fragments, "The great business of life is to watch over yourself."[180]

Other Voices

No person is completely invulnerable, especially after his or her death. Critics relish disputing with the dead, and even friends and admirers feel more comfortable dispensing tempered praise once their subjects are safely in the grave. The passing of years allowed Burke to note that Reynolds was timid—an observation that Malone agreed was "perfectly true"—and to argue that, as a "great generaliser," his friend was too fond of reducing issues more systematically "perhaps than the variety of principles which operate . . . in the human mind and in every human Work will properly endure." But Burke also confessed that he did not know "a fault or weakness of his that he did not convert into something that bordered on a virtue instead of pushing it to the confines of a Vice."[1] Giuseppe Marchi (Reynolds's life-long assistant) told Farington that Reynolds paid Toms the drapery painter only fifteen guineas for a whole-length portrait and that he was "never pleased with anything that was done for Him."[2] Ellis Cornelia Knight framed her character of Reynolds in an unusually even-handed manner, providing us with a rare glimpse of the painter's physical appearance: "I believe he was good, friendly, and benevolent in a high degree. His pronunciation was tinctured with the Devonshire accent; his features were coarse, and his

outward appearance slovenly, but his mind was certainly not inelegant, and the graces which he did not himself possess he could confer on his pictures." He loved high company, she adds, "and wished his house to be considered as a Lyceum. In this he had Rubens and Vandyke in view."[3]

Other voices were equally dispassionate. Whereas Burke had written to his son that "every thing turned out fortunately for poor Sir Joshua from the moment of his Birth to the hour I saw him laid in the Earth,"[4] other assessments of Reynolds's good fortune were often tinctured by a knowledge of how badly his fellow painters fared. "Anthony Pasquin" (John Williams) acknowledged that Reynolds was "uncommonly gifted," that "Nature designed him to be eminent as a Portrait Painter" even if it "denied him the power to be eminent in any other path."[5] There was a polish in his exterior "illustrative of the Gentleman and the Scholar," and he possessed "an equanimity of disposition rarely to be met in persons whose pursuit is universal renown."[6] But Pasquin is severely critical of Reynolds's influence on British painting and aspiring British painters: he was "as injurious to the true principles of painting as a fine prostitute to the establishment of morals."[7] Reynolds pursued "that fashionable herd, who administer encouragement in proportion as their deformities are reduced, and their vanities gratified." He made the tall short and the short tall as the wishes of the sitter wavered: he "very laudably as a man of the world, though not very honorably as an Artist, made his acquired powers obedient to the suggestions of those, who could reward him munificently."[8]

When William Hayley attempted to distinguish the three qualities essential in forming a great artist, he argued that Romney surpassed Reynolds in possessing "an ardent and powerful imagination, acute and delicate sensibility, and a passion for study," but Reynolds, he adds, was pre-eminent in the three great objects of human pursuit: "in fortune, in felicity, and in fame."[9] Richard Cumberland draws the same comparison in even more grandiose fashion, pitting the shy, retiring, contemplative Romney against a Reynolds who "sunned himself in an un-

clouded sky" and whose muse brought him a "cornu-copiae rich and full as Flora, Ceres and Bacchus could conspire to make it."[10]

Northcote, who outlived his master by thirty-nine years, peppered his table-talk and personal memoirs with candid observations on the artist he largely eulogized in his official biography. We learn, for instance, that Reynolds's equanimity—his invariably placid temper—could actually be provocative: "he was too much of a philosopher to be annoyed;—he looked to the end of the year—to the great result. Besides, he was too much amused with what he was about: you might have stuck the *divil* on his back without being able to put him in a fidget."[11] Elsewhere he remarked that "if Sir Joshua had come into the room when I was at work for him, and had seen me hanging by the neck, it would not have troubled him,"[12] an observation that is perhaps based on Northcote's belief that Reynolds had lied to him when he asked his master whether he had indeed recommended Thomas Lawrence rather than Northcote and John Opie to Alderman Boydell. When he looked back on this episode, Northcote sadly concluded that "thus was for ever destroyed a pleasure which I always had from the conversation of a man of Sir Joshua's high abilities, and who till this moment perhaps never knew that I had discovered the least fault in his character or conduct, for we always hate those who we think have any reason to despise us."[13] The principal drawback in his character, Northcote added, "besides this selfishness, was a want of that firm and manly courage and honour which is so absolutely necessary to the highest degree of rectitude."[14] Even so, Northcote wrote to his brother at the moment he was about to leave Reynolds's household that "I know him thoroughly and all his faults I am sure and yet I allmost worship him."[15]

Northcote was perhaps an even shrewder observer of Reynolds's character when his own interests were not at stake. He notes, for example, that although Reynolds was "deeply politic," he wished to project the appearance of childlike innocence; and Reynolds was so successful in this stratagem that his friends thought him barely fit to take care of himself—"but they little knew him!"[16] Reynolds is also said to

have nurtured more contempt for mankind than either Johnson or Goldsmith, but he was able to conceal his animus "under the garb of mildness and childlike simplicity." He listened to others with such patient attention that everyone thought he was admiring what they said, whereas in reality he was afraid of being thought a wit, or of possessing anything formidable in his disposition. "He knew well that to make the world afraid of him would be ruinous to him in his profession." And then Northcote adds, in a stunning conclusion at odds with considerable evidence to the contrary, that "though he kept so much company he had no boon companion—no one had his confidence—he was an isolated being."[17]

Reynolds's other friends apparently did not agree with the severity of Northcote's judgment, but we do find a strain running through their memoirs which suggests that Reynolds was often thought to be a rather diffident—and even a cold—companion. In a letter published in 1773, an anonymous critic (probably James Barry) addressed Reynolds by predicting that his strictures "will mortify you, no doubt, but as you are *a very cool man* with your passions always in a proper subordination to your *interests* I have great hopes that you will make a prudent use of the hints ... that I have given you."[18] Similarly, Malone told Farington that "Sir Joshua was a rare instance of a man relishing pleasure, yet suffering little from disappointments, or what others would have thought mortifications. He certainly had not very strong feelings."[19] This is clearly meant to be thought of as both a defect and a virtue, and it tallies with Johnson's observation (which, Northcote tells us, is based on his high opinion of Reynolds's "benevolence of disposition") that the painter hated "no person living. But I like a good hater."[20] Even Frances Reynolds remarked in her *Essay on Taste* that "a man, subject to anger, is, beyond all comparison, to be preferred to him who is never angry,"[21] but her brother disagreed. "I once heard Sir Joshua say," Northcote reports, "that he thought it a very bad state of mind to hate any man; but that he feared that he did hate Barry, and if so, he had much excuse, if excuse be possible."[22]

If by "much excuse" Northcote means much provocation, then Reynolds, as we have just seen, clearly had good reason to resent Barry's behavior; and yet Northcote also believed that Reynolds's hatred of Barry "never influenced his conduct towards him." Reynolds's stronger passions, which were so habitually kept under control, appear to have surfaced only much later in life, when he felt that both his own authority and the world he knew were being fundamentally shaken. As we shall see, one of the most penetrating analyses of Reynolds's character was provoked by this central episode (the so-called Bonomi affair) at the Royal Academy. In a passage written almost forty years later by a fellow Academician who had no difficulty in becoming a "good hater," Benjamin Haydon attempted to define good breeding and true gentlemanly behavior in his diary in the following manner: "Lawrence & Sir George Beaumont are the two most perfect Gentlemen I ever saw, both naturally irritable & waspish, but both controulling every feeling which is incompatible with breeding." Haydon—as irritable and waspish a person as any he was likely to meet—tellingly yokes a painter with an aristocratic amateur and then stipulates not only that the well-bred man must be able to control his feelings, but that he must have a particular "edge" to him as well. Even more surprising is his citation of Reynolds as he draws his argument to a close:

> Perhaps it may not be a paradox to say the most waspish men are the best bred.
> The perpetual consciousness of a defect of temper which would destroy all affection begets a perpetual effort at controul. Reynolds, Lawrence, & Sir George are examples. Reynolds was naturally irritable. His good fortune & success, with the submission he received, kept him amiable, but the first time he was thwarted he got into a passion, & resigned![23]

We need not accept Haydon's definition of gentlemanly behavior—intriguing as it is—to appreciate the shrewdness of his remarks on Reynolds. Even though (perhaps because) he writes at some distance

from his subject, Haydon notices the perpetual effort at control, the amiability founded (as Hazlitt would argue) on success, and the immediate explosion of feeling when Reynolds's will was thwarted. The only other people to sense that Reynolds was "naturally irritable" were his sisters, and theirs is a complex story. Reynolds was greatly admired by his contemporaries for his imaginative and sensitive portrayal of women, and it is therefore fitting that the final voices I introduce be those of the female friends and relatives who knew him best.

SISTERS AND NIECES

Reynolds may often have thought of marrying, but he never did so. In addition to his attachment to Angelica Kauffman, he was linked—at one time or another—with Mary Hamilton, Sarah Wymondesold (a rich widow), and Mary Horneck, to whom the painter is supposed to have proposed by falling to his knees during a sitting in his studio.[24] There were also rumors, some of them reported in the *Town and Country Magazine,* that the painter had carried on love affairs with his aristocratic sitters and had even kept a mistress.[25] If so, he was as discreet in these as in his other, more public affairs. As for marriage itself, the most convincing explanation of Reynolds's resistance remains a comment he made to Boswell late in life (in 1788) during a conversation in which he admitted the importance of novelty in romantic relationships: "He said the reason why he would never marry was that every woman whom he had liked had grown indifferent to him, and he had been glad that he did not marry her. He had no reason therefore to suppose that it would not be the same as to any other woman."[26] Even his language captures his ambivalence, for we begin by assuming that the eventual indifference belongs to "every woman" before we realize that the indifference belongs, instead, to the painter. The women are indifferent only in the contemporary linguistic sense that they are identical, the same.

Instead of marrying, Reynolds forged an alternative domestic envi-

ronment for himself by living first with his sisters and then by inviting his nieces (Mary and Theophila Palmer, the daughters of his sister Mary) to live with him in London.[27] Theophila ("Offy") remained in his household until she married Robert Gwatkin in 1781, and it is clear that Reynolds—who painted her several times—cared for her deeply, even though he confessed in a letter that he had difficulty expressing his feelings to her: "I never was . . . a great professor of love and affection, and therefore I never told you how much I loved you, for fear you should grow saucy upon it."[28] Mary remained with her uncle until he died, inheriting most of his property and income, and thus becoming quite an eligible match. She married an Irish peer, the Earl of Inchiquin, and eventually became the Marchioness of Thomond.

Reynolds was obviously satisfied with this arrangement. He could draw upon a virtually inexhaustible source of family members to serve him—with niece replacing sister, and niece replacing niece—thus allowing him to devote himself entirely to his work. And, from *their* point of view, it is at least possible that their famous relative not only vouchsafed them a living and a sense of purpose, but also enabled them to live in circumstances that were both materially and culturally superior to those they otherwise might have known. And yet there were problems even for the two nieces. Mary Palmer recalled that her uncle "hated to pay money." She would ask him at breakfast, day after day, to provide her with funds to pay the house bills, but often to no avail.[29] Reynolds would order Frances to use his carriage but was otherwise notoriously parsimonious; according to their fishmonger, "Miss Reynolds never chose, Sir Joshua never paid, and both were good hands at driving bargains."[30] Although they served as housekeepers and companions, Reynolds's sisters and nieces enjoyed much the same fate as his apprentices, whose poor lot Northcote chronicled so vividly in his tabletalk.[31]

These nieces and sisters formed an impressive group. Offy is said to have been an accomplished painter who copied several of her uncle's pictures. The observant Northcote, however, recorded a previously un-

known conversation concerning Offy's artistic aspirations that is much to the discredit of both Reynolds and Johnson: "Miss Palmer one day when Dr Johnson dine'd there show'd him some of her works he said she now might think of maintaining herself and after mentioning two or three schemes said he thought the best thing she could do would be to paint checkers for ale houses but Sir Joshua said she might paint signs as the man did who was employd to paint the red Lion. he dip'd his dog in Blood and then dab'd him upon the Board and so got the drawing."[32] Theophila's sister Mary proved to be both a successful housekeeper and a staunch supporter of Reynolds's posthumous reputation.[33] In his unpublished memoir of Reynolds, Charles Burney remarked that, "from the Peer to the Painter," Mary "was always treated with the utmost respect & admiration. She had all the good sense of her Uncle." "I beg it now from my heart," he continues, "without the least intention that she shd. ever know my opinion during my life, that no female of my acquaintance, apart from her personal charms, was ever possessed of a better understanding, a better taste, or more useful knowledge and accomplishments in every stage of her life than the Marchioness of Thomond."[34]

Reynolds's sisters were just as gifted. As James Clifford has pointed out, each produced a published work "characteristic of her own interests and temperament—Elizabeth on Ezekiel, Mary on comic country characters, and Frances on aesthetic taste."[35] Reynolds's relations with his sister Elizabeth Johnson were particularly stormy, especially following her husband's improvident behavior, bankruptcy, and abandonment of his family. Elizabeth looked to her prosperous brother for relief, but Reynolds, who had already suffered financially by supporting his brother-in-law, was cautious in his response, doling out sums to her children on an irregular basis.[36] Reynolds's young nephew, Samuel Johnson, wrote to his mother in 1775 that "there is no comfort for you from this quarter. Your suppos'd Brother and you could never have had the same parents or be known to one another in your infancy. He desires He may be look'd on as if He did not exist, for He will do

nothing for you. . . . I never heard of such a man."[37] In a letter to his nephew William Johnson of 1781, moreover, Reynolds admitted that it was difficult for him to write with openness and sincerity to "the children of a father and mother who professedly hate me." Your mother, he adds, "has given it under her own hand that she thinks me the greatest villain upon the earth." Only when his nephews' suspicions have been "eradicated" will his own suspicions "be likewise thrown away."[38]

For her part, the deeply religious Elizabeth, who thought that one could not live in London without having a corrupt mind, refused to allow her son Samuel to lodge with Reynolds.[39] As she wrote in a letter to Sir Joshua, "Thy soul is a shocking spectacle of poverty. When thy outside is, as thy inside now is, as I told thee ten year since I will not shut the door against thee. But it may be, thy soul is past all recovery. If so, I shall never see thee more. Thy vissitation is not yet come: and who knows in what shape it will come: or whether it will come at all. Wo be to thee if it does not come."[40] The letter is signed "From thy best friend / Eliz. Johnson." Later, when Malone was gathering material for his biography of Reynolds, Elizabeth wrote scathingly to Frances about the hagiographical tendency of such memoirs:

> You know Mr Malone I believe, the greatest friend and admirer of Sir Joshua that he ever had perhaps, and such an immaculate character as he will I suppose draw of him, will be held up no doubt for humanity to copy after! such perversions in life are melancholy, particularly to his nearest Relations, awakening painful remembrances. such was Mr Burks character of him—in the news paper particularly extolling him for his kindness to all his Relations![41]

Reynolds's relationship with his sister Frances deserves extended scrutiny, for it sheds light not only on the characters of two complex individuals but also on an artistic career that at points mirrored that of the most celebrated English painter of the century. We know little about Frances Reynolds's life, however, and perhaps even less about

those forces that prompted her to try her hand as a painter, poet, and literary theorist. She was apparently a fairly well-known painter of miniatures, and exhibited at least two of her larger canvases at the Royal Academy; she wrote several poems, one of which was revised by Johnson and eventually published;[42] she completed several drafts of a memoir of Johnson, which she also intended to publish; and in 1789 she finally published her *Enquiry Concerning the Principles of Taste, and of the Origin of Our Ideas of Beauty, etc.* These achievements would seem to place her among the most accomplished of the blue-stocking circle, and yet she is almost always remembered as Reynolds's longtime companion and housekeeper, a woman easily overshadowed by her brother's fame.

Part of Frances Reynolds's apparent anonymity is surely linked to her unprepossessing character. Ellis Cornelia Knight wrote that "she was an amiable woman, very simple in her manner, but possessed of much information and talent, for which I do not think every one did her justice, on account of the singular *naïvité* which was her characteristic quality, or defect, for it often gave her the appearance of want of knowledge."[43] Johnson, who invariably referred to her as his dear "Renny," wrote at one point that he hoped her "little head begins to settle";[44] but for the most part his opinion of her was not condescending, especially when he spoke of her character: "whilst the company at Mr. Thrale's were speculating upon a microscope for the mind, Johnson exclaimed, 'I never saw one that would bear it, except that of my dear Miss Reynolds, and her's is very near to purity itself!' "[45] The young Frances Burney thought that Frances Reynolds was needlessly upset by petty matters, and that she was perhaps too upright in her manners: "I fear I have lost all reputation with her for dignity, as I laughed immoderately at her disasters."[46] Later in life Burney described her as "a woman of worth and understanding, but of a singular character": "Whatever she suggested, or planned, one day, was reversed the next; though resorted to on the third, as if merely to be again rejected on the fourth; and so on, almost endlessly."[47] This judgment is borne

out by Malone's remark that Frances possessed a "capricious temper" as well as by her own nephew's comment on the *"changeability of her disposition."*[48] But the young Samuel Johnson also wrote to his relatives that his aunt's "caprice and queer kind of behaviour" had to be balanced against her virtues: "Every body has a bad side as well as a good one, her good one you all know, and this is her bad one."[49]

If Frances Reynolds was irresolute, she could also be inattentive and stubborn. Frances Burney records, with delight as well as exasperation, a session in which Reynolds's sister painted Charles Burney's portrait:

> While she was painting his hair, which was remarkably thick, she asked him, very gravely, whether he could let her have his wig some day to work at, without troubling him to sit.
>
> "My wig?" repeated he, much surprised.
>
> "Yes;" she answered; "have not you more than one? can't you spare it?"
>
> "Spare it?—Why what makes you think it a wig? It's my own hair."
>
> "O then, I suppose," said she, with a smile, "I must not call it a wig?"
>
> "Not call it a wig?—why what for, my dear Madam, should you call it a wig?"
>
> "Nay, Sir," replied she, composedly, "if you do not like it, I am sure I won't."
>
> And he protested, that though he offered her every proof of twisting, twitching, and twirling that she pleased, she calmly continued painting, without heeding his appeal for the hairy honours of his head; and only coolly repeating, "I suppose, then, I must not call it a wig?"[50]

Burney himself did not know how to excuse her strange behavior: "she doubtless intended to expose me as an artificial beau to the company, all in full dress and ready to laugh at a bald head." She "never made the least apology for her mistake or offered a single word to convince me that she thought my [hair] was natural." Frances Reynolds had "genius," he conceded, and a "masculine understanding," but her character was "very singular, for indecision." Her brother used to refer to her, he tells us, as "always in a wonderment."[51] Frances herself, in a

revealing postscript to a letter to Johnson, asks his pardon (as usual) "for sending you such a blotted letter. I never can get either pen ink or paper like other peoples."[52]

Although she clearly lacked the easy confidence and sociability of an Elizabeth Montagu, Frances was nonetheless eager to win her own way in the intellectual world to which Reynolds introduced her, and—if we can believe certain passages in her commonplace book—she nursed an unrequited love for an unidentified "Mr B" and "Mr S" and regretted her failure to live in harmony with her famous brother. Reynolds took a house with his two youngest, unmarried sisters in Plymouth Dock in 1746, and Frances joined him shortly after his arrival in London in 1752 to manage his household in St. Martin's Lane. As his prosperity grew they moved to a large house on the north side of Great Newport Street (where they lived for eight or nine years), and then to a very handsome house on the west side of the square at Leicester Fields, which contained—as we shall see in greater detail in the following chapter—a gallery and painting room, and provision for the grand carriage that his sister felt too shy to use.

In spite of the illustrious world in which she found herself, it is clear that Frances Reynolds experienced increasing difficulty in living with her demanding brother, who finally requested her to leave when one of their nieces was old enough to assume her duties. This was an arrangement that Frances had long feared, yet one for which she had also attempted to prepare herself. As early as 1768, during a trip to Paris, she had purchased a large number of fine paintings that she hoped she could sell to Hester Thrale in return for a comfortable annuity.[53] Her scheme apparently failed, and she kept the paintings as her private treasure, even though it brought her renewed hardships once she had left the security of her brother's household. In a letter to Elizabeth Montagu, written in February 1791, she worried about this "luggage of pictures," which was described, in the sale following her death, as "a genuine collection of ancient pictures by the most approved Masters of the Italian, French, Flemish and Dutch schools."[54]

Frances Reynolds's final separation from her brother's household oc-

curred sometime in the late 1770s,[55] although she had done her best to make amends with Reynolds, and had even enlisted Johnson to prepare a letter of appeal to him. But life with her brother had imposed burdens of various kinds on her. As early as March 1766 we find her copying these verses "To Mrs Knight" into her commonplace book:

> yet do not deem your freind unblest
> nor think tho' here confined
> that in the gloom of Sloth can rest
> the Busy active mind
> still still I feel the flame devine
> which painting's charms inspire
> and still the sister arts combine
> to fan the secret fire
> with these companions pleased I spend
> in sweet repose the hours
> whilst jockand health my steps attend
> and strows my Paths with flowers.[56]

An undated poem (presumably from the mid-1760s) records her deep distress in a posture of religious supplication:

> O God my God relieve my Heart
> From this oppressive load
> That fills my soul with anguish sharp
> Oh haste to help me Lord.

Another entry, dated June 1765, focuses on the source of her anguish in terms suggesting that her tormentor may well have been her brother rather than a neglectful lover:

> far from this cruel man removed
> which once too tenderly I loved
> here fate has kindly driven
> my shaterd bark at length to rest.

These lines—and several surviving letters—suggest that her life was a peripatetic one long before the final separation from her brother's life in London. She was allowed the use of Wick House in Richmond, but even there she seems to have overstepped the bounds of their agreement (and the limits of his patience). The only surviving letter from Reynolds to his sister is a scathing one, filled with his sarcastic reaction to her proprietory demands:

> [1781]
> I am very much obliged to you for your kind and generous offer in regard to the house at Richmond not only in giving me leave to use it occasionally but even as long as I live provided I will give it to you, but as I have no such thoughts at present I can only thank you for your kindness—tho I am much older than you I hope I am not yet arrived to dotage as you seem to think I am, voluntarily to put myself in the situation of receiving the favour of living in my own house instead of conferring the favour of letting you live in it
>
> I am your most affectionate
> Brother[57]

Her exile seems to have begun when she returned to Devonshire in the late 1770s.[58] She confided to her commonplace book that "I am incapable of painting[;] my faculties are all becalmed in the dead repose of Torrington," and in a draft of a letter copied into the same book she wrote that "the highth of my desires is to be able to spend a few months in the year near the Arts and sciences." The mind must have some pursuit,

> and I unhappily having none that is so satisfactory or that appears to me so praiseworthy as painting having been thrown out of the path nature had in a peculiar manner fitted me fore and as it is natural to endevour to excell in something I confess I can't help pleasing myself with the hopes that I might arrive at a tolerable degree of perfection in these little pictures [of children and landscapes] could I refresh imagination and

improve my ideas by the sight of pictures of that sort and by the judgement of the connoisseurs.

If living in London "and not at his house" will bring either her character or that of her brother into question, she will content herself with residing at Windsor. The income Reynolds has given her is satisfactory— "with frugality and oeconomy sufficient to keep me within the sphere of a gentlewoman a state with which I am perfectly contented"—but she still desires to have his own advice: "it would give me the sincerest satisfaction to have his opinion . . . in this as well as every action of my life but he is so much engaged in business that I fear I should receive no answer."

Lacking this advice, she nevertheless resolved to return to London, where she resided in the household of the translator John Hoole (the same house in Great Queen Street, in fact, in which her brother had lived in the early 1740s). But the arrangement with Hoole was apparently not a permanent one, and thus we find her moving several times in the following years, each time seeking "some asylum for the short remnant of my Dayes."[59] The remainder of her life, however, was not nearly so short as she imagined. After her brother's death in 1792, she received an inheritance of £2500 for life (with reversion to Mary Palmer) and promptly purchased a large house on Queen Square. Joseph Moser remarked that

her own works were so numerous that a *large* house was absolutely necessary. She afterwards moved to a *larger* house, and we think to a third in the same square. She was a lady of genius and learning, though with respect to painting, Goldsmith . . . offended her because he, who was eccentricity personified in his scrambling way, observed that she loved pictures better than she understood them. She continued to paint . . . as long as she could hold the pencil, and her easel used frequently to be set up near her parlour window in order advantageously to display some favourite performance to the admiring passengers.[60]

Artistically and financially independent at last, she continued to live by herself—and apparently *for* herself—until her death in 1807.

We might be led to conclude that the split between Reynolds and his sister was occasioned by his attitude toward her artistic aspirations, but the little information we have indicates, in fact, that the problem also lay in her attitude toward her brother's work. She was, by all accounts—including her nephew's—a very difficult person to live with: "what a contradiction!—" the young Samuel Johnson wrote; "but this is one of a thousand."[61] Frances Burney describes her as "living in an habitual perplexity of mind, and irresolution of conduct, which to herself was restlessly tormenting, and to all around her was teazingly wearisome."[62] Like her sister Elizabeth, she was a punctiliously religious person, and on that subject she knew her own mind extremely well: a major element in her separation from her brother was said to be her habit of frequently reminding him "that He was a Clergyman's Son & that it was very improper for Him to set the example of *painting on a Sunday*."[63] She complained more extensively to the young Northcote shortly after he arrived in Reynolds's household:

> Miss Reynolds one day said she thought it was allmost a pitty the science [of painting] had ever been known it so intirely employd the mind of those who have ever made great painters that they neglected every other thing in this life and very seldom thought of the future, alluding to the neglect of the Church which is desagreeable to her. she said her brother had lost as much as he had gain'd that is all the pleasure of Scociety which he had sacrificed to gain a name.[64]

She also confided to Northcote that she considered "Oliver Cromwell a rogue and believes the Trinity tho she told me that [once?] she did not like the creed and did not use to say it." As to Sir Joshua, Northcote continues, "I do not know his Religion he never goes to church which miss Reynolds thinks is very wrong of him."[65] Once her brother died, she remarked that "she saw nothing in him *as a man*, but a *gloomy tyrant*."[66]

It is surely interesting that, following the separation from her brother, Frances Reynolds devoted her talents to writing rather than to painting: she prepared her *Enquiry* in the 1780s, published her poetry *(A Melancholy Tale)* in 1790, and left unfinished, at her death, the different versions of her *Recollections of Samuel Johnson.*[67] Many of her surviving letters document her attempts to publish the *Enquiry,* for she had originally turned to Johnson for an opinion of its quality and for advice on how she might have it printed. Johnson was encouraging in both respects. He praised the book highly, claiming that it had "such force of comprehension, such nicety of observation as Locke or Pascal might be proud of." But he added that her reflections could not "be printed in their present state. Many of your notions seem not very clear in your own mind, many are not sufficiently developed and expanded for the common reader; the expression almost every where wants to be made clearer and smoother. You may by revisal and improvement make it a very elegant and curious work."[68] Somewhat later he offered even more detailed praise and advice:

> Your work is full of very penetrating meditation, and very forcible sentiments. I read it with a full perception of the sublime, with wonder and terrour, but I cannot think of any profit from it; it seems not born to be popular.
>
> Your system of the mental fabrick is exceedingly obscure, and without more attention than will be willingly bestowed, is unintelligible. The Ideas of Beauty will be more easily understood, and are often charming. I was delighted with the different beauty of different ages.[69]

Johnson also agreed to negotiate with the booksellers on her behalf if she promised to keep her authorship a secret, but a series of complications—and her own fear that Johnson maintained a strong "prejudice against *womens* literary productions"—finally stalled their plans. After Johnson had died, however, she confessed that she had "deceived myself. He was sincere, he judged justly of the work, and his opinion exactly corresponded" with Elizabeth Montagu's.[70] In a letter written

to Johnson in 1779, moreover, she confessed that "I am, and *always have been,* very troublesome to you, but you are, and always have been, very good to" me.[71]

In spite of the assurances Frances Reynolds gave both Johnson and Elizabeth Montagu that she wished only to have the volume privately printed, she continued to hope that the book might actually be published. Following Johnson's advice, she had two hundred and fifty copies printed, and sent "poor" Northcote in quest of a bookseller who would be both agreeable to her terms and socially acceptable.[72] In 1785 she wrote to Elizabeth Montagu that "I wishd to leave behind me a respectable memorial of my existence, which I then flatterd myself this would be."[73] Her letters reveal, moreover, that she turned to Elizabeth Montagu for assistance before Johnson's death in 1784; and although her friend was not able to offer her either the criticism or the advice she needed, she did allow Frances to dedicate the volume to her.[74]

If some of the complexities involved in the publication of the *Enquiry* are still not entirely clear,[75] we know even less, in fact, about Frances Reynolds's career as a painter. Northcote reports that she was successful as a painter of miniatures, often reducing the great portraits her brother produced. Reynolds did not approve of her painting full canvases in oil, and she was therefore forced to paint them by stealth in another room of their house while her brother was employed in the painting room. Reynolds jested that "her pictures in that way [in oil] made other people laugh and him cry," perhaps because—as Northcote later remarked—"they were an exact imitation of all his defects."[76] She has left us an unprecedented glimpse of Johnson as a sitter, "so still indeed when sitting for his picture, as often to have been complimented with being a pattern for sitters, no slight proof of his complaisance or his good-nature."[77] But her subject was displeased with her portrait of him (Figure 11), calling it "Johnson's *grimly ghost*" in an allusion to David Mallet's "William and Margaret": "I sat to Mrs. Reynolds yesterday for my picture, perhaps the tenth time, and I sat near three hours, with the patience of *Mortal born to bear.* At last She declared it quite finished

and seems to think it fine. I told her it was Johnson's *grimly ghost.* It is to be engraved, and I think, *In glided* etc. will be a good inscription."[78]

Even in the face of this criticism, Frances Reynolds was able to complete a surprisingly large number of paintings. In addition to the portrait of Johnson, she painted Elizabeth Montagu (Figure 12), Anna Williams, Hannah More, James Harris, James Beattie and his wife, John Hoole, and a self-portrait with her two sisters in which she plays a musical instrument (Figure 13). Johnson and Elizabeth Montagu collected engraved prints of her portraits, and one of Montagu's letters is filled with admiration for Frances's work: "I assure you I was extreamly struck with the Print of Mr Hoole from its perfect resemblance to him; you have convey'd into his eye the celestial fire which glows in his translations" (Figure 14).[79] She also exhibited three paintings at the Royal Academy in 1774 and 1775: *"The Garland," from Prior, Lace Makers* (a miniature), and *Children Going to Bed.* A critic praised this last painting by stating that "we do not remember ever to have seen a prettier subject for the exercise of a lady's pencil than No. 354, nor could it perhaps be better made use of in the hands of the most experienced artists"; and there are other testimonies as well to her "strong traits of originality."[80]

Elizabeth Montagu sat to Frances Reynolds on 6 April 1778, an occasion chronicled by Boswell, who reports that the painter invited a select male company to keep her sitter entertained. At one point Elizabeth Montagu remarked to her, "Very good old woman. Don't make me fifteen." To which Boswell replied: "All your friends, Ma'am, would wish she could."[81] As we have seen, Johnson sat to her perhaps ten times, even though he did not approve of her choice of portrait-painting as a profession: "He thought portrait-painting an improper employment for a woman. 'Publick practice of any art, (he observed,) and staring in men's faces, is very indelicate in a female.' "[82] His observation is an interesting—if troubling—one, for it implies that the professional relationship between painter and subject somehow breaks down if the artist is a woman. The indelicacy he imputes to it is surely

akin to much contemporary reaction to Burney's *Evelina:* women—
especially very young women—were not supposed to look that directly
at their subjects, were not to attend that closely to the language and
manners of life as it was actually lived. And even Frances Reynolds
knew where to draw the decorous line, remarking to Northcote that it
was a great pity that drawing "naked women" from life models "should
be a necessary part in the education of a painter." She, Northcote adds,
draws "all her figures cloath'd except infants which she often paints
from life."[83]

Painting, however, and portrait-painting in particular, lay very close
to the center of Frances Reynolds's life. Writing in her commonplace
book about her experiences in peaceful Torrington, she confessed that
"I want some grateful gale of praise[,] some incentive to emulation to
awake my slumbering faculties[.] I thank my God who put it in my
Head to acquire this delightful Art and in a manner calld my light out
of darkness for necessity struck the hot spark[.] the world receeds[.] I
may have something to fill up the vacuities in my Heart made by un-
grateful returns to the most unfeignd fraternal love and purest friend-
ship." This is the kind of passionate outburst that could be confided to
a commonplace book alone, and it points to her continual difficulties
as she attempted to maneuver what Germaine Greer has called "the
obstacle race," whose daunting barriers female painters of every age
have had to surmount.[84]

In Frances Reynolds's case, the obstacles to artistic independence and
success were paradoxically near to hand, for she practiced an art in
which men were dominant and in which her brother was pre-eminent.
It was primarily through Reynolds that she was allowed access to the
most illustrious subjects and examples of the art of portraiture: as she
was to confess to him in the letter Johnson wrote for her, "I suffer too
much in the loss of your notice; but to that is added the neglect of the
world which is the consequence of yours."[85] But her brother discour-
aged her from painting full portraits, and disparaged those few she did
manage to execute; and it is certainly significant that the one enterprise

in which he did encourage her—and in which she is said to have excelled—was the painting of miniatures, a more "delicate" art in at least two senses of the word.

As an aspiring painter, Frances Reynolds therefore faced a further obstacle within "the private domestic sphere" of her brother's household, for to practice her art in any meaningful way meant that she risked sacrificing her own—and her family's—claims to gentility and social respectability. Given the contours of Reynolds's development as a professional artist, the disturbing irony of Frances's situation should be only too clear: by pleasing in company *and* in his studio, her brother had essentially raised his family to a social level in which only private sketching and painting by a woman—the work of an accomplished amateur—would be tolerated.[86] Passages in her commonplace book, most of them previously unpublished, reveal both how acutely she understood her dilemma and how diligently she attempted to position her ambitions within the compass of a gentlewoman's proper role. She writes that her brother has had the most convincing proof that her intention to paint "does not proceed from a cast of mind inconsistent with the delicacy of the female character[,] whose true exelence consists in not endeveoring to exceel out of the private domestic sphere." She has convinced her brother that her intention was not founded on principles unbecoming to her sex: "neither love of fame or love of money had a share in it." It is unnatural, she adds, for a woman "to quit the domestic path for a public one," and an even more Johnsonian or Austenian pronouncement soon follows: regarding this "every sensible person must be of the same opinion."

In the draft (or copy) of a long letter to a friend, however, she takes a different tack, hoping that her correspondent will not conclude from her "great desire" to study pictures and improve herself that she means to "commence a public Painting," an intention "by no means suitable to my ability or indeed to my disposition." But later in the letter, in one of the most revealing glimpses we have of her aspirations, she both confesses that she "envyd the female competitors in the exhibition"

Figure 17. Reynolds's calling card, engraved by Francesco Bartolozzi.

Figure 18. Margaret Dicksee, *Angelica Kauffmann Visiting Reynolds's Studio,* 1892.

Figure 19. Reynolds, *William Pulteney, 1st Earl of Bath*, 1761.

Figure 20. Reynolds, *Miss Bowles,* c. 1775.

Figure 21. Reynolds, *The Marlborough Family by Sir Joshua Reynolds, Red Drawing Room, Blenheim Palace,* 1777–1778.

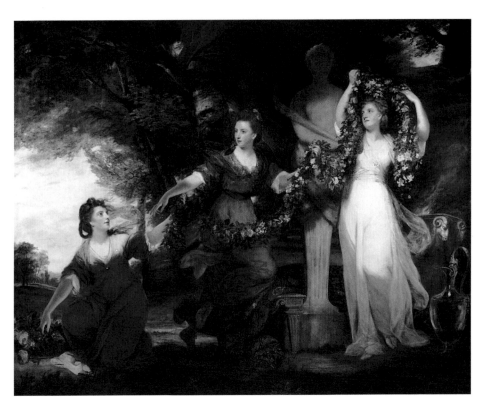

Figure 22. Reynolds, *Three Ladies Adorning a Term of Hymen (The Montgomery Sisters)*, 1774.

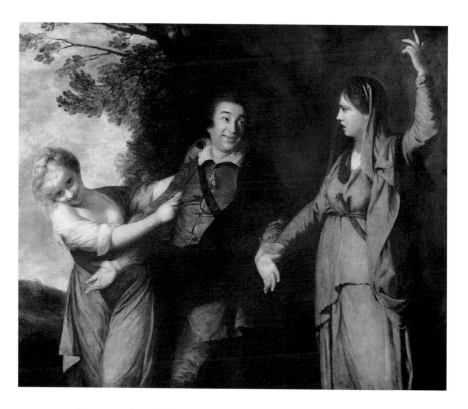

Figure 23. Reynolds, *Garrick between Tragedy and Comedy,* 1761.

THE

THEATRES.

A

POETICAL DISSECTION.

. By Sir NICHOLAS NIPCLOSE, Baronet.

Suppofe JOB living 'midſt the Critic train,
Our Theatres would ope his angry vein.

Behold the Muses ROSCIUS sue in Vain,
Taylors & Carpenters usurp their Reign.

LONDON:
PRINTED FOR JOHN BELL, IN THE STRAND, AND C. ETHERINGTON, AT YORK.
M.DCC.LXXII.

Figure 24. Matthew Darly, caricature of Reynolds, *Garrick between Tragedy and Comedy*, title page of *The Theatres. A Poetical Dissection. By Sir Nicholas Nipclose*, 1772.

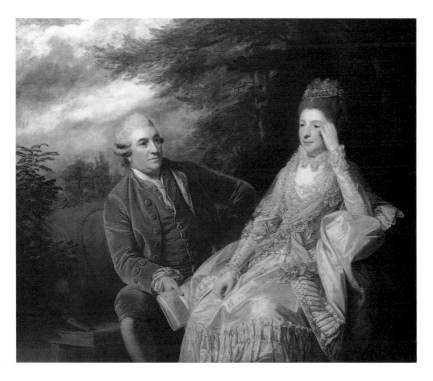

Figure 25. Reynolds, *Garrick Reading to His Wife,* 1773.

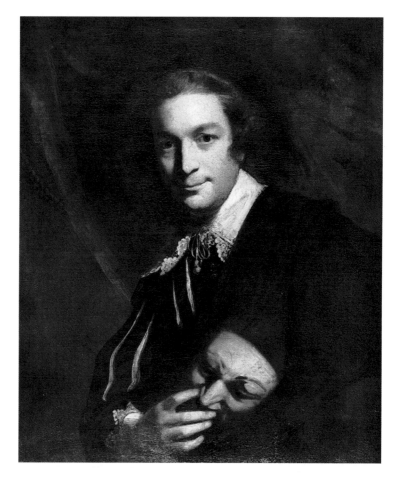

Figure 26. Reynolds, *Harry Woodward*, 1759–1762.

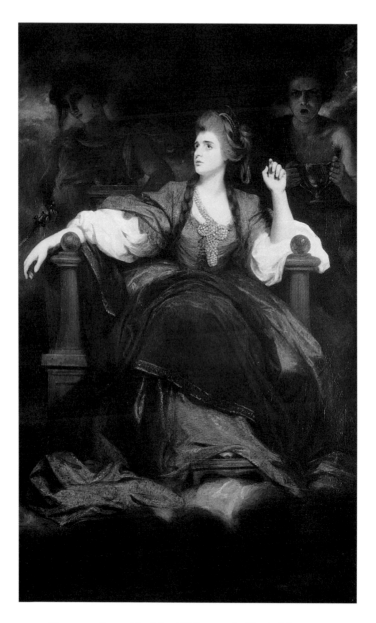

Figure 27. Reynolds, *Mrs. Siddons as the Tragic Muse*, 1784.

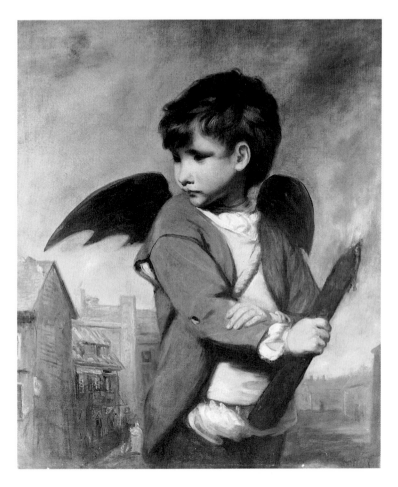

Figure 28. Reynolds, *Cupid as Link Boy,* 1774.

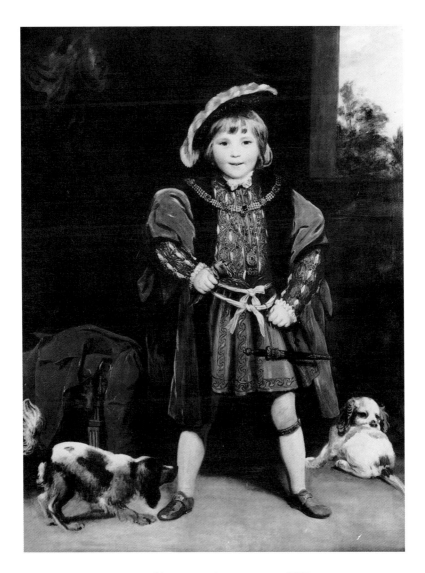

Figure 29. Reynolds, *Master Crewe as Henry VIII*, 1775–1776.

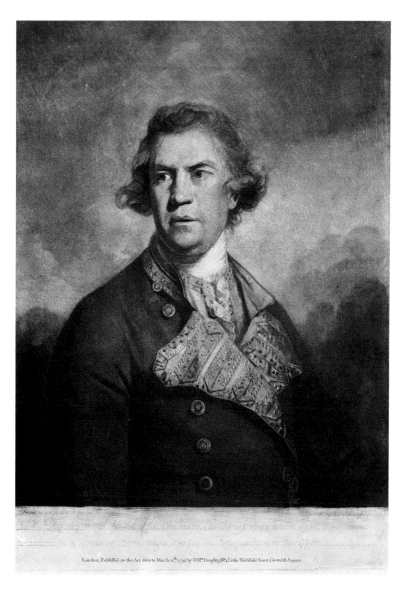

London, Published as the Act directs March 19th 1779 by Willm Doughty, No 1 Little Titchfield Street, Cavendish Square.

Figure 30. William Doughty, mezzotint (scratch proof) after Reynolds, *The Hon. Augustus Keppel, Admiral of the Blue,* 1779.

Figure 31. Reynolds, a page from the "Apologia."

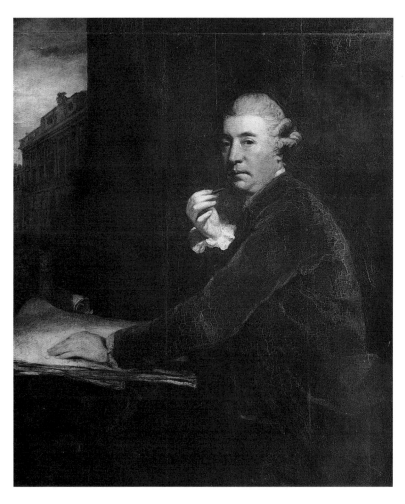

Figure 32. Reynolds, *Sir William Chambers,* 1780.

(presumably at the Royal Academy) and points out that "there were other female competitors besides those who made it a profession." "I never thought it a suitable profession for my sex," she continues, "and very far from meritorious to give up so much time as the attainment of that Art required for ammusement only." But whether the public views her as a public or as a private painter, she adds, "it is natural to suppose I must have sufferd in the opinion of the prudent." Elsewhere she notes that this is "a torment," for it clashes with "the honorable provence of family"; here she consoles herself by reaffirming that "my past conduct with regard to this subject and in every particular instance relating to it has and *ever will have* the full and intire approbation of my best reason." And yet this passage leads directly to one we have already examined, in which she argued that the mind "must have some pursuit." Only the "greatest necessity" will lead her to take advantage of the opportunities London affords "in a manner unsuitable to the character of a gentlewoman both for my own sake as well as My Brothers."

It is very difficult today to gauge the talent Frances Reynolds actually possessed, and we must perhaps reluctantly admit that her brother was in the best position to measure it (even if he found her ambitions disconcerting). She, however, was forced to turn to Johnson and Elizabeth Montagu for the "esteem" and approval Reynolds could only deny her. As she remarked in one of the maxims in her commonplace book, "The first step to be despised is to be pitty'd." Even with her "perplexity of mind and irresolution of conduct" she had enough sense of herself to know that she deserved much better than that. She wrote out the following epitaph in 1766, and one cannot but think that she had herself in mind:

> Symple in manners[,] honest and sincere
> in fame unblemishd and in conscience clear
> nature and truth devoid of every art
> resistless ruled each impulse of her Heart[.][87]

THRALE VERSUS BURNEY

The one voice we have not heard so far belongs to Hester Thrale, later Hester Piozzi, who had ample opportunity to scrutinize both Reynolds and his sister Frances with the eye of a rattlesnake (as she once characterized herself).[88] Hester Thrale thought that Frances Reynolds "had an odd dry Manner, something between Malice and Simplicity, which was entertaining enough," and she records several episodes in her *Thraliana* that bear comparison with Frances Burney's description of Frances Reynolds's painting Dr. Burney's "wig."[89] She had difficulty, however, when she attempted to understand the troubled relationship between Reynolds and his sister: "why," she asked, "should [Sir Joshua] refuse his Purse and even his Civilities to a Sister so amiable & so accomplished as Miss Reynolds?"[90] Her answer, which occurs to her after thinking about Henry Fielding's relationship with his sister Sarah, focuses on sibling rivalry:

> [Reynolds] certainly does not love her as one should expect a Man to love a Sister he has so much Reason to be proud of; perhaps She paints too well, or has learned too much Latin, and is a better Scholar than her Brother: and upon more Reflection I fancy it must be so, for if he only did not like her as an Inmate why should not he give her a genteel Annuity, & let her live where and how She likes: the poor Lady is always miserable, always fretful; yet She seems resolved—nobly enough—not to keep her Post by Flattery if She cannot keep it by Kindness:—this is a Flight so far beyond my power that I respect her for it, and do love dearly to hear her criticize Sir Joshua's Painting, or indeed his Connoisseurship, which I think She always does with Justice and Judgment—mingled now & then with a Bitterness that diverts one.[91]

This is an intriguing response, by turns sympathetic and cool. Hester Thrale provides a reading of their relationship that combines admiration of Frances's resolution to behave nobly—even when provoked—with a mischievous pleasure in her occasional critical triumphs over her brother. Two years later, in 1779, her thoughts turned to Frances

Reynolds once again, this time in connection with her own relationship to Johnson: "How many Times has this great, this formidable Doctor Johnson kissed my hand, ay & my foot too upon his knees! Strange Connections there are in this odd World! his with me is mere *Interest* tho';—he loves Miss Reynolds better."[92]

It should not surprise us that Hester Thrale's running commentary on Reynolds himself is, if not quite uncharitable, begrudging at the very least. She provides a view of him that is tinctured not only by her understanding of Frances Reynolds's precarious position but also by an aversion to those gentle social skills and soothing manners that so enamored Frances Burney, as we shall see. In a revealing passage in her diary, Hester Thrale observes what an "odd Partiality" she herself has "for a rough Character! and even for the hard parts of a soft one! . . . There is no true Affection, no Friendship in the sneakers & Fawners: tis not for Obsequious Civility that I delight in Johnson or Hinchliffe, Sir Richard Jebb or Piozzi."[93] Reynolds may have hoped to please her, but he could not satisfy her as a friend. Hearing that he had suffered a paralytic stroke, she praises him as a glorious painter, pleasing companion, and sensible man, but "he is however not much a Man to my natural Taste: he seems to have no Affections, and that won't do with me—I feel great Discomfort in the Society of a Pococurante." And yet, she adds, "one does not want *every* body to be a *Friend* or an *Admirer*."[94] She respects his work as a portrait-painter—although she says surprisingly little about the remarkable series of pictures he painted for her husband's library at Streatham—but she is contemptuous of his more ambitious historical paintings. He professes "the Sublime of Painting I think, with the same Affectation as Gray does in Poetry, both of them tame quiet Characters by Nature, but forced into Fire by Artifice & Effort." The time will come, she predicts, when a "cool Observer" will criticize Reynolds's *Ugolino* just as harshly as Johnson has attacked Gray's "Bard."[95]

Hester Thrale also held strong reservations regarding Reynolds's role as a man of letters. As early as 1777 we discover her berating him for

being "sufficiently puffed up with the Credit he has acquired for his written Discourses." He has set himself up "as a Sort of Patron to Literature," with his attention focused on "how to propagate Letters written in his Praise, how to make himself respected as a Doctor at Oxford, and how to disseminate his Praise for himself, now Goldsmith is gone who used to do it for him." And then turning once again to his tepid affections, she concludes by arguing that at least Reynolds treated Goldsmith as a friend: "he lent him Money, loved his Company, and a *little* lamented his Death."[96] A year later, in 1778, in her ambitious attempt to quantify the virtues of the men and women she knew (on a scale from 0 to 20), she awarded Reynolds 14 in general knowledge, 12 in person and voice, 10 in manner and in good humor, but flat zeroes in scholarship, humor, and wit.[97] Still later, in the caustic poems she wrote in 1781 to accompany the library portraits at Streatham, she wove these various threads together in her own "Retaliation":

> Of Reynolds what Good shall be said?—or what harm?
> His Temper too frigid, his Pencil too warm;
> A Rage for Sublimity ill understood,
> To seek still for the Great, by forsaking the Good;
> Yet all Faults from his Converse we sure must disclaim,
> As his Temper 'tis peaceful, and pure as his Fame;
> Nothing in it o'er flows, nothing ever is wanting,
> It nor chills like his Kindness, nor glows like his Painting;
> When Johnson by Strength overpowers the Mind,
> When Montagu dazzles, or Burke strikes us blind;
> To Reynolds for Refuge, well pleas'd we can run,
> Rejoyce in his Shadow, and shrink from the Sun.[98]

Her final remarks on Reynolds, however, reveal even deeper springs for her antagonism and distrust. In February 1789, several months before Reynolds lost his sight in one eye, Hester Piozzi met him at a dinner party and noticed that "he grows old, & is under the Dominion of a *Niece:* Oh! that is poor Work indeed for Sir Joshua Reynolds."[99] As she

records this encounter ("we hardly looked at each other") in her diary, she recalls telling Johnson that everyone overrated "that Man's mental Qualities." Johnson replied that "everybody loved Reynolds except *you.* The Truth is I felt that he hated *me;* & suspected that he encouraged Mr Thrale's Attachment to Sophia Streatfield—the charming S.S. as we called her."[100] These are the complicated judgments of a shrewd but not entirely impartial observer, confided to a journal that was not intended for publication (although much of it made its way into the *Anecdotes of the Late Samuel Johnson).*[101] If we are to conclude our variegated portrait of the painter in society as even-handedly as possible, we need to counter some of Hester Thrale's remarks by turning to the pages of the other pre-eminent female diarist of the age.

Frances Burney met Reynolds just as the anonymous publication of *Evelina* was about to ensure her place in the constellation of luminaries that surrounded her musical father. Of all the celebrities she met, Reynolds was by far the easiest with whom to converse.[102] She characterizes him as "pleasant, unaffected, and agreeable";[103] at a time when others were constantly placing her in awkward social situations, Reynolds would rescue her either by dissolving the tension or by taking her aside in "easy" conversation. Her initial impression never really changed: "I like his countenance, and I like his manners, the former I think expressive, soft, and sensible; the latter gentle, unassuming, and engaging."[104] He admired her novelistic eye, remarking that "if he were conscious to himself of any trick, or any affectation, there is nobody he should so much fear as this little Burney!"[105] He encouraged her to think about writing for the stage,[106] and at least one blue-stocking matchmaker (Elizabeth Montagu) attempted to marry the fifty-nine-year-old bachelor to his thirty-year-old friend: "A man who has had two shakes of the palsy! What misery should I suffer if I were only his niece, from a terror of a fatal repetition of such a shock! I would not run voluntarily into such a state of perpetual apprehension for the wealth of the East."[107]

Much later in life, when she prepared her *Memoirs of Doctor Burney*

in 1832, she introduced Reynolds as someone who shared her father's own disposition: "There was a striking resemblance in the general amenity of their intercourse, that not only made them, at all times, and with all persons, free from any approach to envy, peevishness, or sarcasm themselves, but seemed to spread around them a suavity that dissolved those angry passions in others."[108] But it was not, she ultimately concluded, a "suavity" or inoffensiveness that "bore the character of a tame insipidity that never differed from a neighbour; or that knew not how to support an opposing opinion with firmness and independence." In marked distinction to Hester Thrale (and others), Frances Burney argues in the strongest terms that Reynolds was "peculiar in thinking for himself." Although his deafness may have prevented him from following a conversation in its entirety, it also provided him with time for "silent rumination" that enabled him to "surprise the whole company by starting some new and unexpected idea of the subject in discussion." If his remarks led the conversation in a new direction, "he was frankly gratified, but never moved to triumph"; and yet if he incited his companions "to come forth, in battle array, against the novelty of his assertions," he "was never brow-beaten from defending his cause with courage, even by the most eminent antagonist."[109] These are the sentiments of someone who cared very deeply about Reynolds, who lamented the fact that she had not confessed her indebtedness to him before he died, and whose satirical eye was sharpened by the behavior of Frances Reynolds just as it was closed to the possible failings of Frances's brother.

The Marketplace
and the Studio

Reynolds's graceful assimilation into polite society—into a society that clearly reflected his own values and aspirations as an artist and as a gentleman—does much, of course, to explain why he became his country's first indisputably successful *native* painter of portraits. Lacking the royal support that Van Dyck, Lely, and Kneller each in turn received, Reynolds nevertheless enjoyed an unprecedented relationship with his titled patrons and friends. At the same time, however, we should recall the moral of Northcote's story about how other guests often made a lane for Reynolds to pass through when he arrived at a social event: "When a duke or an earl was announced, few of the people took any notice. This shows us the respect and admiration which are paid to great and acknowledged talent, beyond what rank—mere rank alone—can never hope to claim."[1] But Reynolds, as we have seen, never relied on talent alone to secure his success as an artist. He was among the most fervid readers of Johnson's biography of Richard Savage, and he knew that what his friend had written there about the plight of the writer in Augustan society ("Volumes have been written only to enu-

merate the Miseries of the Learned, and relate their unhappy Lives, and untimely Deaths")[2] was equally true for contemporary painters. "It was his opinion," Northcote reported, "that the population of London was no more than just sufficient to afford a reputable maintenance for eight painters only, and this number to include all the different branches of the art."[3] The professional career that Reynolds so quickly and deftly established was grounded not only in raw talent and carefully honed social skills, but in an unflagging industriousness and in a shrewd knowledge and manipulation of the marketplace of art. Before turning, in the final chapter, to an exploration of Reynolds's relationships with his patrons, we therefore need to examine his accomplishments as an eighteenth-century man of business. Such an inquiry will eventually lead us into the painter's studio and back to questions focusing on social intercourse and on Reynolds's conception of human character.

The artistic marketplace beckoning to an aspiring young painter in the fourth and fifth decades of the century was in the throes of a slow but powerful transformation that reflected even more sweeping changes in the economy of the nation as a whole. Britain's gradual evolution from a "client" to a "market" economy affected painters and writers no less than it did the average merchant or shopkeeper. When John Brewer writes that "the objections to the client economy were simple enough: the dependence of the tradesman on aristocratic patronage placed him in a highly vulnerable, occasionally humiliating and certainly weak position *vis-à-vis* his customer," we can immediately gauge the sense in which this predicament characterized relations between painters and their patrons as well. "Clients in the client economy," Brewer adds, "were not 'free' but tied, no matter how discreetly, to their patrons,"[4] a situation that might be said to characterize virtually *any* act of visual portraiture, no matter how dramatically the national economy may have embraced the principles of a free market system. But even for portrait-painters such as Reynolds there were commercial opportunities—alternatives to the traditional dependence on patronage—that had rarely existed before. Louise Lippincott has provided

the best summary of these changes in her detailed analysis of the career of Arthur Pond from roughly 1735 to 1750:

> competition opened up the London art market at a time when more patrons were spending more money than ever before. Painters became increasingly sensitive to the forces of supply and demand as their buyers discovered and exploited alternative sources for art. . . . The effects of the situation were far-reaching. As artists' traditional means of maintaining employment and prices—guilds, gentlemen's agreements, ostracism of foreign artists, and high tariffs on imported art—broke down, the benefactor/client model for patron/artist relations collapsed, too. . . . The problem for English artists was not so much a shortage of patrons or a deficiently educated public as a surfeit of new kinds of buyers with interests and tastes they were unprepared or unable to accommodate. The traditional patron/benefactor was lost in the surge of new customers.[5]

Pond, whom Lippincott characterizes as a "competent artist and first-class opportunist,"[6] manipulated the emerging markets with great dexterity but was nevertheless eager to cultivate more traditional relationships with patrons, which he finally enjoyed late in his career. Reynolds was more fortunate, finding substantial support through his West Country connections relatively early in his career, but he was just as shrewd as Pond as he began the arduous task of establishing an artistic practice in the 1740s.

The very fact that a portrait-painter must build and maintain a "practice" underscores Reynolds's life-long concern with the status of the artist in society. The word itself suggests not only a steady clientele for the painter but also the necessity of hard work, apprenticeship, repetition, and improvement. If we listen to Northcote, we learn that Reynolds actually practiced *too much*: "Ah! it's very hard to know when a picture is finished; it is what Sir Joshua didn't know, for there is scarcely a picture that he painted, whilst I was with him, that was not better at some stage during its progress, than when he left off." Reynolds was never satisfied, Northcote notes; "anything he did appeared

nothing in his own eyes, compared with what he thought it ought to be."[7] The sheer physicality of artistic "practice" links it with those artisanal pursuits that Reynolds, in the *Discourses*, would carefully distance from the grand style in painting: "the industry which I principally recommended, is not the industry of the *hands*, but of the *mind*. As our art is not a divine *gift*, so neither is it a mechanical *trade*." Practice, he adds, is essential to perfection, but must be subsumed under the direction of "principle."[8] As Iain Pears has noted, the painter's ambivalent status is similar to that of the architect, lawyer, or physician, all "asserting their own claims to intellectual and hence social respectability."[9]

Confronted by the burdens and ambiguities of artistic "practice," Reynolds more often than not managed to make a virtue of necessity. Late in his career, when it would be reasonable to assume that the painter had already reaped whatever rewards (his) practice could bring him, Reynolds confessed in a letter to the Duke of Rutland that he was experimenting with a classical subject: "I don't know how to give a description of my Venus, as it is called; it is no more than a naked woman sitting on the ground leaning her back against a tree, and a boy peeping behind another tree. I have made the landskip as well as I could in the manner of Titian. Though it meets with the approbation of my friends, it is not what it ought to be, nor what I should make it. The next I paint I am confident will be better."[10] This extraordinary passage sounds as if it were written by a young and striving painter rather than by an artist who had dominated the field for almost forty years—were it not, perhaps, for a modesty that borders on cynicism ("it is no more than a naked woman sitting on the ground"). The subject is fresh (to Reynolds) but already indebted to the usual Italian sources.[11]

A year later, in 1786, Reynolds would write again to his friend and patron about this painting once it had been exhibited at the Royal Academy: "In regard to the Venus, the Duke of Dorset is to have it, not for himself, but for a French marquis, whose name I have forgot; he is to give me 400 guineas for it. I have since done another with variations,

which I think better than the first; but I am not fond of shewing it till the other is disposed of."[12] Here, in a scarcely less intriguing letter, Reynolds discloses how shrewdly he could capitalize on his own limitations. The first *Venus* is virtually forgotten; the painter scrupulously notes the handsome price it fetched, but cannot remember whose room it will grace. Practice, moreover, has produced a second, more attractive *Venus* that differs from its predecessor not only in its "variations" but in the fact that it is "better." The calculating author of the second painting will not allow it to enter the marketplace until the transaction for the first is complete. The Duke of Dorset thus has the privilege of presenting Reynolds's original canvas without discovering how deficient it may be, and Reynolds has the freedom to market what he judges to be a better painting once the impressive price for its predecessor has been established.

These two revealing passages drawn from Reynolds's last years as an active painter are fully consonant with the mixture of industriousness, resourcefulness, and idealism—for one should always wish to create a "better" picture—that characterized his assault on London forty years earlier. Those artists "who are determined to excel," he remarked, "must go to their work whether willing or unwilling, morning, noon, and night, and will find it to be no play, but, on the contrary, very hard labour."[13]

Reynolds told Northcote that "for many years he laboured harder with his pencil than any mechanic had ever worked at his trade for bread."[14] For his part, Northcote described Reynolds's industry with his usual ambivalence: his master "suffered nothing to turn his attention from [his goal]; no pleasure, no feelings of any kind were allowed to stand in the way; this, indeed, has been the case with all great men, though perhaps in kings and nobles it makes a greater show than in men of inferior station."

Northcote believed, moreover, that Reynolds was at his "busiest" when he was not occupied with his sitters: "it was then that he was pushing his abilities to the utmost; it was then, indeed, that he was

conceiving and executing those things which have made his name so famous as a painter. Seldom did he take exercise; and so closely was his day spent in his professional employment, that if by any chance he found himself in the street during the middle of the day, he felt ashamed, and thought everybody was looking at him."[15] According to Samuel Rogers, Reynolds "was always thinking of his art. He was one day walking with Dr. Lawrence near Beaconsfield, when they met a beautiful little peasant-boy. Sir Joshua, after looking earnestly at the child, exclaimed, 'I must go home and deepen the colouring of my *Infant Hercules*.'"[16] The painter's thoughts, Farington concluded, became "unsettled" whenever he was far from his studio,[17] and Northcote noted that when Reynolds had complied "with the invitations of the nobility to spend a few days of relaxation with them at their country residences, though every luxury was afforded which the heart could desire, yet he always returned home like one who had been kept so long without his natural food."[18] Busy as it was, his studio became a comparative refuge in which—as we have already seen—Reynolds habitually worked on Sundays as well as during the week. "The pupil in art," he lectured his apprentices, "who looks for the Sunday with pleasure as an idle day, will never make a painter."[19]

We can find a pattern of similar advice—directed to himself or to others—woven into the fabric of his entire career. Northcote records an instructive story about a young painter who abandoned a good practice in his native city in order to make an Italian tour. When the aspiring artist met Reynolds in London and "related the circumstance to him, Reynolds blamed him for leaving such a harvest, saying 'You should have staid as long as the rage lasted, and not have left it, as it cannot be recovered when once lost.'"[20] In a letter to the young Barry—a letter he himself characterized as having "the blunt appearance of a dictatorial style"—Reynolds remarked that "whoever is resolved to excel in painting, or indeed any other art, must bring all his mind to bear upon that one object, from the moment he rises till he goes to bed; the effect of every object that meets a painter's eye, may

give him a lesson, provided his mind is calm, unembarrassed with other subjects, and open to instruction."[21] Other English painters working in Rome will be tempted to produce copies of the Italian masters for the London market, but Barry—like Reynolds before him—must paint for himself, not allowing his envious and malicious rivals to draw his attention from "the main object."[22] Many years later, in a shrewd but nonetheless moving letter to Richard Brinsley Sheridan, Reynolds characterized his portrait of his wife, Elizabeth Sheridan, as "the best picture I ever painted, for tho' I have every year hoped to paint better and better, and may truly say, *Nil actum reputans dum quid superesset agendum,* it has not been always the case. However, there is now an end of the pursuit; the race is over whether it is won or lost."[23]

It was discipline such as this that enabled Reynolds "to say of himself when very young, that if he did not prove to be the best painter of his time when he arrived at the age of thirty years he never should be,"[24] or to insult John Flaxman by asking him, "What are you married.—Yes.—said Sir Joshua, 'your improvement is at an end.' "[25] We have no reason to believe that Reynolds ever wavered in his devotion to his practice and his profession; only incipient blindness brought his pencil to a rest, but even then his professional career, broadly construed, was far from over. The comments he made about Garrick's decision to perform on the stage "till a late period of his life" are therefore doubly interesting, for they should be interpreted as a gloss on Reynolds's own character and career: "it was necessary for Garrick to do so, in order to preserve his popularity, and to keep up his importance with the great, who soon neglect and forget those who cease to be the town talk, however eminent they may have been."[26]

Labor, practice, devotion, improvement—these are all essential to Reynolds's success as a painter, but they are also the components of his happiness and vitality as an individual. A surviving fragment from one of his earliest letters preserves the confession that "while I am [painting] I am the happiest creature alive,"[27] and this is later echoed in Northcote's observation that "he never was so happy as in those

hours which he passed in his painting room."[28] He counseled Barry that an artist's work "will be found sufficient to fill up life, if it was much longer than it is,"[29] and he had recourse, years later, to a similar argument when he wrote a character sketch of George Moser, late Keeper of the Royal Academy: "Few have passed a more inoffensive or perhaps a more happy life; if happiness or the enjoyment of life consists in having the mind always occupied, always intent upon some useful art, by which fame and distinction may be acquired. Mr. Moser's whole attention was absorbed either in the practice, or something that related to the advancement, of art."[30] Happiness is to be found both in useful labor and in the fame Reynolds is confident it will bring. The painter who told Sir William Chambers that "distinction is what we all seek after, and the world does set a value on [titles], and I go with the great stream of life,"[31] had little patience with the complaint of the astronomer James Ferguson about a fellowship that had been offered to him by the Royal Academy: " 'Ah,' said Mr. Ferguson, 'I do not want honour, I want bread!' Sir Joshua observed, that the obtaining of honours was the means of obtaining bread."[32]

This fundamental correlation between hard work and fame or happiness was surely just as important to Reynolds as was his devotion to the complicated art of pleasing. And if one looks carefully at the lexicon in which Reynolds characterizes this life of artistic endeavor, one soon discovers the playfulness and perhaps even the ironic detachment that we have already sensed in his character. His letter to the young Barry contains this central piece of advice, which should now be quoted in full: "Were I in your place, I would consider myself as playing a great game, and never suffer the little malice and envy of my rivals to draw off my attention from the main object, which, if you pursue with a steady eye, it will not be in the power of all the Cicerones in the world to hurt you."[33] Similarly, in some autobiographical fragments collected by Malone, Reynolds justified his conduct during his early years in Rome by stating that "I considered myself as playing a great game, and, instead of beginning to save money, I laid it out faster than I got it, in

purchasing the best examples of art that could be procured; for I even borrowed money for this purpose. The possessing of portraits by Titian, Vandyck, Rembrandt, &c. I considered as the best kind of wealth."[34] This early acquisition of capital—first in pictures, then in ideas culled from those paintings—was clearly a calculated gamble; it necessitated laying out money faster than it came in; it made of the young Reynolds both a financial and an artistic debtor and, eventually, both a financial and an artistic success.

When Northcote reflects on Reynolds's professional determination and integrity (near the conclusion of his final conversation with Hazlitt) he invokes the same metaphor in order to suggest the carefully crafted shape of the painter's career: "Sir Joshua always despised malicious reports; he knew they would blow over: at the same time, he as little regarded exaggerated praise. Nothing you could say had any effect, if he was not satisfied with himself. He had a great game to play, and only looked to the result."[35] This is the artist who was determined to be "the best painter of his time" by the age of thirty, but this is also the man of business who never lost sight of what he wanted to achieve or how he wanted to live. His productivity in London in the 1750s was extraordinary, and Northcote notes that his practice was in fact most lucrative around 1758, when he charged only twenty guineas a head, received six sitters a day, "and found it necessary to keep a list of the names of those who waited, until vacancies occurred, in order to have their portraits painted by him." Many of these paintings were sent home "before the colours were dry," and yet even at this phenomenal pace we still find Reynolds bridling at interruptions "by idle visitors, saying, 'those persons do not consider that my time is worth, to me, five guineas an hour.'" In order to meet this increasing demand, Reynolds was assisted in his practice by several drapery painters; "indeed," Northcote notes, "I have heard him observe, that no man ever acquired a fortune by the work of his own hands alone."[36]

Three years later, in 1761, Reynolds is said to have received seven sitters in seven hours,[37] but this frenetic schedule slackened a few years

later when he decided to raise his prices in order to protect his artistic freedom. In a letter of 1777, for example, he writes to a prospective client that his price for a head is 35 guineas, 70 for a portrait "as far as the Knees," and 150 for a full-length. Three sittings of an hour and a half are usually necessary, he notes, but "if the sitter chooses it the face could be begun and finished in one day."[38] But this, of course, was often not the case. As we have seen, Johnson complained to Hester Thrale about having to sit to Frances Reynolds "perhaps the tenth time, and I sat near three hours, with the patience of *Mortal born to bear*,"[39] but Northcote takes pains to point out that this kind of "perseverance was the rule and practice of Sir Joshua's school; for I have known himself, on some occasions, require as many sittings and as long at each time."[40]

Perseverance is a particularly important virtue for the painter of portraits, who must wrestle not only with the changing countenances of difficult subjects, but also—and always—with the changing winds of a fashionable art. Reynolds knew that he was not invulnerable, even though his carefully nurtured social relationships protected him from sudden neglect. Peter Pindar (John Wolcot), writing presumably in the 1780s, argued that "it is a lucky thing for an artist to be possessed of the favour of the fashionable world; fortune then shows no objection towards a co-operation with his labours." In spite of his rivals and a "too great mortality of colours," Reynolds "stands his ground like a Hercules, and defies envy, hatred, and malice; in short, all the virulent attacks made on his performances."[41] Other painters were less fortunate, and one of the few genuinely moving passages in Northcote's biography of Reynolds is his lament for John Opie, once caressed and courted but now almost totally forgotten:

> instead of being the sole object of public attention, and having the street, where he lived, so crowded with coaches of the nobility as to become a real nuisance to the neighbourhood, so, as he jestingly observed to me, that he thought he must place cannon at his door to keep the multitude off from it, he now found himself as entirely deserted as if his house had been infected with the plague.
> —Such is the world![42]

Reynolds, by contrast, was the only painter the sculptor Joseph Wilton thought had been able "to call back the public to himself after they had grown tired of him, and which he had done more than once."[43] He survived rival after rival—Ramsay, Gainsborough, Opie, even Romney—although Romney's success had a lasting effect on Reynolds's popularity as a portrait-painter. Northcote, who was no champion of Romney's talent as an artist, remarked that "the world, as we in general term it, is in this respect just like a child that will fling away the most valuable jewel after having become familiar with it, to grasp at a toy however worthless, if it has but novelty to recommend it."[44] Later, in conversation with James Ward, he tempered his judgment slightly, but he still believed that, following Romney's assault, Reynolds "never after had the run he had at first." But Sir Joshua, he adds, "acted like a prudent man, for whilst the run lasted he feathered his nest, and then didn't care; it also allowed him time for those beautiful fancy pictures, which have so charmed the world ever since."[45]

Rivals as formidable as Romney represented strong antidotes to self-complacency, but they also colored Reynolds's relationships with his fellow artists. Reynolds may have believed that "a man who is at the head of his profession is above it,"[46] but that did not prevent him from harboring intense feelings about those painters who could most easily challenge his professional pre-eminence. His troubled relations with Gainsborough are well known, and are perhaps best explained by Reynolds's dictum that "it was impossible for two painters in the same department of the art to continue long in friendship with each other."[47] Reynolds and Gainsborough apparently reconciled their differences before Gainsborough's death in 1788, but Reynolds had long been keenly aware of his rival's talent as both a portraitist and a painter of landscapes. Northcote in fact draws attention to Reynolds's "liberality of conduct" in bestowing praise on his contemporaries, but he does so by relating a story that is vastly to his master's discredit:

One evening, at the Artists' Club, held at the Turk's Head, in Gerrard-street, Sir Joshua came into the room, having just before seen a very fine

landscape, painted by Gainsborough, with which he had been exceedingly struck, from its extraordinary merit. He was describing its beauties to the members of the Club then present, and finished his eulogium by saying, "Gainsborough is certainly the first landscape painter now in Europe;" when the famous Richard Wilson, the landscape painter, who was one of the auditors of this high commendation, and who, from an excusable jealousy, felt himself offended, after begging leave to add also to this high character of Gainsborough, said, "Well, Sir Joshua, and it is my opinion that he is also the greatest portrait painter at this time in Europe." Sir Joshua felt the rebuke, and immediately apologized for his inattention in making the observation in Wilson's company.[48]

This is a deliciously complicated story in which the urge to deliver "high commendation" is disastrously at odds with the art of pleasing. It appears that Reynolds's genuine enthusiasm has temporarily blinded him to the social context of the club in which he delivers his seemingly inoffensive remarks; he must then bear the social disgrace of hearing Wilson brilliantly imitate and criticize him in the same breath.

I wonder, moreover, whether Reynolds's praise of Gainsborough is not also a subtle stratagem by which he simultaneously accomplishes two ends. In the first place, by extolling his rival so liberally, he reminds his friends of his own generosity of spirit; these are not the words of a mean or jealous rival. At the same time, however, Reynolds effectively focuses his audience's attention on Gainsborough's landscapes and thus *away* from his work as a painter of portraits. Only the irritable Wilson, who has been wounded in his own "department of the art," will remind his fellow painters of the implicit subtext of Reynolds's remark. Reynolds, moreover, may have "felt the rebuke," but he apologizes only for the context in which he delivered his words of praise, not for the aesthetic judgment itself.

When Northcote comments on this intriguing anecdote by once again reminding us of Reynolds's "liberality," it is difficult to decide whether he is being reticent or merely obtuse. The *other* Northcote— the Northcote of unbridled conversation—is twice recorded as having

nurtured ambivalent thoughts about Reynolds's professional generosity. In manuscript notes for the biography, he remarks that Reynolds actually undervalued his own ability as a painter, which in turn begins to explain "that fear and jealousy which he certainly felt towards all those whose merits he thought put his own superiority in danger." He artfully hid this fear, Northcote argues, "by lavishly bestowing patronage and assistance on those whom he was sure could never interfere with himself, that he might by this means appear to the world as a patron of the arts without the risk of hurt to himself."[49] Farington records an even more virulent version in his diary, where Reynolds is said to have recommended "the works of those who He must have despised as Artists, while on the contrary He would not do justice to such as created an apprehension in him,—and would often comply and manoeuvre in a manner unworthy his high *claims*."[50] Malone, who was present during this conversation, defended his friend by declaring that Reynolds did not possess "that pliable temper which accompanys contrivance—He thought him never more so [pliable] than good manners and easy communication required." Once again the argument centers—or founders—on the "readability" of human behavior and character, and specifically on the art of pleasing, which, like Addison's "artificial humanity," may actually disguise baser sentiments.

We are placed in a similar quandary when Northcote offers us another brief story about Reynolds's relations with his fellow painters: "it was said in a contemporary character of Reynolds, at this period [1783], that he had so little of the jealousy of his profession, that when a celebrated English artist, on his arrival from Italy, asked him where he should set up a house, Sir Joshua told him that the next house to his own was vacant, and that he had found his own situation a very good one."[51] On the surface, at least, Reynolds appears to be both helpful and modest: what works for him may also work for someone else. But we do not know whether this "celebrated" artist could afford a house as grand as Reynolds's, let alone whether he would wish to compete for patronage at the very next door. Northcote offers absolutely no

comment on this passage, but Hester Piozzi, in her marginalia, quickly grasped its ambiguity: "That was Insult, not Modesty."[52] Perhaps it was also a challenge: set yourself up in a similar "situation" and we shall see whether you enjoy as much success as I have had.

These are ungenerous thoughts—Northcote's, Wilson's, Piozzi's, mine—about seeming generosity, but they underscore, I think, the ambivalence Reynolds felt in his professional relationships. He was notoriously stinting, for instance, with his assistants and apprentices—stinting in his praise, salary, and attention[53]—and yet he appears to have been unfailingly kind to his "students," with whom he maintained a less formal connection. Thomas Stothard and J. M. W. Turner told Charles Leslie that "they were both often in his rooms when students; and I have known painters of less note who enjoyed the same advantage; one of whom said that, on such occasions, his manners were exactly as Goldsmith described them, 'gentle, complying, and bland.' "[54] While it is unclear from these remarks whether Reynolds's complacency was directed at his sitters or at the students who came to watch and perhaps converse with him, it is nevertheless obvious that painters like the young Turner relished a sense of professional privilege that Reynolds's apprentices and paid assistants sorely missed.

Much of the time, however, Reynolds's protection and aggrandizement of his own practice were beneficial to the entire profession. We know, from the *Discourses,* how eloquently he argued for the intellectual and humanistic claims of painting;[55] and I have traced, in Chapter 1, the ways in which his learning and comportment provided a model by which other artists could enter the "great world" of society on a firmer footing: "he procured for Professors of the Arts a consequence, dignity, and reception, which they had never before possessed in this country."[56] But Reynolds's practices in the marketplace of art were no less helpful to his fellow "Professors." Although it is uncertain whether he was in fact the first English painter to demand that half the price of a portrait be paid at the initial sitting, he was credited with this innovation by Henry Angelo, and we know that Northcote followed suit in his own

practice in the 1780s. Angelo records a conversation between Gainsborough and George III in which the painter confides that he must complete his portraits because he has received "sums in advance" from his sitters. The King replies by declaring, "Aye, aye,—a good custom that—first set on foot, by Sir Joshua—hey? an excellent custom ... professional men cannot be too punctilious on these matters."[57] Even this safeguard, however, could not protect Reynolds from slowly amassing a collection of his own unclaimed or rejected works, which may explain his abrupt answer to an inquiry about his stock of "fancy" paintings: "I have no picture of the kind you mention by me, when I paint any picture of invention it is allways engaged before it is half finished."[58]

In a similar tone, he argued that his design for the Nativity scene in the west window of New College Chapel should, because of its subject, be the most expensive of his artistic commissions. "I verily believe," he wrote, that "it will be the first work of this species of Art, that the world has yet exhibited," and Joseph Hill quotes him as insisting on the sum of 1200 guineas because "it was a larger price than was ever paid before for a picture painted in England."[59] His commission from the Master and Fellows in fact called for a series of drawings or cartoons, but Reynolds confided to his friend William Mason that he found it easier to paint rather than draw the designs, and then shrewdly added that "I suppose persons hereafter may be found to purchase my paintings."[60] It was also his opinion that "a picture given by the painter as a present was seldom considered, by the person who received it, as of much value; whilst, on the contrary, those paid for are esteemed, as their value is thereby ascertained."[61] There were exceptions to this rule, of course, but it is significant that even portraits he painted of friends had prices clearly attached to them. In his letter of January 1790 to Sheridan, for instance, he carefully rehearses the different ways in which the "value" of his portrait of Elizabeth Sheridan as St. Cecilia might be gauged before he offers a price that the dramatist can now—fifteen years later— finally afford:

You will easily believe I have been often solicited to part with that picture and to fix a price on it, but to those solicitations I have always turned my deafest ear, well knowing that you would never give your consent, and without it I certainly should never part with it. I really value that picture at five hundred guineas. In the common course of business (exclusive of its being Mrs. Sheridan's picture) the price of a whole-length with two children would be three hundred; if therefore, from the consideration of your exclusive right to the picture, I charge one hundred and fifty guineas, I should hope you will think me a reasonable man.[62]

Reynolds's insistence on the value of his paintings as commodities— especially those that were not destined to compete in the marketplace— therefore cuts in two directions, for by endowing his pictures with specific monetary values he was ensuring that they would be "esteemed" by their owners while, simultaneously, he protected the market price of paintings that were actually for sale.[63] When, for example, John Boydell first approached Reynolds with his plans for the Shakespeare Gallery and illustrated edition of the plays, Northcote reports that, "unexpectedly, Sir Joshua appeared to be rather shy in the business, as if he thought it degrading himself to paint for a print-seller."[64] Boydell was soon successful, however, as Reynolds indicates in a letter to the Duke of Rutland: "he wishes me to do eight pictures, but I have engaged only for one. He has insested on my taking earnest money, and to my great surprise left upon my table five hundred pounds—to have as much more as I shall demand."[65] This was a shrewd maneuver by Boydell, for it in effect stamped a value on Reynolds's painting even before he had conceived of its subject and thereby prompted the painter to characterize Boydell's scheme as "the greatest news relating to virtu."[66]

Reynolds's boldest stroke as he began to build his practice characteristically combined aspects of his personal as well as professional self-presentation. Reynolds was not the first painter in England to move to an elegant house and to invite his sitters to socialize with him there— Van Dyck, Kneller, even Arthur Pond had successfully ventured in this direction—but he did so with unprecedented thoroughness and self-

consciousness. Writing in 1755, the French visitor Jean-André Rouquet described this general phenomenon with characteristic humor:

> A portrait painter in England makes his fortune in a very extraordinary manner. As soon as he has attained a certain degree of reputation, he hires a house fit for a person of distinction; then he assumes an air of importance and superiority over the rest of his profession, depending less on his personal abilities to support this superiority, than on the credit of some powerful friend, or of some woman of quality, whose protection he has purchased, and which he sometimes courts not much to his honor. His aim then is not so much to paint well, as to paint a great deal.[67]

As Angelica Kauffman wrote to her father, "I could not sustain my character with my work alone. Everything has to be arranged," by which she meant that she "could not possibly receive people in a poorly furnished house."[68]

Northcote supplies the best account of how Reynolds decided to conquer London:

> Finding himself now sufficiently established [in 1760] to move in a higher sphere, Mr. Reynolds quitted his establishment in Newport-street, and removed to Leicester-fields, where he had bought a handsome house on the west side of the square; to which he added a splendid gallery for the exhibition of his works, and a commodious and elegant room for his sitters. In this speculation, as I have heard him confess, he laid out almost the whole of the property he had then realized.

Northcote also tells us that Reynolds's "mode of living was in other respects suitably elegant" and that the painter gave a ball and refreshments to "a numerous and elegant company" when he opened his gallery to the public.[69] And then, once his own talents as a painter and companion had captured his audience, he appears simply to have closed his eyes to the elegant refinements he had so carefully orchestrated: "He also fitted up a splendid painting-room of an octagonal shape and

beautifully decorated, and this very room, when he became celebrated, he suffered to remain tarnished and blackened with smoke, and cared nothing about it."[70] The move to Leicester Fields was thus another carefully calculated gamble that—like his purchase of paintings in Rome—eventually (and in this case quickly) paid off. But such a move was not without its risks, as Reynolds certainly realized. In a recently discovered letter of 5 June 1753 to Joseph Wilton in Florence, Reynolds made it clear that at least three of his colleagues were in serious financial circumstances:

> Mr. Alexander is so very bad that he is a proverb as bad as Alexander. Mr. Hambletons business is very near entirely gone from him[;] he is in a very melancholy situation having engaged a house for three years at 120£ pounds a year[.] Ashly has run into the same dangerous experiment of making a great figure in his house and servants. however he is 20£ more modest in his house than Hambleton, both of them living at this great expence thay were obliged to dispatch their Pictures as fast as they could.[71]

Seven years later, however, Reynolds must have felt confident enough to engage in such a dangerous experiment himself.

Even more ostentatious perhaps than his own house with its elaborate gallery and painting room was the notorious carriage that so mortified his sister Frances:

> The carriage ... was particularly splendid, the wheels were partly carved and gilt; and on the pannels were painted the four seasons of the year, very well executed by Charles Catton, R.A., the most eminent coach-painter of his day.
> The coachman frequently got money by admitting the curious to a sight of it; and when Miss Reynolds complained that it was too shewy, Mr. Reynolds replied, "What! would you have one like an apothecary's carriage?"[72]

This carriage is worth pausing over, for with its allegorical panels and

gilt wheels ("like those made use of by the sheriffs of London")[73] it functions as a fit emblem of the younger Reynolds's shrewdness and aspirations. It was, in the first case, clearly for show rather than use. Northcote reports that "he used to send his sister to ride about in it, for he had no time to ride in it himself . . . a crowd would collect to stare at the carriage, and ask whose it was. Now this was just what Sir Joshua wanted!"[74] The allegorical figures were said to be "curiously painted" by Charles Catton; the liveries of the servants were laced with silver, and the vehicle itself, Northcote adds, "was an old chariot of a Sheriff of London newly done up."[75] The carriage appears to have held a certain talismanic power, as the various accretions of Northcote's dispersed commentary testify, and this may in part stem from the fact that the art of elaborate carriage-painting had severely declined in the eighteenth century. "Coaches built for travelling greater distances and for enduring much harder conditions," Iain Pears notes, "were less well suited to ornate decoration than the more stately and purely urban varieties current at the end of the seventeenth century."[76] Edward Edwards states, for instance, that "at the commencement of the last century, the pannels of coaches were painted with historical subjects, which were often but little suited to the character or profession of the owners," who eventually chose to have their arms alone (or arms supported by flowers and ornaments) depicted on their carriage doors.[77]

Reynolds was thus relying upon an elaborate and out-dated style of decoration that was perhaps more suitable for the coronation of George III than for the "coming out" of a portrait-painter. But as Northcote realized, "Something obvious and palpable, like fine clothes, becomes necessary, to arrest the attention of the public. Sir Joshua knew this."[78] Appearances were crucial, as Chesterfield would remind his son again and again. For many people, Reynolds's carriage therefore functioned as the first step in the process of encountering the painter during this crucial period in his career. The carriage replaced the traditional sign that hung above the tradesman's door, for only Hogarth—on the other side of Leicester Fields—would brandish a Van Dyck's head in front of

his house. The replacement for the traditional painted shop sign, as Lippincott shrewdly senses in her study of Arthur Pond, was invisible and intangible: only reputation could bring prospective clients through the painter's door.[79] Reynolds's brilliant strategy was to make the sign both artful (rather than artisanal) and peripatetic. In semiotic terms, Reynolds's sign was no longer a crude index that directly pointed to what it represented but a symbolic representation that inscribed within its own panels examples of the elevated art to which Reynolds would aspire during his entire career.

And not only elevated art, of course, but social position as well, for even in these early developments we can gauge the extent to which Reynolds was building his career on aristocratic models. Ronald Paulson argues, for instance, that the escutcheon and shop sign were merely two forms—one high and one low—of a single attempt at self-identification.[80] In Reynolds's case we can see how the allegorical images on the panels of his carriage functioned as shop signs while literally displacing the traditional, aristocratic escutcheon. Marcia Pointon, moreover, draws our attention to the "hierarchy of pupils and assistants who possessed none of the rights of apprentices and were dependent on the same uncertain and unpredictable modes of patronage as was Reynolds himself,"[81] and quotes the bitter Amelia Opie as she laments the fate of her husband, John: "Certain it is that the republic of letters and of arts has an aristocratic bias; and many of its members are of such sybaritic habits, such fastidious delicacy, and have such a decided preference for the rich, the polished, and the high born members of its body, that a man of plain, simple, and unobtrusive manners, depending only on his character and his genius for respect, is not likely to be much the object of their notice."[82] Reynolds was neither sybaritic nor fastidiously delicate, and it would be incorrect to conclude that he held a decided preference for the rich and aristocratic members of society; it would, in fact, be difficult to name anyone whose friendship he enjoyed more than that of Johnson, Burke, the Burneys, and even the social-climbing Boswell. But it is nonetheless clear that he worked hard to

attract the "polished" and the "high born" to his establishment in Leicester Fields. He was proud of his aristocratic friends, and the elegant house and rather grandiose carriage reinforced his efforts to meet his subjects and patrons on a common footing.

A surprising amount of Reynolds's "personalia" and furniture—the material culture of his everyday existence—has passed by descent through his family and friends, and many of the surviving items provide an intriguing glimpse of how he fashioned his immediate surroundings. In addition to his sitter's chair and mirror (to which I turn in the next section) Reynolds owned a number of interesting pieces of furniture that may have been specifically designed for his use. Two fashionable cabinets presumably stood in his drawing room. One is a tall "Venetian and glass" Chinese cabinet, brightly colored in vermillion, black, and gilt lacquer, with imperial dragons carved on its panels (Plate VI).[83] A smaller cabinet, also mounted on a stand and also Chinese, is decorated with hillside scenes and painted in black and raised gilt lacquer.[84] A substantial mahogany writing desk is more traditional in design: a large chest with doors is fitted above the writing surface itself (a drawer that disappears when not in use).[85] Two pairs of Reynolds's spectacles have survived (with shagreen cases),[86] together with his silver standish (a triple inkstand), his painting box, mahlstick, easel, palettes, rule, and glass muller (for grinding paints).[87]

Many of the smaller domestic objects reveal the pressure of Reynolds's personal imprimatur. His crest appears, for instance, on each piece of his silver service (with a shell design on the handle's end).[88] His name is engraved on the bases of his silver candlesticks, and a complicated device of the painter's own design, incorporating each of the letters in his name, appears both on his Chinese Lowestoft dinner service (bordered in a blue decoration of floral motifs) (Plate VII)[89] and on his various gaming counters (Figure 15). These mother-of-pearl "chips"—some round, some rectangular—were held in a lacquered papier-maché box with five inner compartments; both the box and the counters were of oriental workmanship.[90] Each of the letters Reynolds

dispatched bore the red wax impression of one of his two seals: either the small medallion-head of Michelangelo, or the allegorical figure of Winter, designed by Pierre Etienne Falconet (Figure 16).[91] His calling card, moreover, was designed and engraved by Bartolozzi, who allowed a decorated sphere bearing the painter's name to be admired by the kneeling figure of Pittura and supported by a putto and a powerful Grace-like character in classical attire (Figure 17).[92] As Reynolds collaborated with his friends in the creation of these designs and objects, one can imagine him taking a certain amount of satisfaction in the sheer control he was able to wield over his personal environment; but it was simultaneously a process that exerted pressure—literally bore the stamp of his own impress—on everyone who entered the world he was fashioning. Whether they lifted his fork, sipped from his cup, opened his letter, or returned one of his mother-of-pearl gaming counters, Reynolds's contemporaries were reminded that this was a person of means, of taste, of imagination—of substance.

In building his practice and presenting himself in this particular way, Reynolds was thus also raising the status of painting (and particularly portrait-painting) as an enterprise. But there were skeptical critics on either side. Offended by Lord Holland's questioning about how long it took to execute a portrait, Reynolds firmly replied, "All my life, my lord."[93] In 1779 he was attacked, in his absence, by a "Mr. B———y," but he had the combined voices of Frances Burney, Hester Thrale, and George Selwyn to uphold the dignity of his profession and his own particular talents as a painter. B———y was "notorious for his contempt of all artists, whom he looks upon with little more respect than upon day-labourers," Burney recorded in her diary; "the other day, when painting was discussed, he spoke of Sir Joshua Reynolds as if he had been upon a level with a carpenter or farrier." B———y had known Reynolds in Minorca and could not understand how he could demand "seventy guineas for scratching out a head!": "I don't want to run the man down; I like him well enough in his proper place; he is as decent as any man of that sort I ever knew; but for all that, sir, his prices are

shameful . . . I have dined in his company two or three times; a very decent man he is, fit to keep company with gentlemen; but, ma'am, what are all your modern dabblers put together to one ancient?"[94] Even Frances Reynolds had her brother in mind when she remarked that "the world in general . . . think no more of a painter than they do of a fiddler or a dancing-master or a piano-forte-maker,"[95] and her observation was corroborated by Rouquet: "Every Englishman constantly holds a pair of scales, wherein he exactly weighs the birth, the rank, and especially the fortune of those he is in company with, in order to regulate his behaviour and discourse accordingly; and on this occasion the rich tradesman is always sure to outweigh the poor artist."[96]

At the same time, Reynolds encountered critical challenges from those who questioned the utilitarian value of his work. A comment delivered by Josiah Tucker, Dean of Gloucester, at a meeting of the Society for the Encouragement of Arts, Manufactures, and Commerce to the effect that "a pin-maker was a more useful and valuable member of society than Raffaelle" provoked a thoughtful response from Reynolds that Northcote read and later included in his biography:

> This is an observation of a very narrow mind; a mind that is confined to the mere object of commerce, that sees with a microscopic eye but a part of the great machine of the economy of life, and thinks that small part which he sees to be the whole. Commerce is the means, not the end, of happiness or pleasure: the end is a rational enjoyment of life, by means of arts and sciences; it is, therefore, the highest degree of folly to set the means in a higher rank of esteem than the accomplished end. It is as much as to say that the brick-maker is a more useful member of society than the architect who employs him. The usefulness of the brick-maker is acknowledged, but the rank of him and the architect are very different. No man deserves better of mankind than he who has the art of opening sources of intellectual pleasure and instruction by means of the senses.[97]

Northcote qualifies these remarks by noting that Reynolds, who was as enthusiastic on behalf of his art as any painter, was yet "totally free

from that weakness so commonly found among professional men, of over-rating either the rank, value, or importance of his profession."

Reynolds treated this "professional kind of mania" as a species of pedantry, we are told, but we also know how vigorously he could contend with those, like Johnson, who went out of their way to denigrate his work:

> Sir Joshua mentioned some pictures as excellent. "It has often grieved me, Sir (said Mr. Johnson), to see so much mind as the science of painting requires, laid out upon such perishable materials: why do not you oftener make use of copper? I could wish your superiority in the art you profess, to be preserved in stuff more durable than canvas." Sir Joshua urged the difficulty of procuring a plate large enough for historical subjects and was going to raise further objections: "What foppish obstacles are these! (exclaims on a sudden Dr. Johnson:) Here is Thrale has a thousand tun of copper; it will serve him to brew in afterwards: Will it not, Sir?"[98]

Johnson's initial overture is one of concern, but thoughts of durability inexorably lead to a ludicrous conclusion that insults both the painter and the brewer at the same time.

Hester Piozzi, who records this conversation, also tells us how Johnson could "sit very quietly in a room hung with the works of the greatest masters" and not even bother to turn them around if "their backs were outermost." Reynolds naturally reacted quite differently. When Sir Abraham Hume remarked that he took great pleasure in seeing rooms furnished with fine pictures, Reynolds responded by saying, "Yes . . . to *see walls decorated with thought.*"[99] This is a response provoked at least in part by the frequency with which paintings were referred to as mere "wall furniture" in the eighteenth century. In the letter to Barry in which he urges the young painter to avoid copying Italian paintings for his English patrons, Reynolds specifically cites "those ornamental pictures which the travelling gentlemen always bring home with them as furniture for their houses."[100] There is a prickliness

in this kind of remark that can easily be reconciled with the practical jokes Reynolds played on the painters and dealers who overestimated their connoisseurship or praised old master paintings at the expense of modern ones.[101]

Reynolds, however, could also go out of his way to patronize the "lesser arts" and by so doing raise their own professional status. We have already seen that he commissioned Charles Catton to paint his coach in what must have been a mutually aggrandizing arrangement, and he also wrote the advertisement for Anthony Poggi's exhibition of fan-painting in 1781, arguing that "none of the inferior arts are ever likely to be improved unless undertaken by men who may be said to be above them; such persons will infuse into those lower departments a style of elegance which will raise them far above their natural rank."[102] This is a process that is remarkably similar to Reynolds's own attempt to elevate portrait-painting by investing it with the formal and intellectual attributes of history-painting. At the end of the third discourse, Reynolds argued that if a painter is "obliged to descend lower, he will bring into the lower sphere of art a grandeur of composition and character, that will raise and ennoble his works far above their natural rank."[103] As Burke noted in his obituary, "In painting pourtraits, he appeard not to be raised upon that platform; but to descend to it from an higher sphere."[104]

And this process, as I have argued, was social and professional as well as artistic. Of those contemporaries who reflected on the social status of painting, only Benjamin West argued that Reynolds's strategy had limited success: "Artists stood, if possible, lower in the scale of society than actors; for Garrick had redeemed the profession of the latter from the degradation to which it had been consigned from the time of the Commonwealth; But Reynolds, although in high repute as a portrait painter, and affecting a gentlemanly liberality in the style of his living, was not so eminently before the public eye as to induce any change of the same consequence toward his profession."[105] There is certainly some truth to these remarks, especially if one considers how

many painters continued to struggle during the second half of the century.[106] But there is envy in West's voice as well, and the parallel with Garrick is one of which Reynolds himself was conscious. In the second of the imaginary conversations he fashioned around Johnson and his colleagues, Reynolds has his friend differentiate between Garrick's character and that of the mimic Samuel Foote: "We all know the difference of their reception in the world. No man, however high in rank or literature, but was proud to know Garrick and was glad to have him at his table. No man ever considered or treated Garrick as a player. He may be said to have stepped out of his own rank into a higher, and by raising himself he raised the rank of his profession."[107] I do not believe that Reynolds could have written these lines, which were probably composed at the very end of his career, without fully realizing how accurately they reflected his own social and professional accomplishments *and* the crucial reciprocity that bound them so closely together. The parallel with Garrick, moreover, extends beyond the table or the sitting room and into the studio itself.

THE OCTAGONAL ROOM

Reynolds moved to No. 47 Leicester Fields in 1760, paying £1650 for a forty-seven-year lease. It was a narrow house located on the west side of the square, but it boasted three floors above the ground floor and basement, and contained enough garden space in back to accommodate the expensive addition (costing another £1500) in which Reynolds and his assistants would work.[108] The modern extension that linked the first half-landing of the old house with the octagonal painting room beyond also served as the painter's picture gallery, in which were displayed not only examples of Reynolds's own work but also paintings drawn from his private collection. Reynolds's gallery was open to the public; aspiring artists sketched there, and prospective clients were offered the opportunity to evaluate the painter's skill and study the variety of his poses. It is probable, for example, that the young Boswell encountered

Reynolds's first portrait of Johnson in the painter's picture gallery before meeting either of the two men who would exert such an influence on his life.[109] In the painting room itself, moreover, Reynolds kept a portfolio "containing every print that had then been taken from his portraits; so that those who came to sit, had this collection to look over, and if they fixed on any particular attitude . . . he would repeat it precisely in point of drapery and position."[110]

The octagonal room in which Reynolds worked was sixteen feet wide and twenty feet long. Northcote tells us that the only source of natural light was a small square window located "nine feet four inches" from the floor.[111] Like Garrick's sitting room, Reynolds's studio was constructed with a panel door that disappeared from view when it was shut; it is also likely that the room concealed another door that enabled the painter to retreat to an outdoor privy, for he had a private staircase built that led directly from the studio to his garden. Northcote told Haydon that he could hear Reynolds "dart down and up again striding over 5 or 6 stairs at a time—anxious not to lose a moment."[112] The studio also contained a fireplace—the cause of an expensive visit from the local "fire-engine" when Reynolds carelessly flung spirits of turpentine into the fire—and was flanked by at least one storage room filled with rejected portraits, old pictures and plaster heads, and the downtrodden Northcote, who was allowed to paint there.[113]

We know that Reynolds worked at Streatham and that he painted his ambitious family portrait for the Duke of Marlborough while staying at Blenheim, but he clearly preferred to work each day in his own studio in Leicester Fields.[114] We unfortunately lack precise details about how the studio was furnished, and the retrospective vision of Margaret Dicksee's *Angelica Kauffmann Visiting Reynolds's Studio*, exhibited at the Royal Academy in 1892 (Figure 18), is surely idealizing if not fanciful.[115] We know that a large copy of Guido Reni's *St. Michael* hung from the ceiling.[116] Northcote speaks frequently of the elegance of the rooms Reynolds added to the house, and refers to the studio as "a commodious and elegant room for his sitters,"[117] which suggests—and I shall

return to this point later—that it served as a second sitting room, as a symbolic as well as a literal extension of the house to which it was joined. During the morning and the early afternoon, as the painter's sitters arrived for their hourly sessions, the studio functioned as a public, social space; it served as an artistic refuge for Reynolds only early in the mornings and on Sundays; in the late afternoon, after seeing as many as seven sitters (but usually only four or five), Reynolds would often take a nap before dining out or entertaining at home.[118]

Reynolds's sitters were often accompanied by their friends, but no one else was allowed to violate the social decorum of the studio. One of Reynolds's commentators has in fact pointed out the affinity between his studio and Richardson's prescription that "the painting-room must be like Eden before the fall; no joyless, turbulent passions must enter there."[119] A series of letters written by Elizabeth Montagu and William Pulteney, Earl of Bath, in December 1761 suggests both the sociable climate of the studio and the careful orchestration carried out by painter and sitter alike. Pulteney agrees to sit to Reynolds "either Wenesday or Saturday next which ever is most convenient to him, and shall be glad to meet Mr Tristram Shandy (as you call him[)], or Mr Stern, (as I must call him, there.[)]"[120] Armed with this information, Elizabeth Montagu immediately wrote in turn to another friend: "Will my Dear Mrs Vesey go with me to morrow at half an hour after one to Mr Reynolds where my Lord Bath is to sit for his picture, where ye facetious author of Tristram Shandy is to make him smile, & where you may see the historical picture in which the Muse of Tragedy & Comedy are disputing for Mr. Garrick?"[121] Elizabeth Montagu's letter suggests the rich assortment of attractions to be found in the painting room, for they will not only share the company of their common friends, Reynolds and the Earl of Bath, but will be entertained by the playful Sterne, whose portrait Reynolds had completed the previous year, and enjoy an examination of the "historical picture" of Garrick—another close friend. The facetious Sterne, moreover, will play an active role in determining how Pulteney will be portrayed (Figure 19), as a second

Extremely detailed accounts have also survived describing the ways in which Reynolds prepared his pigments, ordered them on his palette, and then applied them to the canvas.[130]

Of more interest to us are those recollections that augment our understanding of how Reynolds worked to capture a likeness during the precious minutes of each sitting. Lady Burlington's remarks are similar to those of the fourth Duchess of Rutland, who remembered how Reynolds had recourse to a mirror as well as to an extended view of his sitter: "he would rush forward, and look closely into her eyes, take her well in, and then go as far back as possible, and look at the general effect in a distant glass, chiefly making his picture from that."[131] Occasionally this mirror would be used to capture an unusual (and perhaps slightly distorted) view, as in Reynolds's work on the Nativity for New College, during which, Mason tells us, "three beautiful, young, female children, with their hair dishevelled, were placed under a large mirror, which hung angularly over their heads, and from the reflection in this, he was painting that charming group of angels which surrounded the Holy Infant."[132]

The mirror was normally employed, however, not to capture an unusual angle but to produce the "general effect" noted by the Duchess of Rutland and continually emphasized by Reynolds in the *Discourses* as he extolled the importance of general rather than particular nature.[133] Reynolds's frequent use of a mirror clearly pleased his sitters, especially Dr. James Beattie, who sat for an astonishing five-hour stretch during his first session in August 1773:

> he finished my head, and sketched out the rest of my figure. The likeness is most striking, and the execution most masterly. The figure is as large as life. The plan is not yet fixed for the rest of the picture. Though I sat five hours I was not in the least fatigued; for by placing a large mirror opposite to my face, Sir Joshua Reynolds put it into my power to see every stroke of his pencil; and I was greatly entertained to observe the progress of the work, and the easy and masterly manner of the artist, which differs as much from that of all the other painters I have seen at

letter from Pulteney to Elizabeth Montagu indicates: "I will most certainly be, at Mr Reynolds's, to mend my sickly look, and to sitt down in my Chair, as I think I should do; instead of being half standing. which Criticism of Mr Sternes, I think perfectly right. As for my looks I fear they will not be much mended, by any Physick of Mr Reynolds. He has made an old Man, look as if he was in pain, which an old Man generally is. & so far he is right."[122]

The painter's own friends were allowed to see him only between sittings (if then),[123] and we know from the poet William Mason, who was granted the privilege of watching Reynolds as he retouched paintings or sketched beggars and children, that "his man Ralph had orders to repel visitors, by saying that his master had then a sitter," even if he did not.[124] During the process of painting a portrait, Reynolds appears to have impressed his sitters with a sense of perpetual motion. Malone notes that he always stood while painting—"a practice which, I believe, he first introduced"[125]—and Lady Burlington recalled that "he took quite a quantity of exercise when he painted, for he continually walked backward and forward. His plan was to walk away several feet, then take a long look at me and the picture as we stood side by side, then rush up to the portrait and dash at it in a kind of fury. I sometimes thought he would make a mistake, and paint on me instead of the picture."[126] She did not much care for him, by the way: "he was *a very pompous little man.*"

The chair in which his subjects usually sat—which is preserved in the Royal Academy—was raised on a dais "eighteen inches from the floor, and turned round on castors," thus elevating the sitter above the painter and, in many cases, the viewer as well.[127] Because the chair is similar in design to a low stool that appears in several of Reynolds's portraits, it has been suggested that the extension to the house and all of its furnishings may have been designed by William Chambers, who later built Wick House in Richmond.[128] The painter's brushes were thought by Northcote to be fairly long ("about nineteen inches") and his palettes were held by their handles rather than on the thumb.[129]

work, as the execution of Giardini on the violin differs from that of a common fiddler.[134]

In reality, as Leslie quickly pointed out, Reynolds was simply painting from the reflection in his glass,[135] and one also wonders whether the painter would have warmed to Beattie's comparison of his own skills with those of a violinist. But the mirror (like the canvas that will eventually replace it) clearly emerges in this and other accounts as a common ground for artist and sitter alike, providing the painter with a second perspective while enabling his subjects to admire the "easy and masterly" process by which a work of art is created.

Northcote characteristically took a different view from Beattie's, for he understood how the very process of painting an *ad vivum* portrait could enable the sitter (often described by Northcote as the "employer") to gauge "the slow progress of the business" as well as the "frequent failure of the artist in his intentions." The artist's patrons can also, he adds, interfere with the painter's progress by offering their advice and directions, often believing themselves to be "as well qualified to judge in the affair as the painter himself." They see the emerging portrait "in all its stages of rude imperfection, all of which tend to degrade both the artist and his art in their estimation."[136] And it is in fact probable that, like other painters, Reynolds had recourse to the mirror not merely because it could be placed so as to provide a "general" view but because it functioned as a self-contained representational image that could be copied. Reynolds noted in his memoranda that one should "look at the object from which you are painting, with your eyelids half closed, which gives breadth to the object, and subdues all the little unimportant parts"—which is consistent with his belief in avoiding excessive particularity—but he also advised aspiring painters to "endeavour to look at the subject or sitter from which you are painting as if it was a picture; this will in some degree render it more easy to be copied."[137] When, for example, he was complimented on the extraordinary likeness of his portrait of the lawyer Joshua Sharpe,

Reynolds replied by saying that, because Sharpe "was remarkably still, it became a matter of no more difficulty than copying a barn or any object of still-life."[138]

Permitted to attend "every" sitting Lord Holderness had with Reynolds in 1755, Mason recorded nothing about the interplay of personalities in the studio during this early stage in the painter's career, but he did remember the painter's technique in some detail:

> On his light-colored canvas he had already laid a ground of white, where he meant to place the head, and which was still wet. He had nothing upon his palette but flake-white, lake, and black; and, without making any previous sketch or outline, he began with much celerity to scumble these pigments together, till he had produced, in less than an hour, a likeness sufficiently intelligible, yet withal, as might be expected, cold and pallid to the last degree.

Mason adds that there was a second sitting in which Reynolds introduced "Naples yellow," and a third, and that the finished portrait "turned out a striking likeness . . . which at all times bespoke a fashioned gentleman."[139] Northcote saw things somewhat differently, however: during a subject's first sitting, "the face was a beautiful cloud; everything was in its right place, certainly, but as soft as possible; indeed, they were often stronger likenesses in this state than ever afterwards," especially when the sitter was the elusive David Garrick.[140]

We also learn from Northcote that Reynolds always told his pupils, "as a good mode of study, that a painter should have two pictures in hand of precisely the same subject and design, and should work on them alternately."[141] We do not know how frequently Reynolds acted on his own advice, but the pronouncement is remarkable on its own terms. Northcote introduces Reynolds's statement in a discussion of *The Strawberry Girl*, which the artist "repeated" (rather than copied) several times for the sake of "improvement" (rather than "profit"). No painter could produce more than half a dozen truly original works

during his lifetime, Reynolds argued, "and that picture is one of mine." The repetition that produced several versions of *The Strawberry Girl* appears to be diachronic, whereas the practice Northcote remembers Reynolds urging upon his pupils is clearly synchronic: "if chance produced a lucky hit, as it often does, then, instead of working upon the same piece, and perhaps by that means destroy that beauty which chance had given, he should go to the other and improve upon that. Then return again to the first picture, which he might work upon without any fear of obliterating the excellence which chance had given it, having transposed it to the other."[142] This is an extraordinary notion (perhaps ill-suited to the exigencies of portrait-painting) in which two competing versions of the same subject conspire to build upon each other in an aesthetic drama played out before the painter's (and sitter's) eyes. It is possible, of course, that Reynolds's fascinating vision of how great portraits *might* be created—to which I shall return later in this chapter—may in fact mask his own dissatisfaction with the evolution of the single canvas to which we know he normally (always?) turned his attention. Northcote concludes his discussion by noting that "while he was engaged in painting a picture he never knew when to quit it, or leave off," always encouraged by the hope of improving it, but doomed (in the view of his apprentice) to lose the freshness of its initial rendering.

We know, moreover, not only that Reynolds was reluctant to abandon work on his paintings, but that he did not hesitate to retouch or repaint a canvas if the circumstances of his sitters changed. He finished his portrait of Offy in 1776, but revised his niece's hairstyle and dress five years later so they would look more becoming when she married.[143] The portrait of Malone, begun in 1778, took a long time to complete ("I think I did not in the whole sit for it less than twelve or fourteen times"), but was nevertheless repainted ten years later with similar alterations to the drapery and hair.[144] A request from the Duke of Rutland in 1786 to produce a copy of the portrait Reynolds had

painted ten years earlier of the Earl of Mansfield presented a slightly different dilemma, for Rutland wanted the same image, but he also wanted it painted from life:

> It is thought one of my best portraits [Reynolds told his patron], but he should have sat eight or ten years before; his countenance is much changed since he has lost his teeth. I have made him exactly what he is now, as if I was upon my oath to give the truth, the whole truth, and nothing but the truth. I think it necessary to treat great men with this reverence, though I really think his Lordship would not have been displeased if this strict adherence to truth had been dispensed with, and drawn a few years younger.[145]

The legalistic phrasing—perhaps prompted by Mansfield's position as Lord Chief Justice of the King's Bench—is worth pausing over, for it not only suggests the aesthetic latitude normally at Reynolds's command, but also echoes (or perhaps anticipates) the principles of verbal portraiture that he enunciated in his character sketch of Johnson. You will wonder, he told Boswell, "to hear a person who loved him so sincerely speak thus freely of his friend, but you must recollect I am not writing his panegyric, but as if upon oath not only to give the truth but the whole truth."[146] The implication—once again—is that the painter may be truthful without revealing everything that he sees or knows.

But how does one discover the truth of a sitter's character or circumstances when the prospective subject is known to the painter only by reputation, if at all? The answer I shall suggest here has already been adumbrated in the preceding chapters, in which we saw how Reynolds orchestrated his social and intellectual life in order to expand and sharpen what Malone called his "close study of the characters of men" and "the Delight he felt in considering Man under all his varieties."[147] Beattie, for example, not only sat to Reynolds for five hours during his first session at Leicester Fields, but also breakfasted with the painter before the sitting began.[148] The controversial James Macpherson sat to

Reynolds in April 1779, at least once staying for dinner.[149] Earlier, in 1775, Oldfield Bowles had wondered which of the two leading English painters of children—Reynolds or Romney—should portray his daughter Jane. Bowles was worried about the reputed tendency of Reynolds's canvases to deteriorate, but Sir George Beaumont convinced Bowles to "take the chance; even a faded picture from Reynolds will be the finest thing you have. Ask him to dine with you,—and let him become acquainted with her." According to Leslie, "the little girl was placed beside Sir Joshua at the dessert, where he amused her so much with stories and tricks that she thought him the most charming man in the world. He made her look at something distant from the table and stole her plate; then he pretended to look for it, then contrived it should come back to her without her knowing how. The next day she was delighted to be taken to his house, where she sat down with a face full of glee, the expression of which he caught at once and never lost."[150]

This appealing anecdote, slight as it is, introduces a number of elements that are crucial to our understanding of Reynolds's success. The story of Jane Bowles marks, in the first place, the transition from the table (or sitting room) to the studio; social success in one arena lays the necessary groundwork for artistic success in the other. At the same time, however, the octagonal painting room also emerges as a site of social activity; Jane Bowles—among others—sits down "with a face full of glee." The painter, moreover, is both the socially adept agent provocateur who charms the young girl into revealing herself at the table *and* the powerful artist who can capture these fleeting moments of delight and self-expression. Both of these processes, we should note, are acts of performance. In the eyes of a young child, "the most charming man in the world" is a "contriver," a conjuror, a magician: in the dining room he can make objects vanish and then mysteriously reappear; in the studio he can catch a transitory expression so that it is "never lost."

Why, then, did Oldfield Bowles decide to commission Reynolds—rather than Romney—to paint his daughter's picture (Figure 20)? Based

on the information inscribed in this solitary anecdote, we can be confident that his decision was *not* grounded in an increased knowledge of Reynolds's comparative skill with a brush and canvas, or in any reassurance Beaumont or others could give him that a portrait by Reynolds would indeed keep its freshness. The father's decision must have been based, instead, on what he learned as he ate his dessert. What, precisely, did he see? He witnessed a famous painter, relatively late in his career, take the time to meet him for dinner and eventually draw out his daughter by telling her stories and amusing her with tricks. Jane Bowles was delighted, and surely her father sensed that the painter was enjoying himself as well. He must also have grasped the logic of Beaumont's implicit proposition: that an artist capable of bringing out the best in his daughter at the table was—by extension—the most likely person to paint a memorable portrait of her (it will be "the finest thing you have"). His decision, in short, was predicated on Reynolds's social skills: on his patience, his willingness to take an interest in others, his charm, his good humor, and the sense of excitement his behavior at the table personified. His decision was *not* based on an assumption (or conclusion) that Reynolds was a socially "correct" painter; it was based, instead, on a compelling model of social interaction that the father surmised would be translated first to the studio and then to the portrait itself.

It was a decision based, in other words, on accommodation, provocation, power, and exchange. The painter must first accommodate himself to the wishes of his potential patron by performing at the table even before he enters into a contractual agreement. Leslie's wording is quite revealing here, for Beaumont is said to have advised Bowles to "ask him to dine with you,—and let him become acquainted with her." In actuality, however, this dinner was clearly intended to provide Bowles and his daughter with an opportunity to become acquainted with the painter, who will later, in turn, accommodate his patrons in a studio that incorporates the social dynamic of the sitting room. Reynolds's patrons pose for the painter in a familiar physical and social environ-

ment—familiar because its elegant furnishings replicate their own domestic spaces. Accompanied by their friends and surrounded by an impressive collection of old master paintings, the artist's sitters are meant to enjoy an atmosphere that is both comfortable for them and conducive to the enterprise of the portrait-painter, who is simultaneously their host and their contractual employee.

The most forceful way, then, of framing my argument about the painter in his studio is to insist that, in Reynolds's case, no fundamental difference existed between the octagonal painting room and all those other rooms in which his sitters spun out the days of their lives. The act of entering Reynolds's studio did not necessarily transform those who sat to him. It would be more accurate to say, in fact, that the painter's success in capturing a likeness (or, more ambitiously, in drawing out a sitter so that he or she would reveal more than lay on the surface) was based on precisely the comfort and familiarity these subjects felt when they spent an hour in Reynolds's company. And once they entered his domain, they were, to a significant degree, within his power. For those clients who were charmed by his magic tricks, impressed by his carriage, or enamored of his reputation, this intricate reversal in the dynamic between painter and sitter began before the sitting itself.

In virtually every case, moreover, the atmosphere in Reynolds's studio appears to have been collaborative rather than confrontational; there was clearly a common obligation to put one another at ease. And thus while we know that Reynolds frequently inveighed against painters who were "talkers," he appears to have singled out those artists who were simply too fond of interpreting (and presumably praising) their own paintings rather than getting on—silently—with their real work.[151] Great as his powers of concentration in the studio may have been, it is clear that he depended on his conversational gifts in order to distract his sitters and put them at ease; this is implicit, as we shall see, in his conviction that "the mind always desires to double, to entertain two objects at a time."[152] And we know of at least one case, involving the

creation of Reynolds's powerful portrait of Lord Heathfield, in which the sitter is said to have diverted the painter by relating "some curious narrative, or . . . droll anecdotes."[153]

Social amenities such as these manage to relieve the tedium inherent in the sitting itself, and thus dispel any disquieting sense the sitter may have that both the setting and the social exchange are not, in fact, simulacra of the world outside the studio. By inviting the world in—and by symbolically assuring his clients that they would find themselves in familiar territory—Reynolds was imitating one influential model of the preceding century, embodied by Van Dyck as he frequently entertained his sitters in his quarters in Blackfriars.[154] At the same time, however, Reynolds was clearly at odds with Rembrandt's practice in Amsterdam, where, as Svetlana Alpers has argued, the painter "saw to it that his patrons accommodated to his studio practices[.] . . . the image in which he casts his sitters is his own."[155] In Alpers's schema, Reynolds might best be thought of as one of Rembrandt's counters—a Ter Borch or Flinck—whose success was based on how directly they tied themselves to the social fabric of their patrons. Rembrandt's sitters, she suggests, "leave behind, outside the studio, their social position and are transformed." Most of Reynolds's sitters, I argue, find their social formations inscribed within the painter's house and studio. This does not mean, of course, that "transformation" cannot or does not take place; but when it does occur—as we shall later see—it must be accounted for in a fundamentally different way.

Jane Bowles, in any case, was transformed neither at the table nor in the painting room; Reynolds was simply—and not so simply—able to bring out the best in her both before and after the sittings themselves began. In many of the other surviving anecdotes that touch on life within the studio, however, we detect difficulties or unusual predicaments, often with an attendant breakdown in the authority or control of the painter. Given, for instance, Reynolds's notorious disinclination to work closely with his assistants or apprentices—let alone to take their advice—the following anecdote is all the more extraordinary. According

to Tom Taylor, the picture dealer Woodburn paid a visit to Reynolds's studio when he was a boy of thirteen or fourteen:

> Observing that the boy looked at the head [of a portrait] keenly, and finding that he knew the original, Reynolds asked him if he thought it like. "Yes, Sir; but you have not given the face colour enough." Sir Joshua examined the picture a moment, then said, "You are right, my boy"; and proceeded to scumble some dry vermilion into the "tacky" colour on the cheeks. "That's enough! Stop! Stop!" cried young Woodburn, when he saw the carnation brought up to his notion of what it should be. Sir Joshua stopped, and turning to the lad, who was blushing at his own forwardness, repeated, smilingly, "Quite right, my boy; quite right."[156]

Many of these interruptions, however, appear to have been troublesome either to the painter or to his sitters. The "late unfortunate Queen of Denmark," Northcote tells us, was painted soon before her departure from England, but the portrait was difficult to execute because the "unhappy princess, at the times of her sitting for the portrait, was generally in tears, as if impressed with a presentiment of her future misfortunes."[157] Or the painter himself could discompose his audience—and hence his composition. Reynolds took such quantities of snuff, for example, that he "frequently inconvenienced those sitters who were not addicted to it: so that by sneezing they much deranged their positions, and often totally destroyed expressions which might never return."[158]

The potential for "derangement" in the studio was even greater when the subject was an actor. While sitting to Reynolds—and presumably as a way of amusing him—Garrick related how he had once sat to an "indifferent" painter (possibly Hogarth)

> whom he wantonly teazed; for when the artist had worked on the face till he had drawn it very correctly as he saw it at that time, Garrick caught an opportunity, whilst the painter was not looking at him, totally to change his countenance and expression, when the poor painter patiently

worked on to alter the picture, and make it like what he then saw; and when Garrick perceived that it was thus altered, he seized another opportunity, and changed his countenance to a third character, which, when the poor tantalized artist perceived, he, in a great rage, threw down his pallet and pencils on the floor, saying, he believed he was painting from the devil, and would do no more to the picture.[159]

We might think of Garrick as playing a mischievous Reynolds to our indifferent painter's Jane Bowles. The obliging Mary Ann Yates, on the other hand, who preceded Sarah Siddons as the reigning tragic muse of the London stage, told Reynolds that "I always endeavour to keep the same expression and countenance when I sit to you, Sir; and, therefore, I generally direct my thoughts to one and the same subject."[160]

An obliging attitude, yes, but also an insistence on attitude itself—on the firmly determined and defended pose. Reynolds often found himself on rich creative ground, however, before the posing had begun and after it had ceased. "Stop," he is said to have cautioned Mrs. Moore, "as, turning from his easel on her entrance into his painting-room, he saw a striking effect of half-shadow on the face, from the flat Woffington hat intercepting the high light of the studio window." As she stood just beyond the doorway, Leslie tells us, "her face half light, half shadow, he had put a clean canvas on the easel, and was rapidly laying in the masses of the portrait."[161] Or here is Reynolds himself, commenting on a sitting with an unnamed nobleman whom he caught admiring an old master painting on the wall of his studio:

whilst I had the honor of drawing his portrait, [he] could not keep from turning his eyes from me, and fixing them on this picture in raptures, with such an expression in his countenance as may be imagined from a man of his tender feelings. I snatched the moment, and drew him, as he then appeared to me, in profile, with as much of that expression of a pleasing melancholy as my capacity enabled me to hit off; when the picture was finished, he liked it, and particularly for that expression, though I believe without reflecting on the occasion of it.[162]

"I snatched the moment": the painter's spontaneous decision is itself an imaginative response to the spontaneity he senses in his sitter's absorbed attitude and "tender feelings." It is also, we might add, the temporal equivalent in the studio of the crucial moment to be captured and expressed in narrative painting. "The Sublime impresses the mind at once with one great idea," Reynolds wrote in the *Discourses:* "it is a single blow." [163]

It is often this very lack of control, moreover, that produces the adventitious circumstances the perceptive painter must forcefully seize; and it is no accident, I would argue, that we so often find Reynolds hurriedly improvising in the company of children. Here is Northcote on the genesis of *The Children in the Wood:*

> when the Beggar Infant, who was sitting to him for some other picture, during the sitting fell asleep, Reynolds was so pleased with the innocence of the object, that he would not disturb its repose to go on with the picture on which he was engaged, but took up a fresh canvas, and quickly painted the child's head as it lay before it moved; and as the infant altered its position, still in sleep, he sketched another view of its head on the same canvas. He afterwards finished a back ground of a woody scenery, and by adding the robin red-breast converted it into the subject of the Children in the Wood. [164]

Even recalcitrance or terror could be redeemed. The Duke of Bedford's younger brother, Lord William, appears in their family portrait crouching before a "property dragon," whereas in fact the young boy "had a horror of being painted, and crouched down, half in defiance, half in distrust, of Sir Joshua, in a corner of his painting-room. 'Stay as you are, my little fellow,' said Sir Joshua, and at once transferred the boy's action and expression to the canvas." [165] A similar story has attached itself to the frightened pose of young Lady Anne in the great portrait of the Duke of Marlborough's family at Blenheim: in the painting the four-year-old shrinks from a mask with which an older

sister threatens her (Figure 21); in the studio she shrank from the painter himself.[166]

These strong improvisational skills characterize Reynolds within his painting room no less than they do a playful Garrick in the sitter's chair. The artist's momentary loss of control emerges, in his own imaginative hands, as an opportunity to "snatch the moment" and, in many cases, to break an otherwise rigid social mold. His subjects become his witting or unwitting collaborators in a performance that is acted out both in the studio and on the canvas. When Northcote tells us about the tearful Queen of Denmark—"the execution of this picture was attended with considerable embarrassment, in respect to making it a pleasant performance"—we cannot help noticing the slippage in his language, for the "execution" or "performance" he speaks of is surely a *process* as well as the finished portrait itself. The fact that Reynolds designed his painting room in shrewd imitation of the social world that lay beyond made it no less a carefully contrived stage and the painter himself no less skillful a theatrical manager. Reynolds's passion for the theater needs to be documented, for it provided him, I shall argue, with a way of comprehending the intensely social nature of his work as a painter of portraits and with a means of expressing the dialectical tensions he glimpsed in himself and those around him.

The Studio and the Stage

PORTRAITURE AND PERFORMANCE

Reynolds once told Boswell and Johnson that he "took the altitude of a man's taste by his stories and his wit, and of his understanding by the remarks which he repeated." When he wished to know the "real character" of a man, however, he looked most closely at his "amusements."[1] I have already examined several of Reynolds's own amusements with some care, particularly his love of cards and the obvious delight he took in entertaining. "Everybody has their taste," he wrote to Boswell; "I love the correspondence of *viva voce* over a bottle with a great deal of noise and a great deal of nonsense."[2] Like Boswell, he also nurtured a life-long passion for the theater: for actors, for plays and their authors, for the vivacity and excitement of the green room, for benefits and first nights, for rehearsals and private theatricals, for the intrigue and spectacle of the masquerade.

If Garrick was a close friend, so too were "Mrs. Morris," Elizabeth Hartley, Frances Abington, and Sarah Siddons (all of whom he painted, as he also did Foote and Barry, Sheridan and Goldsmith, Harry Woodward and Mary Ann Yates). He is said to have purchased forty tickets for Frances Abington's benefit performance in March 1775. Johnson himself was among Reynolds's guests, but Boswell reveals that their host

never made it to the theater: "Sir Joshua himself dined with so many sea-officers, Mediterranean friends as he called them; and I suppose they had drank like fishes, for he did not appear at the play, when he should have been at our head."[3] The production of Goldsmith's *She Stoops to Conquer* at Covent Garden in 1773 enabled the painter to attend a rehearsal for the first time, accompanied by his sister Frances and Arthur Murphy; George Colman, the manager, was a close friend as well.[4] Three years later he joined his friends in applauding Garrick's final performances of his most famous roles: Archer, Benedick, Sir John Brute, Don Felix, Kitely, Abel Drugger, and Lear. He was so moved by this last performance, he told Hannah More, that "it was full three days before he got the better of it."[5] In spite of his friendship with Sarah Siddons, however, he confessed that her performances did not make him *"feel."*[6]

Both masquerades and private theatricals provided Reynolds with entertainment of a different kind, for both carried the act of performance out of the theater and into private hands. The painter attended a number of masquerades, appearing at one, in 1772, in domino, the least dramatic of possible costumes—neutral, detached, noncommunicative—but no less intriguing for its silences.[7] Reynolds was also in attendance at the first performance of the Duke of Richmond's private company in 1787. The audience was limited to eighty, and the cast included many of Reynolds's friends in both the male and female roles of *The Way to Keep Him.*[8]

Reynolds's devotion to the theater was not unusual. In vowing to attend each opening and benefit night for Sarah Siddons, for example, he was himself acting in a fairly conventional (if gallant) way. He diverged from his colleagues, however, not just in his professional interest in portraying the leading figures of the London stage, but in the seriousness with which he thought about plays and the nature of theatrical performance. He wrote (as we shall see) a critical essay on Shakespeare. He annotated several of Shakespeare's plays, and kept a commonplace book in which he copied out passages that were of particular interest

to him.[9] In his thirteenth discourse, he proposed a parallel between painting and the theater in his discussion of naturalism in the arts. Although he concedes that it is "a delicate and hazardous thing" to apply the principles of one art to another, he nevertheless argues that it is the "great end" of each of the arts of representation to "make an impression on the imagination and the feeling."[10] The true test of all the arts, he concludes, "is not solely whether the production is a true copy of nature, but whether it answers the end of art, which is to produce a pleasing effect upon the mind."[11] In his examples, moreover, he carefully focuses on the psychological environment of the theater itself, noting that allowances must be granted for the actual site in which the play is acted, the surrounding company, the candles that have been lit, the visible shifting of scenes, and the (unusual) language of blank verse.[12] In acting as in painting, the most "natural" representation (in the crude and fierce expression of violent passion, for instance) may not immediately—or finally—be the most convincing.

Reynolds's knowledge and interest in the theater were so extensive that Sarah Siddons came to rely upon his advice and assistance. We know, for example, that he advised her in the selection of her costumes, and that the dress she wore during Lady Macbeth's sleepwalking scene was of his design.[13] It is only a step, moreover, from active participation in the creation of a theatrical role to a remarkably similar form of activity within the studio itself. Reynolds's sitters often wore their own clothing in his portraits, but he also possessed his own wardrobe of costumes and was not reluctant to ask his sitters to try them on. The Duchess of Rutland complained that Reynolds made her try on eleven different dresses before he painted her in a simple, classicizing costume which she referred to as "that bedgown."[14]

Both within the studio and without we therefore find the painter functioning as stage manager or director: defining the setting, establishing the appropriate pose and choosing the most suitable costume, rehearsing with his subject as sitting follows sitting, and occasionally (as we have seen) capturing spontaneous gestures and attitudes before

they entirely disappear. This activity was, as I have already argued, collaborative in nature, with painter and sitter accommodating each other as they strived to reach common ground. Both the sittings and the finished portrait reflect the contractual basis of their agreement; and the painting that emerges is therefore always—among the many other things it is—a record of this transaction, a record of the personal and artistic encounter that produced it. The painter is thus inscribed within each of the portraits he completes. Because of the way in which he has established his practice and constructed his studio, and because of the collaborative nature of the sitting itself, each of Reynolds's portraits is—by extension—a portrait of the painter in society. As we study each picture, we replicate the painter's own encounter with his sitter, no matter how brief, uncomfortable, artificial, or unsatisfactory it may have been. The relationship between the artist and sitter recorded in the portrait, I would argue, has the capacity to suggest as strongly as any other feature the character of the individual who has been portrayed.

This collaborative view of portraiture has been expressed forcefully (if somewhat fancifully) by Hazlitt in a little-known essay entitled "On Sitting for One's Picture." The "bond of connexion" between painter and sitter, Hazlitt proposes, is most like the relationship between two lovers: "they are always thinking and talking of the same thing, the picture, in which their self-love finds an equal counter-part." As artist and subject reinforce and kindle each other's ardor, nothing is wanting, Hazlitt writes, "to improve and carry to its height the amicable understanding and mutual satisfaction and good-will subsisting between these two persons, so happily occupied with each other!" The tone of this playful essay is characteristically ambivalent, for Hazlitt needs to isolate the vanity of the artist and of the sitter while simultaneously acknowledging the benefits that arise from it. There is a "conscious vanity" in portraiture, he concedes, but "vanity is the *aurum potabile* in all our pleasures, the true *elixir* of human life." Hazlitt clearly has Reynolds in mind as he pursues his argument, and later in the essay

he introduces a flamboyant set-piece in which Sir Joshua's glittering clientele join him in celebrating their "secret and sufficient tie in interest and vanity." And because Reynolds provided his guests with an environment that put them at ease ("it was a rule with Sir Joshua that from the moment the [sitter] entered, he was at home—the room belonged to him"), his hospitality, his social skills, enabled him to assume "a new character" with a "double claim to confidence and respect." [15]

The collaborative nature of such a theory of portraiture sheds light on the agreements, the contractual understandings, that Reynolds did—and did not—make with his prospective sitters. Both of the examples I shall cite involve a Mr. Gardiner, and both date from the same period in Reynolds's career. Mr. William Gardiner wrote to Reynolds from Richmond in May 1774:

Sir

Having been so fortunate as to make Two Astronomical Discoveries, which will probably incline Posterity to wish for a lively Resemblance of me, I would willingly avail myself of your masterly Pencil to gratify them therein.

If you should incline to become my *Magnus Apollo* in this Attempt, I will communicate to you the Way and Means I would recommend to make the Portrait acceptable, by the Introduction of Machinery, of which I can furnish you with great Choice.

My feeble State of Health will not permit me to sit to you in London, so if you should accede to my Proposal, I hope it will prove agreable to you to take the Face here, upon your next Retreat to our little *Alps*.—I shall be attending to know your Pleasure in due Season, and am with Regard

Sir

Yr. most obedt. Servt——[16]

When Charles James Fox asked to have specific parliamentary bills included in the portrait Reynolds was completing of him, the great politician requested these "trifles" with both politeness and charm. [17] He

knew that he was exposing his own vanity to the painter, and that he was placing himself under obligation to his friend. Our pompous astronomer in Richmond, on the other hand, who may have met Reynolds during the painter's visits to Wick House, undermined his peremptory request paragraph by paragraph: first, by drawing attention to his own importance; then by dictating his own terms; and finally by demanding that the sittings take place outside Reynolds's studio. The portrait, as one might guess, was never painted.

A year earlier the Right Honorable Luke Gardiner, M.P. for County Dublin, asked Reynolds if he would "compose a picture" of his fiancée, Elizabeth Montgomery, with her two sisters, the Viscountess Townshend and the Hon. Mrs. Beresford. Gardiner approached the painter in a letter that combines compliment and challenge in a masterly way. He wishes "to have their portraits together at full length, representing some emblematical or historical subject"; but the idea and attitudes that best suit their forms "cannot be so well imagined as by one who has so eminently distinguished himself by his genius and poetic invention." The superior beauty of these women will in itself convey "a degree of instruction" to the painter, and the three sisters, for their part, will devote themselves to the sittings, for they, too, hold a high opinion of Reynolds's powers. The painter, he concludes, will acquire the honor of "conveying to posterity the resemblances of three sisters so distinguished for different species of beauty." By making the portrait "perfect," Reynolds will place a "great obligation" on the fiancé who commissions it.[18]

Gardiner's beautifully balanced sentences, with their equal measure of flattery and graceful assertion, perfectly express—as we shall see in the following chapter—the reciprocal relationship that Reynolds worked so hard to build with his patrons. As one might guess, Gardiner's proposition touched a sympathetic chord, and we find Reynolds responding not only by painting one of his most visually and intellectually ambitious pictures, *Three Ladies Adorning a Term of Hymen* (Figure 22),[19] but by replying to Gardiner in an equally graceful

manner. He thanks him for the "agreeable employment" in which he has been engaged, "and likewise for the very obliging manner in which this favour was conferred." The particular subject chosen by Reynolds and his sitters will enable him to introduce "a variety of graceful historical attitudes." In short, he has every inducement to "exert myself on this occasion, both from the confidence you have placed in me, and from the subjects you have presented to me, which are such as I am never likely to meet with again as long as I live, and I flatter myself that, however inferior the picture may be to what I wish it, or what it ought, it will be the best picture I ever painted."[20] Hazlitt's insistence on the mutual, "sufficient tie in interest and vanity" between painter and sitter could hardly be better illustrated than in this exchange of letters and in the agreement and painting it produced.

A cynical reading of Hazlitt's theory of portraiture might in fact suggest that it is conspiratorial rather than merely collaborative,[21] but we need to remember that Hazlitt conceives of successful portraiture as revelation (including self-revelation) rather than concealment. Having one's picture painted, he argues, "is like the creation of another self"; even a sitter's minute inquiries about himself during the vicissitudes (or boredom) of a sitting "may be supposed to take an indirect and laudable method of arriving at self-knowledge."[22] To find oneself posed in a certain way, within a particular setting, in juxtaposition to another person—let alone *as* someone else or embodying abstract qualities—is to see oneself anew. Portraiture enables one to stand outside oneself, to test one's own conception of self against that of a sympathetic interpreter; and this is a process (I want to insist) crucial to the negotiations and sittings themselves as well as to one's final confrontation with the finished portrait.

By focusing so intently on the social matrix of portraiture, on the dynamics of the sitting, on Reynolds's predilection for collaboration rather than confrontation, I have been elaborating a *transactional* view of portrait-painting, a view that examines the image as a record not just of the broad social pressures that inform a particular historical

moment, but of the individual agreements and encounters between painter and sitter as well. I have explored the collaborative nature of Reynolds's portraiture within the context of theater, moreover, because of the importance of performance in the painter's conception of the artistic process (and, indeed, in the presentation of self in everyday life). Svetlana Alpers has attempted to show how deeply ingrained various notions of performance were in Rembrandt's enterprise: in the act of applying paint, in the artist's interest in outward display, in his theatrical poses for self-portraits, in his penchant for problematizing personification or role-playing, in the rehearsal of scenes within the workshop (which she cannot document), and in his possible (tenuous, I think) relationship to the theater. Rembrandt "got at 'real' life," she concludes, "by attending to the acting of it in the studio."[23] This is surely true, but I cannot think of a successful portrait-painter to whom this formulation would not apply in one degree or another.

In referring to what Alpers calls "the theatrical model," and in surveying Reynolds's actual relationship to the theater of his day, I do not simply want to suggest that the stage provides us with a way of interpreting life within the studio. I am more concerned with what David Marshall has called "the theater that exists outside the playhouse: the theatrical relations formed between people who face each other from the positions of actor and spectator."[24] Essential to such a definition is an acknowledgment that theater shares with other forms of aesthetic and social behavior a basis in performance—but performance defined in broad rather than restrictive, theatrical terms. Performance is not what distinguishes theater from other discursive practices, but what it shares with them. Reynolds was not intrigued and excited by the contemporary theater simply because it was *different* (although it could be), but because, in its performative nature, it disclosed remarkable affinities with his own enterprise. Portraiture diverges from other forms of painting for a variety of reasons, but not least because it is grounded in performance: in the social interchange between painter and sitter, in

the construction (and reconstruction) of roles, and in the action of painting itself—a process (as we have seen) that is closely monitored by subject and painter alike.

I therefore propose a conception of performance that is not limited by a theatrical model. In Richard Schechner's definition, for example, performance is "restored behavior." Performance means "never for the first time. It means: for the second to the *n*th time. Performance is 'twice-behaved behavior.' "[25] With few exceptions, painting and the other representational arts do not show "actual behavior as it is being behaved"—not, at least, in portraiture that is contractual in nature. They are a record or re-enactment, instead, of behavior that has been repeated, rehearsed, restored. In Schechner's terms, many (sometimes most) of our actions are twice-behaved, consciously and unconsciously repeated or rehearsed, thereby forming a continuum extending from ritual (in which there is little scope for deviation) to what he calls "the lots-of-choice of aesthetic theater." Like theater, portraiture allows great room for choice: on the part of the painter, on the part of the sitter, and ideally—in Reynolds's practice—in their collaborative play. Like theater, portraiture presents a re-enactment of behavior: behavior agreed upon by Reynolds and his sitters, rehearsed together, and finally captured—frozen, polished—on the canvas itself. Reynolds's portrait of the Montgomery sisters exemplifies this process. In the agreements and rehearsals that are inscribed within it, the painting represents what Schechner calls a " 'ritual by contract': fixed behavior that everyone participating agrees to do."[26]

Spontaneous behavior, behavior that has not yet been repeated, is therefore all the more unusual; but the very act of capturing it—when the painter asks a sitter to hold or repeat an unexpected pose, for instance—restores it and thereby makes it a conscious, twice-behaved gesture. Mary Ann Yates's declaration ("I always endeavour to keep the same expression and countenance when I sit to you, Sir; and, therefore, I generally direct my thoughts to one and the same subject")[27] should

therefore be seen not as unusual but as paradigmatic, for portraiture in Reynolds's studio was predicated on the repetition of what was familiar and the rehearsal of what was new.

Hazlitt sensed the dramatic nature of the late Georgian sitting when he confessed that he was "as anxious to make good a certain idea I have of myself, as if I were playing a part on the stage."[28] The artist, of course, plays a role as well: not just as director or stage manager, building the scene, but in the execution of the painting itself as he skillfully combines the individual moments of restored behavior. And it is Reynolds's performance, finally, that will be most critically scrutinized as the act of portraiture proceeds from the semi-privacy of sittings and rehearsals to the public domain of the exhibition room and the reproductive print.

THE GENIUS OF LIFE

Conceptualizing performance as restored behavior reminds us that the self can act "in" or "as" another. "The social or transindividual self is a role or set of roles," Schechner observes (echoing, in his own way, the pioneering work of Erving Goffman and Richard Sennett).[29] "Symbolic and reflexive behavior is the hardening into theater of social, religious, aesthetic, medical, and educational process." Reynolds acknowledged as much when he turned to the theater to explain how desirable qualities might become ingrained, might become "second nature." Under the heading "Speaking of Plays" he copied out the following unidentified passage into one of his commonplace books: "To read and get by heart the comic and tragic poets makes a man eloquent in his speech & stile, we acquire a gracefull manner of speaking and acting in publick, we throw aside the boyish fears and discard the clownish bashfullness[,] we accustom ourselves to a distinct clear manner of speaking[,] a courtly and gracefull gesture."[30] These are the elements of self-fashioning—of the performing self—in a relatively rudimentary form (a matter of superficial manners, of "polishing"); but the degree of self-consciousness disclosed in this passage is entirely con-

sistent with Reynolds's own reflections on what a painter must know both about himself and about others.

In the seventh discourse, which is largely devoted to a discussion of taste, Reynolds argues that "every man whose business is description" ought to be acquainted "with that part of philosophy which gives an insight into human nature, and relates to the manners, characters, passions, and affections. He ought to know *something* concerning the mind, as well as a great *deal* concerning the body of man."[31] Circling back to this subject later in his lecture—and armed with a firm belief in the uniform nature of men—Reynolds states that "a knowledge of the disposition and character of the human mind can be acquired only by experience: a great deal will be learned, I admit, by a habit of examining what passes in our bosoms, what are our own motives of action, and of what kind of sentiments we are conscious on any occasion." And then, with a spirited twist to a common maxim, he concludes by claiming that, "as he who does not know himself does not know others, so it may be said with equal truth, that he who does not know others, knows himself but very imperfectly."[32]

What, then, is the nature of man? Reynolds's most direct statement on this subject occurs not in the *Discourses* but in an essay on Shakespeare that he left unfinished and unpublished during his lifetime. Much of what Reynolds says about Shakespeare is consistent with what Johnson had written in the preface to his edition as many as fifteen years earlier, but Reynolds returns to particular subjects—especially the justification of tragicomedy—as if he had to work out a specific argument to his own satisfaction. Shakespeare is warranted in mixing his serious with his comic characters because man is "what he is," Reynolds argues, "an inconsistent being, a professed lover of art and nature, of order, of regularity, and of variety, and who therefore cannot long continue his attention without some recreation; hence it is that the poet relieves the mind of the reader, professedly by episodes, and in a more private manner by similes and illustrations, with which he proceeds so far that it would be open to ridicule but for this reason of variety."[33]

The desire to experience a "pure" form of tragedy, divorced from anything that would divert us, would be attainable only if we were "endued with perfect wisdom and taste. But that is not the case. We are governed by our passions as well as our reason." Man is both a consistent and an inconsistent being, he continues: "a lover of art when it imitates nature and of nature when it imitates art, of uniformity and of variety, a creature of habit that loves novelty." Critics, he points out, depict man as "too uniformly wise, and in their rules make no account for the playful part of the mind."[34]

In the following paragraph, as Reynolds proceeds to explore this "playful part of the mind" in more detail, we begin to sense the restlessness the painter sees in himself and, by extension, in others.

> The mind appears to me of that nature and construction that it requires being employed on two things in order that it may do one thing well. Perhaps this disposition proceeds from the mind having always been accustomed to do many things at once, as in reading and writing, in which, from long habit, the operation of the mind comes to be no operation, or at least not perceptible. This double operation, which it has been so long accustomed to, begins at last to be a thing necessary, and required even, in affairs where a man would wish the whole powers of his mind to concentrate. Hence I would infer that that simplicity which is so much boasted in the ancient drama, or in whatever works of imagination, is even not natural to the mind of man. If I was to judge from my own experience, the mind always desires to double, to entertain two objects at a time.[35]

Robert Moore, the only scholar to comment on this remarkable passage, sees this description of the workings of the mind as an example of the artist's mental habit of generalizing and particularizing at the same time.[36] This may be true, but it is an interpretation that leads us to the question of characterization—of how subjects are to be represented—rather than toward a conception of character that would determine the appropriateness of particular forms of representation.

Reynolds's argument here and in the preceding passages is actually two-fold. Man is fundamentally an inconsistent being because he is torn between his reason and his passions; much as he may attempt to "regulate" and "guard" himself, he is always vulnerable to old habits and fresh desires. But Reynolds endows this traditional view of man with renewed force by associating it with the tensions that play upon the human mind at all times and in the most minute ways: the mind desires "to double," to entertain two objects at once. This is a description of how the mind works, however, not an analysis of why it works in this particular way. Johnson, who investigated these problems with great care throughout the 1750s, argued that the mind ranges back in memory and forward in anticipation because it is always dissatisfied with the vacuity of life held out by the present moment. Reynolds offers a perhaps less penetrating answer, but he too realizes that man is a lover of both regularity and variety, a creature who "cannot long continue his attention without some recreation."

Similar statements about the nature of the human mind are dispersed throughout Reynolds's miscellaneous jottings, even if they did not find their way into the *Discourses*. In a fragment that may have been associated with the composition of the fourth discourse, for example, Reynolds writes that "Shaftsbury says men have too [sic] minds—they have too minds to be pleased . . . The mind has two qualities, or two different modes of receiving pleasure," one approaching the divine just as the other approaches sensuality.[37] And works of art, he adds, are always addressed to "one or the other of those passions." Another short note, this one intended to elucidate Lear's final speech in the fifth act of Shakespeare's play, illustrates Reynolds's belief that the mind can entertain two objects even in the most painful of circumstances. Lear's reference to his poor fool's being hanged had been interpreted by Malone and Steevens as a reference to Cordelia, but Reynolds maintained that it was a stroke of genius ("or of nature") on Shakespeare's part to have this "good-natured, passionate, and rather weak old man" bestow a thought on his fool at a time when he himself was in still

greater distress.[38] A third fragment, entitled "On Prejudice," reinforces Reynolds's cautionary statements about the conflict between reason and passion (or, as he will reformulate it elsewhere, between principles and habits): "In forming the understanding and judgment to acquire the character of what is called a right-headed man, perhaps no part of our conduct is more necessary to be watched and attended than our prejudices, the difficulty lying in distinguishing between those which are to be eradicated and those which ought to be received with respect and reverence."[39] It is precisely this power of distinguishing between salutary and vicious prejudices "that makes what may truly be called the genius of life." The man who lacks this ability, "which is above all rules, is a wrong-headed man, whatever powers of argument he may possess to prove that he acts from reason and (as he is likely to say himself) is superior to vulgar prejudices."

Scattered observations such as these do not in themselves, of course, constitute a coherent and formal theory of character, but taken together they do suggest something of the seriousness and care with which Reynolds approached the question of human behavior. Theory itself, Reynolds insisted, has its limitations. In the essay on Shakespeare he wrote that "theoretical systems appear to have a great propensity to separate in theory what is inseparable in nature," and the example he cites is man's inability to "separate his intellectual from his sensual desires."[40] It is therefore not surprising that when Reynolds began to write the first of his three verbal portraits (a character sketch of Garrick), he not only pointed out the contradictions inherent in human character, but also argued that these very complications afford the portraitist his most promising materials:

> Those only are the favorite characters of a biographer in which are united qualities which seem incompatible with each other, which appear impossible to exist together at the same time and in the same person. The writer reigns here and revels. An opportunity is presented to him of displaying his sagacity and those nicer powers of discriminating between

things which to an ordinary observer appear to have no marks of distinction, as well as of reconciling seeming contradictions.[41]

Here we see what Reynolds calls "the genius of life"—the ability to discriminate between, and thereby reconcile, one's conflicting prejudices and desires—applied to the act of biography itself, which must interpret both the subtle and the strikingly paradoxical marks of human character.

Reynolds's fascination with apparent contradictions, his interest in exploring the warfare between fixed principles and inferior habits and prejudices, also characterizes his verbal portraits of Garrick and Johnson. The sketch of Garrick is extremely brief—a bare two pages—but in his few remarks Reynolds manages to strike at the heart of his friend's public success and private failings. Once again he scrutinizes a pattern of behavior that, as in Goldsmith's life, had its roots in his subject's early development: "Garrick from his early youth, when he used to repeat passages in plays and act whole parts in private theatres, naturally imbibed a desire for popular applause. Afterwards, when he entered the great world and had enlarged his circle, this universal passion was not likely to be much abated."[42] But the qualities that made Garrick such a consummate artist on the stage undermined his relations with close friends, for here too he left nothing to chance, "had too much the same habit of preparing himself, as if he was to act a principal part."

Reynolds dispassionately observes that it was difficult to woo Garrick to one's table and just as difficult to keep him there: "He never came into company but with a plot how to get out of it." Unlike Goldsmith, Garrick understood his own powers only too well and consequently "made himself a slave to his reputation." The strict "rules" by which he governed himself in public and his habit of seeking fame made him unfit for the cultivation of private friendship. Worse, Reynolds argues, this passion for fame, "however proper when within due bounds as a link in the social chain, as a spur to our exertions to acquire and deserve

the affections of our brethren, yet when this passion is carried to excess, like every other excess it becomes a vice, either ridiculous, or odious, or sometimes criminal."[43] By degrees, he sadly comments, every principle of right or wrong, "whatever dignifies human nature, is lost, or not attended to when in competition with the shadow of fame." At the conclusion of this brief sketch, Garrick loses his own individuality as Reynolds points the moral to his tale: "From having no great general principle they live in perpetual anxiety what conduct to take on every occasion to insure this petty praise."[44]

In each of his brief verbal sketches (of Garrick, Goldsmith, and Johnson) Reynolds strives for moral evenhandedness and biographical proportion, qualities that can be seen even more clearly in the artful construction of his two Johnsonian dialogues. The format of each imaginary conversation is the same: the subject is human greatness, the example is David Garrick, and the principal—if somewhat reluctant—speaker is Johnson, who knew Garrick longer, and perhaps more thoroughly, than any of the actor's other friends. Reynolds serves as Johnson's verbal combatant in the first dialogue, Edward Gibbon in the second; in each case, however, the friend who attempts to draw Johnson out (or lead him on) receives a serious drubbing. Alluding to Reynolds's deafness, Johnson suggests that "you may not have understood me; you misapprehended me; you may not have heard me."[45] Even the voluminous Gibbon is cut off in mid-sentence:

GIBBON. I don't understand—
JOHNSON. Sir, I can't help that.[46]

But the reasons behind these harsh replies are quite different. In the first dialogue, Johnson is coaxed into conversation only with difficulty, for the initial subject is predestination and free will, and the very mention of Garrick in this solemn context elicits Johnson's chariest evaluation of his old friend. In the following conversation, however, which is four times as long as its counterpart, Gibbon emerges as Garrick's

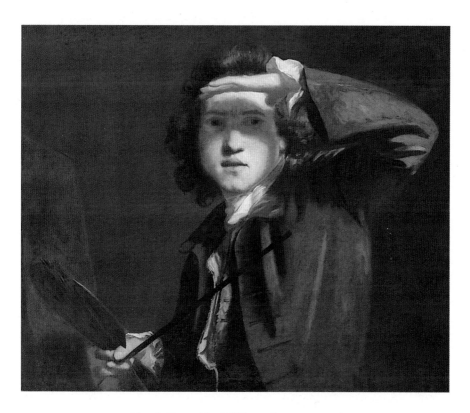

Plate I. Reynolds, *Self-Portrait,* c. 1747–1748.

Plate II. Angelica Kauffman, *Joshua Reynolds*, 1767.

Plate III. Gilbert Stuart, *Sir Joshua Reynolds,* 1784.

Plate IV. Reynolds's court suit.

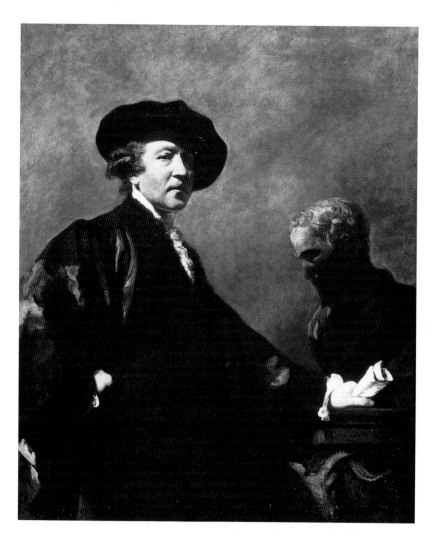

Plate V. Reynolds, *Self-Portrait*, 1780.

Plate VI. Reynolds's "Venetian and glass" Chinese cabinet.

Plate VII. A tureen and a plate from Reynolds's Chinese Lowestoft dinner service.

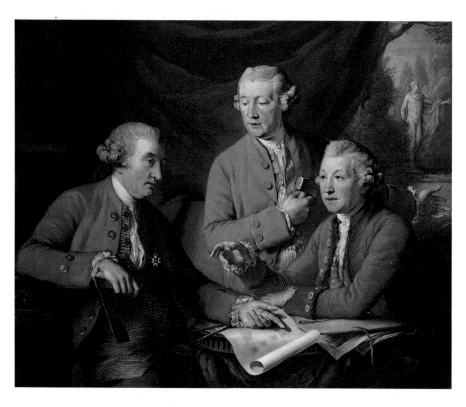

Plate VIII. John Francis Rigaud, *Sir William Chambers, Joseph Wilton,
and Sir Joshua Reynolds,* 1782.

detractor and Johnson as his champion. Having dismissed all common conceptions of greatness and Garrick's tenuous claims to them in the first dialogue, Johnson must now both redefine the various meanings of that word and then show how well Garrick—let alone other men— could measure up to them. Johnson emerges in both dialogues as a formidable and stubborn opponent, but by proportioning the conversations as he does, Reynolds reveals the warmth and generosity of his friend without concealing his peculiarities.

We should not be surprised, moreover, to discover that the consistency between Reynolds's character sketches and the imaginary dialogues extends not only to his portrayal of Johnson but to Johnson's assessment of Garrick as well. Both conversations are filled with echoes of phrases and entire judgments that Reynolds had used elsewhere, but it is to his credit as a writer that these opinions emerge only as the result of a skillful dialectic. When Johnson distinguishes between Garrick's habits and principles, when he examines the causes that produced both his virtues and his failings, when he states that "Garrick left nothing to chance" or that "Garrick, no more than another man, could unite what, in their natures, are incompatible," we feel that Reynolds has earned his conclusions even though he has placed them in his protagonist's mouth.[47] Even after his death Garrick provoked strong reactions among those who understood what a complicated person he had been. The very format of Reynolds's dialogues reinforces the contradictions in Garrick's character, while also revealing the equally complex nature of those who attempted to sort these contradictions out.

These dialogues are not only *about* actors and acting, moreover; their very structure endows them with dramatic force. Like a painted portrait, a dialogue posits what Hazlitt called "another self." As David Marshall has pointed out in his study of Shaftesbury, a dialogue is "a reflection, representation, and enactment of the act of self-division through which an identity is established."[48] Reynolds remembered Shaftesbury's remark that "men have too minds—they have too minds to be pleased." Marshall draws our attention to a similar passage, one that

characterizes the form of the dialogue even as it articulates a theory of identity: the ancient Greeks, Shaftesbury remarked, admonished us to "recognize yourself; which was as much as to say, divide yourself, or be two."[49] Marshall argues that the dramatic method of the dialogue "both forms the fundamental structure of the search for self-knowledge and itself undermines any stable or fixed notion of the self,"[50] an observation that is consistent with Reynolds's fascination with the complicated, divided self in his paintings as well as in his sketches and imaginary conversations.

The humor and intelligence of Reynolds's dialogues demonstrate how keen an observer the painter was when he forsook his studio for the company of his friends. Despite his well-known deafness, these sketches show him to have been a good listener, especially in the surroundings he found most congenial. This was the dramatic scene he relished most, where men and women who respected each other's abilities spoke their own minds freely. According to Hannah More, these dialogues were uncannily accurate: "Dear Sir Joshua, even with his inimitable pencil, never drew more interesting, more resembling portraits. I hear them all speak, I see every action, every gesture which accompanied every word. I hear the deep-toned and indignant accents of our friend Johnson; I hear the affected periods of Gibbon; the natural, the easy, the friendly, the elegant language, the polished sarcasm, softened with the sweet temper, of Sir Joshua."[51] But these imaginary conversations are not important merely because they provide an accurate imitation of how the members of this extraordinary group sounded to each other; Reynolds is more ambitious than this. In a revealing passage in the second dialogue, Johnson extols Garrick's abilities as an actor by comparing him with the mimic Samuel Foote. Foote went out of himself, Johnson argues, "but without going into another man." Garrick, however, not only could produce an exact imitation of the voice and gestures of his original, but could also exhibit "the mind and mode of thinking of the person imitated."[52] This is Johnson's greatest praise of the actor's art, delivered within a sketch that dem-

onstrates just how well Reynolds understood the complexities of verbal as well as visual portraiture.

DIVIDED SELVES

When Reynolds wrote that "the habits of my profession unluckily extend to the consideration of so much only of character as lies on the surface, as is expressed in the lineaments of the countenance," he was expressing an opinion that we must consider rather carefully, even if we make allowances for its modesty and politeness. Similarly, when Johnson argued in Reynolds's tendentious first dialogue that "I have often lamented how dangerous it is to investigate and to discriminate character, to men who have no discriminative powers,"[53] he encapsulated a view that might be applied to much of the portrait-painting of the age in which he lived. Of the hundreds and hundreds of canvases that Reynolds painted, the majority are inevitably portraits in which likeness and appropriateness of representation (of characterization) are more important than the careful discrimination of character. A significant part of Reynolds's reputation will always rest on the suppleness and dexterity with which he captured and molded the appearance of the influential men and women of his generation. A serious attempt to delineate character, to disclose its complexities and explore "the genius of life," could easily be at odds with the primary function of public, commemorative portraiture, even when the process was collaborative in nature. And we should not forget that Reynolds's speculations on human character appear in essentially private sources—unpublished, often unfinished, usually focused on his own character or on those men whose characters he knew best. Armed with these cautions, we can nevertheless turn to a fairly wide range of paintings in which Reynolds's exploration of the complexities of human character and behavior can be reconciled with his practice as an artist.

One of Reynolds's most famous paintings, the portrait of *Garrick between Tragedy and Comedy* (Figure 23), provides perhaps the most

vivid reminder of the artist's fascination with the divided self. Commentators from Horace Walpole to Erwin Panofsky have recognized the painting's affinity with the visual and verbal motif of "The Choice of Hercules," in which the central figure must decide between the stern figure of Virtue or the seductive path of Vice. As Walpole noted, Tragedy "exhorts him to follow her exalted vocation, but Comedy drags him away, and he seems to yield willingly, though endeavoring to excuse himself, and pleading that he is forced. Tragedy is a good antique figure, but wants more dignity in the expression of her face. Comedy is a beautiful and winning girl."[54] More recent criticism, however, has focused on the implied rather than the explicit subject of the portrait. Ellis Waterhouse noticed that the figure of Comedy is painted in the manner of Correggio and Tragedy in the style of Guido Reni, an opposition that not only accentuates the directions in which Garrick is torn but also suggests the choice Reynolds himself was forced to make between intimate and heroic portraiture.[55] Garrick's dilemma (which must also be read as a triumph) is thus Reynolds's as well, for both artists were successful in each of the genres at which they tried their hand. The brilliance of Reynolds's portrait therefore lies not merely in the playful tension between the pose of these three figures and the classical motif they evoke—in which Garrick's Herculean elevation is also a witty comment on modern heroism—but also in Reynolds's ability to introduce the opposing figures of Comedy and Tragedy within the same frame and paint them in pictorial styles that are both different and yet complementary. Reynolds's portrait of Garrick is no less complex than the character he chooses to paint; it serves as a fitting tribute to Garrick because it is serious and comical at the same time, a pictorial approximation of the dramatic tragicomedy that Reynolds attempted to justify in his own writings.

David Mannings summarizes the relation between Garrick and Reynolds quite eloquently when he argues that "this picture is about conflicts that take place and decisions that must be taken at the deepest and most secret levels of creativity."[56] This is surely true, but Reynolds's

concise character sketch of Garrick suggests that many of the misgivings Reynolds harbored about Garrick as a private character, as the man behind the dramatic mask, can also be sensed in this compelling portrait. Like several other commentators, Mannings is uncomfortable with the traditional association of *Garrick between Tragedy and Comedy* with "The Choice of Hercules"—an association recently reinvigorated, however, by the work of Martin Postle[57]—and he therefore introduces other visual analogues (Reni's *Lot and his Daughters* and Rubens's *Triumph of Silenus*) to explain the precise configuration in Reynolds's painting. Garrick is indeed pictured "between" Tragedy and Comedy, Mannings notes, but there is no choice to be made: his body is already turned in the direction of Walpole's "beautiful and winning girl," and his facial expression and outstretched hands communicate an apologetic but inevitable denial to the regally painted figure of Tragedy on the right of the canvas. But this is not a bacchanalian procession in the manner of Rubens, I would argue, nor is Garrick (like Lot) manipulated in one direction by the other figure in the painting. Garrick is genuinely torn between these two women, but the scene is essentially one of seduction and imminent departure. The actor is about to be carried away by the force of Comedy, an uncanny prophecy Garrick would eventually verify by choosing, after prolonged indecision, to play a comic role in his last performance on the London stage.[58]

Reynolds handles this indecisiveness with great dexterity. Robert Moore has argued, for instance, that Garrick is "the master of both ladies," and Ronald Paulson has acutely noted that the actor's preeminence in both tragedy and comedy made no choice possible or even necessary.[59] These observations are consistent with Garrick's status as an actor, but they are actually at odds with the dilemma Reynolds depicts in this portrait. In the painting itself Garrick is—for the moment—master of neither lady; lacking the very control of which he was thought to be master, he attempts to make the most graceful exit he can manage under the circumstances. We may wish to read the expression on Garrick's face as one of genuine regret, but we must also

remember that Garrick "left nothing to chance. Every attitude, however it might have the appearance of immediate impulse, was the result of various trials in his closet."[60] The situation in which Reynolds places him is therefore entirely consonant with the painter's depiction of his private character: "Amongst the variety of arts observed by his friends to preserve [his] reputation, one of them was to make himself rare. It was difficult to get him and when you had him, as difficult to keep him. He never came into company but with a plot how to get out of it. He was forever receiving messages of his being wanted in another place. It was a rule with him never to leave any company saturated."[61] This in itself might be excusable—the stuff of comedy—but Reynolds also knew that "An inordinate desire after fame produces an entire neglect of their old friends, or we may rather say they never have any friends; their whole desire and ambition is centered in extending their reputation by showing their tricks before fresh new men."[62] And what Reynolds accused Garrick of in his private life, others would attack in his professional career. A caricature appearing in 1772 and modeled on the structure of *Garrick between Tragedy and Comedy* (Figure 24) reveals the actor torn between traditional dramatic values on the left—represented by both Comedy *and* Tragedy—and stage mechanics on the right, who will enable Garrick to present the newest farces, spectacles, and pantomimes. Manuscripts labeled "Shakespeare," "Jonson," and "Rowe," meanwhile, are trampled beneath the wavering Garrick's feet.[63]

In painting *Garrick between Tragedy and Comedy,* Reynolds is unlikely to have worried that Garrick "seems to yield willingly" to Comedy, as Walpole put it, nor can it be argued that the painter had Garrick's private failings uppermost in his mind. Even with its comic undertones, this portrait was surely conceived of and executed by Reynolds as an act of celebration and ennoblement—and in this regard it is as characteristic as any of the painter's heroicizing images of his military or aristocratic patrons. But this does not preclude us from examining the painting within the broader contextual understanding of Garrick that Reynolds—as both writer and painter—has established.

What I find most intriguing about this complex portrait, in fact, is the extent to which the very terms in which Garrick is praised for his professional talents are consistent with a much darker reading of his private character. As the caricature will later make clear in a rather crude way, the central tableau of the painting can also be read against itself and ultimately subverted: the painting confirms what Reynolds maintained about Garrick on several occasions, that the characteristics that made him a great actor undercut his value as a friend. His studied appearance and unquenchable thirst for fame made him forfeit "what is truly praiseworthy, steadiness of conduct."[64] Even the beautiful and appealing portrait of *Garrick Reading to His Wife* (Figure 25) depicts a husband awaiting the judgment of his spouse as she appears to concentrate on the lines he has just read. There can be little doubt that Reynolds admired Garrick and that he understood the extent to which both he and his friend were forced to make difficult artistic choices. But his ambitious portrait takes as its subject not only the self-consciousness and divided loyalties that Reynolds sensed in the characters of most people, but the more specific situation in which a person in pursuit of fame lives "in perpetual anxiety what conduct to take on every occasion to insure this petty praise."[65]

Reynolds's *Garrick between Tragedy and Comedy* is not, strictly speaking, a theatrical portrait. It represents, in fact, one of the exceedingly rare instances in which Reynolds resorted to composite portraiture to depict a *male* sitter in the guise of someone else (an exception presumably sanctioned by Garrick's career as a player, as a professional impersonator of others). Reynolds painted at least two other portraits of Garrick—one in the character of Kitely in *Every Man in His Humour* and later an intimate portrait for Henry Thrale's library at Streatham—and in 1772 he was said to be contemplating a multiple portrait of the actor that would "show him as himself, in the center, surrounded by fifteen other Garricks in the costume of some of the most remarkable characters he has played."[66] This is, at best, a problematical description of the proposed portrait, for Reynolds could reveal Garrick "as himself"

only in relation to the "other Garricks" that surround (or inhabit) him; and it is precisely from the interplay among these various images that such a portrait would generate its dramatic charge.

It is natural for us to consider the relation between the dramatic character portrayed and the character of the actor, for portraiture can, like drama itself, reveal the figure behind the mask. This is literally and figuratively the case in Reynolds's portrait of Harry Woodward (Figure 26), an actor in Garrick's company best known for his comic roles in Shakespeare (hence his "Van Dyck" dress). Portraits such as this—and Reynolds painted many of them—perform a double role by commemorating a specific performance for the sitter's immediate audience and by introducing a particular actor to posthumous viewers in an activity associated with his or her profession. But the essential interest we take in this kind of portrait lies in the act of unveiling, a gesture that asks us to study the man or woman who is normally hidden behind the mask or within the theatrical costume. Reynolds's portrait of Woodward forces us to think once again of the difference between public and private roles and of the personal qualities that make these successful impersonations possible.

It is clear from the second of Reynolds's Johnsonian dialogues, moreover, that he diverged from the mainstream of English theatrical discourse by considering both acting and painting to be creative activities in which the artist did not relinquish control of his or her own emotions.[67] As we have seen, Reynolds's Johnson distinguishes between Garrick and Foote by arguing that his friend could go "into another man," but he later clarifies this assertion by refuting Gibbon's statement that Garrick's sensibility, his fine feelings, made him the great actor he was:

JOHNSON. This is all cant, fit only for kitchen-wenches and chambermaids. Garrick's trade was to represent passion, not to feel it. Ask Reynolds whether he felt the distress of Count Ugolino when he drew it.
GIBBON. But surely he feels the passion at the moment he is representing it.

JOHNSON. About as much as Punch feels.[68]

Johnson's view of acting, disclosed within Reynolds's own dialogue, is consistent with Diderot's famous paradox of the actor, which posits a "dual consciousness" that enables the successful player to register and express emotion without actually feeling it.[69] (It should also remind us of Reynolds's interest in how the mind "desires to double," to entertain two objects at the same time.) But Johnson's argument, with its disarming glance at Reynolds himself, also reaffirms a traditional view of art as representation rather than expression in a way that draws attention once again to the discrepancy between private lives and public roles, even if in Garrick's case the two were, as Reynolds believed, tragically confused.

"Theatrical" portraiture in its many forms might best be thought of not as a special kind of portraiture, something to be categorized apart from the stock-in-trade of traditional portrait-painting, but as paradigmatic of what all successful portraiture embodies.[70] Portraits associated with the theater, in other words, explicitly state what is implicitly at stake in all forms of portraiture: the performative nature of the sitting, the collaborative (or confrontational) relationship between subject and painter, and the tension between appearance (likeness) and what lies concealed (or can be disclosed) beneath the surfaces of everyday life. In Reynolds's splendid *Mrs. Siddons as the Tragic Muse,* for example (Figure 27), the painter's friend appears to us as a fully recognizable figure, but she is also portrayed "out of herself" as she takes on the more ambitious role of the tragic muse. According to the actor, this was a pose that she and Reynolds carefully worked out in concert with each other:

> In tribute to his triumphant Genius I cannot but remark his instantaneus decission on the attitude and expression. In short, it was in the twinkling of an eye.
> When I attended him for the first sitting, after many more gratifying

encomiums than I dare repeat, he took me by the hand, saying, "Ascend your undisputed throne, and graciously bestow upon me some grand Idea of the Tragick Muse." I walkd up the steps & seated myself instantly in the attitude in which She now appears. This idea satisfyd him so well that he, without one moments hesitation, determined not to alter it.[71]

It is highly doubtful, of course, that Reynolds made an "instantaneus" decision to depict Sarah Siddons in this particular role; Romney had painted Mary Ann Yates as the tragic muse ten years earlier, and Sarah Siddons had already been praised in a poem bearing this exact title.[72] Sarah Siddons's insistence throughout this passage on the unhesitating and even effortless manner in which both painter and sitter determined and then realized this pose, however, reinforces the impression she wishes to produce here, which is that it was both appropriate and natural for her to be cast as the tragic muse. Her version of the sitting, in other words, provides further substantiation for the claims this painting makes on her behalf, and it simultaneously compliments Reynolds as well. The painter, generous with his "gratifying encomiums," takes the actor by the hand and seats her on her throne, elevating her in the studio just as he will symbolically elevate her in the painting by crowning her as the "undisputed" queen of the English stage. And by elevating Sarah Siddons, he is in effect elevating his own art of impersonation and representation as well. His famous remark about the placement of his signature on this canvas—"I have resolved to go down to posterity upon the hem of *your* Garment"—is both a compliment to Sarah Siddons and an implicit affirmation of the importance of his own work.

If we had only Sarah Siddons's account of its genesis, we would be forced to view Reynolds's painting as the record of a remarkably close collaboration of kindred spirits. It is possible, of course, that she did indeed seat herself "instantly" in the attitude of the tragic muse, but on another occasion she told the painter Thomas Phillips that the unusual pose "was the production of pure accident": "Sir Joshua had

begun the head and figure in a different view; but while he was occupied in the preparation of some colour she changed her position to look at a picture hanging on the wall of the room. When he looked at her, and saw the action she had assumed, he requested her not to move; and thus arose the beautiful and expressive figure we now see in the picture."[73] A third version of this sitting, related by Samuel Rogers, affirms the accidental nature of Sarah Siddons's pose, but provides a different explanation for it: "I was at Sir Joshua's studio when Mrs. Siddons came in, having walked rapidly to be in time for her appointment. She threw herself, out of breath, into an armchair; having taken off her bonnet and dropped her head upon her left hand—the other hand drooping over the arm of the chair. Suddenly lifting her head she said, 'How shall I sit?' 'Just as you are,' said Sir Joshua, and so she is painted."[74]

These conflicting accounts of the composition of *Mrs. Siddons as the Tragic Muse*—which range from the mundane and the adventitious to the self-aggrandizing and the inevitable (or, in Michael Fried's influential terms, from absorption to theatricality)—nicely mirror the tension Reynolds depicted in the painting itself between the actual historical figure and the more idealized character under which she is subsumed. Samuel Rogers's insistence on the accidental determination of the pose may undercut some of Sarah Siddons's rather extravagant claims in her first version of the sitting, but it nevertheless pays tribute to Reynolds's ability to discern the ideal in the actual, to take advantage of the accidents that nature produces. Reynolds drew attention to this very situation later in the same year when he delivered his twelfth discourse: "It is better to possess the model with the attitude you require, than to place him with your own hands: by this means it happens often that the model puts himself in an action superior to your own imagination. It is a great matter to be in the way of accident, and to be watchful and ready to take advantage of it."[75] A painting may serve as the record of artistic collaboration, but it may also, of course, serve as the record of a sitting in which the drama is of a very different kind: not collaboration, but experimentation; not the effortless realization of

a predetermined idea, but the imaginative transformation of the accidental into an unexpectedly more appropriate image.

Of the three explanations that have survived, Sarah Siddons's second version of her sitting to Sir Joshua is finally the most intriguing, for it suggests that the pose she accidentally assumed was superior to the position in which the artist had initially placed her. Reynolds immediately sensed the appropriateness of the altered pose because his sitter was *naturally* absorbed in the activity of viewing a painting on the wall of his studio, and this is precisely the impression he wished to convey of the tragic muse herself in his finished portrait. In this version of the story, the drama enacted within Reynolds's studio is identical to that pictured in the painting that serves as the idealized record of it, and it is therefore fitting that the object of the actor's absorption should itself be a painting.[76] The power of the image on the wall produces an effect that no amount of rehearsing within the studio could achieve. In this account, at least, the power of painting is commensurate with the dramatic power to which Reynolds's portrait of Sarah Siddons pays tribute.

The relation between image and beholder represents Reynolds's most ambitious and sophisticated attempt to embody in his painting the conflicts and discrepancies that he found rooted in human character. In the portraits considered so far, I have confined myself to the conflicts or tensions inherent in the image itself: Garrick's pose, or the play between an actor's face and his discarded mask, or the canvas as a record of the process that produces it. The implicit relationship between Garrick and Hercules, however, turns the table on us as viewers. The tensions and conflicts that we previously detected in the visual text have now been extended to the process of interpretation; as viewers, we are necessarily implicated in the complexities of representation. In Reynolds's hands, composite portraiture demands that we "entertain two objects at the same time," that we produce a literate response to the image we contemplate by comparing it to a prototype with which it is visually or verbally associated. For the portrait of *Garrick between Tragedy and Comedy* we must construct an equation that will enable us

to measure the relation between Garrick and Hercules, Tragedy and Virtue, Comedy and Vice. In viewing borrowed attitudes, we must perform that "double operation" which Reynolds described in his essay on Shakespeare. This phenomenon of "seeing double" can be illustrated most clearly in Reynolds's humorous portrait of *Cupid as Link Boy* (Figure 28), which is a composite portrait in a literal sense because it actually merges the figure of Cupid with that of a contemporary child. The urchin's wings allow us to see both Cupid as a link boy and the link boy as a modern-day cupid, carrying his phallic torch to light the way for lovers (as well as prostitutes and their clients) through the darkened streets of London.

Reynolds's extensive use of visual allusion eventually earned him a reputation as a plagiarist, but Walpole argued that these borrowed attitudes were a witty form of quotation. "A quotation from a great author," he wrote, "with a novel application of the sense, has always been allowed to be an instance of parts and taste; and may have more merit than the original,"[77] an opinion that Reynolds affirmed in the *Discourses* when he stated that "what is taken from a model, though the first idea may have been suggested by another, you have a just right to consider as your own property."[78] In his portrait of *Master Crewe as Henry VIII* (Figure 29), for example, Reynolds has "appropriated" Holbein's portrayal of the king to suit his own purposes. "Is not there humour and satire," Walpole continued, "in Sir Joshua's reducing Holbein's swaggering and colossal haughtiness of Henry VIII, to the boyish jollity of Master Crewe?" There is diminishment here, to be sure; even the boy's denomination as "Master" Crewe reminds us of how much his title, like the iconic image of the king, has deteriorated with the passage of time. But the painting does not exert its comical sway over us merely by building upon discrepancy; there is a certain appropriateness here as well. Reynolds's allusion suggests that, if there is a measure of the tyrant in the boy, so there is also an element of boyishness in the tyrant. The child's costume and pose enable us to see his character in a new light, or at least to sense more vividly the self-satisfaction and budding

imperiousness that he shares with other boys of similar age and social standing. As the dog in the lower left-hand corner of the painting suggests, this portrait works by a process of defamiliarization: just as the dog must sniff the boy's leg to make sure that this is indeed his master, so we too must sort out the congruence or discrepancy implicit in this double image. The delighted boy, moreover, is himself unconscious of the dilemma he has provoked.[79] Here, as in all of Reynolds's composite portraits, the suggestion of tension or conflict has been transferred from the subject of the painting to its beholder. To signify this reversal, the dog on the right turns his head in our direction as if to ask what all the fuss is about. Any sense of incongruity or witty analogy remains ours alone.

Patrons and Politics

THE GREAT SYSTEM

It might be argued that Reynolds was born to be patronized. This, at least, is how Malone interpreted a story handed down in the painter's family. Joshua was the seventh of eleven children, and his father, Samuel, "had a notion, that it might at some future period of life be an advantage to a child to bear an uncommon christian name, which might recommend him to the attention and kindness of some persons bearing the same name, who, if he should happen to have no natural object of his care, might be led even by so slight a circumstance to become a benefactor."[1] Northcote finds this to be an improbable story, virtually "unworthy of notice," but he implicitly draws the same conclusion as he strives to be more "minutely particular."[2] Reynolds, we learn, was baptized after an uncle of the same name who lived in Exeter. The Rev. Joshua Reynolds, Fellow and Bursar of Corpus Christi College, Oxford, and Rector of Stoke Charity, Hampshire, served as the infant's godfather and did, in fact, take a serious interest in Reynolds's welfare, leaving him a bequest of £330.[3] In giving their son an unusual first name, Reynolds's parents were thus already forging alliances for him, laying the groundwork for future support.

Reynolds would in turn perform similar acts of generosity for his

own younger relatives. When he wrote to his nephew William Johnson in Calcutta in 1781, moreover, he offered him this shrewd piece of advice: "To make it peoples interest to advance you, that their business will be better done by you than by any other person, is the only solid foundation of hope, the rest is accident."[4] Reynolds characteristically advised his nephew to work hard, to aspire toward "superior knowledge," and to make a "usefull man" of himself; but he also acknowledged the degree of calculation—even of manipulation—necessary to ensure that it was in the best interest of others to promote one's own interests. Patronage was therefore normally a reciprocal relationship for Reynolds, who understood its dispensations both as benefactor and as recipient, and who surely recognized the mutual self-aggrandizement of painter and sitter inscribed within the forms of portraiture he most successfully practiced.

English artists continued to depend upon patronage of various kinds even as their nation evolved from a client to a market economy. Looking back to the days of Sir James Thornhill, Northcote noted how disorganized painting was as a profession and concluded that "he who had the greatest acquaintance, whatever were his abilities, was sure to get the most money."[5] Reynolds was fortunate in finding support within two distinct communities, both of them based in his native West Country. The first was a society of artists. As Northcote boasted in his life of Reynolds, "the county of Devon has produced more painters than any other county in England,"[6] and thus when the young painter arrived in London he not only was apprenticed to Hudson, but soon joined a virtual fraternity of Devonshire artists (Francis Hayman, Richard Cosway, Ozias Humphry, John Opie, and eventually Northcote himself).

The second coterie was social and aristocratic. As a young boy Reynolds became close friends with Richard Edgcumbe, who also drew and painted,[7] and it was Richard's father, Lord Edgcumbe, who "persuaded many of the first nobility to sit to [Reynolds] for their pictures" after he returned from Rome.[8] Richard Edgcumbe was the common

friend of Reynolds and Horace Walpole, who treated the painter as his social equal.[9] It was through the Edgcumbes that Reynolds met the Dukes of Devonshire and Grafton, both of whom he painted, as well as, years earlier, Commodore Augustus Keppel, through whose generosity the young painter was able to sail to Gibraltar and eventually on to Italy. Keppel remained Reynolds's life-long patron and close friend. Reynolds painted him at least seven times, and when Keppel—now an admiral and a viscount—was acquitted during a court-martial in 1779, Reynolds wrote him a letter overbrimming with pride and joy: "Amidst the rejoicing of your friends, I cannot resist offering my congratulations for the complete victory you have gained over your enemies. We talk of nothing but your heroic conduct."[10] Reynolds sealed his happiness by having William Doughty immediately produce a large mezzotint from one of his portraits of Keppel (Figure 30), an act of congratulation (and circulation) benefiting subject, artist, and engraver alike.[11]

Reynolds's relationship with Keppel is worth pausing over, not least because his famous portrait of the Commodore, dramatically picturing him against a tumultuous sea, was generally thought by his contemporaries to signal the beginning of his ascendancy among English painters. Among other things, their relationship is paradigmatic of how often, and how easily, patronage and friendship would become intertwined during Reynolds's career. Northcote tells us that during the voyage to the Mediterranean Keppel treated Reynolds "in all respects as a brother."[12] Here is how, in an appreciative letter to his original patron, Lord Edgcumbe, Reynolds himself interpreted Keppel's behavior:

> Your Lordship will excuse me if I say, that from the kind treatment and great civilities I have received from the Commodore, I fear I have even laid your Lordship under obligations to him upon my account; since from nothing but your Lordship's recommendation [could I] possibly expect to meet with that polite behaviour with which I have always been treated: I had the use of his cabin and his study of books as if they had been my own; and when he went ashore, he generally took me with him;

so that I not only had an opportunity of seeing a great deal, but I saw it with all the advantages as if I had travelled as his equal.[13]

Reynolds's friendship with Keppel led to similar relationships with his two sisters, one of whom became the Marchioness of Tavistock; and it was through the Keppels that Reynolds met the Duke of Cumberland, whom he painted in 1755.[14] These important ties, forged so early, held him in good stead throughout his career, often producing a ripple effect in polite society as one introduction, one commission, led to yet another.[15]

We have already seen, in the previous chapters, how carefully and skillfully Reynolds wove his course through the labyrinth of social and professional decorum in eighteenth-century England. His affable reply to criticism from the Earl of Carlisle needs to be balanced against his curt response to Lord Holland, who offended the painter by asking him how long it took to execute a portrait.[16] I believe that Reynolds strongly shared what has been called Edmund Burke's "ambivalence" toward the hierarchical structures his own work—and that of Reynolds—supported.[17] And yet, like Burke, he chafed at the embarrassing abuses, at the misuse of aristocratic privilege, rather than at the system itself. What he wrote of the "submission," the "deference" we owe to others in the seventh discourse could justifiably be extended far beyond questions of aesthetic judgment and taste. A man who thinks that he is "guarding himself against prejudices by resisting the authority of others," he writes, "leaves open every avenue to singularity, vanity, self-conceit, obstinacy, and many other vices, all tending to warp the judgment, and prevent the natural operation of his faculties."[18] He would have understood Burke's wish to "preserve morem majorum" (our ancestral traditions)[19] as well as Johnson's insistence on the duty of maintaining subordination of rank: "Sir, I would no more deprive a nobleman of his respect, than of his money. I consider myself as acting a part in the great system of society, and I do to others as I would have them to do to me. I would behave to a nobleman as I should expect he would

behave to me, were I a nobleman and he Sam. Johnson."[20] Without "fixed invariable rules for the distinction of rank," Johnson concludes, "there would be a perpetual struggle for precedence."

It was, in fact, Reynolds's ability to think for himself in polite society that first captured Johnson's attention and convinced him that the young painter was worth getting to know. Reynolds and Johnson were introduced to each other in the house of the two Miss Cotterells, who were regretting the death of a friend "to whom they owed great obligations." Reynolds responded by observing that "you have, however, the comfort of being relieved from a burthen of gratitude." His reply shocked his genteel friends, who found it "too selfish; but Johnson defended it in his clear and forcible manner," Boswell tells us, "and was much pleased with the *mind*, the fair view of human nature, which it exhibited, like some of the reflections of Rochefoucault. The consequence was, that he went home with Reynolds, and supped with him."[21] Not to be eclipsed by Reynolds's independence at the Miss Cotterells', Johnson managed on another occasion to offend his hostesses when he believed they were paying too much attention to the Duchess of Argyll and another noblewoman and not enough to him: "resolving to shock their supposed pride, by making their great visiters imagine that his friend and he were low indeed, he addressed himself in a loud tone to Mr. Reynolds, saying, 'How much do you think you and I could get in a week, if we were to *work as hard* as we could?'—as if they had been common mechanicks."[22] To Northcote, who retails both of these stories from Boswell, Johnson's behavior reveals "pride, envy, and vulgarity," all completely at variance with Reynolds's disposition; but Northcote is nonetheless sensitive to the issues of obligation, deference, and patronage that are at play here. An unwillingness to be obligated to others proceeds from a dignity of soul: "A virtuous reverence of ourselves is the foundation of respect from others." And yet such independence can easily "swell into deformity." To determine, like Johnson, "to go through life, and to resist all patronage whatsoever, may indicate a proud and unsocial spirit!"[23]

A painter of portraits may be proud, but he cannot, in Reynolds's or Northcote's world, be unsociable.[24] The painter's nineteenth-century biographers were struck by how quickly his sitters became his friends, especially at such an early stage in his career,[25] but Hazlitt, of course, had already examined the common bond that drew the painter and his subject together. Here is his great set-piece on the social texture of life within the studio:

> Sir Joshua must have had a fine time of it with his sitters. Lords, ladies, generals, authors, opera-singers, musicians, the learned and the polite, besieged his doors, and found an unfailing welcome. What a rustling of silks! What a fluttering of flounces and brocades! What a cloud of powder and perfumes! What a flow of periwigs! What an exchange of civilities and of titles! What a recognition of old friendships, and an introduction of new acquaintance and sitters. It must, I think, be allowed that this is the only mode in which genius can form a legitimate union with wealth and fashion.[26]

Hazlitt, as we have already seen, sensed "a secret and sufficient tie in interest and vanity" between painter and sitter. "The lady of quality, the courtier, and the artist, meet and shake hands on this common ground." The painter, moreover, exercises what Hazlitt calls "a sort of natural jurisdiction and dictatorial power over the pretensions of the first to external beauty and accomplishment, which produces a mild sense and tone of equality."

The Hazlitt of *The Plain Speaker* exaggerates, of course, but his theory of portraiture, which is at once theatrical and social, helps to explain the *edge* the painter often held in the social dynamic of the sitting. In conversation with Hazlitt, Northcote went out of his way to insist that, while Reynolds's manners were indeed affable and obliging, "he flattered nobody; and instead of gossiping or making it his study to amuse his sitters, minded only his own business." As an index of the painter's refusal to crouch to the great, Northcote discloses that he "never even gave them their proper titles. I never heard the words *'your lordship or*

your ladyship,' come from his mouth." And Johnson, we learn, was the only person whom Reynolds addressed as "Sir."[27]

There were, inevitably, exceptions and complications in his relationships with the large and diverse group of patrons with whom he worked. Hazlitt may have envisaged him as "dictatorial" within the octagonal room, but Northcote realized that it was only when he was painting beggars that he "could have complete command" there.[28] Flattery, verbal as well as pictorial, could hardly be avoided, and a reading of the letters Reynolds wrote in 1790 reveals that no fewer than three patrons were thanked in precisely the same terms. He tells Sir William Chambers that the King's interest in his welfare represents "the greatest honour of my life."[29] Within a few months he responds to Catherine the Great's praise of his *Discourses* by characterizing her compliment as "the great honour of my Life."[30] Two months later he tells the Duke of Leeds that his approval of his final self-portrait marks "the greatest honour of my life."[31] Reynolds also found it difficult to escape invitations for weekends in the country that would deprive him of precious time in the studio, and he often remarked that "he could not dun persons for debts whom he was continually in the habit of meeting at dinner parties."[32]

Nothing tested the painter's complacency more, however, than the glimpses of superiority, condescension, insensitivity, or outright thoughtlessness that occasionally revealed themselves to his observant eye. He often reacted affably, and sometimes even with amusement. He may have been embarrassed when it was pointed out to him that he should have removed his muddy boots before presenting himself to his hosts at Blenheim, for instance, but when the Duchess of Marlborough ordered a footman to sweep up large quantities of snuff while he painted the great group portrait of her family, he asked the servant to wait until he had finished, for "the dust raised by the broom would do much more injury to his picture than the snuff could possibly do to the carpet."[33] He was diverted by the Duchess of Cumberland's condescending remark that "I come to your house to sit for my portrait,

because I thought it would be much more convenient to you, as you would have all your materials about you and at hand." Reynolds might have pointed out, Northcote adds, that this was the *only* way he would have painted her portrait, and that her husband had not conceived it to be beneath his dignity to sit to Reynolds in Leicester Square.[34] And when the Duchess of Bedford complained to him that his portrait of her daughter, the Duchess of Marlborough, was not a good likeness, he simply bowed, thanked her for her approbation, and pretended not to be able to hear her distinctly even though she continued to repeat her disapproval of the painting.[35] According to Amelia Opie, Reynolds adopted a somewhat similar strategy when asked to render his opinion on various matters, for he had "a method of laughing a he! he! he! *so equivocally tuned,* that the parties interested in understanding it favourably might do so without any great strength of self-flattery."[36]

Occasionally, however, Reynolds's complacency, his disposition to smooth over social or professional difficulties, simply dissolved, thereby exposing a critical and often exasperated voice. We can gauge this as early as Reynolds's encounter with his fellow Englishmen in Rome, whom he caricatured with such spirit in his youthful travesty of *The School of Athens* in 1751. From observations he made at the time, we know that he was highly critical of those travelers "who most pique themselves on studying Vertu." Instead of examining the beauty of the great works surrounding them, they simply wrote down the cold facts dispensed by their antiquarian guides. The English gentlemen he observed in the Vatican "scarcely ever looked at the paintings the whole time."[37] And yet it would be these very men—and others like them— on whom Reynolds's fortunes as a painter would soon depend. In abandoning what was clearly a natural talent for caricature, Reynolds argued that it would "corrupt his taste as a portrait painter, whose duty it becomes to aim at discovering the perfections only of those whom he is to represent."[38]

Skillful as Reynolds was in discovering perfections, he could not turn a blind eye on the imperfect world around him, and at three different

moments in his life we therefore find him mounting an implicit or explicit critique of aristocratic privilege. In conversation with Boswell in 1785 he delivered "a very instructive lecture" on the young Earl of Pembroke, whose philandering was losing him "the consequence which he should have in his country from his rank, fortune, and talents. He is conscious he is not the great Earl of Pembroke." Boswell was particularly struck by the image with which his friend concluded his remarks: "Were it not that he has a great title, he would sink. His coronet, as if made of cork, keeps his head swimming above water."[39]

The Earl of Pembroke represents a member of the nobility who refuses (or is unable) to live up to the responsibilities he has been groomed to bear—domestic behavior alone, moreover, is mentioned here—and Reynolds is consequently severe in his judgment. In conversation with one of his patrons, the Duke of Devonshire, he is more affable, less judgmental, but nevertheless honest in the distinctions he draws between their different stations in life. While the two were talking, the Duke first ordered his servant to have his chariot brought to the door; a moment later he rang again and told the servant he would ride instead; not long afterward he rang the bell once again and informed the servant that, instead of riding, he would join his wife in their coach. He then expressed surprise that a painter of Reynolds's fame and fortune "did not retire from further exertion."

> Sir Joshua replied "To me the practise of my profession is everything; it is a constant occupation for my mind, gives me further hopes of reputation & such other advantages as arise from it." He then added, "Your Grace's situation is very different. You are in possession of all that can enable You to make a choice, of what may be agreeable to you. Rank; Princely fortune you possess; but in my situation I have a constant impulse to one thing; Your Grace has not," and Sir Joshua then remarked upon His having so frequently varied in His choice of amusement since He came into that room.[40]

Reynolds's initial reply is precisely what we would expect him to make,

but his extended remarks are unusual in their forthrightness and in the painter's willingness to draw attention to the breach that separates him from his companion.

In his conversation at Devonshire House, Reynolds was cool and analytical. At the house of Dudley Long, in company with the Duke of Devonshire and several other peers as they talked about happiness, Reynolds was silent for some time before delivering what his friend Charles Burney called a "harangue."

> "You none of you, my lords, if you will forgive my telling you so, can speak upon this subject with as much knowledge of it as I can. Dr. Burney perhaps might; but it is not the man who looks around him from the top of a high mountain at a beautiful prospect on the first moment of opening his eyes, who has the true enjoyment of that noble sight: it is he who ascends the mountain from a miry meadow, or a ploughed field, or a barren waste; and who works his way up to it step by step; scratched and harassed by thorns and briars; with here a hollow, that catches his foot; and there a clump that forces him all the way back to find out a new path;—it is he who attains to it through all that toil and danger; and with the strong contrast on his mind of the miry meadow, or ploughed field, or barren waste, for which it was exchanged,—it is he, my lords, who enjoys the beauties that suddenly blaze upon him. They cause an expansion of ideas in harmony with the expansion of the view. He glories in its glory; and his mind opens to conscious exaltation; such as the man who was born and bred upon that commanding height, with all the loveliness or prospect, and fragrance, and variety, and plenty, and luxury of every sort, around, above, beneath, can never know; can have no idea of;—at least, not till he come near some precipice, in a boisterous wind, that hurls him from the top to the bottom, and gives him some taste of what he had possessed, by its loss; and some pleasure in its recovery, by the pain and difficulty of scrambling back to it."[41]

As Lawrence Lipking notes, "Satisfaction and pathos are exquisitely balanced in this artistic retrospect,"[42] and so too are the painter's un-

usual self-assertiveness and his firm but polite critique, which—in its very artistry—strives to please those whom it would instruct.

Reynolds's familiarity with men and women of rank and power placed him in an unusual situation, one filled with what Burke called "peculiar advantages . . . to those who chose to make use of them."[43] Johnson, for instance, wrote to Reynolds in 1776 on behalf of an aspiring artist, Charles Paterson: "Your character and station enable you to give a young man great encouragement by very easy means. You have heard of a Man who asked no other favour of Sir Robert Walpole, than that he would bow to him at his levee."[44] Because of his opportunity to spend time in private with people who were then at leisure and in good humor, Reynolds should have been able (Burke thought) to "obtain favours from them which would give you a patronage almost equal to that of a prime minister." Reynolds allowed that there was some truth in what his friend said, but he asked Burke how he could "presume to ask favours from those to whom I became known only by my obligations to them."[45] But presume he did, often becoming an intermediary on behalf of younger artists and—most assiduously—his sisters' children. In 1783, for instance, we find him asking Lord Hardwicke if he would write to his brother, the Bishop of Ely, on behalf of John Palmer, who was eager to be ordained. Hardwicke immediately asked his brother to "be so good as to let me Know what Answr I shall make to Sir Joshua. He is One I wd willingly oblige if I could."[46]

The painter's efforts to find an appropriate ecclesiastical living for another nephew, Joseph Palmer, provide an interesting glimpse of how skillful Reynolds was in forging reciprocal relationships with even the most powerful of his patrons.[47] Sir Joshua first asked Lord Townshend, recently appointed Lord Lieutenant of Ireland, to bestow a living upon young Palmer. According to Northcote, "the very same morning on which Lord Townshend received Sir Joshua's letter, he came instantly to him, and, in the most gracious manner, assured him that he felt great pleasure in the opportunity Sir Joshua had put in his power of testifying his friendship for him, and that he should most certainly remember

him on the first occasion that might offer to serve him. Accordingly, very shortly after, he bestowed on this young clergyman a deanery in Ireland."[48] In 1784 Townshend was succeeded as Lord Lieutenant by the Duke of Rutland, one of Reynolds's greatest patrons, and during the following two years, as the painter incessantly reminded his friend of the advancement his nephew desired within the church, he simultaneously became more deeply enmeshed in the Duke's wide-ranging aesthetic interests.[49]

Reynolds served as Rutland's painter, as his artistic adviser, and as one of his commercial agents. The Duke had written to Reynolds about Joseph Palmer in a letter of 24 September 1784, announcing that "your Nephew is appointed one of my Chaplains, & I trust you believe me that I cannot want inclination to serve any connexion of yours, & I hope that my Government will be of sufficient duration to enable me to render him a very independant Gentleman."[50] In his letter of reply, Reynolds acknowledges the "good inclinations" he is convinced the Duke bears his nephew, and then immediately turns to the portrait he has been painting of Rutland, to the alteration he has made in the Duke's portrait of the Earl of Chatham, and to the loss of color the Duke has noticed in Reynolds's design for the Nativity scene in the West Window of New College, Oxford, which had recently been shaken in the carriage during its transit to Belvoir Castle.[51] In May 1785 Reynolds arranges to send the landscape painter John Webber to Ireland so that he can execute six "views from Nature" for Rutland; two months later we learn that a misunderstanding concerning the cost of Webber's passage from London has persuaded Reynolds to cancel the arrangement: "in short, I thought it would be a troublesome business, and that it would be better to have done with it."[52]

In the same letter, however, we first hear Reynolds advising Rutland on his proposed purchase of Poussin's *Seven Sacraments,* an extraordinarily important series of paintings in the Bonapaduli Palace. Rutland's agent in Rome, James Byers, has arranged for the Duke to buy the pictures for £2000; he has also arranged to have copies made that

can be substituted for the seven originals so that the papal authorities will not notice their loss. Reynolds responds to this news with enthusiasm and determination: "I would by all means recommend your Grace to close with it," he writes; "I have not the least scruple about the sending copies for originals." Without wishing to take the paintings from the Duke's own hands, Reynolds confesses that he would certainly "be glad to be the purchaser myself. I only mean that I recommend only what I would do myself. I really think they are very cheap."[53]

Two weeks later he promises to cast a critical eye on some verses by George Crabbe (Rutland's chaplain) and the day following—a day during which he leaves London for a brief trip to Brussels—he asks his patron to intervene "in a matter which relates to myself." Although Reynolds has been made Principal Painter to the King, the salary attached to this position has been reduced from £200 to £50 a year, and Reynolds is therefore eager to procure what he calls a "very honourable compensation." He proposes to serve as "secretary and register to the Order of the Bath," which is in the gift of William Pitt, the Prime Minister, but Pitt has not paid "much attention to the arts," and Reynolds must therefore ask the Duke of Rutland to intercede on his behalf. The difficulties he faces in visiting the Duke in Ireland "are very great," he adds, "yet in this case, if your Grace can procure me this honourable place, I should think it an indispensible duty to make my personal appearance to return my thanks with the order about my neck."[54]

Reynolds was disappointed in this particular quest for preferment, but not so his nephew Joseph Palmer. Reynolds wrote frequently to the Duke in the late summer and early fall, usually about the international art market and occasionally about the Poussins, whose purchase he thought would be "a real national object."[55] In December, having painted the Duke's three sons, he was promising to "set furiously about" completing a similar portrait of his three daughters; he had also, by this time, agreed to take care of *The Seven Sacraments* when they arrived in London.[56] In January 1786 he informed Rutland that he was painting

the Earl of Mansfield for him; in February he reported progress on numerous paintings and on several purchases with which he was assisting his patron, and apologized for his nephew, who had visited England without "your Grace's leave, which he was in duty bound to do."[57] In March he thanks Rutland for "the dignitary which you have been pleased to conferr on my nephew," who must now be "the happiest of men," but no specific form of preferment is mentioned, and in June, not surprisingly, he finds himself "mortified" not to be able to accept the Duke's invitation to visit him in Ireland, for he must complete his commission for the Empress of Russia.[58]

At the end of August Reynolds announces that Poussin's "pictures are in the river" and that he expects them to be delivered to Leicester Fields quite soon, but he writes to the Duke now, rather than waiting to inspect the paintings, because his letter can be carried by his nephew, who is about to return to Ireland. "If I can do nothing for him during your Grace's administration," he continues, "I must give up all thoughts, or rather he must give up all expectations, from any advantage he is to receive from my interest with the great."[59] This is as straightforward—and plaintive—a request as Reynolds will make. He is "not so ambitious as to think of bishopricks," but he does hope that Rutland can "make him at once what you was so good as to say you would do one time or another, *an independent gentleman.*" Once this has been accomplished, the painter "shall never pretend to have any further demands on your Grace on his account."[60]

Ten days later Reynolds can report that the Poussins are safe in his house and that he hangs over them all day, examining each one "with the greatest accuracy." They have, he must confess, "a most unpromising appearance," for they are encrusted with dirt and have a few holes, but otherwise they are in fine condition; and if Italy is now poorer, then "England is richer than it was, by this acquisition."[61] A month later, in a letter of 4 October, the two strands in this reciprocal arrangement are finally tied together. Reynolds begins by saying that he can fill the entire letter with the happiness he and the members of his family

feel following Rutland's act of kindness toward Joseph Palmer, who would soon be made Dean of Cashel. But the Duke, he realizes, "would rather hear about the pictures," and he therefore tells him what further complications have arisen as the pictures have been relined and cleaned. A Neapolitan with a reputation for having "an extraordinary secret for cleaning pictures" has been recommended to Reynolds, who first decides not to take the risk, finally sends for him, and eventually tests him by having him clean some of the dirtiest paintings in his own collection. The experiment is a success, and the Italian is therefore entrusted with the Poussins, with Reynolds himself always in attendance while the cleaner is at work: "He possesses a liquid which he applies with a soft sponge only, and, without any violence of friction, takes off all the dirt and varnish without touching or in the least affecting the colours. With all my experience in picture cleaning, he really amazed me. The pictures are now just as they came from the easel." Reynolds can finally "safely congratulate your Grace on being relieved from all anxiety" in words that perfectly apply to his own hard work and trepidation as well: "We are safely landed; all danger is over."[62]

This particular form of cross-patronage, of mutual obligation and aggrandizement, reveals just how strongly Reynolds took to heart the advice he had already dispensed to William Johnson when he counseled him "to make it people's *interest* to advance you, that their business will be better done by you than by any other person."[63] But successful as he was in negotiating the extensive system of patronage within these aristocratic circles, he was nevertheless denied the ultimate form of patronage he and his rivals desired—patronage by the King. This is not to argue, of course, that Reynolds was neglected by George III. The King saw fit to knight him, to have him serve as the first President of the Royal Academy of Arts and as the King's Painter. But Northcote could write that at the summit of his reputation, in 1767, Reynolds still lacked what painters like Francis Cotes already enjoyed: the opportunity to paint the King[64] (and—by extension—to have one's work take its place in that long tradition of portraits devoted to the English mon-

archy). Reynolds therefore made it a condition of his acceptance of the Presidency of the Royal Academy that he be allowed to paint both the King and the Queen,[65] but, as Derek Hudson has pointed out, he never enjoyed the patronage extended to Sir William Beechey, Gainsborough, Hoppner, and Zoffany, or even Copley and West, both of them Americans.[66] His sole experiments in royal iconography were the "clumsy, awkward and lifeless" Royal Academy portraits of the King and Queen in 1779, the portrait of George III when Prince of Wales, and the oil sketch of his marriage ceremony—with the last two paintings remaining in the artist's studio until his death.[67] As the exhibition at the Queen's Gallery in 1994 vividly demonstrated, the young couple responded with warmth and congeniality to Gainsborough, who completed fifteen matched oval portraits of the royal family as well as the greater, more stately pieces. As Gainsborough remarked, I talk "bawdy to the king, & morality to the Prince of Wales."[68]

Hudson is surely correct in assuming that the King's treatment of Reynolds "is something not to be fully explained, perhaps, by Reynolds' associations with the left wing in politics." Reynolds was clearly not the political "Pococurante" Northcote took him to be,[69] but neither was he normally outspoken in his political sentiments. He was a close friend of Johnson as well as Burke, and—perhaps most tellingly—he simply could not afford, as a portrait-painter, to ally himself too closely with either political party.[70] His personal feelings toward the King appear to have been ambivalent. In a letter of 1773 to Lord Grantham, he praised their monarch's knowledge and intelligence; but in a letter of September 1784 to Boswell his remarks are particularly severe: "Poor Ramsay is dead, and your humble servant succeeds him as King's Principal Painter. If I had known what a shabby miserable place it is, I would not have asked for it. Besides, as things have turned out, I think a certain person is not worth speaking to, nor speaking of, so I shall conclude."[71]

Henry William Beechey attributed the King's neglect to near-sightedness, an explanation that would seem to be at odds with the King's patronage of other painters. At another point Beechey remarked that

George III objected to finding "red trees" in Reynolds's portraits, paintings that he also considered to be "coarse and unfinished" in their appearance.[72] Johnson had even more severe things to say about the Queen's aesthetic taste: "I don't imagine she has any other Idea of a Picture, but that it is a thing compos'd of many Colours." In the long run, he argued, "it has always been more profitable to be popular among the People than favour'd by the King," and any sign of royal neglect "will be a reflection forever on the Court not to have employ'd him."[73]

It is more likely, however, that Reynolds simply did not work hard enough at ingratiating himself at court. "Anthony Pasquin" (John Williams) reports that the painter was asked to produce a drawing of the coronation procession in the manner of Van Dyck's sketch for Charles I. Reynolds is said to have agreed to produce an oil sketch, but wanted to be properly rewarded, asking a thousand pounds—a proposition that so offended the King that he promptly dropped the idea.[74] Reynolds's dedication of the first seven discourses to the Academy's royal patron is generous, but it is anything but fulsome. Peter Pindar compared Reynolds to West by ironically lamenting that "Reynolds is no favourite, that's the matter, / He has not learnt the noble art to flatter!"[75] Henry Angelo agreed with this assessment, and so did Northcote, who once confided to a friend that Reynolds was never again employed by the King following his original commission (which itself was delayed ten years) because the King and Queen "were afraid of him." The painter was "a great man and a philosopher. He felt his own dignity." Such a man, Northcote argued, "one would be almost induced to think was born to be a King—but certainly not to be a courtier." George III and Queen Charlotte were comparatively young and inexperienced (the King was only thirty-one when he knighted Reynolds), and the royal couple "could not endure the presence of him; he was poison to their sight." Reynolds, moreover, certainly recognized the value of royal favor, for he "had a thorough knowledge of the world. He would gladly have possessed it but the price would have cost *him* too much."[76] I find this interpretation to be quite compelling, for it is predicated on Reynolds's

sense of a fine but discernible line separating habitual complaisance, on the one hand, and one's essential dignity, on the other. As we shall see in the following pages, Reynolds's ability to maintain his customary composure when he believed that his personal integrity was under attack became increasingly tenuous during the final years of his life.

FURIOUS PURPOSES

For more than four years, from 1786 to 1790, the Royal Academy failed to appoint a new Professor of Perspective, and Reynolds, as the Academy's long-time President, argued that this vacancy not only had disrupted the institution's program of instruction, but had become a public embarrassment to its members. Save an "Infant Academy," he told his fellow Academicians, "from the disgracefull appearance of expiring with the decrepitude of neglected old age."[77] Reynolds was an old man himself at the time. A year earlier, having lost the sight of one eye and fearful of losing sight in the other, he had virtually abandoned his practice as a painter, completing a few commissions but rarely engaging in new ones. His retirement, however, was not without drama and incident, for he had been immersed for some time in a battle of wills at the Academy, in whose affairs he remained keenly interested. In the winter of 1789–90 he proposed that an Italian architect, Giuseppe Bonomi, be elected an Associate, an Academician, and subsequently the Academy's Professor of Perspective.

Much to Reynolds's surprise, his colleagues opposed their President's recommendations with both warmth and tenacity, and the aging painter found himself—for the first time in his professional career—thwarted by what he soon came to believe was a hostile, impolite, and disloyal group of followers. His fellow Academicians did not like the fact that Bonomi was a foreigner, or that Sir Joshua had proposed him as a favor to one of his own patrons, the Earl of Aylesford. They therefore elected a number of Associates before finally turning to Bonomi (for whom Reynolds himself cast the deciding vote); and when, at a

subsequent meeting, they refused to promote the Italian to full status as an Academician, and behaved in what Reynolds believed was an insolent fashion, the President resigned both from the chair and from the Academy itself.

Reynolds's actions—and those of his colleagues—quickly filled the pages of London's newspapers and pamphlets, with fierce partisanship on either side. For his part, the retired President consulted with his closest friends and wrote his own heated vindication of his conduct at the Academy. He called it his "Apologia," his "Justification in the matter of Bonomi and the resignation of the Presidt's Chair,"[78] but he neither completed nor published it, instead setting it aside after his colleagues, in a conciliatory mood and supported by the intercession of the King, beseeched him to resume his former duties and contrived a way for him to return to Somerset House while also saving face. He complied with their request, and died in office two years later.

Although the incident itself and the pamphlet war it generated held the attention of London society for several weeks, the Bonomi affair has largely been neglected by Reynolds's modern commentators. This fracas at the Royal Academy is unlikely to draw the attention of many art historians because it is a personal and institutional dispute not directly related to actual paintings; but even those interested in the relationship between individual works of art and the context in which they are created have been noticeably silent. Reynolds's biographers seem to be faintly embarrassed by the incident; the historians of the Royal Academy tend to treat it as yet another internecine quarrel in the early years of a fledgling institution.[79] Even Frederick Hilles, who carefully edited the "Apologia" in 1936 (it has never been critically examined until now), remarked that it is "worth reading, if only to illustrate Sir Joshua's state of mind at the time."[80] Hilles reminds us of Edmond Malone's remark that Reynolds suffered "little from disappointments, or what others would have thought mortifications,"[81] and thus the painter's response to the treatment he received at the Royal Academy in the early months of 1790 marks an exception, in Hilles's eyes, to his nor-

mally acquiescent behavior. This is surely true, and the incident marks—as I shall argue—the final, ironic chapter in a personal history that was otherwise characterized by a uniformity of easy, congenial behavior. But there is much more at stake here as well, for the Bonomi affair reveals deep-seated fissures in the artistic, social, and political life of Britain during the final decade of the eighteenth century.

We are faced with an interesting array of sources as we attempt to reconstruct the events of late February and early March 1790. In addition to the important accounts by Northcote, Malone, and Farington, we have Reynolds's "Apologia," his letters to friends, poems and accounts published in the London press, and the official minutes kept by both the Council and the General Assembly of the Royal Academy. The literal cause of the dispute was noted by Northcote, who tells us that "a spirit of resistance appeared" when Reynolds exerted his influence on behalf of Bonomi's election to a full Academicianship, "owing, I believe, to some misconception, or to some informality on the part of Sir Joshua, in producing some drawings of Bonomi's."[82] The question of *how* a candidate should best present his credentials for the Professorship had in fact been raised several months earlier by another Associate, Edward Edwards, who demanded permission to deliver a probationary lecture to be judged by five people, one of them not drawn from the Academy itself.[83] In response to this request, the Council ruled on 11 December that "whoever is a Candidate to be an Academician, for the purpose of being hereafter Professor of Perspective: must produce a Drawing.—& inform Mr. Edwards, that there will be an Election for an Academician, on ye 10th. of Feby. next."[84] Edwards refused to submit to this ruling, and Reynolds was therefore confident of Bonomi's chances for election when he presented the architect's drawings at the crucial meeting of the General Assembly two months later.

The minutes of the 10 February meeting are exceedingly brief, but they are accompanied by a folded note that has been inserted in the Academy's records at this point; it is in Reynolds's hand, and provides a relatively dispassionate view of the turbulent proceedings:

The Prest. open'd the business of the meeting, that it was to choose an Academician in the room of Mr. Meyer[,] that he need not repeat what he had so often said at former meetings, the necessity of filling up the place of Professor of Perspective which had been so long vacant to the great disgrace of the Academy. Mr. Bonomi as they all knew had been many Years a candidate for that place. And as the Academicians had at last taken this business up by Electing him an Associate for this very purpose, His drawings now were on the table for their inspection.—And as his rival Mr. Edwards appear'd to have declin'd the contest from his not sending a specimen, He hoped the Question before them would be, Ay. or No—was he, or was he not qualified for the office.———

Mr. Tyler demanded by whose authority the drawings were sent to the Academy.

—The President answer'd, by mine

Mr Tyler then moved that those Drawings should be put out of the room,—this motion was seconded by Mr. Banks.

The Question being then put.—was carried by a great majority.———

The President afterwards endeavoured to explain, but being refused a hearing—he immediately proceeded to the Election &c &c.

Henry Fuseli received nineteen votes, Bonomi eight, Humphry two, Edwards and Peter Francis Bourgeois one each. In the run-off, Fuseli received twenty-one votes to Bonomi's nine and was duly elected an Academician.

Contrary to what Northcote writes, Reynolds was neither informal nor working under a "misconception" when he introduced poor Bonomi's drawings to the General Assembly: he knew precisely what he was doing, and he shepherded the architect's candidacy just as carefully here as he had when Bonomi was elected an Associate. We know, for instance, that he wrote to a fellow Council member, John Bacon, in January, chastising him for declaring that he would vote for Edwards whether or not a drawing was produced: "This report I have treated with the contempt such a Calumny deserves."[85] But the drawings, after all, are not the real issue, which centers on William Tyler's question ("by whose authority"?) and on Sir Joshua's answer: "by mine." Tyler

and Thomas Banks are not merely questioning *whose* authority, but authority itself; and Reynolds, who has the authority of the Council's edict behind him, answers with a personal response—the kind of assurance that his colleagues had long trusted and accepted—rather than with a more accurate, institutional one.

Four weeks later, after an intense period of public sniping and private negotiation, the General Assembly passed Thomas Sandby's motion that

> the President had acted in conformity with the intention of the Council, in directing Mr. Bonomi to send a Drawing or Drawings, to the General Meeting, to evince his being qualified for the Office of Professor of Perspective.
>
> But the General Meeting not having been informed of this new regulation of the Council, nor having consented to it, (as the Laws of the Academy direct) The generality of the Assembly judged their introduction irregular, and consequently Voted for their being withdrawn.————[86]

Face was thus saved on both sides, and a committee was appointed to accompany Reynolds back to Somerset House, his "declared objection to resuming the Chair being now done away."[87] This is true so far as it goes, but just as important to the aggrieved Reynolds was the *behavior* of his antagonists during the preceding month. By refusing to bow, by refusing to defer even to the preliminary intercession of the King, Reynolds carefully defined the terms under which he would return and under which his integrity would be protected. At the same time, it was essential to Reynolds that his former colleagues apologize for the impoliteness and lack of deference with which he had been treated, and Northcote's account of the deliberations that took place in the early days of March almost suggests a meeting between a benign monarch and his wayward subjects:

> They had an interview with him at his house in Leicester Square, and were received with great politeness; and every mark of respect was ex-

pressed by those who had hitherto been deemed least cordial to the interests of the President. . . . [Reynolds], after a handsome declaration of his gratitude for this honourable proceeding towards him, consented to resume the chair, and the whole of the delegates were invited to dine with him, in order to convince them that he returned to his office with sentiments of the most cordial amity.[88]

Both this scene of mutual liberality and the barebones account of the fateful meeting of the General Assembly in February are far removed from Reynolds's actual responses to the treatment he received at Somerset House. He wrote twice, heatedly, to Sir William Chambers, the Academy's Treasurer and principal founder, in an attempt to justify both his resignation and his decision not to withdraw it.[89] At the same time, he drafted his vehement and sometimes inchoate "Apologia," which reads radically differently from any of his polished, more even-tempered writings (Figure 31). Here, in a remarkable moment-by-moment rendering of how the meeting proceeded, Reynolds provides a clear picture of his apprehensions and responses. He tells us that he lost his confidence the minute he arrived at the Academy: "A greater number than ever appeard[.] I suspected that this number was not in my favor[.] . . . Instead of the members as usual stra[g]gling about the room, they were allready seated in perfect order and with the most profound silence."[90] He searched for the candidates' drawings, and "at last spyed those of Mr. Bonomi thrust in the darkest corner at the farthest end of the room[.]"[91] When Reynolds asked the Secretary, John Richards, to show the drawings to the assembly, Richards at first pretended not to hear the President. After a second request he arose and "in a sluggish manner walked to the other end of the room (passing the drawings) rung the bell and then stood with his folded arms in the middle of the room; Observing this extraordinary conduct of the Secretary, <I found he had joined the Party which I considered as a rebellion in him>."[92] Richards refused to touch the drawings himself, instead ringing a bell for the servant, who would have to "mount that

long flight of steps in order to move two drawings from one side of the room to the other." It was an act, Reynolds remarks, that revealed the "rude spirit and gross manners of this cabal."[93]

Against Reynolds's restrained description of the events that followed—the dispassionate commentary left in the Minutes Book—we can place the personal account he included in the "Apologia."

> *As soon as the Prst. sat down,* <Mr. Tyler> *an academician who is & has been long considered as the spokesman of the party demanded* <in a peremptory tone> *who ordered those drawings to be sent to the Academy. The President answerd it was by his order. He asked a second time in a still more peremptory tone. The President said I did.* I move that they be sent out or turned out of the room. Does any one second this motion—Mr. Barry rose with great indignation[.] No[,] says he[.] Nobody can be found so lost to all shame as to dare to second so infamous a Motion. Drawings that would do honour to the greatest Academy that ever existed in the world &c. <he said much more with great vehemence>. Mr. Banks with great quietness seconded the motion[.] On the shew of hands a great majority appeared for their expulsion[.] The President then rose to explain to them the propriety of Mr. Bonomi's drawings being there, to oppose Mr. Edwards['s,] which were expected and orderd by the Council[,] but he was interrupted from various quarters that the business was over, they would hear no explanation, that it was irregular[,] Mr. Copley said[,] to talk upon business that was past & determin'd. The Prest. acquiesced and they proc[e]eded in the Election.[94]

It was, in short, a world turned upside down for the aging President of the Academy: large numbers, ominous silence, feigned deafness, bad manners, collusion, and open rebellion. To everyone's astonishment, even James Barry rose to Reynolds's defense. As an anonymous pamphleteer remarked, "He, who had formerly, with his fist clenched in the very face of the President, threatened him with a personal assault when his measures were right, now seemed disposed to offer the same insult to any one who should dare to oppose them, when they were wrong."[95]

Barry's surprising volte-face serves as an apt emblem for much of

the tumult that had characterized the proceedings of the Royal Academy during its first twenty-odd years. The Academy was established, we should remember, only after the autocratic Sir William Chambers was usurped from his position at the Society of Artists in 1768. It was the wily Chambers who then outflanked his rivals at the Society by petitioning his former pupil, George III, to bestow his royal patronage upon an academy founded on aristocratic rather than democratic principles.[96] Reynolds prudently followed these skirmishes from the sidelines, neither encouraging those who seceded from the Society of Artists nor rejecting their entreaty to serve as the Academy's first President once the King's intentions were firmly established.[97] Within a few months Reynolds could write to the young Barry, who was studying in Rome, about the "establishment of a royal academy here": "the first opportunity I have I will send you the discourse I delivered at its opening, which was the first of January [1769]. As I hope you will hereafter be one of our body, I wish you would, as opportunity offers, make memorandums of the regulations of the academies that you may visit in your travels, to be engrafted on our own, if they should be found useful."[98] The letter closes, however, with the new President's "apology for the blunt appearance of a dictatorial style in which I have obtruded my advice."[99]

This "appearance of a dictatorial style" is closely tied to the nature of Reynolds's authority and to his manner of invoking it. As a critic, as an arbiter of taste, he grew to have few rivals; and he was therefore justified in writing of himself in 1790 that "as for the authority of my opinion, I shall affect no modesty[;] it may be said [that it] has been the business of my life, and I have had great opportunities, and hope it will not be concluded because I cannot Paint my[se]lf in such a manner as to add authority."[100] As a painter, as an administrator, as a public figure, however, he often found his authority challenged; and it was therefore characteristic of him to protect his own dignity—and eventually the dignity of his office—by refusing to petition or campaign for what he thought he should rightfully be offered. The delegation

headed by Benjamin West in 1790 (Chambers was *not* of the company) uncannily mirrors the original delegation of painters that Chambers led to Reynolds's house in 1768.

In the intervening years, moreover, Sir Joshua had been faced with a similar dilemma when one of his major rivals as a portrait-painter, Allan Ramsay, died, thus forcing George III to appoint a new Principal Painter. Samuel Johnson offered his friend this blunt advice in a letter of 19 August 1784:

> That the President of the Academy founded by the King, should be the King's painter is surely very congruous. You say the place ought to fall into your hands *with asking for*, I suppose You meant to write *without asking for*. If You ask for it I believe You will have no refusal, what is to be expected *without* asking, I cannot say.
>
> Your treatment at court has been capricious, inconsistent, and unaccountable. You were always honoured, however, while others were employed. If You are desirous of the place, I see not why You should not ask it. That sullen pride which expects to be solicited to its own advantage, can hardly be justified by the highest degree of human excellence.[101]

As we have seen, Reynolds swallowed his "sullen pride," was duly appointed (but never employed), and wrote to his friends that his new position was "a most miserable office," "a place of not so much profit, and of near equal dignity with His Majesty's rat catcher."[102] Reynolds was elevated so little by this new honor, he told the Duke of Rutland, that he "need not make any resolution to behave with the same familiarity as I used to with my old acquaintance."[103]

The dying Johnson was relieved that his friend had condescended to ask for a title that was rightfully his—and that the King had granted his request—for he knew that Reynolds was prepared to step down from the Presidency if he were to be disappointed. "I am glad that a little favour from the court has intercepted your furious purposes," he wrote to him in early September 1784: "I could not in any case have approved such publick violence of resentment, and should have con-

sidered any who encouraged it, as rather seeking sport for themselves, than honour for You. Resentment gratifies him who intended an injury, and pains him unjustly who did not intend it. But all this is now superfluous."[104] Or nearly so. Reynolds needed this new mark of royal favor, Leslie argues, because he was already, by 1784, encountering growing dissension within the Academy. Chambers, we should remember, had always been a force to reckon with, and when Reynolds painted his portrait for the Academy's new quarters at Somerset House, which Chambers had designed, he intended that it should be hung to flank his own in the Assembly Room (Figure 32).[105] Farington noted that Chambers "in many respects had too much considered himself and had assumed improperly, great power. . . . Sir Joshua Reynolds had felt it, & had told him in the Council, that though He (Sir Joshua) was President, Sir Wm. was Viceroy over him."[106] John Francis Rigaud's group portrait of Chambers, Joseph Wilton, and Reynolds (Plate VIII) reflects a sense of this uneasy balance of power. The architect, sculptor, and painter are each associated with the paraphernalia of their artistic professions—plan, portfolio, and statue—but the cluster of gesturing hands suggests that this artistic "Gang of Three," as David Mannings has appropriately labeled them,[107] is essentially at cross-purposes, with Chambers and Reynolds engaged in an administrative stand-off. The collusion of Chambers and several of the younger members of the Academy in 1790 therefore posed a powerful threat to the ailing President. It was Chambers who framed the argument against Bonomi's election to the Professorship, and it was to Chambers that Reynolds gave the two heated letters he addressed to his fellow Academicians. In a sentence deleted from the "Apologia" he wrote, "Sir Wm. little thinks that he is guilty of high treason against the Institution."[108]

Reynolds clearly did, and the language of the "Apologia" is therefore heavily steeped in the discourses of warfare, rebellion, and political economy. Much of the President's rhetoric attempts to capture the conniving, virulent, and irrational behavior of his antagonists. In arguing that an ingenious Associate (Edwards) could provide lectures on per-

spective in lieu of a Professor, and in employing "the plural number (we)," Chambers reveals the fact that "he had enlisted himselfe under the banner of this resolute partizan Mr. Tyler who had courage to dare anything, to brow-beat the President in his Chair."[109] William Tyler is always the "daring" man or the "impudent bold man."[110] Reynolds (as we have seen) discovers that the Secretary, Richards, "<had joined the Party which I considered as a rebellion in him>."[111] Edwards's friends represent "<the whole Cabal Party the existence of which is so much to be lamented>"; they are "turbulent Spirits" who would move "heaven & earth" to foil the President's plans.[112] Such a successful rebellion, he adds, "<loses its name and is stampt with the sanction of lawful reformation or revolution>."[113]

Even men as distinguished as West have been "incited by a few of the most inconsiderable members who perhaps had no other object at first in view than to elevate themselves into some consequence in the Academy conscious of their own nothingness out of it."[114] This is a jibe at the architect Tyler (among others), whose profession is similarly disparaged when Reynolds, in his conclusion, denigrates "Men who have been used to lay[ing] down the law in Alehouses to Masons & Bricklayers [who then] presume to interfere in a higher station where he has crept in by mere accident."[115] Reynolds's vehemence is so high-pitched in the closing pages of the manuscript that his incomplete sentences flow into each other:

To venture myself with a set of men the majority of which either from weakness or malevolence ar[e] so ready to be led away and enlist under the banner of <what ever> be led to wherever impudent boldness will undertake to direct them I cannot act with such a majority and that majority increasing every [?day;] the Elections are already in their hands and I am sorry to see so much timidity where I expected more firmness ... I did not quit my station because I could not persuade the Aca[demicians to] defend the garrison to the last and dye in the breach even after Sir Wm. Chamb[ers] had deserted the defence and and had

joined in the attack <but by their junction they were so insultingly> triumphant insolent.[116]

And so on, until the "Apologia" finally, mercifully breaks off.

"I cannot act with such a majority." Reynolds depicts his fellow Academicians as an unbridled, unprincipled, essentially lawless cabal that poses a threat to all that has been meticulously nurtured during the past two decades: "The whole Fabric[,] the work of years[,] was shaken to its very foundation and all its glory tarnishd."[117] Like Chambers before him, Reynolds must contend with an artistic society that has become increasingly democratic, and it is ironically now Chambers himself—acting on behalf of this insolent majority—whose objections Reynolds must strive to refute. Chambers's first objection is that Bonomi is a foreigner, "which indeed," Reynolds admits, "could not be denied."[118] The President carefully points out, however, that the Academy has never made distinctions between "Natives & Foreigners,"[119] that several members of the Academy are not native-born, that Bonomi himself has lived in England for over twenty-five years (he is "not a temporary sojourner amongst us"), and has therefore probably spent as much time in this country as Sir William had before *he* was elected an Academician. According to Reynolds, Chambers—who had been born in Stockholm—has "himself perhaps begun to reflect that the objection to Foreigners was peculiarly improper from him."[120]

At the root of Reynolds's argument, moreover, is his conviction that objections to an artist's nationality are essentially "illiberal." They reveal a narrowness of character in those who profess such sentiments while simultaneously impeding the development of what Reynolds believes must be an eclectic and organic institution ("foreign manure," he writes, will accelerate the Academy's growth). To buttress his remarks, he cites a counter-example in France twenty years ago, when the guiding spirit behind the famous Gobelins tapestry factory was a Scot, James Neilson.[121]

Such illiberality, furthermore, characterizes the second of Chambers's

objections, which is that "he was sorry to hear of Peers interfering in our little Academical concerns. That he was still more sorry to hear the P[resident] accused of being influenced by such undue applications."[122] Like Reynolds himself, Giuseppe Bonomi was indeed "under the Patronage and Protection" of the Earl of Aylesford, whom Reynolds painted three times (his name is entered in the painter's pocketbook for 10 February, the day of the election, as well as for the following week).[123] It is impossible to determine to what extent Aylesford's influence on Reynolds was indeed "undue"; Bonomi, after all, had become one of Reynolds's friends, and the painter thought highly enough of him to engage him in the creation of a monument in memory of Edmund Burke's sister, Juliana French, a year later.[124] Given the social and economic realities of the world in which he lives—and in which the Royal Academy has been established—Reynolds finds it difficult to take such an objection seriously. It is not a "disgrace," he argues, to have a patron, nor is it the duty of an Academician to determine where an artist has been born or who first recommended him. "Is it to be a fixed principal with the members of the Academy to set their faces against every artist that has had the good fortune to find a Patron"?[125] Such an attitude is both illiberal and unrealistic.

Having, to his satisfaction, refuted these specious arguments, Reynolds turns in the "Apologia" to an analysis of the institutional mission of the Academy and the role of its President. Throughout his defense, Reynolds argues that his colleagues must follow the rule of law within an institution sponsored by the King himself; they must put individual opinions and friendships aside and—like judges on the bench—"give their Vote to the general Interest and honour of the Academy."[126] He draws an analogy between the Academy and the larger civic polity in which they all participate: "no private friendship or even relation should outweigh the duty and obligation which they owed to society."[127] To act otherwise would be "disgracefull," a word that he tirelessly invokes as he pursues the distinctions that separate his own actions from those of his antagonists.

As the Academy's first President and "general Superintendent," Reynolds is obligated to "preserve and keep the Academy in repair," just as Sir William Chambers would be expected to replace a decaying pillar in the actual fabric of the building.[128] By filling the vacant Professorship, he is attempting to "make the Academy itself whole and complete."[129] Any attack upon the President himself, moreover, reflects badly on the entire institution: "Is any one so ignorant," he asks in an unpublished fragment entitled "The Academical Disputes," "as not to be sensible that degrading the President is undermining and destroying the credit & respectability of the whole Academy"?[130] To treat their "principal officer with unprovoked insolence" is preposterous, he argues.[131] Such behavior cannot be explained "unless their passion[s] were irritated by some irregular or overbearing tyrannical conduct in the President, so that it was irksome to them to do even their duty under such circumstance[s]."[132] Reynolds strongly believes that he has not engaged in such "tyrannical conduct," but he is also convinced of the deference that should be paid to anyone seated in the Academy's chair. Separating himself from his office, he insists that "as an individual I require no personal respect but sitting here as President I betray my trust if I do not require it. It is to be hoped that nothing of this *temper* remains any longer in the Academy."[133]

"*Temper*" is a polite and cool-headed description of the resistance Reynolds has encountered. Normally, as he reflects on the treatment he has received, he waxes intemperate himself, fuming at the "unprovoked" nature of the "insolence" or—more often—the "insult" he has received. The President's supporters within the Academy signed a note of protest in which they specifically pointed to this "unprovoked and unmerited personal insult to the President, from whose performances the Arts have received so much honour, and from whose services the Academy has received so many important benefits."[134] It was, in short, his opponents' insulting behavior, their contemptuous disrespect for the authority he personally and institutionally embodied, that galled both Reynolds and his followers. We have already seen how he chafed

when Richards ordered the Academy's servant to climb a flight of stairs in order to move Bonomi's drawings from one side of the room to the other. Near the end of the "Apologia" he mentions that the Academy's official letter of thanks to him was not even signed by the Chairman, "according to regularity & cust[o]m," "but by the Secretary alone and sent to the Ex President in the manner of a Common Note closed with a Waver and without even an Envelope and presented to the Ex president by the hands of the common errant boy of the A[cademy] . . . Whether this was studied neglect or ignorance of propriety I have no means of knowing."[135] All he can sadly conclude is that those who have now undertaken to administer the Royal Academy "are as little versed in the little requisites of civil intercourse, as they appear to be unknowing of the more substantial interest and true honour of that society of which they are member[s]."[136]

We do not know with whom—if anyone—Reynolds shared these drafts, although it is clear that the painter spoke with warmth to the friends who visited him in Leicester Square once he had resigned his post. He asked Bonomi if he could keep one of the fateful drawings so that he could display it as a "full vindication" of the work he had recommended. In a letter to the architect, he apologized for having been the cause of so much needless trouble and remarked that he could not persuade himself "any longer to rank with such beings."[137] Years later Bonomi would recall that Reynolds said to him, "pointing to the Hackney Coachman in Leicester Square, *'I would sooner belong to a club of such people as these than to that body.'*"[138]

When the crisis had passed, however, one of his nieces recorded him as being in "high spirits" as he prepared to resume the chair:

they had all acknowledged themselves wrong. He told me he would rather have declined accepting it again, as he feels himself getting old: but it was impossible after the concessions they had made him. Indeed he has reason to feel himself in spirits from the honour he gains by this affair, for all the kingdom have been interested about him, and that his resig-

nation would be a public loss. The King has behaved very handsomely to my uncle: at first in expressing his wish that he should not resign; and on Wednesday at the levee, when my uncle's message was delivered to him (I think by Lord Heathfield), whether he had his Majesty's permission to take his seat again, the King bid him "tell Sir Joshua that it was his most earnest wish that he should do so." [139]

By December, when he delivered his final discourse to the Academy, he was prepared to be generous indeed. Although he argued that none of the professorships "should be ever left unfilled," [140] he began by belittling the disputes of the previous winter: "Among men united in the same body, and engaged in the same pursuit, along with permanent friendship occasional differences will arise." [141] But these "little contentions" will not be noticed by others, and "they ought certainly to be lost amongst ourselves, in mutual esteem for talents and acquirements." Every controversy ought to be "sunk in our zeal for the perfection of our common Art." [142]

SIR JOSHUA'S FRENCH REVOLUTION

And so the controversy *has* sunk, and in reviving it I am interested not simply in placing Reynolds's behavior within the context of complacency—the art of pleasing—in which it clearly (if incongruously) fits, but in situating it in contemporary political discourse as well. The central issue, as I have suggested, is one of authority; and the major concern of Reynolds's contentious colleagues is whether the President has, in his own words, engaged in "overbearing tyrannical conduct" or presented the "appearance of a dictatorial style." It is interesting to note, for example, how often the lexicon of authority and tyranny is invoked by both Reynolds's friends and his foes. In his *Testimonies to the Genius and Memory of Sir Joshua Reynolds,* published in 1792, the year Reynolds died, Samuel Felton collected a number of poetical tributes that had appeared in the popular press. We thus find the poet "Fresnoy" exclaiming:

To thee, the Monarch of the finest art,
That charms the eye, and captivates the heart,
Both sexes kneel, all women and all men.[143]

Another anonymous writer in Felton's volume contemplates the Orphic head of Reynolds, affixed to a palette, floating down the Thames to Somerset House, where a pack of artists contends "to possess its brains."[144]

In his *Farewell Odes,* Peter Pindar alludes both to Reynolds's preeminence among contemporary painters and the consequent envy of his peers,[145] and this is the thematic focus of the Earl of Carlisle's "Verses to Sir Joshua Reynolds, On his late Resignation of the President's Chair of the Royal Academy." Carlisle argues that the painter is

Too wise for contest, and too meek for strife,
Like *Lear,* oppress'd by those you rais'd to life,
Thy sceptre broken, thy dominion o'er,
The curtain falls, and thou'rt a King no More.—[146]

"Accept again thy pow'r," his friend intones, "resume the Chair— / 'Nor leave it till you place an Equal there.' "[147] But even with such an exhortation, Carlisle's poem suggests that a significant moment in the drama of Reynolds's life has now been reached.

Several of Carlisle's motifs can be found in a long-winded defense of Reynolds that appeared at the same time. The author, Edward Jerningham, depicts a "wild Faction" only too eager to "Insult the Father of the modern school":

Oh, and is all forgot?—The sons rebel,
And, Regan-like, their hallow'd fire expel.
Cou'd not his faculties, so meekly borne,
Arrest the hand that fix'd the rankling thorn?

Mixing his metaphors even more strongly, Jerningham asks us to

Mark, mark the period, when the children stung
The parent's feelings with their serpent tongue;
It was while dimness veil'd the pow'rs of sight,
And ting'd all nature with the gloom of night.[148]

Reynolds appears in the poem, in swift succession, as King Lear, Christ, and Milton (if not God himself), and the Shakespearean analogy was quickly taken up by one of Reynolds's antagonists, the anonymous author of the *Observations on the Present State of the Royal Academy*, which was hurriedly printed in the spring of 1790 in an attempt to prevent Reynolds from returning to the chair. The self-proclaimed "Old Artist" who is responsible for the pamphlet notes that although Jerningham likened Reynolds to King Lear, the difference between the two is obvious: Lear withdrew after he had given everything to his daughters, whereas Reynolds withdrew because he could not keep everything to himself.[149]

Reynolds's associate is both clever and tireless in his defense of the Assembly's actions. We learn from him that the aging President expected "a continuance of that subservient disposition among the Academicians, which he had long been accustomed to receive from them."[150] But honorable men could not be expected to behave in a subservient fashion when their leader failed to speak truthfully with them: Reynolds is (unfairly) accused of incorrectly stating that Edwards had declined to be a candidate; he had no "justifiable authority to make such a declaration." In doing so, the President, he argues, "was guilty of a deception, as a public character, presiding in the Academy, which, I trust, he could never have brought himself to practice in his private capacity.—Indeed, he had been so long in the habit of dictating from his gilded chair, and had been so continually flattered by the submission of those over whom he presided."[151] In Reynolds's second letter addressed to Chambers, moreover, he is seen to insult his colleagues by letting it appear that he "quitted the Presidency of the Academy, because he could no longer be the tyrant of it."[152] During that Presidency,

"the love of power,—the thirst of rule,—and a dictatorial spirit have been evident, from the beginning of his administration to the close of it."[153] His resignation, this critic continues, will turn out to be advantageous to the Academy because selfish "patronage, caprice, and ambition" will be removed. Just as important, he argues, "the natural equality of power which belongs to the society at large, [will no longer] be swallowed by one overbearing and tyrannical individual."[154]

These are arguably exaggerated complaints, but they are far less heated than Reynolds's own response in the "Apologia," and they clearly and coherently present the perspective of those who did not flourish under this President's reign (Fuseli was suspected of having "a considerable hand in composing the pamphlet").[155] One of the most intriguing features of the argument elaborated here is the observation that, in polite society—in the world beyond the Academy—Sir Joshua's interpretation of the Bonomi affair will undoubtedly be accepted. Like so many other contemporary commentators, this author explains how the fledgling painter became a part of the society he depicted; but this time the narrative is not even grudgingly admiring of its subject. Because of "his elegant mode of living,—his general information, with the candour in which he knows how to clothe his opinions, and the amiable manners he can, at any time, assume,—as well as from his courtly disposition to pay all due respect to persons in superior station, he most certainly contrived to move in a sphere of society in which no Painter was seen to accompany him."[156] Because he is known in society only as a talented artist and "as a man of the most mild and pleasing demeanour," his friends in the great world have no difficulty in supporting his reputation and cause. And thus, as a consequence, "the tricks of his pencil,—the prejudice of his criticism, and his over-bearing love of power, are not known, or at least believed among them."[157] Edward Gibbon came to the same conclusion in a letter to his friend: "I hear you have had a quarrel with your Academicians. Fools as they are! for such is tyranny of character, that no one will believe your enemies can be in the right."[158] Tyranny of character (for Gibbon) was

tyranny of appearances—of reputation—for at least one of Reynolds's colleagues. The life-long practice of complacency had become a protective envelope even when Reynolds behaved in what appeared to be a very different fashion at the Royal Academy.

The language of tyranny, rebellion, and abdication that we find in Reynolds's writings and in those of his contemporaries is anything but exceptional; it can be found throughout most eighteenth-century discourse—which had inherited and domesticated the vocabulary of Shakespeare, Milton, Dryden, and Pope—and we have already encountered it during the turmoil that accompanied the founding of the Royal Academy: "it was a matter of the utmost indifference to you who was damned for it so that you got up to the heaven of a knighthood. Heaven itself cannot produce a more flagrant instance of base apostacy."[159] Reynolds makes an explicit connection in his "Apologia," however, between his own unapostasized state and Milton's vision of a world of fallen angels:

> no doubt appearances are against the Pr[esident]. He cannot
> reasonably expect such perfect confidence from the world in
> his favour—[that] like Uriel he *only is*
> faithful found
> Amongst the faithless faithful only He
> Amongst innumerable false.[160]

Reynolds's memory of the closing passage in Book V of *Paradise Lost* is not precisely accurate—and he is obviously thinking of Abdiel rather than Uriel—but the analogy poignantly reflects the painter's sense of alienation as well as self-righteousness. It can therefore hardly be a coincidence that, as Reynolds came to the close of his final discourse to the Academy on 10 December, Edmund Burke immediately rose, took the painter by the hand, and quoted the following lines from the opening of Book VIII:

The Angel ended, and in *Adam's* Ear
So charming left his voice, that he a while
Thought him still speaking, still stood fix't to
hear.[161]

Reynolds had intended "that the last words which I should pronounce in this Academy, and from this place, might be the name of—MICHAEL ANGELO,"[162] but his gesture was countered by that of Burke, whose clever analogy named Reynolds himself as—Raphael. It could be argued that Reynolds was in good company as either of Milton's angels, and it is clear that he saw both Burke and himself in Abdiel's role, for the following August he published a mezzotint from his best portrait of Burke, with Milton's lines describing his unfallen angel appended beneath it.[163]

It is likely that, if Reynolds shared his "Apologia" with anyone, he did so with Burke, whose counsel he sought more often than ever following the death of Johnson in 1784. We know that Reynolds and Burke were frequently together in 1789 and 1790; we know, moreover, that Burke shared his work with his long-time friend as he drafted his reflections on the French Revolution. The shared Miltonic allusions link Reynolds and Burke together in an intriguing way in 1790, but they also point to a much stronger bond between the two men, one that was political—cultural in the broadest sense of the term—as well as personal.

In twice invoking the allusion to Abdiel, Reynolds clearly saw both himself and his friend as outcasts: one from the Royal Academy, which had been established by the King; the other, as a Whig, from the ministry that currently directed the King's government. Both men, moreover, shared the same response to the political changes that were buffeting France and that had sent strong reverberations throughout England. And both writers therefore employed what Albert O. Hirschman has recently called "the rhetoric of reaction," a strategy by which the status quo is defended against what are perceived to be radical and dangerous agents of change. Much of Reynolds's reaction to the

dispute at the Royal Academy in 1790 was influenced by his sense of the broader changes that were threatening both French and English society; and thus the Bonomi affair might best be seen as a reflection or re-enactment in miniature of the political tumult that had engulfed France and still posed dangers within England. Burke entitled his book, after all, *Reflections on the Revolution in France, and on the Proceedings in Certain Societies in London Relative to that Event*,[164] and it was largely through his friend's eyes that Reynolds interpreted these disturbing events.

As early as 1778, Johnson in fact complained that Reynolds was unduly influenced by Burke in his political views: "Reynolds is too much under Fox and Burke at present," he told Boswell. "He is under the *Fox star* and the *Irish constellation*. He is always under some planet."[165] Boswell might have countered by noting that both he and Reynolds were primarily of Johnson's school, and that Johnson did not easily countenance what he considered laxity in his friends' political views. Northcote was more even-handed, noting that both men were under great obligations to each other.[166] But even Northcote was easily misled by Reynolds's response *in society* to the French Revolution, claiming that the painter did not mingle in the political debates at the Club in 1789, instead preserving "the same friendly tenor of conduct and suavity of manners to his associates there, that he exercised towards all men in private life: for politics never amused him nor ever employed his thoughts a moment."[167]

Others knew better. Boswell had written to Reynolds about his convictions as bluntly as he could in 1784: "I know your political principles, and indeed your settled system of thinking upon civil society and subordination, to be according to my own heart."[168] And thus when Charles James Fox's niece, Caroline, burst out "into glorification of the Revolution" during a dinner conversation with Reynolds at Holland House, she was, in her own words, "grievously chilled and checked by her neighbour's cautious and unsympathetic tone."[169] Malone, who was as vehement in his denunciation of the French as Burke himself, praises

his friend for "the rectitude of his judgment concerning those pernicious doctrines" that fueled the Revolution.[170] Reynolds "was lavish in his encomiums" on the *Reflections*, "never weary of expressing his admiration of the profound sagacity which saw, in their embryo state, *all the evils with which this country was threatened by that tremendous convulsion.*"[171] Reynolds well knew how eagerly "all the wild and erroneous principles of government" the revolutionaries were attempting to establish in France "would be cherished and enforced by those turbulent and unruly spirits among us, whom *no King could govern, nor no God could please.*" The allusion to "Absalom and Achitophel" is Reynolds's own, for Malone tells us that, long before the *Reflections* were published, Reynolds frequently "avowed his contempt of those 'Adam-wits,' who set at nought the accumulated wisdom of ages, and on all occasions are desirous of beginning the world anew."[172] Although Reynolds's voice is filtered through Malone's own virulence here, both the language and the sentiments are consonant with the apologist who would lament, a few months later, that "the whole Fabric the work of years was shaken to its very foundation and all its glory tarnishd."[173]

Reynolds visited the Burkes at Beaconsfield in July and then in mid-October 1789, just a few weeks before Burke would write his famous first letter to Charles-Jean-François Depont concerning "the astonishing scene now displayed in France."[174] Burke showed part of the *Reflections* to Reynolds and a small handful of other friends early in 1790; one of them, Sir Philip Francis, conveyed his strictures to Burke on 19 February, and it is clear from their correspondence that Burke was circulating a substantial section of the book in both manuscript and proofsheets, including the famous set-piece on Marie Antoinette.[175] It is this important passage, perhaps above all others, that would strike the deepest chord in Reynolds: not the theatrical handling of the mob's invasion of the royal palace at Versailles, necessarily, but the moral Burke drew from this event when he concluded that "the age of chivalry is gone" and with it the principles of "subordination" and "obedience" that had their origin in this ancient code.[176]

"Are all orders, ranks, and distinctions to be confounded?" Burke asked in another famous outburst earlier in the *Reflections*.[177] The "mixed system of opinion and sentiment" based on "the antient chivalry" has, "without confounding ranks," produced "a noble equality, and handed it down through all the gradations of social life." "It was this opinion which mitigated kings into companions, and raised private men to be fellows with kings. Without force, or opposition, it subdued the fierceness of pride and power; it obliged sovereigns to submit to the soft collar of social esteem, compelled stern authority to submit to elegance, and gave a domination vanquisher of laws, to be subdued by manners."[178] Burke's discourse on a vanishing social economy in Europe—a discourse based on "manners" in the broadest sense of the word—bears a striking resemblance to Joseph Addison's description of the virtues of complaisance, with which we are already familiar. Complaisance, he wrote,

> renders a Superior amiable, an Equal agreeable, and an Inferior acceptable. It smooths Distinction . . . produces Good-nature and mutual Benevolence, encourages the Timorous, sooths the Turbulent, humanises the Fierce and distinguishes a Society of Civilised Persons from a Confusion of Savages. In a word, Complaisance is a Virtue that blends all Orders of Men together in a Friendly Intercourse of Words and Actions.[179]

The principles of chivalry, Burke remarked, also harmonize "the different shades of life"; they incorporate into politics "the sentiments which beautify and soften private society."[180] Such virtues, such sentiments may depend upon all "the pleasing illusions" that make power gentle and obedience liberal, as Burke puts it, but they are nevertheless essential to the maintenance of civilized society. "There ought to be a system of manners in every nation which a well-formed mind would be disposed to relish," Burke concludes. "To make us love our country, our country ought to be lovely."[181]

Burke acknowledges that the line of demarcation signaling "where

obedience ought to end, and resistance must begin, is faint, obscure, and not easily definable."[182] Revolutions should not be determined by single acts or events; governments must be "abused and deranged indeed" before their subjects may act; and, whether one's cause is right or wrong, "a revolution will be the very last resource of the thinking and the good."[183] Burke is therefore adamant in his portrayal of a stable, unchanging England founded on native prejudice and "our sullen resistance to innovation."[184] We have not materially changed in four hundred years, he argues: "we still feel within us, and we cherish and cultivate, those inbred sentiments which are the faithful guardians, the active monitors of our duty, the true supporters of all liberal and manly morals."[185] Burke's essential conservatism—"A disposition to preserve, and an ability to improve, taken together, would be my standard of a statesman. Everything else is vulgar in the conception, perilous in the execution"[186]—leads him to embrace gradual, even "imperceptible" growth.[187] To preserve *and* to reform is quite different from what has been proposed by those whose motive it is "to destroy an old scheme of things, because it is an old one."[188] Like Reynolds, Burke invokes what Hirschman defines as "the perversity thesis": the argument that any "purposive action to improve some feature of the political, social, or economic order only serves to exacerbate the condition one wishes to remedy."[189] The "work of ages" cannot be reformed in a few months, Burke writes,[190] although it may well be destroyed. Or, as Reynolds had declared in his seventh discourse, "Men's minds must be prepared to receive what is new to them. Reformation is a work of time."[191]

The contours of Burke's famous defense can thus be read as a gloss on Reynolds's experience at the Royal Academy and his reactions to it in February and March of 1790, but it would presumably be more accurate to say that Burke's own discourse set the broader terms for the painter's response. In the *Reflections* Reynolds would have heard his friend cautioning against "*new* power in *new* persons" and speculating that "those who quit their proper character, to assume what does not belong to them, are, for the greater part, ignorant both of the character

they leave, and of the character they assume."[192] Surely this is advice that Reynolds would have kept in mind when, in the "Apologia," he decried an antagonist (Tyler) who presumed "to interfere in a higher station where he has crept in by mere accident."[193] In the *Reflections* Reynolds would have read of insidious "cabals," a "gang of usurpers," traitors, bold and faithless men, rash and ignorant counsel, "turbulent, discontented men," daring and violent men who teach "servile, licentious, and abandoned insolence."[194] He would have seen his friend describe the treacherous breeding-ground of academies and clubs in both France and England, and would have heard him support the integrity of the English constitution with precisely the same metaphorical insistence on the wholeness of this edifice or "fabric" that he would adopt in his own defense of the Royal Academy's constitution.[195] For Reynolds, as for Burke, "historically sanctioned practices are to be cherished for something apart from themselves," as David Bromwich has recently noted: "The value they represent, and in the name of which [Burke] defends them, is *order*."[196]

It is possible that Reynolds began to frame his own thoughts on the revolution in France. Hilles discovered that, on the back of Mary Palmer's fair copy of the fifteenth discourse, Reynolds had written the gist of an argument concerning the downfall of the ancien régime: the Bourbons, he wrote, cultivated arts that added splendor to the nation but they neglected more fundamental trades that would support the French economy. The French may have placed too great an emphasis on ornament, Reynolds writes, "but does it follow that a total revolution is necessary," "that because we have given ourselves up too much to the ornaments of life, we will now have none at all"?[197] This was already an established principle in Reynolds's mind, one that he had adumbrated in the seventh discourse, in which he warned that "he who neglects the cultivation of those ornaments, acts contrary to nature and reason"[198] In the final discourse itself, Reynolds boasted that "it is no small satisfaction to be assured that I have, in no part of [my lectures], lent my assistance to foster *newly-hatched unfledged* opinions."[199] One of the

principal objects of his addresses has been to ensure that "the young Artist" is not seduced from the right path by following "what, at first view, he may think the light of Reason."[200]

This distrust of showy appearances, of facile novelty, is also at the heart of Reynolds's final commentary on the French Revolution, his so-called Ironic Discourse. Like his remarks on the fall of the *ancien régime,* this unfinished and long-unpublished essay was written on the verso of the fair copy of his final discourse,[201] and both in physical format and in its ironic argument it should be seen as a substantiation of Burke's dictum in the *Reflections* that "to make everything the reverse of what they have seen is quite as easy as to destroy."[202] Indeed, for Reynolds as well as for Burke, to reverse *is* to destroy.

Reynolds's "sixteenth" discourse, which his friends persuaded him could "bring up the rear of his last volume,"[203] may itself be ironic, but the painter's introduction, written in the third person, is as straight-forward as it can be. Here we learn that Reynolds's ironic experiment in fact owes its origin to a conversation on Burke's *Reflections,* a book that he enthusiastically admired "both in regard to the doctrine which it contained, and the eloquence in which that doctrine was conveyed."[204] The conversation turning to "the power which is lodged in majorities," Sir Joshua argued that, in politics as well as in art, matters should be determined by the learned few rather than "the ignorant majority." The tree of knowledge, after all, "does not grow upon a new made, slender soil"—a favorite Burkean metaphor—"but is fastened by strong roots to ancient rocks, and is the slow growth of ages." Learning may be more widely diffused than before, but this "smattering of knowledge" does not qualify people to "set up for legislators" in either politics or the arts: "Few people reach the summit from which they look down on the rest of mankind."[205] To be a politician, Reynolds adds, is "as much a trade or profession as his own"; like a true taste in art, the science of politics is acquired by study and labor.[206]

These principles and suppositions, to which Reynolds and his friends so easily and firmly adhere, are nevertheless felt to be out of step with

the views of those whom the painter variously calls the majority, the vulgar, the ignorant; and in a playful, malicious moment he therefore speculates on what it would be like to produce a lecture that would actually "come home to the bosoms of the ignorant (which are always the majority)." Such a set of ironic pronouncements would be thought to contain more "sound doctrine" than what Reynolds normally delivers in the Academy; "proceeding *ex cathedra*" from the President's chair, such a discourse "would probably so poison the minds of the students as might eventually keep back the harvest of arts which we expect from the nation, perhaps for fifty years."[207] If Reynolds (like Burke) argued on behalf of prejudice in the fifteenth discourse, for example, he would simply reverse his argument in its successor: "But shall we in these enlightened times tamely adopt and inherit their ignorant prejudices? No! Let us examine everything by the standard of our own reason, renounce all prejudices for the reputed wisdom of others."[208] And if, in the fifteenth discourse, Reynolds drew his students' attention to the firm ground on which "the fabrick of our Art is built,"[209] the absurdity of his ironic vision, he trusted, would reinforce his views in the sixteenth: "Destroy every trace that remains of ancient taste. Let us pull the whole fabric down at once, root it up even to its foundation. Let us begin the art again upon this solid ground of nature and reason. The world will then see what naked art is, in its uneducated, unprejudiced, unadulterated state."[210] These are the sentiments—and this is the language—in which, in the "Apologia," Reynolds had already cast the voices of Chambers and Richards, Tyler and Banks.

Malone decided not to include the Ironic Discourse in his friend's collected works, and it remained among Boswell's papers, unpublished and unknown, until 1952. One cannot help but wonder how William Blake would have annotated it, considering that it already represented an ironic and contradictory marginal gloss no less acidulous than Blake's own (although with quite different intentions and effects). The Ironic Discourse's vehemence and elitism—indeed, its self-complacency—should be compared to the more generous remarks Reynolds

made at a dinner party at Topham Beauclerk's in April 1775. According to Boswell, Reynolds said that "the more artificial wants we could make to be gratified, the greater our happiness. That this was the advantage of civilized society. He said he saw in this nation all the symptoms of a great and flourishing state: magnificence, elegance, plenty; everybody living better than formerly."[211] The following fifteen years, however, have clearly brought significant changes. The gratification of "artificial wants" has led, in France at least, to the fatal neglect of fundamental needs;[212] and the benignity, the egalitarianism of Reynolds's optimistic view has been quenched by forces, resistance, opposition that he can no longer entirely control. If the majority were still living better in 1790, in Reynolds's eyes they were behaving worse.

At one point, Boswell, into whose hands many of Reynolds's papers fell, clearly intended to write a proper life of his friend; he collected material, and he drafted a few preliminary biographical sketches.[213] It was generally assumed that Boswell abandoned his scheme because he was not familiar enough with the painter's profession, and there is probably some truth in this. But Boswell had learned a great deal in writing his life of Johnson, and it appears that he doubted whether Reynolds would make a proper biographical subject. Following Reynolds's death in 1792, he wrote that "Sir Joshua was indeed a man of pleasing and various conversation, but he had not those prominent features which can be seized like Johnson's." Although Boswell had been able to gather various anecdotes concerning him, he confessed that "I doubt much whether I could write a life of him."[214] Boswell's dilemma lay precisely in his friend's virtues, amiability, and success. The easy affability and gentle manners that had characterized Reynolds both socially and professionally throughout his career would ironically work against him within a biographical narrative. Reynolds's complaisance, his art of pleasing, his very blandness (to adopt Goldsmith's word)— everything that was prized by his friend posed problems for his biographer. As Burke wrote to Malone in 1795, "The very qualities which made the society of our late friend so pleasant to all who knew him,

are the very things that make it difficult to write his Life, or to draw his Character."[215] It was also a life without real drama—except, of course, for the Bonomi affair—and here Boswell also found himself stymied, for he told Joseph Farington that in publishing a life of Reynolds he would probably offend his niece, Mary Palmer (now Lady Inchiquin), since he believed that Reynolds was actually to blame in his quarrel at the Royal Academy.[216]

The Bonomi affair therefore represents, among other things, Sir Joshua's French Revolution: the point at which a distinguished public figure, someone who had endeavored to elevate the status of the arts within English culture, found himself betrayed, abandoned, attacked, deposed by the very people it had been his obligation to nurture and protect. He argued along institutional lines, attempting to separate himself personally from the presidential chair in which he sat; but he could not see that he had, in a sense, *become* the establishment, that his own inflexibility and sense of self-worth posed inherent dangers to an academy designed to train new generations of artists.

Partially blind, almost totally deaf, deprived of the principal activity that had given his life meaning, he became, like his Ironic Discourse, a counter-example to so much that he had personally or professionally embodied. Reynolds's confrontation with his fellow Academicians provides a full and complicated example, moreover, of what Patricia Crown has recently characterized as the essential dialectic of eighteenth-century art, which she describes "as a series of ruptures with tradition and the establishment's attempts to suppress what were perceived as artistic insurrections."[217] But the issues embedded in Reynolds's resignation should also remind us of how intricately the career of one painter intersects with the life of artistic institutions, with contemporary political discourse and actual historical events, and with the shifting social formations in which both private individuals and public entities are grounded.

Abbreviations

Barrell, *The Political Theory of Painting*	John Barrell, *The Political Theory of Painting from Reynolds to Hazlitt: "The Body of the Public."* New Haven: Yale Univ. Press, 1986.
Boswell's Life of Johnson	James Boswell, *Boswell's Life of Johnson,* ed. George Birkbeck Hill, rev. L. F. Powell. 6 vols. Oxford: Clarendon Press, 1934–1950; 2nd ed. of vols. 5–6, 1964.
Burke, *Correspondence*	Edmund Burke, *The Correspondence of Edmund Burke,* ed. Thomas W. Copeland et al. 10 vols. Cambridge: Cambridge Univ. Press; Chicago: Univ. of Chicago Press, 1958–1978.
Burke, *Reflections*	Edmund Burke, *The French Revolution, 1790–1794,* ed. L. G. Mitchell. *The Writings and Speeches of Edmund Burke,* vol. 8. Oxford: Clarendon Press, 1989.
Cotton, *Sir Joshua Reynolds, and His Works*	William Cotton, *Sir Joshua Reynolds, and His Works.* Ed. John Burnet. London, 1856.
Cotton, *Sir Joshua Reynolds' Notes and Observations*	*Sir Joshua Reynolds' Notes and Observations on Pictures, Chiefly of the Venetian School, Being Extracts from His Italian Sketch Books,* ed. William Cotton. London, 1859.
Farington, *Diary*	Joseph Farington, *The Diary of Joseph Farington,* ed. Kenneth Garlick, Angus Macintyre, and Kathryn Cave. 16 vols. to date. New Haven and London: Yale Univ.

Press for the Paul Mellon Centre for Studies in British Art, 1978–.

Farington, *Memoirs*	Joseph Farington, *Memoirs of the Life of Sir Joshua Reynolds.* London, 1819.
Felton, *Testimonies*	[Samuel Felton], *Testimonies to the Genius and Memory of Sir Joshua Reynolds. Compiled by John Cranch.* London, 1792.
Gwynn, *Memorials*	Stephen Gwynn, *Memorials of an Eighteenth Century Painter (James Northcote).* London, 1898.
Haydon, *Diary*	Benjamin Robert Haydon, *The Diary of Benjamin Robert Haydon,* ed. Willard Bissell Pope. 5 vols. Cambridge: Harvard Univ. Press, 1960–1963.
Hazlitt, *Complete Works*	William Hazlitt, *Complete Works,* ed. P. P. Howe. 21 vols. London and Toronto: J. M. Dent, 1930–1934.
Hilles, *Literary Career*	*The Literary Career of Sir Joshua Reynolds,* ed. Frederick W. Hilles. Cambridge: Cambridge Univ. Press, 1936; rpt. Hamden, Conn.: Archon, 1967.
Hudson, *Reynolds*	Derek Hudson, *Sir Joshua Reynolds: A Personal Study.* London: Bles, 1958.
Johnson, *Letters*	Samuel Johnson, *The Letters of Samuel Johnson,* ed. Bruce Redford. The Hyde Edition. 5 vols. Princeton: Princeton Univ. Press; Oxford: Clarendon Press, 1992–1994.
Johnsonian Miscellanies	*Johnsonian Miscellanies,* ed. George Birkbeck Hill. 2 vols. Oxford, 1897.
Leslie and Taylor	Robert Charles Leslie and Tom Taylor, *Life and Times of Sir Joshua Reynolds: With Notices of Some of His Cotemporaries.* 2 vols. London, 1865.
Malone	Edmond Malone, "Some Account of the Life and Writings of Sir Joshua Reynolds," in *The Works of Sir Joshua Reynolds,* ed. Malone, 1:iii–lxxi. 2 vols. London, 1797.
Mannings, *Self Portraits*	David Mannings, *Sir Joshua Reynolds PRA (1723–1792): The Self Portraits.* Plymouth: Plymouth City Museums and Art Gallery, 1992.

Northcote, *Life*	James Northcote, *The Life of Sir Joshua Reynolds.* 2nd edn. 2 vols. London, 1818. (Mrs. Piozzi's copy, now in the Houghton Library, contains her marginalia.)
Penny, *Reynolds*	*Reynolds,* ed. Nicholas Penny. London: Royal Academy of Arts and Weidenfeld and Nicolson; New York: Abrams, 1986.
Postle, *Sir Joshua Reynolds: The Subject Pictures*	Martin Postle, *Sir Joshua Reynolds: The Subject Pictures.* Cambridge: Cambridge Univ. Press, 1995.
Radcliffe, *Sir Joshua's Nephew*	*Sir Joshua's Nephew: Being Letters Written, 1769–1778, by a Young Man to His Sisters,* ed. Susan M. Radcliffe. London: John Murray, 1930.
Reynolds, *Discourses*	Sir Joshua Reynolds, *Discourses on Art,* ed. Robert R. Wark. 1959; 2nd edn., New Haven and London: Yale Univ. Press for the Paul Mellon Centre for Studies in British Art, 1975.
Reynolds, *Letters*	Sir Joshua Reynolds, *Letters of Sir Joshua Reynolds,* ed. Frederick Whiley Hilles. 1929; rpt. New York: AMS Press, 1976.
Reynolds, *Portraits*	Sir Joshua Reynolds, *Portraits,* ed. Frederick W. Hilles. London: Heinemann; New York: McGraw-Hill, 1952.
Ward, *Conversations*	James Ward, *Conversations of James Northcote R.A. with James Ward on Art and Artists,* ed. Ernest Fletcher. London: Methuen, 1901.
Wendorf, *The Elements of Life*	Richard Wendorf, *The Elements of Life: Biography and Portrait-Painting in Stuart and Georgian England.* Oxford: Clarendon Press, 1990; corrected edn., 1991.
Wendorf and Ryskamp, "A Blue-Stocking Friendship"	Richard Wendorf and Charles Ryskamp, "A Blue-Stocking Friendship: The Letters of Elizabeth Montagu and Frances Reynolds in the Princeton Collection." *Princeton University Library Chronicle* 41 (1979–1980): 173–207.
Whitley, *Artists and Their Friends*	William T. Whitley, *Artists and Their Friends in England, 1700–1799.* 2 vols. London and Boston: Medici Society, 1928.

Notes

Introduction

1. I should make it clear that I am *not* paying particular attention to the ways in which politeness is reflected or embodied in Reynolds's own paintings. This subject has frequently been raised in relation to early eighteenth-century portraiture, often by linking specific poses with visual exemplars in etiquette and conduct books of the period; the focus of such studies is thus on the sitter's attitude, gesture, expression, or air. See Alastair Smart, "Dramatic Gesture and Expression in the Age of Hogarth and Reynolds," *Apollo* 82 (1965): 90–97, and *Allan Ramsay: Painter, Essayist, and Man of the Enlightenment* (New Haven and London: Yale Univ. Press for the Paul Mellon Centre for Studies in British Art, 1992), pp. 49–52; David Mannings, "A Well-Mannered Portrait by Highmore," *Connoisseur* 189 (June 1975): 116–119; Arline Meyer, "Re-Dressing Classical Statuary: The Eighteenth-Century 'Hand-in-Waistcoat' Portrait," *Art Bulletin* 77 (March 1995): 45–63; and—for a wide-ranging survey of the customs themselves—Joan Wildeblood and Peter Brinson, *The Polite World: A Guide to English Manners and Deportment from the Thirteenth to the Nineteenth Century* (London: Oxford Univ. Press, 1965). Brian Allen, "The Age of Hogarth, 1720–1760," in *The British Portrait, 1660–1960* (Woodbridge, Suffolk: Antique Collectors' Club, 1991), pp. 129–183, provides a useful discussion of how slowly the Augustan faces of Kneller's generation were supplanted by the more sophisticated and open countenances painted by Gainsborough and Reynolds. The art they inherited, he writes, was "devoid of even the slightest glimmer of humour. Gentility must be enhanced and preserved at all times, stressing the somewhat impersonal public role of the polite, well-bred gentleman"

(p. 131). Mannings offers a similar description of the "self-control" and "equanimity" that characterize the social codes underlying the sobriety of male portraiture early in the century; see "Shaftesbury, Reynolds, and the Recovery of Portrait-Painting in Eighteenth-Century England," *Zeitschrift fur Kunstgeschichte* 48 (1985): 319–328.

2. *Boswell's Life of Johnson,* 5:211.

3. Reynolds, *Discourses,* p. 230.

4. I am indebted, in part, to Andrew Hemingway, *Landscape Imagery and Urban Culture in Early Nineteenth-Century Britain* (Cambridge: Cambridge Univ. Press, 1992), p. 14, for this formulation.

5. Bourdieu, *Distinction: A Social Critique of the Judgement of Taste,* trans. Richard Nice (Cambridge: Harvard Univ. Press, 1984), p. 101; see also his *Outline of a Theory of Practice,* trans. Richard Nice (Cambridge: Cambridge Univ. Press, 1977), pp. 82–87.

6. Edward Young, *Conjectures on Original Composition* (1759), in *Eighteenth-Century English Literature,* ed. Geoffrey Tillotson, Paul Fussell, Jr., and Marshall Waingrow (New York: Harcourt Brace Jovanovich, 1969), p. 878.

7. Royal Academy MS. Nor/5 (21 Sept. 1771); cf. Gwynn, *Memorials,* p. 112, quoted below in Chapter 3.

8. In *Poetry As an Occupation and an Art in Britain, 1760–1830* (Cambridge: Cambridge Univ. Press, 1993), Peter T. Murphy offers a somewhat similar analysis of the relationship between poetic and social propriety in the career of Robert Burns. Burns is a more extreme example, of course, of the provincial outsider—"The society he wishes to enter is a decorous one, and he is not a decorous person" (p. 3)—but Murphy's alignment of artistic and social behavior, his insistence that "writing poetry in a culture in which poetic form is alive is a way of behaving," bears many similarities to the paradigm I ascribe to Reynolds.

9. See Richard Wendorf, "The Artful Encounter," *Humanities* 14:4 (July–Aug. 1993): 9–10.

10. Interview, Dec. 1991.

11. See "On Sitting for One's Picture," in Hazlitt, *Complete Works,* 12:107–116, and my discussion below, in Chapter 4.

12. Quoted by Susan Sontag, *On Photography* (New York: Farrar, Straus and Giroux, 1977), p. 187.

13. *Boswell's Life of Johnson,* 1:447; Kramnick, *Republicanism and Bourgeois Radicalism: Political Ideology in Late Eighteenth-Century England and America* (Ithaca: Cornell Univ. Press, 1990), p. 4.

14. Leslie and Taylor, 2:611.

15. Solkin, "Great Pictures or Great Men? Reynolds, Male Portraiture, and the Power of Art," *Oxford Art Journal* 9:2 (1986), esp. pp. 42, 47–48. Solkin's powerful

argument in this essay needs to be qualified in several ways. First, it is far from clear that the aristocracy lost any of its power during the eighteenth century; if anything, it may well have gained ground. See John Cannon, *Aristocratic Century: The Peerage of Eighteenth-Century England* (Cambridge: Cambridge Univ. Press, 1984), Linda Colley, *Britons: Forging the Nation, 1707–1837* (New Haven: Yale Univ. Press, 1992), ch. 4, and J. C. D. Clark, *English Society, 1688–1832: Ideology, Social Structure, and Political Practice during the Ancien Régime* (Cambridge: Cambridge Univ. Press, 1985), pp. 104–106, who nevertheless argues that "England increasingly possessed a unified, not a stratified, patrician corps. It expressed the solidarity not of a caste or of an economically-defined class but, principally, of a culturally-defined elite" (p. 103). Second, even if the central issue is whether the aristocracy was *thought* to lose power, one needs to gather considerably more contemporary evidence than Solkin does in order to mount a plausible case; and some of that evidence should naturally come from the mouths of aristocrats as well as commoners. Colley is particularly good at showing how a sense of vulnerability may have washed across England's political elite following the nation's defeat in the American War of Independence, but this came virtually at the close of Reynolds's career. Third, as I have suggested above, an argument that views Reynoldsian portraiture as part of a sophisticated effort to prop up a psychologically impoverished nobility needs to be placed in the context of Reynolds's work as a whole, which includes a virtual pantheon of exalted commoners whom Reynolds further exalts—Burke, Johnson, Goldsmith, Burney, Garrick, Siddons. In this particular essay, Solkin figures Reynolds as an appropriate successor to the Richard Wilson he revealed (literally unmasked) in his landmark Tate Gallery exhibition (and with Reynolds quite conscious of the ambitious role he plays). I think, finally, that the essay is too neat and too narrowly argued, but I cannot think of anything else written about Reynolds—with the possible exception of John Barrell's chapter on the *Discourses* in *The Political Theory of Painting*—that genuinely provokes fundamental reassessment. One might compare Solkin's argument, moreover, with the following (and, to my mind, simplistic) assessment of Gainsborough's society portraits by Jack Lindsay in *Thomas Gainsborough: His Life and Art* (New York: Universe Books, 1981), p. 3: "he had to maintain his interest in the rich or noble people he depicted by concentrating on the problems of paint they set him with the fine texture of their clothes, the ringlets of their hair, and so on: not so that he might glorify the sitters, but so that he might learn more about ways of seeing and representing the subtle textures and movement of forms in the world of nature."

16. Kramnick, *Republicanism and Bourgeois Radicalism*, p. 4. See Lawrence Stone and Jeanne C. Fawtier Stone, *An Open Elite? England, 1540–1880* (Oxford: Clarendon Press, 1984), for a cautionary examination of this problem.

17. *Painting and the Politics of Culture: New Essays on British Art, 1700–1850,*

ed. John Barrell (Oxford and New York: Oxford Univ. Press, 1992), p. 4. Cf. E. P. Thompson, *Customs in Common* (New York: The New Press, 1991), p. 6: "indeed, the very term 'culture,' with its cosy invocation of consensus, may serve to distract attention from social and cultural contradictions, from the fractures and opposi-tions within the whole."

18. Hazlitt, "Whether Genius Is Conscious of Its Powers?" in *Complete Works*, 12:117.

19. Northcote is a particularly slippery source, and I have therefore added other documentation whenever possible. On the collaborative nature of Northcote's bi-ography of Reynolds, see Ronald Lightbown's introduction to the facsimile edition; for the often fuzzy distinction between what should be attributed to Northcote and what to Hazlitt, see Haydon, *Diary*, 3:464.

20. See Joel Fineman, "The History of the Anecdote: Fiction and Fiction," in *The New Historicism*, ed. H. Aram Veeser (New York: Routledge, 1989), for a recent rehabilitation of a form that he views as a "*historeme*, i.e., as the smallest minimal unit of the historiographic fact," and as "the literary form or genre that uniquely refers to the real" (pp. 57, 56). One might ask whether, in Fineman's scheme, bi-ography is somehow not a literary form or fails to refer to the real.

21. Pointon, *Hanging the Head: Portraiture and Social Formation in Eighteenth-Century England* (New Haven and London: Yale Univ. Press for the Paul Mellon Centre for Studies in British Art, 1993), glances at the social environment of the studio and at the "performance art" inscribed within a theory of portraiture as process rather than as product (p. 41); but here, as elsewhere, the broad scope of her study prevents her from closely examining issues that I take to be crucial to an understanding of portrait-painting in the eighteenth century. My own approach might be thought of as the complement to hers—and thereby, one might argue, burdened by restrictions of its own.

22. Pollock, *Vision and Difference: Femininity, Feminism, and Histories of Art* (London: Routledge, 1988), p. 97.

23. See Hilles, *Literary Career*, p. 77, where Reynolds goes so far as to suggest that one might well write about an author in order to discover his ignorance.

24. *The New Art History*, ed. A. L. Rees and Frances Borzello (Atlantic High-lands, N.J.: Humanities Research International, 1988), p. 8.

25. Thompson, *Customs in Common*, pp. 57, 71, 85.

1. The Art of Pleasing

1. Burke, *Correspondence*, 7:75–76 (Yale Center for British Art, MS. Reynolds 55). Burke's later addition to this assessment can be found in his *Correspondence*, 9:329 (quoted in Chapter 2, above); the ms., with Edmond Malone's commentary,

is in the library of the Victoria and Albert Museum (Forster Collection, MS. 48 D2, 13/1–2).

2. *Boswell's Life of Johnson*, 5:102; cf. 1:2.

3. [Frances Burney D'Arblay], *Memoirs of Doctor Burney* (London, 1832), 1:343.

4. *Boswell's Life of Johnson*, 1:1.

5. *Collected Works of Oliver Goldsmith*, ed. Arthur Friedman (Oxford: Clarendon Press, 1966), 4:358.

6. Burke, *Correspondence*, 7:76.

7. *The Guardian*, ed. John Calhoun Stephens (Lexington: Univ. Press of Kentucky, 1982), p. 527. The concept of complaisance was embedded in much courtesy literature of the seventeeth century, and at least once surfaced as the specific subject of such a book: see *The Art of Complaisance or the Means to oblige in Conversation*, 2nd edn. (London, 1677).

8. *The Guardian*, p. 528.

9. Ibid.

10. Ibid.

11. Ibid., p. 529.

12. James Prior, *Life of Edmond Malone, Editor of Shakespeare* (London, 1860), p. 190.

13. Forrester, *The Polite Philosopher* (1734), p. 12.

14. Ibid., pp. 14, 24.

15. Ibid., p. 55.

16. *Boswell's Life of Johnson*, 1:1, 3:5.

17. Malone, 1:xliii–xliv.

18. Northcote, *Life*, 1:179.

19. Hilles, *Literary Career*, p. 183.

20. Northcote, *Life*, 1:67.

21. Ibid. *Like* a man of great mind but *not* a man of great mind? Northcote's construction is awkward, ambiguous, or both.

22. Burke, *Correspondence*, 9:329; Boswell, *Letters of James Boswell*, ed. Chauncey Brewster Tinker (Oxford: Clarendon Press, 1924), 2:441.

23. Hesther Lynch Thrale Piozzi, *Anecdotes of the Late Samuel Johnson, LL.D.*, in *Memoirs and Anecdotes of Dr. Johnson*, ed. Arthur Sherbo (London: Oxford Univ. Press, 1974), p. 129.

24. Pevsner, *The Englishness of English Art* (1956; rpt. Harmondsworth: Penguin, 1964), pp. 74, 79.

25. Gwynn, *Memorials*, p. 114.

26. Northcote, *Life*, 1:55.

27. Reynolds, *Letters*, p. 121.

28. In *Literary Career,* p. xx, Hilles notes Reynolds's use of this word, but he gives no examples.

29. Wind, *Hume and the Heroic Portrait: Studies in Eighteenth-Century Imagery,* ed. Jaynie Anderson (Oxford: Clarendon Press, 1986), ch. 1.

30. Leslie and Taylor, 2:641–642; cf. Svetlana Alpers's approach in *Rembrandt's Enterprise: The Studio and the Market* (Chicago: Univ. of Chicago Press, 1988), esp. ch. 4.

31. *The Guardian,* pp. 527, 528.

32. *Miscellanies by Henry Fielding, Esq., Volume One,* ed. Henry Knight Miller (Oxford: Clarendon Press; Middletown, Conn.: Wesleyan Univ. Press, 1972), pp. 123, 142.

33. *The Guardian,* p. 143.

34. Hazlitt, *Complete Works,* 11:294.

35. Christopher Lawrence, "The Nervous System and Society in the Scottish Enlightenment," in *Natural Order: Historical Studies of Scientific Culture,* ed. Barry Barnes and Steven Shapin (Beverly Hills and London: Sage, 1979), pp. 19–40, explores the social consequences of positing direct correlations between the physiognomy of a gentleman's or laborer's nervous system (on the one hand) and his comparative taste or sensibility (on the other); but see also Paul Langford, *A Polite and Commercial People: England, 1727–1783* (Oxford: Clarendon Press, 1989), p. 120, who quotes the remarks of the poet-physician John Armstrong on servants born with sensations as delicate as those of their masters.

36. See John Barrell, *English Literature in History, 1730–80: An Equal, Wide Survey* (London: Hutchinson; New York: St. Martin's Press, 1983), ch. 1, and *The Political Theory of Painting,* pp. 17–20; Lawrence Klein, "The Third Earl of Shaftesbury and the Progress of Politeness," *Eighteenth-Century Studies* 18 (1984–1985): 186–214 (now expanded in *Shaftesbury and the Culture of Politeness: Moral Discourse and Cultural Politics in Eighteenth-Century England* [Cambridge: Cambridge Univ. Press, 1994]); Paul Langford, *A Polite and Commercial People: England, 1727–1783* (Oxford: Clarendon Press, 1989), pp. 59–121; Treadwell Ruml II, "Joseph Andrews as Exemplary Gentleman," *Studies in Eighteenth-Century Culture* 22 (1992): 195–207; and David Solkin, *Painting for Money: The Visual Arts and the Public Sphere in Eighteenth-Century England* (New Haven and London: Yale Univ. Press for the Paul Mellon Centre for Studies in British Art, 1993), ch. 1. Stephen Copley, "The Fine Arts in Eighteenth-Century Polite Culture," in *Painting and the Politics of Culture: New Essays on British Art, 1700–1850,* ed. John Barrell (Oxford and New York: Oxford Univ. Press, 1992), pp. 13–37, describes the other side of this coin: that is, contemporary valuation of the various arts and their moral effects in society, the appropriate audiences for the arts, and the place of art in a commodity economy.

37. Defoe, *The Compleat English Gentleman* (c. 1729), ed. Karl D. Bülbring (London, 1890), p. 3.

38. *The Spectator,* ed. Donald F. Bond (Oxford: Clarendon Press, 1965), 2:165.

39. Quoted by Klein, "The Third Earl of Shaftesbury," pp. 190–191.

40. See David Marshall, *The Figure of Theater: Shaftesbury, Defoe, Adam Smith, and George Eliot* (New York: Columbia Univ. Press, 1986), chs. 1–3; Klein, "The Third Earl of Shaftesbury"; and my extended discussion in Chapter 4. For an examination of how these issues were formulated across the channel, see Peter France's *Politeness and Its Discontents: Problems in French Classical Culture* (Cambridge: Cambridge Univ. Press, 1992).

41. Quoted by Klein, "The Third Earl of Shaftesbury," p. 192.

42. *The Guardian,* p. 143.

43. Hogarth, *The Analysis of Beauty,* ed. Joseph Burke (Oxford: Clarendon Press, 1955), p. 137.

44. Reynolds, *Portraits,* p. 74.

45. Leslie and Taylor, 1:326 n.; Wendy Wassyng Roworth, "Kauffman and the Art of Painting in England," in *Angelica Kauffman: A Continental Artist in Georgian England,* ed. Roworth (London: Reaktion Books, 1992), p. 14.

46. See *The Political Theory of Painting,* esp. chs. 1 and 2, and Solkin, *Painting for Money,* ch. 1, who notes that it is "but a short step from Locke's or Steele's language of good company, civility, and conversation, to the language of portraiture" (p. 31).

47. Felton, *Testimonies,* p. 66; Cotton, *Sir Joshua Reynolds, and His Works,* p. 40.

48. Reynolds, *Discourses,* p. 117.

49. Ibid., p. 132.

50. Ibid., p. 131.

51. There is no comprehensive study of Richardson's varied career, although Carol Gibson-Wood's monograph is forthcoming. For two initial steps in this direction, see Roger Lonsdale, "Jonathan Richardson's *Morning Thoughts,*" in *Augustan Studies: Essays in Honor of Irvin Ehrenpreis,* ed. Douglas Lane Patey and Timothy Kerrigan (Newark: Univ. of Delaware Press; London and Toronto: Associated University Presses, 1985), pp. 175–194, and Wendorf, *The Elements of Life,* ch. 5.

52. Reynolds, *Discourses,* pp. 134–135.

53. Quoted by Iain Pears, *The Discovery of Painting: The Growth of Interest in the Arts in England, 1680–1768* (New Haven and London: Yale Univ. Press for the Paul Mellon Centre for Studies in British Art, 1988), p. 9.

54. Northcote, *Life,* 1:301.

55. Ibid., 2:57.

56. Ibid., 2:56.

57. Ward, *Conversations,* p. 172; cf. Northcote, *Life,* 2:264.

58. Northcote, *Life,* 2:56.

59. Malone, 1:xlvi–xlvii.

60. Hazlitt, *Complete Works,* 11:319; cf. Northcote, *Life,* 2:320–321.

61. Farington, *Memoirs,* p. 7.

62. Reynolds, *Portraits,* p. 21; Goldsmith, *Complete Works,* 4:358.

63. Hazlitt, *Complete Works,* 16:190.

64. Malone, 1:liii.

65. Ibid. The *Oxford English Dictionary* quotes Goldsmith.

66. Johnson, *Letters,* 1:244, 4:388.

67. *Boswell's Life of Johnson,* 3:5 (cf. 3:192).

68. Berg Collection, New York Public Library.

69. Ibid.

70. *The Letters of Dr. Charles Burney,* vol. 1 (1751–1784), ed. Alvaro Ribeiro, S.J. (Oxford: Clarendon Press, 1991), p. 44.

71. Northcote, *Life,* 2:56.

72. Hazlitt, *Complete Works,* 11:261.

73. Ibid., 16:183.

74. Leslie and Taylor, 2:611.

75. Northcote, *Life,* 2:100, 2:245.

76. Reynolds, *Discourses,* pp. 132–133.

77. *Boswell: The Ominous Years, 1774–1776,* ed. Charles Ryskamp and Frederick A. Pottle (London: Heinemann; New York: McGraw-Hill, 1963), p. 335.

78. Piozzi, *Anecdotes,* p. 112. The subject is Johnson's annoyance "that the upper ranks should be dignified with the name of *the world.*"

79. Malone, 1:li.

80. Northcote, *Life,* 1:294.

81. Quoted in *Boswell: The Applause of the Jury, 1782–1785,* ed. Irma S. Lustig and Frederick A. Pottle (London: Heinemann; New York: McGraw-Hill, 1981), p. 319 (from the *Public Advertiser*). See also Northcote, *Life,* 2:244, and Whitley, *Artists and Their Friends,* 2:52. For an analysis of hangings as a public event, see Peter Linebaugh, *The London Hanged: Crime and Civil Society in the Eighteenth Century* (Cambridge: Cambridge Univ. Press, 1991), and E. P. Thompson, *Customs in Common* (New York: The New Press, 1991), p. 48 n.

82. Reynolds, *Letters,* p. 128.

83. Leslie and Taylor, 2:471.

84. Yale Center for British Art, MS. Reynolds 33. John Edgcumbe informs me that the book was given to Reynolds by his father on his eighth birthday.

85. Ibid., front pastedown.

86. Ibid., p. [vi].

87. Ibid., p. 2.

88. Ibid., p. 3.

89. Ibid., p. 8.

90. Ibid., pp. 55–56.

91. Ibid., pp. 3, 4.

92. Ibid., p. 56.

93. Northcote, *Life*, 2:77.

94. Malone, 1:xlv–xlvi (my emphasis).

95. Hazlitt, *Complete Works*, 11:308–309; cf. 11:292.

96. Edwards, *Anecdotes of Painters Who Have Resided or Been Born in England; with Critical Remarks on Their Productions* (London, 1808), p. 196.

97. *Memoirs of Richard Cumberland* (London, 1806), p. 258.

98. *The Literary Works of Sir Joshua Reynolds,* ed. Henry William Beechy [*sic*] (London, 1846), 1:32.

99. *Complete Works*, 11:292.

100. Northcote, *Life*, 2:322.

101. Farington, *Memoirs*, p. 66.

102. Hazlitt, *Complete Works*, 11:252.

103. See Mannings, *Self Portraits,* which includes all of the paintings I examine with the exception (as we shall see) of the image of Reynolds standing at his easel.

104. John Steegman makes a similar point in a now somewhat dated essay; see "Portraits of Reynolds," *Burlington Magazine* 80 (Feb. 1942): 33–35.

105. David Mannings, "The Sources and Development of Reynolds's Pre-Italian Style," *Burlington Magazine* 117 (April 1975): 212–222.

106. See Wendorf, *The Elements of Life,* pp. 249–260.

107. Mannings, *Self Portraits,* p. 6 (no. 3). See also his "Sources and Development of Reynolds's Pre-Italian Style," p. 219.

108. Algernon Graves and W. V. Cronin, *History of the Works of Sir Joshua Reynolds* (London, 1899–1901), 2:796; it also appears as pl. 30 in Christopher White, David Alexander, and Ellen D'Oench, *Rembrandt in Eighteenth Century England* (New Haven: Yale Center for British Art, 1983). The youthful face appears to belie a date of 1772, but his countenance is difficult to date. Malone noted that at age sixty-eight Reynolds looked like a man of fifty (1:cviii n.).

109. Letter to me, 9 Aug. 1994.

110. Penny, *Reynolds*, p. 170, and Desmond Shawe-Taylor, *Genial Company: The Theme of Genius in Eighteenth-Century British Portraiture* (Nottingham: Nottingham Univ. Art Gallery; Edinburgh: Scottish National Portrait Gallery, 1987), pp. 28–29, who makes an interesting case for the "Northern" look of the painting.

111. See Ellis Waterhouse, "Reynolds, Angelica Kauffmann, and Lord Boringdon," *Apollo* 122 (1985): 270–274, for the dating of the portrait and for an in-

teresting argument concerning Kauffman's humorous intentions here: "I doubt if, otherwise, Reynolds would have allowed himself to be painted in a Van Dyck habit, especially after such a short acquaintance" (p. 271).

112. Ellen G. Miles, *American Paintings of the Eighteenth Century* (Washington, D.C.: National Gallery of Art, 1995), p. 173, points out, however, that Stuart's "looser brushwork was undoubtedly a conscious imitation of Reynolds' own technique" as well as Gainsborough's.

113. See Susan Rather, "Stuart and Reynolds: A Portrait of Challenge," *Eighteenth-Century Studies* 27 (1993–1994): 61–84, who quotes the sitter's response: "Sir Joshua said, if that was like him, he did not know his own appearance" (p. 63). Rather has written an exhaustively researched essay in which she offers, among other interesting points, the possibility that Stuart intended his portrait to serve as a "particularized" image in defiance of Reynolds's insistence on the general. That this was also an *American* gesture I cannot judge, nor am I convinced by her argument that the portrait is both satirical and mundane, predicated on the senses of hearing and touch. It is possible, as Rather notes, that Stuart invoked contemporary associations of snuff-taking with irascibility; but surely the primary breach of decorum lay in the very act of including the business of snuff within the painting in the first place.

114. See my discussion in *The Elements of Life,* pp. 95–98.

115. Burke, *Correspondence,* 7:75–76.

116. Compare Rather, "Stuart and Reynolds," who cites the portrait's "penetrating effect of lifelikeness, its unflinching presentation of the mundane" (p. 76), with Mannings, *Self Portraits:* "a sharply-focused and probably rather good, if unimaginative likeness" (p. 8). There were at least three sittings, each in Reynolds's studio; see William T. Whitley, *Gilbert Stuart* (Cambridge: Harvard Univ. Press, 1932), p. 46.

117. Royal Academy MS. Nor/6 (19 Dec. 1771).

118. Mannings, *Self Portraits,* no. 6. This painting was also eventually owned by Lawrence.

119. Farington measured Reynolds, and others, for the Royal Academy Club, which had been established 23 Nov. 1787 (Yale Center for British Art, MS. Reynolds 53).

120. Mannings, *Self Portraits,* no. 4.

121. Ibid., nos. 7–8.

122. Mannings, *Self Portraits,* no. 10.

123. Ibid., no. 12; cf. no. 13.

124. Ibid., no. 16.

125. Penny, *Reynolds,* no. 117.

126. For a commentary on the relation between this painting and Rembrandt's, see Julius S. Held, *Rembrandt's "Aristotle" and Other Rembrandt Studies* (Princeton:

Princeton Univ. Press, 1969), pp. 24–25, and Christopher White et al., *Rembrandt in Eighteenth Century England*, p. 37.

127. Piozzi, *Anecdotes*, p. 142.

128. Malone, 1:lxxvii n. See Penny, *Reynolds*, no. 149, and Mannings, *Self Portraits*, no. 22.

129. [D'Arblay], *Memoirs of Doctor Burney*, 2:279–280.

130. *Boswell: The Great Biographer, 1789–1795*, ed. Marlies K. Danziger and Frank Brady (London: Heinemann; New York: McGraw-Hill, 1989), p. 170.

131. See Mannings, *Self Portraits*, no. 23.

132. Farington, *Diary*, 4:1330. The King, of course, may have been protecting himself so that he would not have to knight every President of the Academy.

133. See Alastair Smart, *Allan Ramsay: Painter, Essayist, and Man of the Enlightenment* (New Haven and London: Yale Univ. Press for the Paul Mellon Centre for Studies in British Art, 1992), p. 223, and William T. Whitley, *Gainsborough* (London: J. Murray, 1915), p. 75. Gainsborough seems to be lashing out in two directions at once, for "poetical impossibilities" and "roast beef" are surely antinomies. One should recall Jean-André Rouquet's observation of 1755, in *The Present State of the Arts in England*, that "artists have been sometimes distinguished by the title of knights; but not to mention that this distinction is not so highly esteemed at present by the English as formerly, it is too often granted to persons incapable of adding dignity to it, or of rendering it an object of envy" (p. 16).

134. Quoted by Whitley, *Artists and Their Friends*, 1:251–253.

135. Northcote, *Life*, 1:173; George Steevens, "Anecdotes," in *Johnsonian Miscellanies*, 2:322.

136. Ward, *Conversations*, p. 80.

137. Sitter Book, 1769; Royal Academy MS. Rey/1/12.

138. Whitley, *Artists and Their Friends*, 1:257.

139. Northcote, *Life*, 1:228.

140. Farington, *Diary*, 4:1137; Malone is refuting a critical Northcote.

141. Farington, *Memoirs*, p. 85 n.; Mary Palmer is quoted by Cotton, *Sir Joshua Reynolds, and His Works*, p. 178.

142. Frances Burney, *Diary and Letters of Madame D'Arblay (1778–1840)*, ed. Charlotte Barrett and Austin Dobson (London and New York: Macmillan, 1904–1905), 2:87–92; [D'Arblay], *Memoirs of Doctor Burney*, 2:221–238.

143. Berg Collection, New York Public Library.

144. Northcote, *Life*, 2:93–95.

145. William Roberts, *Memoirs of the Life and Correspondence of Hannah More*, 3rd edn. (London, 1835), 1:52, 1:80.

146. *Boswell's Life of Johnson*, 4:312 (where the reference to Reynolds is provided by Hill); cf. 3:375.

147. Whitley, *Artists and Their Friends*, 1:300.

148. Malone, 1:lv–lvi.

149. Northcote, *Life,* 2:96.

150. See George C. Brauer, Jr., *The Education of a Gentleman: Theories of Gentlemanly Education in England, 1660–1775* (New Haven: College and University Press, 1959), pp. 136–138.

151. [D'Arblay], *Memoirs of Doctor Burney,* 2:x.

152. Northcote, *Life,* 1:298–299.

153. Fielding, "Essay on Conversation," in *Miscellanies,* p. 142.

154. Northcote, *Life,* 2:47.

155. Farington, *Diary,* 2:478.

156. Brewer, "Commercialization and Politics," in Neil McKendrick, John Brewer, and J. H. Plumb, *The Birth of a Consumer Society: The Commercialization of Eighteenth-Century England* (London: Europa; Bloomington: Indiana Univ. Press, 1982), p. 217. See also Solkin, *Painting for Money,* ch. 1, who nevertheless notes that "their egalitarian rhetoric notwithstanding, the sociable ideals of the early eighteenth century posed no threat whatsoever to the established hierarchy of political and social power; they simply offered that structure an additional means of support" (p. 40).

157. Brewer, "Commercialization and Politics," p. 218.

158. Ibid., p. 219.

159. Ibid., p. 228.

160. See Leslie and Taylor, 1:272, 1:354, 1:388, 2:15.

161. See Louise Lippincott, *Selling Art in Georgian London: The Rise of Arthur Pond* (New Haven and London: Yale Univ. Press for the Paul Mellon Centre for Studies in British Art, 1983), pp. 29, 30, 42.

162. Leslie and Taylor, 1:154, 1:228 n., 1:273.

163. Reynolds, *Letters,* pp. 33–34.

164. *Boswell's Life of Johnson,* 4:28.

165. Hilles, *Literary Career,* pp. 187–188.

166. Ibid., p. 210.

167. Whitley, *Artists and Their Friends,* 2:119.

168. *The Letters of Edward Gibbon,* ed. J. E. Norton (London: Cassell, 1956), 2:160.

169. Johnson, *Letters,* 2:171.

170. *Boswell: The Ominous Years,* p. 148.

171. Ibid., p. 336.

172. *Boswell's Life of Johnson,* 3:328–329.

173. The social nuances of gambling have not been closely examined; for some preliminary remarks, see J. C. D. Clark, *English Society, 1688–1832: Ideology, Social*

Structure and Political Practice in the Ancien Régime (Cambridge: Cambridge Univ. Press, 1985), pp. 108–109.

174. Farington, *Diary,* 2:306–307.

175. Leslie and Taylor, 2:586.

176. Reynolds, *Letters,* p. 128.

177. *Boswell: The Applause of the Jury,* p. 320.

178. Northcote, *Life,* 1:251.

179. Hilles, *Literary Career,* p. 209 (copied from an unidentified source).

180. Reynolds, "An Essay on First Impressions," in Cotton, *Sir Joshua Reynolds, and His Works,* p. 232.

2. Other Voices

1. Burke, *Correspondence,* 9:329; his schema is obviously Aristotelian.

2. Farington, *Diary,* 9:3238.

3. Ellis Cornelia Knight, *The Autobiography of Miss Knight,* ed. Roger Fulford (London: William Kimber, 1960), p. 27.

4. Burke, *Correspondence,* 7:92.

5. Pasquin, *Memoirs of the Royal Academicians; Being an Attempt to Improve the National Taste* (London, 1796), rpt. with *An Authentic History,* introd. R. W. Lightbown (London: Cornmarket Press, 1970), pp. 69–70.

6. Ibid., pp. 72, 70.

7. Ibid., p. 72.

8. Ibid., p. 68.

9. Hayley, *The Life of George Romney, Esq.* (London, 1809), pp. 189–190.

10. *Memoirs of Richard Cumberland* (London, 1806), pp. 463–464.

11. Leslie and Taylor, 2:159.

12. Gwynn, *Memorials,* p. 210.

13. Ibid., p. 230.

14. Ibid., p. 225.

15. Royal Academy MS. Nor/15 (3 Jan. 1776).

16. Ward, *Conversations,* p. 186.

17. Ibid., p. 85. Northcote qualifies this last remark by adding that no one could "enter into his feelings with regard to that great love for art which filled his mind." As we have already seen, Charles Burney (among others) clearly believed that he shared Reynolds's confidence.

18. Quoted by Whitley, *Artists and Their Friends,* 1:288–289. Martin Postle discusses the attribution to Barry in *Sir Joshua Reynolds: The Subject Pictures,* p. 154.

19. Farington, *Diary,* 2:478.

20. Northcote, *Life,* 2:196.

21. Quoted by Northcote, *Life*, 2:116.

22. Ibid., 2:196.

23. Haydon, *Diary*, 3:126–127.

24. For Kauffman, see Farington, *Diary*, 9:3192; for Hamilton, Hudson, *Reynolds*, p. 142; for Wymondesold, *Boswell in Extremes, 1774–1776*, ed. Charles McC. Weis and Frederick A. Pottle (London: Heinemann; New York: McGraw-Hill, 1970), pp. 256, 312; and for Horneck, Whitley, *Artists and Their Friends*, 1:149, and Hazlitt, *Complete Works*, 12:112.

25. These "Memoirs of The Modern Apelles and The Amiable Laura" seem not to be corroborated by any other source—and even the biographical facts relating to Reynolds's life are inaccurate—but the rarity of the publication, combined with the contemporary currency it must have had, may warrant a short synopsis. Our heroine is a "Miss J——ngs," daughter of a gentleman in the navy, who is taken up by a Lord F., who appears to keep her, and who sends her to Reynolds to sit for her picture. The painter draws out the sittings "in order to be blessed with her repeated visits." He accepts the payment of a hundred-pound note, places it in a gold snuffbox "wherein was his own miniature," entreating her "to preserve that for his sake, as the greatest favour on earth he could at present request." Lord F. then finds the snuffbox and deserts her. Reynolds offers her his "purse and person": "Her present situation would not let her refuse either, as it would have been ridiculous to have laid claim to virtue, though she probably might to chastity, from his lordship's inabilities; and as the knight had already made a very favourable impression on her, she, with seeming reluctance, yielded to his proposal, and since that time there is great reason to believe they have been mutually happy" (p. 404).

26. *Boswell: The English Experiment, 1785–1789*, ed. Irma S. Lustig and Frederick A. Pottle (London: Heinemann; New York: McGraw-Hill, 1986), p. 205; in the same conversation Reynolds states his belief that marriages are usually of the middling sort, neither extremely happy nor extremely unhappy.

27. Hudson, *Reynolds*, pp. 148–153, provides a good summary of Reynolds's household arrangements. His sister Mary served very briefly, whereas Frances lived (on and off) with him for almost thirty years; another niece, Elizabeth ("Betsey") Johnson, also served her uncle.

28. Reynolds, *Letters*, p. 55.

29. Farington, *Diary*, 9:3238.

30. Hudson, *Reynolds*, p. 147.

31. See, for example, Gwynn, *Memorials*, p. 111, where Northcote complains about his "dismal hole."

32. Royal Academy MS. Nor/6 (19 Dec. 1771).

33. See Cotton, *Sir Joshua Reynolds, and His Works*, pp. 189–190.

34. Berg Collection, New York Public Library. Burney mentions that she

painted as well: "I lately was favoured with the sight of her excellent portrait of her most noble head painted by herself with a resemblance & force" of which her uncle would not have been ashamed. Haydon, in his *Diary* (5:487), reports that all three sisters painted.

35. Clifford, *Dictionary Johnson: Samuel Johnson's Middle Years* (New York: McGraw-Hill, 1979), p. 284.

36. For the Johnsons and Palmers in Torrington, see Clifford, *Dictionary Johnson*, pp. 282–284; for Reynolds's fitful support, see Radcliffe, *Sir Joshua's Nephew*, pp. 105, 111, 122–123, 132–133, 172, and 199–200.

37. Radcliffe, *Sir Joshua's Nephew*, p. 123.

38. Yale Center for British Art, MS. Reynolds 8.

39. See Clifford, *Dictionary Johnson*, p. 283 and n., and Leslie and Taylor, 1:461.

40. *Johnsonian Miscellanies*, 2:455–456 n.

41. Yale Center for British Art, MS. Reynolds 57 (4 Dec. 1796).

42. For a recently published poem, see *Frances Reynolds and Samuel Johnson* (The Johnsonians; privately printed, 1995).

43. Ellis Cornelia Knight, *The Autobiography of Miss Knight*, ed. Roger Fulford (London: William Kimber, 1960), p. 26.

44. Johnson, *Letters*, 3:202.

45. Northcote, *Life*, 1:80. See Thomas Campbell, *Dr. Campbell's Diary of a Visit to England in 1775*, ed. James L. Clifford (Cambridge: Cambridge Univ. Press, 1947), p. 55, for another instance of Johnson's denigrating her: "as to that quoth the Doctor it is no great matter, for she could not tell, after she had read it, on which side of the question Mr. Burke's speech was."

46. Frances Burney, *Diary and Letters of Madame D'Arblay (1778–1840)*, ed. Charlotte Barrett and Austin Dobson (London and New York: Macmillan, 1904–1905), 2:166.

47. [D'Arblay], *Memoirs of Doctor Burney*, 1:331–332.

48. Farington, *Diary*, 4:1138; Radcliffe, *Sir Joshua's Nephew*, p. 107.

49. Radcliffe, *Sir Joshua's Nephew*, pp. 150, 151.

50. [D'Arblay], *Memoirs of Doctor Burney*, 1:333–334.

51. Unpublished memoir of Reynolds, Berg Collection, New York Public Library.

52. Hyde Collection (10 April 1776).

53. Northcote, *Life*, 1:202; Wendorf and Ryskamp, "A Blue-Stocking Friendship," p. 186.

54. Wendorf and Ryskamp, "A Blue-Stocking Friendship," pp. 205–206; Whitley, *Artists and Their Friends*, 1:299.

55. According to Hester Thrale, she was still living with Reynolds in June 1777; see *Thraliana: The Diary of Mrs. Hester Lynch Thrale (Later Mrs. Piozzi), 1776–1809*,

ed. Katharine C. Balderston (Oxford: Clarendon Press, 1942; 2nd edn., 1951), 1:79. In her correspondence with Johnson, she writes from Dover Street in 1779.

56. Private collection. All references to Frances's commonplace book are to this source. Parts of the book were published by Leslie and Taylor, 1:92 n. (whose transcription is not to be trusted), and by Hudson, *Reynolds,* pp. 146–147, who focused on her "abandonment to introspection," which her brother presumably found "demoralizing and disturbing."

57. Reynolds, *Letters,* pp. 79–80.

58. Leslie and Taylor, 1:92 n., who base their assertion on the prose passages they quote from Frances's commonplace book, which includes a variety of material, much of it undated. The verses I have quoted above from the commonplace book *are* dated, or easily linked with those that are; they all seem to have been written in the mid-1760s, long before her final separation from her brother. At some point, however, Frances Reynolds turned the book upside down and began writing from the other end, and it is here that these long prose reflections appear. Although they are not dated, their reference to Windsor—and to the more extensive exile she currently must endure—supports a date soon following her separation from Reynolds. It is worth noting, moreover, that the focus on painting in these passages links them with the concerns to be found in the poem addressed "To Mrs Knight / March 1766" and to her exhibitions of 1774 and 1775, and distinguishes them from the letters exchanged with Elizabeth Montagu between 1781 and 1789, which are largely devoted to the disposition of her *Enquiry* or to the collection of paintings she had acquired (see Wendorf and Ryskamp, "A Blue-Stocking Friendship").

59. Wendorf and Ryskamp, "A Blue-Stocking Friendship," p. 206.

60. Quoted by Whitley, *Artists and Their Friends,* 1:298–299.

61. Radcliffe, *Sir Joshua's Nephew,* p. 151.

62. [D'Arblay], *Memoirs of Doctor Burney,* 1:332.

63. Mary Welch Nollekens, quoted by Farington, *Diary,* 6:2232. Compare Gainsborough, quoted by John Hayes, *Gainsborough: Paintings and Drawings* (London: Phaidon Press, 1975), p. 17: "I generally view my Works of a Sunday, tho: I never touch"

64. Royal Academy MS. Nor/3 (10 Aug. 1771); previously published, with errors, by Whitley, *Artists and Their Friends,* 2:281. Northcote adds that Reynolds "is surely a man of vast capacity and a great scholar."

65. Royal Academy MS. Nor/9 (8 April 1772). Frances Reynolds chastised Northcote when she caught *him* painting on a Sunday, "but Sir Joshua took no more notice of it than if it had been another day perhaps rather pleased to see a fondness for work, tho now he hardly ever paints sundays, but twice since I have been here." Perhaps the fullest account of Reynolds's religious beliefs is Boswell's, recorded in 1788: "We had a dispute with Courtenay for the soul as separate from

matter, in which Sir Joshua was clear, as he was for a future state, from his notions of God; yet he was for religion in all countries as something in aid to morality and *therefore* divine; but he did not allow of any preference which one religion had in being *revealed* more than any other. Very loose thinking. I was strenuous for the Christian revelation as putting immortality beyond a doubt" (*The English Experiment,* p. 196).

66. Farington, *Diary,* 4:1137–1138.

67. See *Johnsonian Miscellanies,* 2:250–300; *Conversations, or, The Bas Bleu: Addressed to Mrs. Vesey,* exh. cat. (Cambridge, Mass.: Houghton Library, 1977), pp. 2–3.

68. Johnson, *Letters,* 3:355–356.

69. Ibid., 4:30.

70. Huntington Library MS. MO 4650 (12 July 1785, to Elizabeth Montagu).

71. Hyde Collection (9 July [1779]).

72. Huntington Library MS. MO 4651 (5 Feb. 1789, to Elizabeth Montagu); Wendorf and Ryskamp, "A Blue-Stocking Friendship," pp. 204–205.

73. Huntington Library MS. MO 4650.

74. See Wendorf and Ryskamp, "A Blue-Stocking Friendship," pp. 200–201.

75. For the publication details, see James L. Clifford's introduction to the facsimile edition of her essay (Los Angeles: Augustan Reprint Society, 1951).

76. Northcote, *Life,* 2:160; Hazlitt, *Complete Works,* 11:254. One might compare Reynolds's sharp tongue here with his response when he learned that Elizabeth Sheridan would not sing at one of his dinner parties: "what reason could they think I had to invite them to dinner, unless it was to hear her sing, for she cannot talk?" Quoted by Northcote, *Life,* 2:85 n.

77. *Johnsonian Miscellanies,* 2:274–275.

78. Johnson, *Letters,* 4:188; cf. Northcote, *Life,* 2:159. This portrait, in Buffalo, has generally been thought to correspond to the sitting described in this anecdote, although Helen Ashmore has pointed out to me that it makes Johnson look rather young. She suggests, instead, that the problematical Haverford College portrait of Johnson in old age, long thought to have been painted by Reynolds but now of questionable authorship, may have been executed by Frances Reynolds and thus be the portrait in question. I thank Helen Ashmore for sharing her work on Frances Reynolds with me, and for reminding me of the context of Johnson's remarks: that his allusion to the grimly ghost is couched in a letter filled with death and written when he himself was seriously ill.

79. Wendorf and Ryskamp, "A Blue-Stocking Friendship," p. 197.

80. Whitley, *Artists and Their Friends,* 1:298.

81. *Boswell in Extremes,* p. 243 and n. 3.

82. *Boswell's Life of Johnson,* 2:362. This statement should be compared with

the gentle coquetry of his letter of 16 June 1780 to her, however: "I am very willing to wait on You at all times, and will sit for the picture, and, if it be necessary, will sit again, for wherever I sit, I shall be always with you" (*Letters*, 3:278).

83. Royal Academy MS. Nor/7 (21 Dec. 1771).

84. Of the many recent studies of female painters, Greer's is the only one to devote attention to Frances Reynolds, and its examination of her plight is a fairly cursory one: see *The Obstacle Race: The Fortunes of Women Painters and Their Work* (New York: Farrar Straus Giroux, 1979), pp. 31–32.

85. *The Letters of Samuel Johnson*, ed. R. W. Chapman (Oxford: Clarendon Press, 1952), no. 1149 (3:270); cf. Northcote, *Life*, 1:203.

86. The situation was similar in the other arts: see Richard Leppert, *Music and Image: Domesticity, Ideology, and Socio-Cultural Formation in Eighteenth-Century England* (Cambridge: Cambridge Univ. Press, 1988), chs. 3 and 7, and Mary Poovey, *The Proper Lady and the Woman Writer: Ideology as Style in the Works of Mary Wollstonecraft, Mary Shelley, and Jane Austen* (Chicago: Univ. of Chicago Press, 1984), esp. ch. 1.

87. Commonplace book, private collection. Compare the epitaph written at the end of the manuscript in which she shared a long poem with Johnson (Hyde Collection):

> Stay Passenger if now thy Breast,
> Is with the Weight of Woes opprest,
> Think I on Earth once trod like you,
> My sorrows many [,] comforts few,
> And let the thought that [what] I am here,
> Check every woe save pitys tear,
> For Pitys gentle springs may prove
> The source of end [le]ss joys above.

88. *Thraliana*, 1:414.
89. Ibid., 1:268–270.
90. Ibid., 1:79.
91. Ibid., 1:80.
92. Ibid., 1:415.
93. Ibid., 1:470.
94. Ibid., 1:382.
95. Ibid., 1:459–460.
96. Ibid., 1:80.

97. Ibid., 1:330. She decided she did not know Reynolds well enough to rank him in religion and morality, Johnson's strong suits.

98. Ibid., 1:473.

99. Ibid., 2:728.

100. Ibid., 2:728–729.

101. For an analysis of the *Anecdotes*, see Wendorf, *The Elements of Life*, pp. 191–206.

102. D'Arblay, *Diary*, 2:149, 2:181.

103. Ibid., 2:149.

104. Ibid., 1:104.

105. Ibid., 1:185.

106. Ibid., 1:194–195.

107. Ibid., 2:163; compare 1:133.

108. [D'Arblay], *Memoirs of Doctor Burney*, 1:331.

109. Ibid., 2:366.

3. The Marketplace and the Studio

1. Ward, *Conversations*, p. 80.

2. Johnson, *Life of Savage*, ed. Clarence Tracy (Oxford: Clarendon Press, 1971), p. 4. See Iain Pears, *The Discovery of Painting: The Growth of Interest in the Arts in England, 1680–1768* (New Haven and London: Yale Univ. Press for the Paul Mellon Centre for Studies in British Art, 1988), ch. 4, for a summary of the obstacles painters faced.

3. Northcote, *Life*, 2:65. In the Houghton Library copy, Mrs. Piozzi has inserted one of her visual pointers in the margin next to Northcote's conclusion: "What would he now say when more than eight hundred come forward and claim a maintenance, and their number is every day increasing?"

4. Brewer, "Commercialization and Politics," in Neil McKendrick, John Brewer, and J. H. Plumb, *The Birth of a Consumer Society: The Commercialization of Eighteenth-Century England* (London: Europa; Bloomington: Indiana Univ. Press, 1982), p. 198.

5. Lippincott, *Selling Art in Georgian London: The Rise of Arthur Pond* (New Haven and London: Yale Univ. Press for the Paul Mellon Centre for Studies in British Art, 1983), p. 73.

6. Ibid., p. 75.

7. Ward, *Conversations*, pp. 220–221. For an example of over-finishing, see Robin Simon, *The Portrait in Britain and America with a Biographical Dictionary of Portrait Painters, 1680–1914* (Oxford: Phaidon Press; Boston: G. K. Hall, 1987), p. 103.

8. Reynolds, *Discourses*, p. 117.

9. Pears, *The Discovery of Painting*, p. 111.

10. Reynolds, *Letters*, p. 124.

11. It is interesting that Reynolds fails to acknowledge his previous paintings of Venus. William Mason notes that he followed the composition of the painter's "first Venus" in December 1759 (Cotton, *Sir Joshua Reynolds' Notes and Observations*, p. 55). Ellis Waterhouse, *Reynolds* (London: Kegan Paul, Trench Trubner, 1941), records that *Venus Chiding Cupid for Learning to Cast Accompts* was exhibited at the Royal Academy in 1771 and—in another version—1776; the *Venus and Cupid* to which Reynolds refers here was exhibited in 1785. Postle, *Sir Joshua Reynolds: The Subject Pictures*, p. 200, notes that Reynolds had also made a copy of Titian's *Venus and Cupid with a Lute Player*.

12. Reynolds, *Letters*, p. 155.

13. Northcote, *Life*, 1:213; cf. Gwynn, *Memorials*, p. 100. The young John Constable was impressed by Reynolds's observation that "there is no *easy* way of becoming a good painter." See Ann Bermingham, *Landscape and Ideology: The English Rustic Tradition, 1740–1860* (Berkeley and Los Angeles: Univ. of California Press, 1986), p. 117.

14. Ward, *Conversations*, p. 219. In a letter home, Northcote remarked that Joseph Wright loved to paint so much that he rose with the sun, his palette all ready to go (Royal Academy MS. Nor/8 [29 March 1772]).

15. Ward, *Conversations*, pp. 77–79.

16. *Reminiscences and Table-Talk of Samuel Rogers: Banker, Poet, and Patron of the Arts, 1763–1855*, ed. G. H. Powell (London: R. Brimley Johnson, 1903), p. 9.

17. Farington, *Memoirs*, p. 85.

18. Northcote, *Life*, 1:119.

19. Ibid., 1:119; cf. *Boswell's Life of Johnson*, 2:515 and 4:414.

20. Northcote, *Life*, 2:173 n.

21. Reynolds, *Letters*, p. 20.

22. Ibid., p. 17.

23. Ibid., p. 191.

24. Gwynn, *Memorials*, p. 112; cf. p. 65, where Northcote extolls an expansive, Johnsonian definition of genius as "strong intellectual power": "It was this idea which made Sir Joshua Reynolds say that, had he been bred a surgeon, as was at first intended, he should have endeavoured to complete his career in being the greatest physician of his time; meaning to express that it was his ambition and not the particular love of the art of painting which made him eager to excel."

25. Farington, *Diary*, 6:2145; cf. William Hayley, *The Life of George Romney, Esq.* (London, 1809), p. 24: "Married, (exclaimed Sir Joshua) then you are ruined as an artist."

26. *The Literary Works of Sir Joshua Reynolds,* ed. Henry William Beechey (London, 1846), 1:231.

27. Reynolds, *Letters,* p. 3.

28. Northcote, *Life,* 1:119.

29. Reynolds, *Letters,* p. 17.

30. Malone, 1:xxvi n.

31. Leslie and Taylor, 2:611.

32. Northcote, *Life,* 2:45.

33. Reynolds, *Letters,* p. 17.

34. Malone, 1:xxix.

35. Hazlitt, *Complete Works,* 11:319.

36. Northcote, *Life,* 1:83–85.

37. Cotton, *Sir Joshua Reynolds, and His Works,* p. 75, following the painter's pocketbook.

38. Reynolds, *Letters,* p. 56.

39. Johnson, *Letters,* 4:188.

40. Northcote, *Life,* 2:159.

41. Quoted by Northcote, *Life,* 2:134, under the year 1782.

42. Ibid., 2:127.

43. Ibid.

44. Ibid., 2:128.

45. Ward, *Conversations,* p. 178.

46. Hazlitt, *Complete Works,* 11:187.

47. Northcote, *Life,* 2:238. On 11 Sept. 1778, Northcote wrote from Rome to his brother that "I believe no people hate Envy and dispise one another like painters" (Royal Academy MS. Nor/44).

48. Northcote, *Life,* 2:237–238.

49. Gwynn, *Memorials,* pp. 224–225.

50. Farington, *Diary,* 4:1137.

51. Northcote, *Life,* 2:173.

52. In the Houghton Library copy. On the same page she remarks that Reynolds was "liberal & noble" in paying Gainsborough more than he had asked "for his celebrated girl and pigs."

53. For first-hand accounts of Northcote's experience, see Gwynn, *Memorials,* pp. 49, 63–64, 66, 225–226, and passim. Northcote persevered by asking questions; otherwise Reynolds was silent.

54. Leslie and Taylor, 2:300.

55. See, for instance, Rensselaer W. Lee, *"Ut Pictura Poesis": The Humanistic Theory of Painting* (1940; rpt. New York: Norton, 1967), and Larry Silver, "Step-Sister of the Muses: Painting as Liberal Art and Sister Art," in *Articulate Images:*

The Sister Arts from Hogarth to Tennyson, ed. Richard Wendorf (Minneapolis: Univ. of Minnesota Press, 1983), pp. 36–69.

56. Northcote, *Life,* 2:322.

57. Angelo, *Reminiscences,* 1:355; see also Leslie and Taylor, 1:224. Gilbert Stuart "alleged that he had adopted this practice on the advice of Lord St Vincent, the Duke of Northumberland and Colonel Barre"; see Marcia Pointon, *Hanging the Head: Portraiture and Social Formation in Eighteenth-Century England* (New Haven and London: Yale Univ. Press for the Paul Mellon Centre for Studies in British Art, 1993), p. 50, who also supplies the information about Northcote. Nicholas Penny should also be quoted here: "Reynolds was certainly a shrewd business man; he may also have had a mean streak; but no student of his ledgers could suppose him to have been a very careful book-keeper"; see "Reynolds and Picture Frames," *Burlington Magazine* 128 (1986): 812.

58. Reynolds, *Letters,* p. 56.

59. Ibid., p. 61; Hill is quoted by Cotton, *Sir Joshua Reynolds, and His Works,* p. 138.

60. Cotton, *Sir Joshua Reynolds' Notes and Observations on Pictures,* p. 58. The designs were purchased after Lady Thomond's death by Lord Normanton "for upwards of £12,000" (p. 58 n.).

61. Northcote, *Life,* 1:110.

62. Reynolds, *Letters,* pp. 190–191.

63. Gainsborough often commodified his paintings in a different way by exchanging them for various services, including medical attention; see Martin Postle, "The Golden Age, 1760–1790," in *The British Portrait, 1660–1960* (Woodbridge, Suffolk: Antique Collectors' Club, 1991), p. 187.

64. Northcote, *Life,* 2:226.

65. Reynolds, *Letters,* p. 174. Northcote, *Life,* 1:226, says that the bank bill of £500 was actually presented by an intermediary, the editor George Steevens. Reynolds eventually painted three subjects; their actual market value was later determined at auction following the lottery to dispose of the Shakespeare Gallery in 1805 (see Edward Edwards, *Anecdotes of Painters Who Have Resided or Been Born in England; with Critical Remarks on Their Productions* [London, 1808], pp. 204–205).

66. Reynolds, *Letters,* p. 174.

67. [Jean-André] Rouquet, *The Present State of the Arts in England,* pp. 38–39.

68. Quoted by Angela Rosenthal, "Kauffman and Portraiture," in *Angelica Kauffman: A Continental Artist in Georgian England,* ed. Wendy Wassyng Roworth (London: Reaktion Books, 1992), p. 102.

69. Northcote, *Life,* 1:102 and n. Whitley, *Artists and Their Friends,* 1:151, notes that carriages could draw directly up to Reynolds's door in Leicester Fields, a convenience that was lacking in Great Newport Street.

70. Northcote, quoted by Ward, *Conversations,* p. 204.

71. See Martin Postle, "An Early Unpublished Letter by Sir Joshua Reynolds," *Apollo* 141 (June 1995): 17.

72. Northcote, *Life*, 1:103. Even Gainsborough purchased a carriage (as he also did a country house at Richmond and old master paintings), but he did so much later in life; see [Christopher Lloyd], *Gainsborough and Reynolds: Contrasts in Royal Patronage* (London: The Queen's Gallery, 1994), p. 14.

73. Northcote, quoted by Ward, *Conversations*, p. 204.

74. Ibid., p. 204. Frances Reynolds's use of the carriage can be tracked in *James Beattie's London Diary, 1773*, ed. Ralph S. Walker (Aberdeen: Aberdeen Univ. Press, 1946).

75. Gwynn, *Memorials*, p. 245 and n.

76. Pears, *The Discovery of Painting*, p. 114.

77. Edwards, *Anecdotes of Painters*, p. 37. Beechey, *The Literary Works of Sir Joshua Reynolds*, 1:139–140, states that the carriage was painted in the "ornamental manner of the time," but Edwards (and Pears) are more reliable sources.

78. Ward, *Conversations*, p. 204.

79. See Lippincott, *Selling Art in Georgian London*, p. 33; Pears, *The Discovery of Painting*, p. 115, supplies additional information about the decline of sign-painting in the eighteenth century.

80. Paulson, *Popular and Polite Art in the Age of Hogarth and Fielding* (Notre Dame, Ind.: Notre Dame Univ. Press, 1979), pp. 34, 42–44.

81. Pointon, *Hanging the Head*, p. 38.

82. John Opie, *Lectures on Painting delivered at the Royal Academy . . . to which are prefixed a memoir by Mrs. Opie* (London, 1809), pp. 20–21.

83. Private collection. In describing items in this collection, I have drawn upon information supplied by the owners, family records, and professional appraisals (as well as my own examination).

84. Private collection.

85. Collection of E. Madow.

86. Private collection (see Penny, *Reynolds*, no. 166) and collection of Dr. John Edgcumbe.

87. All private collection except for one of the palettes (in the Royal Academy); see Penny, *Reynolds*, nos. 162, 164, 166, 167.

88. Private collection and collection of Dr. John Edgcumbe.

89. Private collection.

90. See [Hazel Berriman], *Sir Joshua Reynolds P.R.A.: 250th Anniversary Exhibition* (Plymouth: City Art Gallery, 1973), no. 93.

91. See Cotton, *Sir Joshua Reynolds, and His Works*, p. 187. Reynolds complimented Falconet in one of his notebooks by stating that "few people like my friend Falconet undertake to translate a writer for the sake of discovering his Authors ignorance of the subject on which he writes" (Hilles, *Literary Career*, p. 77).

92. It is worth pointing out, given my discussion of the studio and the stage in the following chapter, that Pittura sports a long necklace with a small theatrical mask attached to it. The calling card was mistakenly cited as a bookplate in *An Exhibition of Books, Manuscripts, and Prints Pertaining to Sir Joshua Reynolds* (New Haven: Yale Univ. Library, 1973), no. 192.

93. Cotton, *Sir Joshua Reynolds, and His Works,* p. 140.

94. *Diary and Letters of Madame D'Arblay (1778–1840),* ed. Charlotte Barrett and Austin Dobson (London and New York: Macmillan, 1904–1905), 1:300–301.

95. Reported by Northcote, quoted by Hazlitt, *Complete Works,* 11:187.

96. *The Present State of the Arts in England,* p. 17.

97. Northcote, *Life,* 2:78. By posing the example of a pin-maker, Josiah Tucker (and Reynolds) may have been thinking of Adam Smith's introductory remarks on the division of labor in *An Inquiry into the Nature and Causes of the Wealth of Nations,* ed. R. H. Campbell and A. S. Skinner (Oxford: Clarendon Press, 1976), 1:14–15.

98. Hesther Lynch Thrale Piozzi, *Anecdotes of the Late Samuel Johnson, LL.D.,* in *Memoirs and Anecdotes of Dr. Johnson,* ed. Arthur Sherbo (London: Oxford Univ. Press, 1974), p. 93, who firmly anchors this anecdote in her discussion of Johnson's "utter scorn of painting." Cf. Morris Brownell, *Samuel Johnson's Attitude to the Arts* (Oxford: Clarendon Press, 1989), p. 38.

99. Farington, *Diary,* 9:3445.

100. Reynolds, *Letters,* p. 17.

101. See, among other sources, M. Kirby Talley, Jr., " 'All Good Pictures Crack': Sir Joshua Reynolds's Practice and Studio," in Penny, *Reynolds,* p. 69.

102. Whitley, *Artists and Their Friends,* 2:112; cf. Reynolds's purchase of the fan Pope presented to Martha Blount (Northcote, *Life,* 1:213).

103. Reynolds, *Discourses,* p. 52.

104. Burke, *Correspondence,* 7:75.

105. John Galt, *The Life, Studies, and Works of Benjamin West* (London, 1820), 2:3.

106. See Pears, *The Discovery of Painting,* p. 109.

107. Reynolds, *Portraits,* p. 99. I turn to these conversations in detail in Chapter 4.

108. Hudson, *Reynolds,* p. 73. See A. St. John Adcock, *Famous Houses and Literary Shrines of London* (London: J. M. Dent and Sons; New York: E. P. Dutton, 1912), pp. 57 and 59, for illustrations of Reynolds's house on Great Newport Street and of the staircase in Reynolds's house at 47 Leicester Square (later destroyed); see Giles Walkley, *Artists' Houses in London, 1764–1914* (Aldershot, Hants.: Scolar Press, 1994), for a more recent appraisal that includes Henry Bunbury's illustration of Reynolds at work in his studio (*A Family Piece;* pl. 3) and a view, originally by Farington, of Wick House in Richmond (pl. 15).

109. See Irma S. Lustig, "Facts and Deductions: The Curious History of Reynolds's First Portrait of Johnson, 1756," *The Age of Johnson* 1 (1987): 174.

110. Northcote, *Life*, 1:83.

111. Ibid., 1:103.

112. Ibid., 2:37 n.; James L. Clifford, *Dictionary Johnson: Samuel Johnson's Middle Years* (New York: McGraw-Hill, 1979), p. 19.

113. Northcote, *Life*, 2:26–27, who records an accident in which "one of those pictures by Lely" fell from the wall, bringing down a thundering avalanche of plaster heads from which he barely escaped. For a description of a similar residence (still standing), see Warren Mild, *Joseph Highmore of Holborn Row* (Ardmore, Penn.: privately printed, 1990), pp. 214–215.

114. Ellis Waterhouse, "Reynolds, Angelica Kauffmann, and Lord Boringdon," *Apollo* 122 (1985): 274, suggests that Reynolds may also have painted the small-scale, full-length portrait of John Parker, Lord Boringdon, at Saltram.

115. See Michael Levey, *The Painter Depicted: Painters as a Subject in Painting* (London: Thames and Hudson, 1981), pl. 57, who points out that the real interest we might take in the painting lies in the artist's focus on one of her precursors (pp. 62–65), and Frances Gerard, "Angelica Kauffmann and Joshua Reynolds," *Art Journal* (1897): 82, who identifies the other woman in the studio as Lady Wentworth.

116. [Christopher Lloyd], *Gainsborough and Reynolds: Contrasts in Royal Patronage*, p. 21.

117. Northcote, *Life*, 1:102. Ellis Waterhouse, "Reynolds, Angelica Kauffmann, and Lord Boringdon," p. 270, points out that "Reynolds was in fact one of the most active *marchands amateurs* of his time. I have always supposed—but I am afraid that this cannot be supported from contemporary sources—that Reynolds hung many of his Old Masters on the walls of the room in which he imprisoned his sitters, while he was painting from them. They thus provided themes for conversation with otherwise uninteresting sitters, who might perhaps be encouraged to buy one."

118. See, for example, Malone, 1:liv, and Cotton, *Sir Joshua Reynolds, and His Works*, pp. 90–91 (who notes the nap).

119. Mrs. Jameson, quoted by Cotton, *Sir Joshua Reynolds, and His Works*, p. 36.

120. Huntington Library MS. MO 4243.

121. Huntington Library MS. MO 6362; printed in *Mrs. Montagu, "Queen of the Blues": Her Letters and Friendships from 1762 to 1800*, ed. Reginald Blunt (London: Constable, 1923), 1:14.

122. Huntington Library MS. MO 4247.

123. Malone, 1:liv.

124. Cotton, *Sir Joshua Reynolds' Notes and Observations on Pictures*, p. 49. Cf. John Hayes, *Gainsborough: Paintings and Drawings* (London: Phaidon Press, 1975),

p. 14, and Rouquet, *The Present State of the Arts in England,* pp. 42–43, for similar instructions.

125. Malone, 1:lix.

126. W. P. Frith, *My Autobiography and Reminiscences* (New York, 1888), 2:88.

127. Northcote, *Life,* 1:103.

128. Penny, *Reynolds,* p. 336; the conjecture has been made by John Harris, *Sir William Chambers: Knight of the Polar Star* (London: Zwemmer, 1970), p. 223.

129. Northcote, *Life,* 1:103.

130. See, for instance, Mason, in Cotton, *Sir Joshua Reynolds' Notes and Observations on Pictures,* pp. 49–50; Farington, *Diary,* 8:2836–2837, who provides a diagram of the pallet; Talley, " 'All Good Pictures Crack,' " who synthesizes much of this material; and Barbara A. Buckley, "Sir Joshua Reynolds, *The Ladies Amabel and Mary Jemima Yorke,*" *Bulletin of the Cleveland Museum of Art* 73 (1986): 350–371.

131. Quoted by Robin Simon, *The Portrait in Britain and America,* p. 112. Simon finds that these two accounts both confirm and contradict each other; but the Duchess of Rutland does not specify where the canvas was placed and Lady Burlington simply does not mention the use of a mirror. The essential similarity here lies in Reynolds's constant activity and in his need to take a distant view of his sitter. One of Reynolds's dicta on painting—as recorded in Northcote's *Life,* 2:58—urges his followers to "paint at the greatest distance possible from your sitter, and place the picture near to the sitter, or sometimes under him, so as to see both together": that is, place the picture near to the painter's *view* of the sitter. For Gainsborough's practice, which was to place the sitter and canvas at right angles to each other and to place himself at an equal distance from them, see Hayes, *Gainsborough,* p. 24.

132. Cotton, *Sir Joshua Reynolds' Notes and Observations on Pictures,* p. 58.

133. The mirror survives in a private collection; see Penny, *Reynolds,* no. 165, who quotes the old label on its back: "This cheval-glass . . . was kept in his painting room and placed at an angle so that all his sitters on looking into it saw the progress of their portrait." The mirror was originally a Chippendale fire-screen in the Chinese manner, which the painter converted; it is surprisingly small, standing only 122 centimeters high.

134. Quoted from Beattie's diary by Northcote, *Life,* 1:299.

135. Leslie and Taylor, 2:33.

136. Northcote, *Life,* 1:241–242; cf. Ward, *Conversations,* pp. 208–209.

137. Northcote, *Life,* 2:58, 2:62.

138. Leslie and Taylor, 2:476.

139. Cotton, *Sir Joshua Reynolds' Notes and Observations on Pictures,* pp. 50–51. We might justifiably ask who "fashioned" this gentleman. Lord Holderness com-

missioned Reynolds, we are told, because he admired the portrait Reynolds had recently completed of the young Lords Huntingdon and Stormont, "just arrived from their travels." The portrait can thus be read both as a record of the "natural" attitude they had mastered and as part of the fashioning process.

140. Ward, *Conversations*, pp. 207–208.

141. Northcote, *Life*, 2:7.

142. Ibid.

143. Hudson, *Reynolds*, p. 152.

144. James Prior, *Life of Edmond Malone, Editor of Shakespeare* (London, 1860), p. 434.

145. Reynolds, *Letters*, pp. 147–148.

146. Reynolds, *Portraits*, p. 73.

147. Farington, *Diary*, 4:1137.

148. Northcote, *Life*, 1:299.

149. *Boswell: Laird of Auchinleck, 1778–1782*, ed. Joseph W. Reed and Frederick A. Pottle (London: Heinemann; New York: McGraw-Hill, 1977), pp. 58–59 n.

150. Leslie and Taylor, 2:134; cf. Felicity Owen and David Blayney Brown, *Collector of Genius: A Life of Sir George Beaumont* (New Haven and London: Yale Univ. Press for the Paul Mellon Centre for Studies in British Art, 1988), p. 27. John Ingamells, *The Wallace Collection: Catalogue of Pictures: British, German, Italian, Spanish* (London: Wallace Collection, 1985), p. 148, notes that "Oldfield Bowles's diaries are said to give a different account" ("Information from A. H. Lowther-Pinkerton in 1967").

151. See, for instance, Northcote, *Life*, 2:62, and Ward, *Conversations*, p. 118.

152. Reynolds, *Portraits*, p. 119; see my discussion in the following chapter.

153. Northcote, *Life*, 2:235 n.

154. See Wendorf, *The Elements of Life*, pp. 83–84.

155. Alpers, *Rembrandt's Enterprise: The Studio and the Market* (Chicago: Univ. of Chicago Press, 1988), p. 86.

156. Leslie and Taylor, 2:359–360.

157. Northcote, *Life*, 1:156.

158. John Thomas Smith, *Nollekens and His Times* (London, 1829), 2:295.

159. Northcote, *Life*, 1:106. See Ronald Paulson, *Hogarth*, rev. edn. (New Brunswick, N.J.: Rutgers Univ. Press, 1991–1993), 2:250 and 3:285–286.

160. Quoted by Northcote, *Life*, 1:106; cf. Gwynn, *Memorials*, pp. 85–86.

161. Leslie and Taylor, 2:315.

162. Quoted by Northcote, *Life*, 1:68.

163. Reynolds, *Discourses*, p. 65.

164. Northcote, *Life*, 1:284–285. It is worth noting both Northcote's language here—which transforms the beggarly "object" into the "subject" of a fancy

painting—and the footnote in which he points out that the infant's mother "carelessly" let the child fall from the high perch of the sitter's chair: "by great good fortune," he adds, "the child received no material injury from the accident." Postle, *Sir Joshua Reynolds: The Subject Pictures*, pp. 62–66, provides the fullest account of Reynolds's treatment of children both as models and as subjects in their own right.

165. Leslie and Taylor, 2:184.

166. Ibid., 2:197–198.

4. The Studio and the Stage

1. *Boswell's Life of Johnson*, 4:316 (a view that appears to be contradicted by Reynolds in another of his maxims: see Hilles, *Literary Career*, p. 104).

2. Reynolds, *Portraits*, p. 16.

3. *Boswell: The Ominous Years, 1774–1776*, ed. Charles Ryskamp and Frederick A. Pottle (London: Heinemann; New York: McGraw-Hill, 1963), p. 102.

4. Leslie and Taylor, 2:17.

5. William Roberts, *Memoirs of the Life and Correspondence of Mrs. Hannah More* (London, 1835), 1:59; see also Leslie and Taylor, 2:150. Pat Rogers, "David Garrick: The Actor as Cultural Hero," in *Drama and the Actor*, ed. James M. A. Redmond (Cambridge: Cambridge Univ. Press, 1984), pp. 63–83, points out how difficult it was for people, including prominent politicians, to procure tickets for these performances.

6. Farington, *Diary*, 4:1297.

7. See Terry Castle, *Masquerade and Civilization: The Carnivalesque in Eighteenth-Century English Culture and Fiction* (Stanford: Stanford Univ. Press, 1986), p. 59. Reynolds painted Catherine Hunter with a mask (she had planned her elopement at a masquerade); see Leslie and Taylor, 1:207–208.

8. Leslie and Taylor, 2:507–509.

9. See Hilles, *Literary Career*, ch. 2, for a good summary not just of Reynolds's Shakespearean ambitions, but of his general interest in the theater.

10. Reynolds, *Discourses*, p. 242.

11. Ibid., p. 241.

12. Ibid., p. 239.

13. Leslie and Taylor, 2:383–384; see also 2:489.

14. Ibid., 1:248.

15. Hazlitt, *Complete Works*, 12:111.

16. Reynolds, *Letters*, p. 241.

17. Leslie and Taylor, 2:429–430.

18. Northcote, *Life*, 1:290–291.

19. See, for instance, E. H. Gombrich, "Reynolds's Theory and Practice of Imitation," *Burlington Magazine* 80 (Feb. 1942): 40–45.

20. Reynolds, *Letters,* pp. 35–36.

21. Richard Brilliant begins to explore such a relationship between accomplices in *Portraiture* (London: Reaktion Books; Cambridge: Harvard Univ. Press, 1991), p. 84 and passim.

22. Hazlitt, *Complete Works,* 12:108.

23. Alpers, *Rembrandt's Enterprise: The Studio and the Market* (Chicago: Univ. of Chicago Press, 1988), p. 55.

24. Marshall, *The Figure of Theater: Shaftesbury, Defoe, Adam Smith, and George Eliot* (New York: Columbia Univ. Press, 1986), p. 1. See also, in this connection, Jean-Christophe Agnew, *Worlds Apart: The Market and the Theatre in Anglo-American Thought, 1550–1750* (Cambridge: Cambridge Univ. Press, 1986), esp. ch. 3.

25. Schechner, *Between Theater and Anthropology* (Philadelphia: Univ. of Pennsylvania Press, 1985), p. 36.

26. Ibid., p. 37.

27. Northcote, *Life,* 1:106.

28. Hazlitt, *Complete Works,* 12:109.

29. Ibid. See Erving Goffman, *The Presentation of Self in Everyday Life* (New York: Doubleday, 1959), esp. ch. 1 ("Performances"), and Richard Sennett, *The Fall of Public Man* (New York: Alfred A. Knopf, 1977).

30. Hilles, *Literary Career,* p. 209. Here and elsewhere I have added punctuation in brackets to Hilles's text.

31. Reynolds, *Discourses,* pp. 117–118.

32. Ibid., p. 132.

33. Reynolds, *Portraits,* p. 118. Arthur Sherbo, *The Birth of Shakespeare Studies: Commentators from Rowe (1709) to Boswell-Malone (1821)* (East Lansing, Mich.: Colleagues Press, 1986), pp. 134–135, points out that the missing part of this essay was printed in Edmond Malone's edition of Shakespeare (1790), I, i, 143–144 n., where Reynolds argues that "we should acknowledge this passion for variety and contrarieties [i.e., for tragicomedy] to be the vice of our nature."

34. Reynolds, *Portraits,* pp. 118–119.

35. Ibid., p. 119.

36. Moore, "Reynolds and the Art of Characterization," in *Studies in Criticism and Aesthetics, 1660–1800,* ed. Howard Anderson and John S. Shea (Minneapolis: Univ. of Minnesota Press, 1967), p. 340.

37. Hilles, *Literary Career,* p. 222.

38. Ibid., p. 99.

39. Reynolds, *Portraits,* pp. 157–158.

40. Ibid., p. 118. Burke, we should recall, would say precisely this about Reynolds's own systematizing; see his memorial tribute in his *Correspondence*, 9:329, quoted above in Chapter 2.

41. Reynolds, *Portraits*, p. 40. For a more extensive analysis of Reynolds's sketches of Goldsmith and Johnson, see Wendorf, *The Elements of Life*, pp. 233–237.

42. Reynolds, *Portraits*, p. 86.

43. Ibid., p. 87.

44. Ibid., p. 88.

45. Ibid., p. 94.

46. Ibid., p. 102.

47. See ibid., pp. 96, 104, 105, 103.

48. Marshall, *The Figure of Theater*, p. 38.

49. Ibid., p. 37.

50. Ibid., p. 44.

51. Leslie and Taylor, 2:260.

52. Reynolds, *Portraits*, pp. 98–99.

53. Ibid., p. 94.

54. Walpole, *Anecdotes of Painting in England; [1760–1795]*, vol. 5, ed. Frederick W. Hilles and Philip B. Daghlian (New Haven: Yale Univ. Press; London: Oxford Univ. Press, 1937), p. 61.

55. Waterhouse, *Painting in Britain 1530 to 1790* (1953; 4th edn., Harmondsworth: Penguin, 1978), p. 225. In *Genial Company: The Theme of Genius in Eighteenth-Century British Portraiture* (Nottingham: Nottingham Univ. Art Gallery; Edinburgh: Scottish National Portrait Gallery, 1987), p. 20, Desmond Shawe-Taylor makes the provocative suggestion that Reynolds was also playfully pitting Plato against Aristotle here (as he had before in his parody of *The School of Athens*). See also Martin Postle, "Gainsborough's 'Lost' Picture of Shakespeare: 'A Little out of the Simple Portrait Way,' " *Apollo* 134 (1991): 374–379.

56. Mannings, "Reynolds, Garrick, and the Choice of Hercules," *Eighteenth-Century Studies* 17 (1983–1984): 283.

57. Postle, *Sir Joshua Reynolds: The Subject Pictures*, pp. 21–30, where he persuasively argues for affiliations between this painting and Shaftesbury's *Characteristics* (which includes the "tablature of the Judgement of Hercules"), Ovid's *Amores*, and William Dobson's *Self-Portrait with Nicholas Lanier(?) and Sir Charles Cotterell*. Nicholas Penny notes yet another visual source in Giulio Romano; see "Arising from the Reynolds Exhibition," *Burlington Magazine* 128 (Oct. 1986): 761.

58. Joseph Burke, *English Art, 1714–1800* (Oxford: Clarendon Press, 1976), p. 208, whose source is Joseph Knight, *David Garrick* (1894), pp. 276–280.

59. Moore, "Reynolds and the Art of Characterization," p. 334; Paulson, *Em-

blem and Expression: Meaning in English Art of the Eighteenth Century (London: Thames and Hudson; Cambridge: Harvard Univ. Press, 1975), p. 80.

60. Reynolds, *Portraits,* p. 86.

61. Ibid., pp. 86–87.

62. Ibid., p. 87.

63. Penny, *Reynolds,* pl. 195.

64. Ibid., p. 88.

65. Ibid.

66. Hudson, *Reynolds,* p. 122 (he provides no source). For portraits by Reynolds's contemporaries, see *Thirty Different Likenesses: David Garrick in Portrait and in Performance* (Buxton: Buxton Museum and Art Gallery, 1981).

67. The most convincing analysis I have seen of theatrical discourse devoted to the question of an actor's emotions during the act of performance is an unpublished essay by my colleague Scott Gordon.

68. Reynolds, *Portraits,* pp. 104–105.

69. See Joseph R. Roach, *The Player's Passion: Studies in the Science of Acting* (Newark: Univ. of Delaware Press; London and Toronto: Associated University Presses, 1985), pp. 147–149 and passim; Edward Burns, *Character: Acting and Being on the Pre-Modern Stage* (London: Macmillan, 1990), p. 185; and Michael Wilson's interesting argument (somewhat divergent from mine) in "Garrick, Iconic Acting, and the Ideologies of Theatrical Portraiture," *Word and Image* 6 (1990): 368–394 (esp. pp. 392–393).

70. By "theatrical portraiture" I mean portraits of actors rehearsing, performing on the stage, sitting in the guise of one of the characters they have portrayed (*Mrs. Abington as Miss Prue,* for example), or, as in the case of Harry Woodward, gently alluding to their profession. The scholarship on such portraiture is burgeoning. I am indebted to Edgar Wind, who long ago argued that portraits of actors provide the "acid test" for his comparison of Reynolds and Gainsborough; he shrewdly observes that "the actor is, so to speak, a living metaphor" (*Hume and the Heroic Portrait: Studies in Eighteenth-Century Imagery,* ed. Jaynie Anderson [Oxford: Clarendon Press, 1986], p. 34). More recently, Postle has argued that "it was through theatrical personalities, in particular, that Reynolds exploited the cult of personality and made the greatest inroads into allying his portrait practice to high art"; see *Sir Joshua Reynolds: The Subject Pictures,* p. 20, and also p. 32, where he points out that Reynolds was far more likely to follow the performance of a play than the original text, but also less likely (than Zoffany or William Hamilton) to see his own paintings in a subsidiary role to an actual performance on the stage. See also Shearer West, *The Image of the Actor: Verbal and Visual Representation in the Age of Garrick and Kemble* (London: Pinter Publishers, 1991), ch. 2; Ronald Paulson's provocative discussion in *Breaking and Remaking: Aesthetic Practice in*

England, 1700–1820 (Brunswick, N.J.: Rutgers Univ. Press, 1989), pp. 277–296; and Joseph F. Musser, Jr., "Sir Joshua Reynolds's 'Mrs. Abington as 'Miss Prue,'" *South Atlantic Quarterly* 83 (1984): 176–192, in which he raises some interesting questions but reaches conclusions that are opposed to my own.

71. Quoted by Roger Manvell, *Sarah Siddons: Portrait of an Actress* (New York: Putnam, 1971), p. 98.

72. See Leslie and Taylor, 2:420–421. Wind, *Hume and the Heroic Portrait*, pp. 44–45, adds valuable information about Mary Ann Yates's performance as the Tragic Muse at the Shakespeare Jubilee and subsequently on the London stage; Sarah Siddons had apparently not yet performed this role herself, and Reynolds's portrait of her may therefore have helped to promote her career.

73. Leslie and Taylor, 2:422.

74. Whitley, *Artists and Their Friends*, 2:5.

75. Reynolds, *Discourses*, pp. 222–223.

76. Compare Northcote's similar story of the nobleman absorbed in the contemplation of an old-master painting: *Life*, 1:106, quoted above in Chapter 3.

77. Walpole, *Anecdotes of Painting in England*, ed. Ralph N. Wornum (London, 1849), 1:xvii n.

78. Reynolds, *Discourses*, p. 222.

79. Master Crewe may be unconscious of the dilemma, but very much aware that he is on show, playing a part, as Desmond Shawe-Taylor points out in his perceptive commentary on this painting in *The Georgians: Eighteenth-Century Portraiture and Society* (London: Barrie and Jenkins, 1990), p. 216. Shawe-Taylor also considers the relationship between masquerades and sittings in the studio; see pp. 168–170.

5. Patrons and Politics

1. Malone, 1:iv. The story was circulated by Thomas Percy, according to Allan Cunningham, *Lives of the Most Eminent British Painters, Sculptors, and Architects* (London, 1829–1833), 1:207, who notes "the shrewdness of calculation here." One should recall Burke's remark that "the sound of his name was so well adapted for a title, that it seemed as if it had been chosen for the purpose."

2. Northcote, *Life*, 1:8.

3. The bequest of £330 is mentioned in a letter from Reynolds to John Palmer, 27 Oct. 1769 (Hyde Collection). Reynolds kept a chronology of his family in his early commonplace book, where he mentions a great-grandfather Joshua Reynolds (born 2 Jan. 1609/10) as well as his uncle Joshua, whom he lists as serving as a godfather: "Thursday about ½ an hour after 9 in the morning I Joshua Reynolds was born" (16 July 1723; Yale Center for British Art, MS. Reynolds 33).

4. Yale Center for British Art, MS. Reynolds 8; misquoted and incomplete in Reynolds, *Letters*, pp. 76–77.

5. Northcote, *Life*, 1:131.

6. Ibid., 1:3.

7. William Mason, in Cotton, *Sir Joshua Reynolds' Notes and Observations*, p. 32.

8. Ibid., p. 50. For a full history of Reynolds's relationship with the Edgcumbes, see Leslie and Taylor, 1:267–268.

9. Frederick W. Hilles, "Horace Walpole and the Knight of the Brush," in *Horace Walpole: Writer, Politician, and Connoisseur*, ed. Warren Hunting Smith (New Haven: Yale Univ. Press, 1967), pp. 142–145, 157.

10. Reynolds, *Letters*, p. 68.

11. See Timothy Clifford, Antony Griffiths, and Martin Royalton-Kisch, *Gainsborough and Reynolds in the British Museum* (London: British Museum, 1978), p. 49 (no. 130). For an interesting discussion of the political dimension of such events, see Gerald Jordan and Nicholas Rogers, "Admirals as Heroes: Patriotism and Liberty in Hanoverian England," *Journal of British Studies* 28 (1989): 201–224.

12. Northcote, *Life*, 1:31.

13. Reynolds, *Letters*, pp. 7–8; I have emended the text, in brackets.

14. Cotton, *Sir Joshua Reynolds' Notes and Observations*, p. 81; Leslie and Taylor, 1:140–141.

15. See David Mannings, "The Sources and Development of Reynolds's Pre-Italian Style," *Burlington Magazine* 117 (1975): 212–222, for an examination of some of Reynolds's earliest commissions. In "Reynolds' Portraits of the Stanley Family," *Connoisseur* 194 (Feb. 1977): 85–89, he observes that Reynolds dominated the upper layers of the patronage system because his portraits could be hung with Van Dyck's "without looking absurd" (p. 89).

16. See above, Chapters 1 and 3.

17. See Isaac Kramnick, *The Rage of Edmund Burke: Portrait of an Ambivalent Conservative* (New York: Basic Books, 1977), and John Cannon, *Aristocratic Century: The Peerage of Eighteenth-Century England* (Cambridge: Cambridge Univ. Press, 1984), pp. 167–168.

18. Reynolds, *Discourses*, p. 133.

19. Quoted by Conor Cruise O'Brien, *The Great Melody: A Thematic Biography and Commented Anthology of Edmund Burke* (Chicago: Univ. of Chicago Press, 1992), p. 394.

20. *Boswell's Life of Johnson*, 1:447. For a similar view, see Adam Smith, "Of Propriety," ch. 2 ("Of the origin of Ambition, and of the distinction of Ranks"), in *The Theory of Moral Sentiments*, ed. D. D. Raphael and A. L. Macfie (Oxford: Clarendon Press, 1976), pp. 50–58. For an exposition of the political consequences

of such a system, see J. G. A. Pocock, "The Classical Theory of Deference," *American Historical Review* 81 (1976): 516–523 (where deference is "not only a voluntary but also a political act"), and J. C. D. Clark, *English Society, 1688–1832: Ideology, Social Structure and Political Practice during the Ancien Régime* (Cambridge: Cambridge Univ. Press, 1985), pp. 93–118 ("The Social Theory of Elite Hegemony"). E. P. Thompson, *Customs in Common* (New York: The New Press, 1991), offers a view of subordination based on the uneasy relationship between patrician and plebian cultures: "the larger outlines of power, station in life, political authority, appear to be as inevitable and irreversible as the earth and sky. . . . This does not preclude resentment or even surreptitious acts of protest or revenge; it does preclude affirmative rebellion" (p. 43).

21. *Boswell's Life of Johnson,* 1:246.

22. Ibid.; see Northcote, *Life,* 1:73, for an even more embarrassing visit by Johnson, who was mistaken for a robber by the maidservant.

23. Northcote, *Life,* 1:71–72.

24. The exception, of course, is Gainsborough, who is said to have slashed one canvas with a penknife when a patron disapproved of it, and to have told a nobleman, "Damn the dimple in your chin," when he was asked to overlook it. See Jack Lindsay, *Thomas Gainsborough: His Life and Art* (New York: Universe Books, 1981), pp. 37, 55.

25. Leslie and Taylor, 1:128.

26. Hazlitt, *Complete Works,* 12:110. See my discussion in the preceding chapter.

27. Ibid., 11:303–304. Northcote speculates that Reynolds's practice may have had its origins in his initial awkwardness, or in his confusion in addressing the variety of characters he met.

28. Ward, *Conversations,* p. 121.

29. Reynolds, *Letters,* p. 195.

30. Ibid., p. 205.

31. Ibid., p. 207.

32. Northcote, *Life,* 1:119 and 2:267.

33. Northcote, *Life,* 1:294; John Thomas Smith, *Nollekens and His Times* (London, 1829), 2:295.

34. Northcote, *Life,* 2:9.

35. Gwynn, *Memorials,* p. 234; see Leslie and Taylor, 2:199, for a different version.

36. John Opie, *Lectures on Painting delivered at the Royal Academy . . . to which are prefixed a memoir by Mrs. Opie* (London, 1809), pp. 39–40. I am grateful to Alvaro Ribeiro for this reference as well as for drawing my attention to a letter of 29 Jan. 1811 from Sarah Harriet Burney to Charlotte (Francis) Barrett: "I am very apt to smirk at such grey jockies rather hypocritically—Like Sir Joshua Reynolds'

he, he, he, recorded in her Memoir of her husband by clever Mrs. Opie" (Berg Collection, New York Public Library).

37. Northcote, *Life,* 1:39.

38. Ibid., 1:46. See also Hazlitt, *Complete Works,* 11:303; Leslie and Taylor, 1:46–47 and 1:55; and Penny, *Reynolds,* pp. 20–21.

39. *Boswell: The Applause of the Jury, 1782–1785,* ed. Irma S. Lustig and Frederick A. Pottle (London: Heinemann; New York: McGraw-Hill, 1981), p. 339.

40. Farington, *Diary,* 10:3645.

41. [Frances Burney D'Arblay], *Memoirs of Doctor Burney* (London, 1832), 2:280–282. One should append to this outburst the lines Reynolds placed in Johnson's mouth in one of his imaginary dialogues: "What fell into [Garrick's] lap unsought, I have been forced to claim. I began the world by fighting my way. There was something about me that invited insult, or at least a disposition to neglect; and I was equally disposed to repel insult and to claim attention, and, I fear, continue too much in this disposition now it is no longer necessary." See Reynolds, *Portraits,* p. 101, and Wendorf, *The Elements of Life,* pp. 235–238.

42. Lipking, *The Ordering of the Arts in Eighteenth-Century England* (Princeton: Princeton Univ. Press, 1970), p. 205, where he speculates that the polished embellishments of this passage suggest that the painter had a hand in composing the written version of his speech. Cf. Barrell, *The Political Theory of Painting,* pp. 133–134, who closely examines Reynolds's use of "the extensive prospect," which was often invoked as a metaphor for "the extensive political, moral and social comprehension that characterised, it was claimed, the aristocratic member" of society. Barrell argues that, in Reynolds's outburst, such a prospect does not function metaphorically for the aristocracy—for whom it simply represents a figure for the eminence they enjoy "as a result of the nature and quantity of their inherited fortunes"—so much as for "whoever can appropriately be represented as a labourer."

43. Northcote, *Life,* 2:40–41.

44. Johnson, *Letters,* 2:353.

45. Northcote, *Life,* 2:40–41.

46. Reynolds, *Letters,* pp. 106–107.

47. Reynolds had earlier asked Garrick whether he would consider putting Joseph's *Zaphira* on the stage (Reynolds, *Letters,* pp. 40–41). Garrick was suitably annoyed: "I hate this traffick wth friends." See *The Letters of David Garrick,* ed. David M. Little and George M. Kahrl (Cambridge: Harvard Univ. Press, 1963), 3:954 (no. 859) and 3:1002 (no. 903).

48. Northcote, *Life,* 2:41. Townshend actually made Palmer Chancellor of Ferns.

49. On Rutland as a patron, see Cannon, *Aristocratic Century,* p. 67 n., who notes that by 1818 the 6th duke had twenty-nine livings in his hands, the third largest

number in the country; and Iain Pears, *The Discovery of Painting: The Growth of Interest in the Arts in England, 1680–1768* (New Haven and London: Yale Univ. Press for the Paul Mellon Centre for Studies in British Art, 1988), pp. 157 and 259 n. 4.

50. Yale Center for British Art, MS. Reynolds 14 (misdated 1782 in the file).

51. Reynolds, *Letters*, pp. 110–111.

52. Ibid., p. 126.

53. Ibid., pp. 125–126.

54. Ibid., pp. 131–133.

55. Ibid., p. 139.

56. Ibid., p. 145.

57. Ibid., p. 149.

58. Ibid., pp. 150–151.

59. Ibid., p. 157.

60. Ibid., pp. 157–158.

61. Ibid., pp. 160–161.

62. Ibid., pp. 162–163. The danger was not completely over, of course, because Rutland died in 1787. In a letter to Joseph Palmer of 7 Dec., Reynolds writes that "I really condole with you on the loss of your Patron the Duke of Rutland[.] you are not likely to find another with whom I have equal interest, I had even a demand upon him having made him a considerable present of a Picture, indeed two Pictures, but so near his death that I never receiv'd his thanks for them." Reynolds nevertheless mentions several other possible patrons and, alluding to a poem by Swift, writes that "you will be the Hare with many friends if you do not get something amongst all those great men" (Yale Center for British Art, MS. Reynolds 24).

63. Reynolds, *Letters*, p. 77. For another example of cross-patronage, see Nigel Aston, "Lord Carysfort and Sir Joshua Reynolds: The Patron as Friend," *Gazette des Beaux-Arts* 112 (1988): 205–210.

64. Northcote, *Life*, 1:160–161.

65. Leslie and Taylor, 1:366.

66. Hudson, *Reynolds*, p. 71.

67. The assessment is Christopher Lloyd's in *Gainsborough and Reynolds: Contrasts in Royal Patronage* (London: The Queen's Gallery, 1994), p. 17. See also Martin Postle, "A Taste for History: Reynolds, West, George III, and George IV," *Apollo* 138 (1993): 186–191.

68. Lloyd, *Gainsborough and Reynolds*, p. 17.

69. See, for example, Northcote, *Life*, 2:249–250 (quoted later in this chapter).

70. For a succinct summary of the complicated political world in which Reynolds practiced his art, see Penny, *Reynolds*, p. 35, and Leslie and Taylor, 1:225 and 1:273–274. Paul Monod, "Painters and Party Politics in England, 1714–1760," *Eighteenth-Century Studies* 26 (1992–1993): 367–398, provides a full rehearsal of

party affiliations among artists, drawing attention particularly to the association of Italian art and history-painting with Jacobitism in England. Reynolds, he concludes, was the "first major British artist to carry no discernible taint from study abroad"; his "Italianate style became hugely popular among government Whigs after 1753" (p. 376). See also Ellis Waterhouse, "Reynolds's Sitter-Book for 1755," *Walpole Society* 41 (1966–1968): 112–167.

71. Jeremy Black and Nicholas Penny, "Letters from Reynolds to Lord Grantham," *Burlington Magazine* 129 (1987): 730–734; Reynolds, *Portraits*, p. 152.

72. *The Literary Works of Sir Joshua Reynolds,* ed. Henry William Beechy [*sic*] (London, 1846), 1:171–172 n.; Leslie and Taylor, 2:449.

73. Quoted by Ozias Humphry to his brother William, 19 Sept. 1764 (Hyde Collection); reprinted in *Johnsonian Miscellanies,* 2:401–402.

74. Pasquin, *Memoirs of the Royal Academicians; Being an Attempt to Improve the National Taste* (London, 1796), rpt. with *An Authentic History,* introd. R. W. Lightbown (London: Cornmarket Press, 1970), p. 69.

75. Quoted by Leslie and Taylor, 2:474.

76. *Reminiscences of Henry Angelo, with Memoirs of His Late Father and Friends* (London, 1828–1830), 1:359–360, 1:363; Northcote is quoted by Whitley, *Artists and Their Friends,* 1:255–256.

77. Hilles, *Literary Career,* p. 254. Most of the passages I quote from the "Apologia" are drawn from this edition, but I have, for the sake of clarity, revised Hilles's method of transcribing the manuscript: words in square brackets are emendations; words in angled brackets were deleted in the manuscript.

78. Ibid., p. 249.

79. See, for example, Sidney C. Hutchison, *The History of the Royal Academy, 1768–1968* (London: Chapman and Hill, 1968), who characterizes the affair as another "pin-prick for Reynolds" (pp. 69–70). William Sandby, writing a similar history in 1862, took the matter more seriously but misjudged the underlying forces: "That such a trifling circumstance should have estranged one so eminent in his art, and so revered by his brethren, would indeed have been a disaster to the rising Academy, and it is greatly to the credit of the Council that they immediately took measures for bringing about a reconciliation between them and the President"; see *The History of the Royal Academy of Arts from Its Foundation in 1768 to the Present Time* (London, 1862), 1:167. A welcome exception to the usual silence accorded the Bonomi affair is Martin Postle's intelligent commentary in *Sir Joshua Reynolds: The Subject Pictures;* see esp. pp. 217–218, where Postle points out the popular linkage of Reynolds's paintings to Burke's politics, and pp. 274–275, where he examines Reynolds's conception of "the Academy as a microcosm of a larger European artistic community."

80. Hilles, *Literary Career,* p. 176.

81. Malone is quoted by Farington, *Diary*, 2:478.

82. Northcote, *Life*, 2:252.

83. Royal Academy Council Minutes, 11 Dec. 1789.

84. Ibid.

85. Reynolds, *Letters*, p. 192.

86. Royal Academy General Assembly Minutes, 3 March 1790.

87. Ibid.

88. Northcote, *Life*, 2:259.

89. Reynolds, *Letters*, pp. 194–199.

90. Hilles, *Literary Career*, p. 262.

91. Ibid.

92. Ibid.

93. Ibid.

94. Ibid., pp. 264–265.

95. *Observations on the Present State of the Royal Academy*, pp. 8–9.

96. For the distinction, see Leslie and Taylor, 1:294, and—for a highly critical view—Robert Strange, *An Inquiry Into the Rise and Establishment of the Royal Academy of Arts* (London, 1775), pp. 99–100. David Solkin has carefully analyzed the ideological differences between the Society of Artists and the fledgling Academy in *Painting for Money: The Visual Arts and the Public Sphere in Eighteenth-Century England* (New Haven and London: Yale Univ. Press for the Paul Mellon Centre for Studies in British Art, 1993), pp. 259–276, where he links contemporary debates over these two institutions with the recent Wilkite controversies and with a much older and broader discussion of the role of the arts in the public sphere. Solkin notes that, as early as his *Idler* essays of 1759, Reynolds served as the "leading spokesman" for a view of artistic behavior that was not inclined "to surrender its authority on matters of taste to the large and relatively uninformed art public," and therefore eagerly seconded Shaftesbury's efforts "to define both a standard of artistic dignity and a set of criteria for membership of the 'republic of taste' " (pp. 254–255). Patricia Crown offers a similar analysis of Reynolds's resistance to "the popularity and accessibility of the modern [Rococo] style"; see "British Rococo as Social and Political Style," *Eighteenth-Century Studies* 23 (1989–1990): 269–282.

97. It was widely thought (at least by Reynolds's critics) that it was the promise of a knighthood that swayed the painter into Chambers's camp. See, among others, Strange, *An Inquiry*, p. 99, and [William Thompson], *The Conduct of the Royal Academicians* (London, 1771), p. 46.

98. Reynolds, *Letters*, p. 19.

99. Ibid., p. 20.

100. Hilles, *Literary Career*, pp. 185–186, a discarded draft of the preface to a

catalogue for "Ralph's Exhibition," which enabled Reynolds to sell his collection of old-master paintings (their purchase, at a modest price, had already been rejected by the Royal Academy).

101. Johnson, *Letters*, 4:375.

102. Reynolds, *Letters*, p. 112. Reynolds was not the only figure to compare himself to the King's ratcatcher when offered such a title: see Thomas Gray's refusal of the poet laureateship in 1757 in the *Correspondence of Thomas Gray*, ed. Paget Toynbee and Leonard Whibley (Oxford: Clarendon Press, 1935), 2:543–544.

103. Reynolds, *Letters*, p. 113.

104. Johnson, *Letters*, 4:388.

105. See Penny, *Reynolds*, pp. 284–285.

106. Farington, *Diary*, 3:31; cf. Northcote, *Life*, 2:145. Significant as it was, the Bonomi affair was but one episode in a series of disputes at the Academy that usually pitted Reynolds against the Academy's "Viceroy." Among the other contentious issues were the possible adoption of uniforms by the Academicians, decisions about picture-hanging at the annual exhibitions, and eventually the question of whether the deceased President would be allowed to lie in state in Somerset House before his funeral took place in St. Paul's. See Hudson, *Reynolds*, pp. 126, 221, 228; and Northcote, *Life*, 2:218.

107. *Self Portraits*, pp. 43–44.

108. Royal Academy MS. Rey / 3 / 90v.

109. Cf. Hudson, *Reynolds*, pp. 219–220, who quotes from a contemporary poem in which Chambers is guilty of "mischievous *browing*."

110. Hilles, *Literary Career*, p. 260; Royal Academy MS. Rey / 3 / 93.

111. Hilles, *Literary Career*, p. 262.

112. Ibid., p. 256 (cf. p. 262); Royal Academy MS. Rey / 3 / 93.

113. Hilles, *Literary Career*, p. 266.

114. Ibid.

115. Ibid., p. 276.

116. Ibid., p. 275.

117. Ibid., p. 276.

118. Ibid., p. 268.

119. Ibid., p. 269.

120. Ibid., p. 270.

121. Ibid.

122. Ibid., p. 261.

123. Noted by Hilles, *Literary Career*, p. 271 n.

124. Burke, *Correspondence*, 6:66, 6:209.

125. Hilles, *Literary Career*, p. 271.

126. Ibid., p. 253.

127. Ibid., p. 255.

128. Ibid., pp. 253–254.

129. Ibid., p. 253.

130. Royal Academy MS. Rey / 3 / 93.

131. Hilles, *Literary Career*, p. 265.

132. Ibid., p. 266.

133. Royal Academy MS. Rey / 3 / 93.

134. Quoted by Hudson, *Reynolds*, p. 219; the signers were Barry, Nollekens, Northcote, Opie, Rigaud, Thomas Sandby, and Zoffany (three of them, it should be noted, "Foreigners").

135. Hilles, *Literary Career*, p. 274.

136. Ibid.

137. Reynolds, *Letters*, p. 193.

138. Haydon, *Diary,* 4:573 (July 1839). Earlier, in 1826, Haydon noted that "the party that expelled Reynolds & brought the Academy into contempt is dead & powerless. This party I attacked & successfully. Young men of talent have been admitted, & the whole state & condition are improved" (3:90).

139. Leslie and Taylor, 2:585–586. Reynolds's good "spirits" appear to have continued in the ensuing two years. In 1792 Burke wrote that "nothing can equal the Tranquility with which he views his End. He congratulates himself on it as an happy conclusion of an happy life" (*Correspondence,* 7:41).

140. Reynolds, *Discourses,* p. 266.

141. Ibid., p. 265.

142. Ibid.

143. Felton, *Testimonies,* p. 75.

144. Ibid., p. 78. Cf. a similar speculation in one of the newspapers after Reynolds resigned: "Sir Joshua's vacant chair, we suppose, will be cut into pieces by the students, to have some relic of their ingenious President; as the students in painting at Antwerp did by that of Rubens, after his decease" (quoted by Felton, *Testimonies,* p. 87 n.). For other contemporary accounts in the press, see Hudson, *Reynolds,* p. 219, and Hilles, *Literary Career,* p. 175.

145. Felton, *Testimonies,* p. 81. In 1785 Pindar defended Reynolds from the machinations of his colleagues at the Academy by attacking Sir William Chambers: "Though *thou* 'midst dulness mayst be pleased to shine, / Reynolds shall ne'er sit cheek by jowl with swine" (Leslie and Taylor, 2:473).

146. Farington, *Memoirs,* p. 111.

147. Ibid., p. 114.

148. Felton, *Testimonies,* pp. 86–87.

149. *Observations,* p. 11.

150. Ibid., p. 4.

151. Ibid., pp. 6–7.

152. Ibid., p. 9.

153. Ibid., p. 17.

154. Ibid., pp. 18–19.

155. Gwynn, *Memorials*, p. 217.

156. Ibid., pp. 10–11.

157. Ibid., p. 11.

158. *The Letters of Edward Gibbon,* ed. J. E. Norton (London: Cassell, 1956), no. 761 (3:194). Not everyone agreed. Dr. Michael Lort, writing to George Steevens on 19 Feb. 1790, noted that "Sr Joshua sure[?] has managed ill to have such a majority agt him, and will make me and others not in the least suspect he must have been in the wrong—in chusing a nail that would not drive" (Hyde Collection).

159. "Fresnoy," in the *Middlesex Journal;* cited by Whitley, *Artists and Their Friends,* 1:251–252.

160. Hilles, *Literary Career,* p. 267.

161. Leslie and Taylor, 2:594; cf. Whitley, *Artists and Their Friends,* 2:134–135.

162. Reynolds, *Discourses,* p. 282.

163. James Prior, *Memoir of the Life and Character of the Right Hon. Edmund Burke* (London, 1824), pp. 401–402, who also notes that Burke "urged the strongest remonstrances against the application of such lines to him" and that Reynolds reluctantly suppressed the edition, instead issuing prints without the verses, which Burke would then substitute for an earlier print whenever he found one in the house of a friend.

164. Burke's preliminary draft began, "Reflections on Certain Proceedings of the Revolution Society"; see James T. Boulton, *The Language of Politics in the Age of Wilkes and Burke* (London: Routledge and Kegan Paul; Toronto: Univ. of Toronto Press, 1963), p. 77.

165. *Boswell's Life of Johnson,* 3:261.

166. Gwynn, *Memorials,* p. 236.

167. Northcote, *Life,* 2:249–250.

168. *Letters of James Boswell,* ed. Chauncey Brewster Tinker (Oxford: Clarendon Press, 1924), 2:319.

169. Leslie and Taylor, 2:544 n.

170. Malone, 1:lvi.

171. Ibid., 1:lvii (my emphasis).

172. Ibid.

173. Hilles, *Literary Career,* p. 276. Malone's invocation of "turbulent . . . spirits," moreover, is an exact harbinger (or echo) of a phrase in the "Apologia" (Royal Academy MS. Rey / 3 / 93).

174. Burke, *Correspondence,* 6:41.

175. Prior, *Memoir of . . . Burke,* p. 408: Burke "submitted to him in manuscript the Reflections on the Revolution in France, to which the painter gave the highest praise." See also the fifth edition of Prior's life (London, 1854), p. 306; Burke, *Correspondence,* 6:85–92; and Boulton, *The Language of Politics,* pp. 75–82. It is worth noting that Burke's and Fox's opposing Parliamentary speeches on the Revolution were delivered in February as well; see Burke, *Correspondence,* 6:81–82.

176. Burke, *Reflections,* p. 127. David Bindman, " 'Revolution-Soup, Dished Up with Human Flesh and French Pot-Herbs': Burke's *Reflections* and the Visual Culture of Late Eighteenth-Century England," in *British Art, 1740–1820: Essays in Honor of Robert R. Wark* (San Marino, Calif.: Huntington Library, 1992), pp. 125–143, argues that Burke was influenced by visual traditions as he wrote, and suggests that the figure of Marie Antoinette bears "comparison with Reynolds's paintings in the elevated style of aristocratic beauties" (p. 128).

177. Burke, *Reflections,* p. 105.

178. Ibid., p. 127.

179. *The Guardian,* ed. John Calhoun Stephens (Lexington: Univ. Press of Kentucky, 1982), No. 162 (p. 528); see my discussion above, in Chapter 1.

180. Burke, *Reflections,* p. 128.

181. Ibid., p. 129.

182. Ibid., p. 81.

183. Ibid.

184. For Reynolds on prejudice, see Hilles, *Literary Career,* pp. 136, 157–158. Barrell, *The Political Theory of Painting,* p. 146, suggests that Reynolds may anticipate Burke here, and later notes (p. 159), as I do later in the chapter, the relationship between the *Reflections* and Reynolds's Ironic Discourse.

185. Burke, *Reynolds,* p. 137.

186. Ibid., p. 206.

187. Ibid., p. 217.

188. Ibid., p. 138.

189. Hirschman, *The Rhetoric of Reaction: Perversity, Futility, Jeopardy* (Cambridge: Harvard Univ. Press, 1991), p. 7; for his analysis of Burke, see esp. p. 15.

190. Burke, *Reflections,* p. 217.

191. Reynolds, *Discourses,* p. 141.

192. Burke, *Reflections,* pp. 59, 62.

193. Hilles, *Literary Career,* p. 276.

194. See Burke, *Reflections,* pp. 61, 64, 89, 90, 97, 138, and passim.

195. Ibid., pp. 72, 85–86, 118–19, 143, 176, 216, and 292. Both Boulton, *The Language of Politics,* pp. 111–112, and F. P. Lock, *Burke's Reflections on the Revolution in France* (London: Allen and Unwin, 1985), p. 128, draw attention to the importance of this metaphor in Burke's thought.

196. Bromwich, *A Choice of Inheritance: Self and Community from Edmund Burke to Robert Frost* (Cambridge: Harvard Univ. Press, 1989), p. 54. Cf. Boulton, *The Language of Politics*, pp. 105–109, and J. G. A. Pocock's introduction to his edition of Burke's *Reflections* (Indianapolis: Hackett, 1987), p. xliv: "Burke's central doctrine is that the social order antedates the human intellect and sets the moral and practical conditions under which both theory and practice must be carried on."

197. Hilles, *Literary Career*, pp. 188–189. Reynolds's relationship to contemporary French culture has never been thoroughly explored; for two interesting steps in this direction, both examining Reynolds's knowledge of French art, see Robert Rosenblum, "Reynolds in an International Milieu," in Penny, *Reynolds*, pp. 43–54, and J. Douglas Stewart, "Pigalle, the Antique, *et al.*; The Genesis of Reynolds's *Banastre Tarleton*," *Gazette des Beaux-Arts* 112 (1988): 261–268.

198. Reynolds, *Discourses*, p. 135; he repeats this argument in the "Apologia" (Hilles, *Literary Career*, p. 255).

199. Reynolds, *Discourses*, p. 269.

200. Ibid., p. 270.

201. Reynolds wrote part of it on the back of a letter to the *Gentleman's Magazine* that was published in July 1791, thus enabling us to date it fairly accurately; see Reynolds, *Portraits*, p. 124. David Bindman, *The Shadow of the Guillotine: Britain and the French Revolution* (London: British Museum, 1989), p. 67, includes the Ironic Discourse in his extensive survey of artistic responses to the French Revolution in England. The bicentenary of the Revolution in 1989 has helped to generate a great deal of fresh scholarship, although significant studies, such as Ronald Paulson's *Representations of Revolution, 1789–1820* (New Haven: Yale Univ. Press, 1983), and W. J. T. Mitchell's chapter on Burke in *Iconology: Image, Text, Ideology* (Chicago: Univ. of Chicago Press, 1986), had already appeared. In addition to Bindman's important book, see the monographs by Steven Blakemore, *Burke and the Fall of Language: The French Revolution as Linguistic Event* (Hanover, N.H.: Univ. Press of New England, 1988); Seamus Deane, *The French Revolution and Enlightenment in England, 1789–1832* (Cambridge: Harvard Univ. Press, 1988); and Barton R. Friedman, *Fabricating History: English Writers on the French Revolution* (Princeton: Princeton Univ. Press, 1988). There are also useful collections of essays edited by Blakemore, *Burke and the French Revolution: Bicentennial Essays* (Athens: Univ. of Georgia Press, 1992); Ceri Crossley and Ian Small, *The French Revolution and British Culture* (Oxford: Oxford Univ. Press, 1989); H. T. Dickinson, *Britain and the French Revolution, 1789–1815* (New York: St. Martin's Press, 1989); Bernadette Fort, *Fictions of the French Revolution* (Evanston, Ill.: Northwestern Univ. Press, 1991); James A. W. Heffernan, *Representing the French Revolution: Literature, Historiography, and Art* (Hanover, N.H.: Dartmouth College/Univ. Press of New

England, 1992); and Mark Philp, *The French Revolution and British Popular Politics* (Cambridge: Cambridge Univ. Press, 1991).

202. Burke, *Reflections*, p. 216.

203. Reynolds, *Portraits*, p. 130.

204. Ibid., p. 127.

205. Ibid., p. 128.

206. Ibid., p. 130.

207. Ibid.

208. Ibid., pp. 136–138.

209. Reynolds, *Discourses*, p. 269.

210. Reynolds, *Portraits*, pp. 140–142.

211. *Boswell: The Ominous Years, 1774–1776*, ed. Charles Ryskamp and Frederick A. Pottle (London: Heinemann; New York: McGraw-Hill, 1963), p. 140.

212. Hilles, *Literary Career*, pp. 188–189.

213. See Reynolds, *Portraits*, pp. 12–24.

214. Ibid., pp. 19–20.

215. Burke, *Correspondence*, 8:252.

216. Farington, *Diary*, 2:319. Boswell was, however, sympathetic to his friend's plight. He wrote that Reynolds was "shamefully used by a junto of the Academicians," and following Reynolds's death he was aware of the troublesome nature of his "democratic" colleagues at the Royal Academy; see *Boswell: The Great Biographer, 1789–1795*, ed. Marlies K. Danziger and Frank Brady (London: Heinemann; New York: McGraw-Hill, 1989), pp. 43, 267. For an interesting discussion of the Academy later in the decade, see Aileen Ward, " 'Sr Joshua and His Gang': William Blake and the Royal Academy," in *William Blake and His Circle* (San Marino, Calif.: Huntington Library, 1989), pp. 75–95.

217. Crown, "This Is Not a Conclusion," *Eighteenth-Century Studies* 25 (1991–1992): 618.

Acknowledgments

The research for this book was begun with the support of a National Endowment for the Humanities Research Fellowship at the Newberry Library in Chicago, and was completed with an equally generous fellowship from the John Simon Guggenheim Memorial Foundation. I am indebted to Richard Brown, Charles Cullen, Ruth Hamilton, and Mary Beth Rose for a most productive year at the Newberry, and to Joel Connaroe and G. Thomas Tanselle of the Guggenheim Foundation for enabling me to pursue my research over an extended period of time. Jean Hagstrum, James King, Lawrence Lipking, Charles Ryskamp, and Barbara Stafford wrote on behalf of this project in its initial stages; I am grateful to them for their early—and continuing—interest in an enterprise that has inevitably taken many unexpected turns. I also wish to thank Lawrence Dumas, Dean of the College of Arts and Sciences at Northwestern University, and Richard De Gennaro, Roy E. Larsen Librarian of Harvard College, for their personal and institutional support.

Because this book draws heavily on unpublished manuscript material, it gives me great pleasure to thank the collectors and institutions who have so graciously allowed me to quote from their collections: Mary Hyde Eccles; the Beinecke Rare Book and Manuscript Library, Yale University; the Berg Collection of the New York Public Library;

the Henry E. Huntington Library; the Library of the Royal Academy of Arts; the Yale Center for British Art; and the owner of a private collection. I am also indebted to this anonymous owner and to Dr. John Edgcumbe for permission to refer to and illustrate objects of clothing, furniture, and personalia that were once in Reynolds's possession.

This is, at the same time, a book that is heavily dependent upon printed sources. In addition to the Newberry Library, I wish to extend my thanks to the Bancroft Library (Peter Hanff), the Beinecke Library (Ralph Franklin, Vincent Giroud, Steven Parks), the Boston Athenaeum (Rodney Armstrong), the British Library (Nicolas Barker), Harvard's Fine Arts Library (Mary Clare Altenhofen, Jeffrey Horrell, Cathrine Wolcott), the Harry Ransom Humanities Research Center (Thomas Staley), the Huntington Library (William Moffett), the New York Public Library, Northwestern University Library (Rolf Erickson, Russell Malone), the Paul Mellon Centre for Studies in British Art (Brian Allen), Princeton University Library (Charles Green, William Joyce, Margaret Sherry), the Library of the Royal Academy of Arts (MaryAnne Stevens), the Library of the Victoria and Albert Museum, Harvard's Widener Library (Barbara Mitchell), and the Yale Center for British Art (Elisabeth Fairman, Patrick Noon, Duncan Robinson). My colleagues in the Houghton Library have provided unstinting support for this project, as in all of our endeavors together. I wish to thank Roxana Breckner, Scott Gordon, Dennis Marnon, and Mariana Oller in particular for their assistance in the preparation of this book.

For permission to reprint material first published in somewhat different form, I thank the Clarendon Press for material from *Tradition in Transition,* ed. James Basker and Alvaro Ribeiro, and from my book *The Elements of Life;* the National Endowment for the Humanities for material from the journal *Humanities;* and the Princeton University Library for material from the *Princeton University Library Chronicle.* Portions of this book have been presented as talks and lectures at the College Art Association's annual meeting, Harvard's Center for Literary and Cultural Studies, the Johnson Society of the Midwest, Lafayette College, the University of New Hampshire's interdisciplinary faculty

seminar, Williams College, the Yale Center for British Art, and regional and national meetings of the American Society for Eighteenth-Century Studies.

The list of colleagues who have read parts or all of this book in manuscript would be embarrassingly long if it did not also remind me of the many friendships such a project continues to sustain. I therefore most warmly thank Brian Allen, Hugh Amory, Helen Ashmore, Leonard Barkan, Walter Jackson Bate, Martin Battestin, Linda Docherty, Mary Hyde Eccles, John Edgcumbe, Eleanor Garvey, Scott Gordon, Lawrence Lipking, David Mannings, Dennis Marnon, Heather McPherson, Elizabeth Morse, Ronald Paulson, Ruth Perry, Martin Postle, Alvaro Ribeiro, John Riely, Joseph Roach, Wendy Roworth, Paul Staiti, Janice Thaddeus, and Bernard Timberg.

The six years I have spent researching and writing this book have been regularly punctuated by extended conversations with my fellow Reynoldsians, who have been—to a person—uncommonly generous with their knowledge and advice. I therefore wish to pay particular tribute to Brian Allen and John Edgcumbe (who are preparing a new edition of the correspondence), Christopher Lloyd (who mounted the Gainsborough and Reynolds exhibition at the Queen's Gallery in 1994), David Mannings (who curated the exhibition of self-portraits in Plymouth in 1992 and is preparing the vast catalogue raisonné), Martin Postle (who sent me proofs of *Sir Joshua Reynolds: The Subject Pictures* and who is completing a general critical study of the paintings), John Riely (who is preparing a scholarly biography), and Wendy Roworth (who curated the important Angelica Kauffman exhibition in Brighton and York in 1992). I also wish to thank Michael C. Copland-Griffiths, D.C., and his family for many acts of kindness.

This is the third book my editor Lindsay Waters and I have collaborated on, and I am pleased that he has finally allowed me to express my appreciation of his long-standing support. To him and to his colleagues at Harvard University Press, particularly Nancy Clemente, Alison Kent, Annamarie McMahon, and William Sisler, I remain extremely grateful.

Index